THE RHETORIC OF PERSPECTIVE

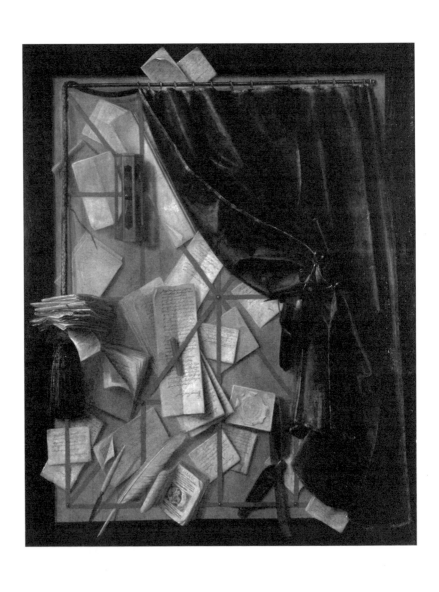

THE RHETORIC OF
PERSPECTIVE

REALISM

AND

ILLUSIONISM IN

SEVENTEENTH-

CENTURY DUTCH

STILL-LIFE

PAINTING

HANNEKE GROOTENBOER

THE UNIVERSITY OF CHICAGO PRESS

CHICAGO AND LONDON

Hanneke Grootenboer is a Mellon Postdoctoral Fellow and Lecturer in the Department of Art History and Archaeology at Columbia University.

The University of Chicago Press, Chicago 60637

The University of Chicago Press, Ltd., London

© 2005 by The University of Chicago

All rights reserved. Published 2005

Printed in the United States of America

14 13 12 11 10 09 08 07 06 2 3 4 5

ISBN: 0-226-30968-1

Publication of this book has been aided by a grant from the Millard Meiss Publication Fund of the College Art Association.

MM

Frontispiece: Cornelius Gijsbrecht, *Trompe l'Oeil Letter Rack* (1668). Courtesy of Museum voor Schone Kunsten, Ghent.

Library of Congress Cataloging-in-Publication Data

Grootenboer, Hanneke.

The rhetoric of perspective : realism and illusionism in seventeenth-century Dutch still-life painting / Hanneke Grootenboer.

p. cm.

Includes bibliographical references and index.

ISBN 0-226-30968-1 (alk. paper)

1. Still-life painting, Dutch—17th century. 2. Visual perception. 3. Realism in art—Netherlands. I. Title.

ND1393.N43G76 2005

2004020661

⊗ The paper used in this publication meets the minimum requirements of the American National Standard for Information Sciences—Permanence of Paper for Printed Library Materials, ANSI Z39.48-1992.

FOR MY PARENTS

I would now happily remain at the table while it was being cleared. . . .
I cherished as though for their poetic beauty, the broken gestures of
the knives still lying across one another, the swollen convexity of a dis-
carded napkin into which the sun introduced a patch of yellow velvet,
the half-empty glass which thus showed to greater advantage the no-
ble sweep of its curved sides and, in the heart of its translucent crystal,
clear as frozen daylight, some dregs of wine, dark but glittering with
reflected lights, the displacement of solid objects, the transmutation of
liquids by the effect of light and shade, the shifting colours of the plums
which passed from green to blue and from blue to golden yellow in the
half-plundered dish, the chairs, like a group of old ladies, that came
twice daily to take their places round the white cloth spread on the
table as on an altar at which were celebrated the rites of the palate, and
where in the hollows of the oyster-shells a few drops of lustral water
had remained as in tiny holy water stoups of stone; I tried to find beauty
there where I had never imagined before that it could exist, in the most
ordinary things, in the profundities of "still life."

—Marcel Proust, *Remembrance of Things Past*

CONTENTS

ILLUSTRATIONS

ACKNOWLEDGMENTS

This book owes a debt of gratitude to many individuals without whose support, encouragement, and feedback it could not have been written. Michael Ann Holly, Douglas Crimp, Ernst van Alphen, and Mieke Bal taught me how to read paintings and look critically at texts. In many ways, this book reflects their teachings and springs from the challenge posed by their methods of looking and thinking. I am also grateful to Norman Bryson, Joan Copjec, James Elkins, Keith Moxey, Nanette Salomon, Janet Wolff, and Christopher Wood for many valuable suggestions I received during the years in which this book was conceived.

Financial support came from the Samuel H. Kress Foundation for Art Historical Research, the Prins Bernhard Stichting, the Andrew W. Mellon Foundation, and the Millard Meiss Publication Grant.

Many friends on both sides of the Atlantic have contributed to this project in so many ways. I want to mention specifically Natasha Goldman, Viktor Horsting, Luc Kinsch, Peggy Nikolopoulou, Kirsi Peltomäki, my brother Roel Grootenboer, and my sister Juul Grootenboer. Very special thanks go to Markha Valenta for her wonderful editing of the text. Also, I would like to thank my friends, colleagues, and the staff at the University of Rochester, Tulane University, and Columbia University.

My parents, Mariëtte and Ruud Grootenboer, provided unconditional support throughout my studies; I cannot but dedicate this book to them. The book's conception as much as its completion, however, is the result of an ongoing dialogue with Yasco Horsman that started many years ago and continues to be my greatest source of inspiration.

THE RHETORIC OF PERSPECTIVE

Aesthetic judgment confronts us with the embarrassing paradox of an instrument that is indispensable to us in knowing the work of art, but that not only does not allow us to penetrate its reality but also at the same time points us toward something other than art and represents art's reality to us as pure and simple nothingness.

—Giorgio Agamben, *The Man without Content*

We shall now, for the sake of the feeble-minded, proceed to still life.

—Gerard de Lairesse, *Groot Schilderboek*

THE THOUGHT OF PAINTING

The Truth in Painting

Martin Heidegger has said that art is the setting-into-work of truth; that art lets truth originate.[1] Does art *have* an origin to begin with, or *is* it an origin by nature; a way in which truth comes into being, and becomes historical, as Heidegger indeed suggests? The answer to this question cannot be univocal. Yet in the history of art, we can name a point of origin when one of the arts, namely, painting, did let a certain kind of truth originate. This moment is the discovery of perspective.

From the point of its origin onward, perspective has manifested itself as a separator. It divides the natural space of the beholder—*perspectiva naturalis*—from the artificial space in painting—*perspectiva artificialis*—and, as a consequence, forces a division in the corpus of pictures between perspectival and nonperspectival, realist and nonrealist images. Perspective splits real space outside a picture frame from the mathematical space that has to be *imagined* within a picture frame. Erwin Panofsky's distinction between obvious and disguised symbolism also implies that perspective has created a distance between realistically painted objects and their meaning.[2] The discovery of perspective has created a clear-cut caesura between the appearance of reality and the reality of appearance.

Perspective makes a particular claim to truth. A geometrical method designed to render pictorial space, it promises a truthful—even scientific—representation of reality. It is a "seeing through," as if through a window, to invoke Leon Battista Alberti's famous metaphor. According to Piero della Francesca, perspective is also a "view forward," a prospective view into an imaginary space: a *prospectiva pingendi*. Samuel van Hoogstraten translates the term in Dutch as *deurzigtkunde*: the art of transparency.[3] Perspective provides

a view of that which it shows. Through that which it shows, which is what we see, it makes the picture plane transparent and, hence, renders itself invisible.

Perspective produces "naturalism" in painting. In all its variations and notwithstanding the inconsistencies within its system, it remains the tool par excellence for creating a true image of reality, a truth in painting. Throughout the history of art, truth in painting has emerged in various manifestations. Quattrocento and cinquecento realism differs from Dutch paintings of the Golden Age. Nineteenth-century French realism varies greatly from the photo-realism of the 1960s. In *The Truth in Painting*, Jacques Derrida elaborates on the question of what *the* truth in painting may be, having found a pretext in one of Cézanne's enigmatic expressions ("I owe you the truth in painting . . ."). Can we find *the* truth in painting in *vraisemblance*, that is, in realism in the broadest sense of the term? In his introduction, Derrida presents at least four possibilities of how truth may be represented in painting.[4] Or must we seek truth not exactly "in" a painting, but behind its surface, concealed in deeper layers of meaning? Do we have to search for truth as if we were engaging in an archaeological excavation? Can truth at all reveal itself, or must we admit that truth can never be presented, not even in painting?

In this study, I address these questions by limiting myself to two variations of truth in painting. The first variation concerns truth in seventeenth-century easel trompe l'oeils. Trompe l'oeils display objects so realistically painted that the distinction between reality and representation is beyond our perception—at least for a split second. These deceptive images demonstrate that realism in painting can be surpassed only by a form of hyper-realism that takes us by surprise. The trompe l'oeil is a practical joke that provokes our eyes to the point of insult, and of doubt: the deceit undermines our reliance on our perceptions.[5] The moment we are snared by the trompe l'oeil's lure, we enter a realm of illusion that forces itself upon us as a truth, whose artificiality we detect belatedly.

Maurice Merleau-Ponty has said that a picture is not a trompe l'oeil.[6] He might have meant to say that a picture does not deceive our eyes as a trompe l'oeil does, or that the trompe l'oeil falls outside the category of painting insofar as it transcends painting.[7] In any case, through its optical effect, the trompe l'oeil clearly distinguishes itself from more conventional kinds of truthful representation. It belongs to the category of illusionist imagery. How does illusionism relate to realism? Does illusionism appear as hyper-realistic, and is it consequently deceptive? How are we then to understand

truth in painting, if a hyperrealistic image results in the opposite of truthful representation, namely, deceit? Or is illusionism the unmasking of realism's shortcomings?[8]

I attempt to answer these questions by juxtaposing the category of trompe l'oeil to a second variation of truth in the so-called Dutch breakfast still life. I compare the illusionist trompe l'oeil to the realist breakfast still life in order to analyze the nature of the difference between illusionism and realism. My analysis will clarify the link between pictorial truth and optical deception, to the extent that they both constitute effects of perspective, as well as illuminate the relation of image to meaning and to modes of looking and interpretation.

Still Life's Philosophical Reflections on Vision

Dutch seventeenth-century still-life painting provides an excellent site for addressing questions concerning truth in painting. To begin with, the still life is arguably the most philosophical genre.[9] Certainly, *vanitas* images have been most thought-provoking in their engagement with ontological problems. It is no coincidence that the still lifes of Cézanne are central to Merleau-Ponty's thought, or that Van Gogh's *Pair of Shoes* has been a recurring point of reference for twentieth-century philosophies of art.[10] It is also remarkable that the very first photographs were shots of typical still-life scenes and that cubism's final break with realism developed within a series of still-life paintings.

Dutch still lifes in particular are especially preoccupied with virtually scientific modes of describing inanimate objects, flowers, shells, fruits, and other edibles. The genre is a product of Dutch seventeenth-century culture and its expressed fascination with observing and recording reality in a variety of circumstances. The science of vision flourished in the Netherlands, and its investigations resulted in new technologies, such as the microscope and the camera obscura, just as the Golden Age was drawing to a close. The Dutch also were pioneers in mapmaking, another mode of recording the world. Research in sciences other than optics, such as botany, called for scientific modes of illustrating plants and flowers at different stages of growth ad vivum, from life.[11] In the field of philosophy, epistemological questions were approached in the context of optical and technological developments. Within this cultural environment, Dutch artists made meticulously detailed recordings of the visible world their specialty. Painters specialized in particular subject matter and became masters in the representation of church interiors, exotic fruits and flowers, cityscapes, shells, and so forth.

The paintings of the Golden Age are testimonies to this preoccupation with a scientific mode of observing and describing every thinkable detail of the visible world.

Still life has a particular investment in the "art of describing" because it is purely descriptive: literally nothing distracts from the objectifying representation of mere objects. Not intending to tell a story or communicate a message, still life calls attention to the mere recording of objects, or rather to the artist's scrutinizing gaze upon these objects. Still life invites us to look at the overlooked, to use Norman Bryson's phrase, and show how still-life artists were looking *for* the overlooked as well. They picture the margins of their visual fields, or rather they show scenes that would normally reside in the margins of a major painting. Still-life artists have promoted what used to be called "by-work" in narrative pictures into an independent form of painting.

In his *Inleyding* (1678), Samuel van Hoogstraten calls still-life artists "ordinary soldiers in the army of art" and correspondingly places the still life in the lowest category of painting because it presents mere *parerga*. He adds, however, that if a still life is of excellent quality, it can be ranked superior to works of lesser merits that are executed by "generals" in the army of art, the history painters.[12] Van Hoogstraten defines *parerga* as "overmaet of toegift tot het voornaemste werk" (superfluity or adornment of the principal work).[13] He borrows the term from Junius's *De pictura veterum* (The Painting of the Ancients), which does not discuss still life per se but only considers the value of minor details in high-ranked paintings: "yet must wee never be so inconsiderate in our judgement, as to preferre the by-work before the work."[14] The fact that still lifes display what previously had been considered supplementary to major paintings implies that they do not necessarily contain an intended meaning. The first "theorist" of still life, Gerard de Lairesse, indeed confirms that the still life lacks meaning. In his *Groot Schilderboek* (1707), he expresses his surprise at the arbitrary subjects chosen by still-life artists. Even Willem Kalf, whose work De Lairesse highly appreciates, is guilty of creating images without providing reasons for painting objects in one particular arrangement rather than another. Disapproving of still-life artists' liberty to paint as they please, De Lairesse strongly recommends that painters make an effort to add deeper thoughts to their pictures.[15] Hence, he provides a long list of examples illustrating how still lifes can be deployed for expressing a specific meaning (*een byzondere zin*).[16] By the same token, he states that it is against the nature of still life to represent any suggestion of pictorial depth such as views onto landscapes or architecture in the background. One of

the questions I will address in this study finds its motivation in De Lairesse's remarkable statement: Could there be a relation between the absence of pictorial depth and the lack of a deeper meaning in still life? And how can that relation be formulated or reformulated on the basis of trompe l'oeil paintings, which show objects that are as flat as the wall on which they hang? What does the representation of mere objects have to do with their placement in the pictorial space?

De Lairesse seems to have used the placement of objects when he attempts, as one of the first, to define the difference between trompe l'oeil and still-life painting. In Van Hoogstraten's *Inleyding*, the distinction between lifelike and deceptive images remains blurred, in particular when he writes that "a perfect painting is like a mirror of nature which makes things which do not actually exist appear to exist, and thus deceives in a permissible, pleasurable, and praiseworthy manner."[17] On the contrary, De Lairesse writes:

> As the Nature and Property of the Places for Still-life, they are two-fold, close and open; the one representing it as if *hanging against a Wall* or Wainscot, and the other, as *lying on a Bench or Table, or on the Ground.*[18] [italics in the original]

My choice of breakfast still lifes by Pieter Claesz. (c. 1597–1661) and Willem Claesz. Heda (c. 1594–c. 1680) displaying objects and edibles arranged on a table, as well as trompe l'oeil paintings by Cornelius Norbertus Gijsbrechts (c. 1610–post-1678) and Samuel van Hoogstraten (1627–1678) presenting objects attached to a wall, is motivated by De Lairesse's distinction as well as by the pictures' commitment to representing *parerga* and their high level of self-reflexivity. Gijsbrechts ironically criticizes the status of representation in his extremely sophisticated practical jokes, whereas Van Hoogstraten's trompe l'oeils reveal strategies of self-promotion. Claesz. and Heda, who invented the specialty of the breakfast still life, develop an alternative mode of representation by reducing painting to its bare essentials.

The breakfast still life is tremendously vague about its subject matter.[19] Showing objects that are not even admirable in reality, it stresses its display of typical *parerga*. Crockery and everyday kitchen utensils, along with banal edibles, are placed in styled chaos on a tabletop. In composing their breakfast paintings, Claesz. and Heda deploy a strategy of extreme reduction. It seems as if even color has been drained from the canvas: without exception, Claesz. and Heda paint their breakfasts in monochrome colors that never achieve brightness. The little material that their breakfasts do offer the viewer is rendered in a realism that is remarkable even today. Their compositions are

characterized by a lack of narrative, color, and beautiful objects, absences whose only compensation is the great artistic skills of both artists. Claesz. and Heda have made realistic representation into the very subject matter of their paintings.

Like the breakfasts, Gijsbrechts's trompe l'oeils lack a specific meaning in De Lairesse's sense of the word.[20] Most of his pictures display letter racks or feigned cabinet doors that are so faithfully rendered that even today they deceive eyes trained by photography and television. Gijsbrechts playfully explores the limits of representation by including references to the craft of painting. His famous *chantourné*, a cutout panel of a painter's easel, offers commentary on the status of representation as well as on the provocation of the viewer. The three artists exhibit a "repetition compulsion" in their work. Over and over again, they painted the same topic with only slight variations. Their serial paintings consequently reveal a fascination with their subject matter as much as they suggest a preoccupation with recording it.[21]

The breakfasts by Claesz. and Heda and Gijsbrechts's trompe l'oeils are all relatively flat. In the breakfast pieces, the objects are arranged in a shallow space that is not wider than the depicted table. Whereas still life in general scarcely offers a view with great depth, the flatness of the breakfast piece is enhanced by the empty background against which the objects are projected. Gijsbrechts's letter rack trompe l'oeils are as flat as the real-life models they represent: the pictorial space in his work is scarcely deeper than an inch. The combination of a lack of depth and a lack of narrative with the extreme lifelikeness that we repeatedly see in these images raises the question whether these aspects mutually influence each other. The operation of perspective is obvious in pictorial scenes that stage a view into a landscape or an interior. It remains unclear, however, how perspective can be responsible for the lifelikeness of relatively flat images such as these still lifes. Is realism born as an effect of perspective? If we assume it is, then perspective should be understood as laying out the conditions for the reproduction of the real in painting. I believe that breakfasts and trompe l'oeils indicate that perspective's impact goes further than providing a method of representation. My comparison of the work of Claesz. and Heda with the pictures of Gijsbrechts demonstrates that perspective establishes the conditions for vision and the visible, rather than for representation.[22] The still lifes I investigate here deploy a rhetoric of perspective that enables scenes to emerge under a gaze that is not the gaze of a person. We, as viewers, do not look into a pictorial depth that offers itself to us, but rather the objects are pushed forward by their shallow space and actively confront our gaze.

Painting as Treatise; Perspective as Rhetoric

I will investigate the nature of the difference between realist and illusionist images (and the related issues of vision, perception, and perspective that my investigation entails) within a phenomenological paradigm. The existential phenomenology of Merleau-Ponty and Heidegger, as well as Jacques Lacan's use of phenomenology in elaborating his theory of the gaze, engages with the complexities of our perception of the visual world. Merleau-Ponty makes perception itself into the object of his phenomenology. In his work, he criticizes the scientific model of thought founded upon a traditional subject-object division as a form of thinking "which looks from above."[23] This scientific model does not question the function of perception in scientific research, but rather takes it for granted. In contrast to this form of thinking, Merleau-Ponty makes perception the main subject of his phenomenology. He finds in Cézanne's paintings a model for his own thought.[24] Cézanne's struggle with depth and his firm denial of linear perspective as the means to obtain spatial illusion led Merleau-Ponty to his understanding of depth as the existential dimension of the visual field. Influenced by Panofsky's essay on perspective, Merleau-Ponty reveals himself as a genuine perspectivist. The geometrical perspectival system poses a crucial problem for the philosopher concerning the status of truth in our visual field. He observes that the rendering of pictorial space does not in the least match our perceptual field: "Perception does not give me truths like geometry," he states, "but presences."[25] Perspective produces a truth in painting that fundamentally differs from the absolute certainty that our perception offers when we say that an object is *there*. Merleau-Ponty implies that truth cannot be presented in our perception, but that it can only be *represented* by means of geometry.

For Merleau-Ponty, the visual field is conditioned by the reversibility of seeing and being seen. We exercise our vision while simultaneously being subjected to the vision of surrounding objects. The things around us occupy possible points from where we can be viewed, even as we are looking at them. We share the quality of visibility with the things around us. The objects, in fact, return our gaze; they "look back" at us.[26] Merleau-Ponty never underestimates the value of painting, as it visualizes the chiasm of seeing and being seen by revealing how objects return our gaze. Assigning an important place to painting in his oeuvre, he never uses pictures simply to illustrate his thoughts, but treats them as indispensable contributions to his philosophy. For Merleau-Ponty, paintings are capable of making those complexities of depth visible that remain invisible in our perceptual field.

In philosophical writing (by Descartes, among others), perspective often has been understood as a model for both vision and thought. Merleau-Ponty refines this idea in stating that every theory of painting can be considered a metaphysics. His former student Hubert Damisch further elaborates this claim in *The Origin of Perspective,* where he suggests that painting not only shows but also "thinks."[27] While Damisch returns to this idea several times in his book, he never fully develops it.

I will elaborate on Damisch's notion of the "thought of painting." My hypothesis is that painting is a kind of thinking, and that perspective serves as a rhetoric of the image. I suggest that perspective is a model of thought as much as a system of persuasion. The rhetoric of perspective convinces us of that which painting shows, while it provides a method for that which painting "thinks." I want to demonstrate how painting is a form of thinking, and what individual pictures correspondingly have to say about the relationship between their truth, their meaning, and their appearances. Perspective, insofar as it is a rhetorical paradigm, determines, as well as complicates, the relation of image to meaning, and this relation is visualized, and theorized, by painting itself within the pictorial space. Following Michael Ann Holly in this regard, who suggests that an image predicts its own methods of interpretation, I believe that in a similar way an image—always—anticipates possible ways of looking at it through its perspectival configuration.[28] In this study, I analyze this role of perspective by presenting close readings of trompe l'oeils and breakfast still lifes. The notion of reading should be taken quite literally here. I suggest that the images themselves should be understood as theories of vision, as treatises on their own representation. My method of close reading is based upon Mieke Bal's innovative theory of reading images demonstrated in *Reading "Rembrandt": Beyond the Word-Image Opposition* (1991).

The meaning of the term "rhetoric" in this study derives from analyses of literature and images by Roland Barthes and by Paul de Man. In his famous essay "Rhetoric of the Image," Roland Barthes elaborates a structural analysis of an advertisement for Panzani pasta products. The advertisement shows several Panzani products, along with some vegetables, spilling out of a shopping bag. In an effort to skim off the different messages that this image contains, Barthes distinguishes three levels of meaning production: a linguistic message (the word "Panzani"), a denoted message, and a connoted message. The levels of denotation and connotation are difficult to distinguish from each other. They are both iconic messages, and, moreover, the literal image and its symbolic or cultural meaning are received simultaneously by the viewer. (For instance, the literal message of the composition of

edibles sends us a cultural, aesthetic signified, Barthes writes, in recalling the tradition of alimentary still-life painting.) Third, the denoted and connoted levels are inextricably intricated with the message's photographic medium. The photograph of the pasta products documents the scene rather than creates it, and while specific aspects, such as framing, light, composition, et cetera, actively construct the image, the photographic medium does not generate a transformation in the same way that a code does. Barthes claims that the act of making this picture appears not to intervene with the objects it presents: the photograph as such is a message without a code. Never experienced as illusion, the photograph possesses a truth effect that enables the *real unreality* of the picture to be fully understood, immediately and in an unmediated manner. Barthes concludes that the presumed absence of a code in the photographic message is its myth of naturalness.

Barthes calls a set of connoted signifieds a rhetoric, indicating an aspect of ideology. The signifiers of connotation constitute "scattered traits" (the pasta, the shopping bag, the still-life composition, and so on) whose discontinuous interrelationship is transformed into a natural and obvious connection. The different meanings of these connoted scattered traits are, so to speak, "set" or "staged" in the denoted syntagm. Connotation is then a system of signification—a rhetoric—that is pictured and naturalized by the denotational syntagm. The rhetoric of the image is enacted through the entanglement of the denotative and connotative levels, which fit together like a puzzle, and whose "fitting" functions as a "naturalizer." Although I do not embrace Barthes's system of structural analysis (which he himself later revised in *Camera Lucida*), his notion of a message without a code is analogous to the "naturalizing" "truthful" effect of perspective in which I am interested.

Norman Bryson modifies Barthes's terms of denotation and connotation, in order to apply them to painting, by connecting them with Barthes's notion of "the effect of the real." [29] Whereas Barthes states that in photography denotation and connotation are indistinguishable, Bryson argues that in painting this distinction is not only visible but essential. The interpretive threshold in painting is formed by what Bryson calls the minimal schema of recognition relative to the represented story, a level of denotation that is governed by iconographic codes. Connotation results from elements in a painting that exceed the minimal schema of recognition, while naturalizing denotation in such a way that the latter appears as truth. According to Bryson, the effect of the real is thus produced by confirming the minimal schema of recognition by means of connotation. [30]

Although Bryson's revision of Barthes's concepts offers useful guide-lines for reading painting as a system of signs, it does not do full justice to Barthes's original ideas.[31] It seems as if Bryson understands denotation and connotation as collections of pictorial elements, as domains of information, while for Barthes the terms refer solely to the relationship between signifier and signified. Not their distinction but their interconnection is important for Barthes's investigation of how images signify. A demarcating borderline cannot be drawn between connotation and denotation, because the *syntagm* of the denoted message "fits into" the *system* of the connoted message. The presumed "logic" the image thus presents, its naturalness or its "truth," is brought about by a form, a structure, in which all the elements seem to fit, and that is called the rhetoric of the image.

Barthes's rhetoric of the image is useful for my investigation of truth in painting to the extent that perspective may be considered a message with-out a code. Perspective is a structure, comparable to that of a sentence, as Damisch states; an empty paradigm that is filled in painting, and that holds the different elements and meanings "in place."[32] Perspective does not pos-sess a lexicon that determines the relation between sign and meaning, as iconography does, but it partly structures and naturalizes the presence of pictorial elements in relation to their meanings. Furthermore, perspective's intervention in producing an image remains for the most part invisible; con-sequently, it can be said to be rhetorical, in Barthes's sense of the term, in-sofar as it produces an image in which literal and symbolic messages cannot be distinguished from each other.

The impossibility of deciding between the figural and literal readings that one text evokes is a recurring motif in the work of Paul de Man. The study of tropes and figures (which is de Man's working definition of rhetoric) is not a mere extension of grammatical models. Whereas in "Rhetoric of the Image" (written in 1964), Barthes still clings to the idea that there might be a single rhetorical form common to the dream, the image, and literature, de Man firmly denies such a possibility. There is no such thing as a con-struction that can contain rhetoric because tropological language always transgresses its limits and its domain. The analysis of rhetoric thus always occurs in relation to the excess of a text, the residue of language that remains partly indeterminate. In the words of Andrzej Warminski, the construction of an epistemologically reliable semiotic, or grammatical, model of a text is impossible, because there always will be certain matter that is excluded, for which the model cannot account, and which therefore disrupts a full understanding of the text.[33] Here, rhetoric constitutes not a solution to the

problem of this indeterminate residue of language, but the knowledge that what is left out is what we call rhetorical. The construction of an epistemologically reliable tropological model of a text is equally impossible. Reading a text thus always confronts us with the impossibility of reducing a text to one of its functions, whether by means of grammar, trope, or reference. De Man mentions that rhetoric that is considered a form of persuasion is performative, while rhetoric understood as a system of tropes deconstructs its own performance.[34]

The distinction between grammar and rhetoric is one of de Man's primary concerns, a distinction that is based upon the twofold relation of grammar to logic and to meaning. Grammar and (referential) meaning are fundamentally incompatible, while grammar and logic have a relation of "unsubverted support."[35] The rhetorical dimension of language always mediates between grammar and logic, while simultaneously generating a divergence between grammar and meaning. Rhetoric is what subverts and interrupts language, and what produces text (rather than mere performative effects), in other words, that which *is* text: "Rhetoric is a text in that it allows for two incompatible, mutually self-destructive point of views, and therefore puts an insurmountable obstacle in the way of any reading or understanding."[36] This is what de Man calls an allegory of reading, narrating the impossibility of reading either literally or figuratively.

I suggest that if perspective has added a dimension to painting, it must be a rhetorical dimension, in de Man's sense of the phrase, that interferes in the relations between grammar and logic, and between grammar and meaning. Perspective produces a visual text that allows for different, mutually exclusive readings and greatly complicates the correlation between pictorial sign and meaning. This leads me to argue that perspective is an allegorical form that narrates the impossibility of deciding whether a literal or a figural meaning prevails in a painting: that is, whether a painting is meaningful or simply realistically rendered. If we cannot "read" a painting without being confronted by contrasting literal and figurative points of view, we might be able to read it differently: namely, as a philosophical treatise whose rhetoric is perspective. Walter Benjamin claims that the method for writing a philosophical treatise should be considered like an allegory of truth.[37] My argument that perspective is a rhetoric must be understood in Benjamin's terms. Panofsky has called perspective a symbolic form. I will argue in this study that, like rhetoric, perspective is an allegorical form; in other words, it is an allegory of truth in painting. My presentation of perspective as rhetoric is further supported by Blaise Pascal's notion of a rhetoric (an art of

persuasion, as he calls it) that is modeled on geometry.[38] I will demonstrate that the geometrical system of perspective is a pictorial equivalent and, as such, an outstanding example of Pascal's geometrical rhetoric. Indeed, Pascal has speculated on the implications of perspective for judgments of truth.

We will see that when depth withdraws itself from the scene of painting in the shallow breakfasts, and notably in the flat trompe l'oeils, the rhetorical paradigm of the image comes to the surface and lays bare its strategies, which otherwise remain buried in the depth of the pictorial field. Applied to painting, de Man's allegory of reading does not have to obscure an image's meaning for us, but the confrontation it evokes reveals something other than truth or meaning, namely, thinking. The emptiness of breakfasts that manifests itself on the level of both pictorial space and signification contains a meaning in and of itself. The practical joke of the trompe l'oeil is not a bizarre consequence of perspectival painting, but its deception points to what I believe is an essential aspect of painting, namely, the ability to reach a level of truthfulness that ends in deception. Heidegger has defined thinking as the process that

> . . . brings something before us, *represents it.* . . . We do not simply accept [thinking] as it happens to fall to us; no, we undertake, as we say, to get behind the thing. . . . Thinking is superficial or profound, empty or meaningful, irresponsible or compelling, playful or serious.[39]

In this study, I aim to demonstrate how painting represents thinking in a way that is superficial *and* profound, empty *and* meaningful, playful *and* serious.

Realism and the Problem of Description in Still Life: The Contemporary Debate

Since the problematic of Dutch realism as well as the debates about it have been widely commented upon, I will not repeat the arguments in detail here; a general summary suffices.[40] The issues largely circulate around the simple problem of whether naturalistic depictions of reality in seventeenth-century Dutch art contain a deeper meaning or must be considered as slices of life, as snapshots avant la lettre.

Scholars who advocate an iconological approach to Dutch art seek moral symbolism in pictorial themes, analyzed with contemporary emblem books in hand. They consider pictorial realism a vehicle for deciphering the mentality of the seventeenth-century (Protestant) citizen. Eddy de Jongh established this "emblematic approach," a method of interpretation that applies to virtually all pictorial categories that were invented in the Golden Age

but that has been primarily employed for genre images. Van Hoogstraten's statement that "accessories . . . explain something covertly" [bywerk dat bedektlijk iets verklaert] leads De Jongh to claim that Dutch *vraisemblance* is not "real" realism, but "seeming realism" [schijnrealisme]. Images intend to convey a "realized abstraction" through their mimesis. Essentially, this concept seems to be a limited version of Panofsky's notion of disguised symbolism, tailored to seventeenth-century painting. De Jongh himself has warned of the danger of overinterpretation that his method may entail.[41]

The emblematic approach has been sharply criticized from two separate positions. Svetlana Alpers states in *The Art of Describing* (1983) that De Jongh's method is misleading because it assumes that emblem books exerted a one-sided influence on painting and refuses to consider painting's impact on emblem books. Furthermore, she argues that in the context of the widespread Dutch culture of optical experimentation, painting was simply another mode of observing and recording reality. The Dutch genres exhibit a preoccupation with new developments in the science of vision and are themselves like experiments: painting as a mirror, or a map, of the visual world.

Another group of art historians who distance themselves from the emblematic approach are linked by their interest in the stylistic and formalist qualities of Dutch naturalism, which includes the historical circumstances of artistic processes, patronage, and collecting.[42] These scholars consider the descriptive manner to be a stylistic, or rhetorical, mode of painting. For them, pictorial realism is employed by painters purely for artistic reasons, in order to demonstrate skill and virtuosity. According to this paradigm, images do not by definition disguise didactic or symbolic messages, except in the case of clearly allegorical pictures.

Discussions of the still life have remained close to the general debates on Dutch painting. For years, Ingvar Bergström's *Dutch Still-Life Painting in the Seventeenth Century* (1947) and Charles Sterling's *Still Life Painting* (1952) were among the very few reference points in the study of the still life. In the final decades of the twentieth century, however, we can speak of a genuine revival of appreciation for still-life painting, given the many exhibitions that have been held and the number of publications that have appeared. In recent years, the study of still life has shifted toward economical and cultural-historical approaches that focus on the consequences of Dutch imperial success. Indeed, the *pronk* still lifes and compositions with shells, exotic flowers, or fruits display products brought home through trade with the West and East Indies.[43] The painted objects can be considered as commodities rather than as carriers of hidden messages, and the brilliance and attention with which they are rendered may even point in the direction of an early form of commodity

fetishism.[44] Both the abundant *pronk* still lifes and the modest breakfasts may reveal a troubled Dutch Protestant culture, where too much wealth and luxury resulted in "an embarrassment of riches," as Simon Schama puts it.[45] One of the side effects of the sudden wealth in the Netherlands was the development of an art market in the modern sense, a topic that has recently enjoyed extensive attention.[46] Despite the low rank of the still life relative to other pictorial genres, and the condescending references to it in art theoretical writings of the time, the still life developed as a highly popular genre that was marked, however, by oscillating prices.[47]

In French art historical writing, the attitude toward realism, and toward Dutch painting in particular, differs significantly from the Anglo-Saxon or Dutch approach. Rather than separating the practice of interpretation from formalist analysis, French art history easily combines them in close readings of artworks that integrate and are strongly informed by philosophy, semiotics, and aesthetics. Louis Marin applies Barthes's terms of *le lisible* and *le visible* to seventeenth-century still life, and Daniel Arasse and Georges Didi-Huberman have shown great insights in their analyses of the detail in Dutch realism.[48]

Bryson's *Looking at the Overlooked: Four Essays on Still Life Painting* (1990) is a unique enterprise in the study of still-life painting. Bryson attempts to develop a critical discourse around still life within the theoretical context of our own time. The still life has been under-interpreted, he states in his introduction, because art history has scarcely taken into account that painting in general is not only made of pigments, but of signs that produce meaning in a dialogue between picture and interpreter. Still-life painting engages with still-life conventions as a series of works rather than as a genre. The category of the still-life image has been produced by institutions of criticism over the course of ages, as well as by the painters themselves who consulted compositional schemes that were already developed. Bryson adds that the category is as much produced by the actual object and by the level of material culture to which it belongs. Correspondingly, he investigates the still life as a response to the slowly developing material life related to the culture of the table. Appearing within the higher discourses of culture, the low-level culture of the domestic, including the daily banality of preparing food, eating, and drinking, resides in the realm of routine and repetition. This domain of the household is filled with objects and habits that form the basis of existence but that remain largely overlooked. Bryson's thesis is that the still life evaluates this low-plane reality through visual representation and by means of semiotic processes.

All four essays are brilliant analyses of the involvement of still life within high-plane and low-plane reality, megalography and rhopography, high and low pictorial genres, and the related aspect of power. The third essay, entitled "Abundance," is of particular importance here, as it deals with Dutch seventeenth-century still life in terms of the sudden Dutch accumulation of wealth and power and the consequences of this growth for patterns of consumption and possession. Influenced by Schama's *Embarrassment of Riches*, Barthes's essay "The World as Object," and the Lacanian theory of the gaze, Bryson offers great insights into the meaning of the breakfast and *pronk* still life. His discussion of the trompe l'oeil in the fourth essay forms the basis of my own approach to these images.

Outline

My first chapter, entitled "The Invisibility of Depth: Merleau-Ponty, Lacan, and the Lure of Painting," focuses on the role of depth in the field of vision and in painting as the determining factor for understanding the discrepancy between perception and vision. Merleau-Ponty and Lacan point out that perception does not fully cover the field of vision but that a blind spot remains, whose presence in a painting is visualized to the extent that objects in pictures "look back" at us. I demonstrate how the moment of deception in trompe l'oeils and how the Heideggerian notion of "nearness" in breakfasts further indicate an absence in our perception that nonetheless is present in vision. Since Ernst Gombrich's *Art and Illusion* (1960), the field of art history has been defined as the realm of perception rather than the realm of vision. This definition has severely limited philosophical readings and, as a consequence, interpretations of early modern art. I make a case for reading breakfast and trompe l'oeil paintings as valuable contributions to our understanding of the complexities of vision, and I demonstrate how art historical modes of looking and interpreting can profit from a reading of painting that goes beyond the limitations of perception.

Having thus distinguished perception from vision on the basis of a specific absence, or invisibility, I explore in the following chapter, "Truth in Breakfast Painting: *Horror Vacui* versus the Void and Pascal's Geometrical Rhetoric," how this absence is variously visualized in breakfast still lifes. The emptiness characteristic of breakfasts reveals itself as the locus where depth and truth in painting are inextricably intertwined. The truthfulness of these images can partly be explained by a rhetoric based upon geometry and developed by Pascal in his essay "The Mind of the Geometrician." Pascal's struggle with the notion of seduction, insofar as it differs from more

innocent persuasion, can in turn be clarified by my comparison of a serene breakfast with a rich banquet piece by Jan Davidsz. de Heem. The void in breakfasts, as opposed to *horror vacui* in banquets, is partly responsible for the reality effect of the former, or rather for their truth effect, and is produced by perspective's inclination for making itself and its strategies invisible.

Perspective's strategies are difficult to observe because we are always caught in its configuration, looking "through" it rather than "at" it. In the third chapter, "The Rhetoric of Perspective: Panofsky, Damisch, and Anamorphosis," I therefore begin with an examination of the construction of anamorphic perspective, a mode of representation that offers an alternative point of view for observing orthodox perspective. A discussion of the theories of perspective by Panofsky and Damisch leads me to claim that what perspective shows is an empty structure, fundamentally paradoxical in its pretensions. Drawing on the analysis of the Lacanian gaze developed in my first chapter, I show how Gijsbrechts's trompe l'oeils permit an alternative viewpoint that enables us to "see" the operation of perspective. Since anamorphoses are as perspectival as perspective is anamorphic, and given anamorphosis's fundamentally allegorical form, I claim that perspective should be understood as an allegorical rather than a symbolic form.

In my last chapter, "Perspective as Allegorical Form: *Vanitas* Painting and Benjamin's Allegory of Truth," I make a case for understanding perspective as allegory. Benjamin claims that in philosophical writing truth can only be represented as allegory. His definition of allegory builds on the image of *vanitas* and its relation to nostalgia. As my reading of anamorphosis and *vanitas* images demonstrates, perspective's structure is similar to that of allegory. I suggest that Gijsbrechts deploys perspective as an allegory by combining two perspectival configurations within one of his trompe l'oeils. Following Benjamin, I claim that perspective represents truth in painting through its allegorical form, which functions as a rhetoric of the image. This understanding of perspective as allegorical form reveals how traditional art historical interpretations of early modern art have been shaped by a model of thought that is based upon orthodox perspective. More importantly, the allegorical function of perspective reveals how in art historical discourse, as a result of perspective's impact on modes of looking, a symbolic interpretation has prevailed over an allegorical one.

This study intends to demonstrate how the deployment of perspective in still-life painting points to a truth in painting that falls beyond the picture's frame, and perhaps even beyond our perception—in the narrow sense of the word. This truth in painting, I believe, cannot be found by employing

interpretive methods that search for meaning, but instead calls for a different mode of looking. The still life anticipates such a mode of looking by raising issues concerning the nature of its own representation, which do not lead us, as viewers, to interpretation but to a state that is most thought-provoking, namely, thinking.

Between art and deception runs only a thin demarcation line.

—Tacitus, *Annales*

THE INVISIBILITY OF DEPTH
MERLEAU-PONTY, LACAN, AND THE LURE OF PAINTING

Introduction: Realism and the Problem of Description
in Diderot and Schopenhauer

In 1636 Pieter Claesz. painted *Little Breakfast* (plate 1). A table covered with green and white cloth displays a modest arrangement: a pewter plate holding a herring cut in pieces, another plate with some pepper, and a wafer glass with beer. On the right side of the table lies a roll of freshly baked bread, flanked by a crushed hazelnut shell and, on the left side, a knife, its handle projecting over the table's edge. While the meal of fish and bread is an austere one, the table is neatly covered: the white cloth is impeccably clean and well ironed, as the trim creases reveal. The breakfast is simple, the display sober. That is all there is.

What is to be seen here? What does this still life have to offer us, aside from a well-composed view of essentially nothing? The table with its humble objects is surrounded by an empty background of an indefinable color, lacking any signs that might signify its being a wall. We may assume that the table is situated indoors, and that it is placed against a wall; but it could just as well be floating in some indefinite no-man's-land. Lacking a view of the table legs, there is no indication of where, or even if, the table is grounded. Moreover, the monochrome colors of the painting underscore the futility of the presentation, as if the painting wishes to excuse itself for the simplicity of its performance.

This painting does not seem well equipped to confront us with a typical dilemma from art history. In fact, however, it very effectively encompasses debates in Anglo-Saxon art history regarding the question of whether banal daily life objects should be considered primarily symbolic or primarily

realistic. Clearly not telling a story, *Little Breakfast* is purely descriptive, merely providing an effect of the real, to use Barthes's famous phrase. As critical studies of this panel have shown, not much can be said about Claesz.'s serene painting, precisely because there is so little to see. We are thus left with the question of the significance of this panel's insignificance.

Still lifes in general, and Claesz.'s breakfast in particular, possess the rare quality of raising the issue of the nature of their own representation. Their combination of a high level of lifelikeness, an absence of narrative, a shallow space, and an almost serene silence have filled scholars and writers throughout the ages with mixed feelings of admiration and irritation—admiration because of the artist's virtuosity in rendering a nearly perfect image of reality, and irritation because the image has nothing more to offer than a meticulously painted recording of meaningless daily life objects. Such discussions of still lifes offer us interesting examples of how they have confronted scholars with the simple yet disturbing question of what still lifes are "about."

Significantly, this is a question that traditionally has remained largely unaddressed in most writings, especially before Ingvar Bergström's *Dutch Still-Life Painting in the Seventeenth Century*, published in English in 1953. Two such analyses that I will consider, which confirm the way in which still lifes have provoked viewer reactions that sharply contrast with responses to other genres, are Denis Diderot's reaction to the still lifes of Jean-Baptiste-Siméon Chardin in the *Salon of 1765* and Arthur Schopenhauer's irritation toward Dutch breakfast still lifes in his magnum opus, *The World as Will and Representation* (1818). Both philosophers are representatives of (and partly responsible for) the dominant discourse that, until just a few years ago, silenced still lifes rather than opening them up to discussion.

These two instances of still lifes' appearance in art theoretical writings also raise the issue of realism in a particularly interesting way. Diderot finds himself speechless in front of Chardin's still lifes because of their natural description of reality. His response introduces the problem of the status of narrative painting relative to descriptive painting, which I will discuss in light of his notion of the "hieroglyph" and its relation to *peripateia*. By contrast, Schopenhauer's disapproval of Dutch breakfast paintings derives from his extreme bodily reaction to their naturalness, "proving" the characteristic truthfulness of breakfast still lifes: they strongly appeal to a realistic mode of reading that considers the painted *as real*. I present both texts here to elaborate how the non-narrative still-life genre foregrounds the problematics of realism.

Diderot and the Failure of Words

In 1759 Denis Diderot began to write about the Salon exhibitions that were held in the Louvre in Paris every two years. Diderot's art critiques were published in the *Correspondance Littéraire*, an exclusive journal with a small elite group of subscribers who lived outside of France. Given that his handful of readers were not able to see the artworks on display in the Louvre, Diderot took up a most ambitious enterprise in attempting to offer his readers full descriptions as substitute. For that purpose, he invented what he called the hieroglyph. The hieroglyph is a textual vehicle that was supposed to transmit Diderot's immediate viewing experience when standing in front of the artworks in the Louvre to the imagination of his readers. The hieroglyphs—detailed descriptions punctuated with Diderot's intensely personal, often highly emotional response to artworks—were intended to evoke mental images that Diderot called tableaux. Such tableaux, or paintings, would emerge before the mind's eye of his reader as substitutes for the actual artworks. In the course of reading, Diderot's hieroglyph was supposed to efface itself in order to serve solely as a transparent channel for the tableaux, or mental images.

Attempting to capture in words a material work of art in all its aspects, Diderot loses himself in endless digressions that include thorough *ekphrases*, philosophical reflections, literary intermezzos, and highly personal affective responses. The result is that the reader of the *Salons* can easily do without the original artwork from which Diderot's flow of words springs. In fact, the artworks themselves often turn out to be shockingly boring in comparison to Diderot's fascinating hieroglyphs. An exceptionally gifted writer, Diderot's verbal caprioles eloquently and effectively compete with the pictures inspiring them. Regardless of how prosaic, playful, and picturesque his descriptions may be, however, they ultimately remain incapable of fully translating a picture into words. So, in the course of writing the *Salons*, Diderot admits that language, when faced by painting, is doomed to fail in immediacy. Such explicit confessions notwithstanding, Diderot's persistent lengthy digressions could be read as implicitly continuing to argue for the superiority of language over painting.

There is one instance in the *Salon of 1765*, however, when Diderot finds himself speechless in front of a work of art. Considering still lifes by Chardin, he suddenly loses his ability to digress. The brilliant writer, who, brimming with enthusiasm, easily dwells on a landscape painting (by Joseph Vernet, for instance) for over twelve pages, sees himself confronted with some crockery and fruit, the beauty and realism of which take not only his

breath away but apparently his words as well. He praises Chardin's creations for their unequaled color and perfect harmony, but he can only offer his readers a poor substitute:

> I am going to say one thing about Chardin, and here it is: select a spot, arrange the objects on it just as I describe them, and you can be sure you'll have seen this picture.[1]

Without even trying to create a hieroglyph, Diderot proceeds to describe several of Chardin's works by merely naming the objects they display. Hardly anywhere in his *Salon of 1765* is his writing so plain and formal as it is here. Notwithstanding his thoughts on the superiority of language over painting, Diderot acknowledges defeat in front of Chardin's canvases, resisting any possible inclinations to overcome his speechlessness. Indeed, he refuses to shift to a more suitable register of language, a flexibility he has demonstrated extensively in other commentaries and that could have assisted him in "finding" words. Considering Diderot's amazing capacity for producing text, his incapacity to write on Chardin's still lifes is suspect, to say the least. His resistance is all the more surprising if we realize that Chardin, whom Diderot calls "the greatest magician," is one of his favorite painters. The problem is that Chardin's still lifes pose a serious threat to Diderot's hieroglyphic system of writing because they are purely descriptive.[2]

Diderot's invention of the hieroglyph relies heavily on the notion of *peripateia* in painting, the arrested single moment, or "pregnant moment," as Gotthold Lessing calls it, representing the entire story in one scene.[3] Both Lessing and Diderot explain the arrested moment in painting as a combination of not one but two instances of visualization. The first moment of visualization concerns the painter, who has only an instant at his disposal, "no longer than the blink of an eye," that is supposed to convey the entire story.[4] According to Diderot, *peripateia* is effective only when the viewer can "absorb the picture with a blink of his eye." Similarly, Lessing writes that the pregnant moment as well as the point from which it is viewed, if correctly chosen, ought to give the viewer free rein to the imagination: "The more we see, the more we add in our imaginations, the more we must think we see."[5] Diderot's hieroglyph is closely related to the pregnant moment insofar as it is his desire to see "more" that drives him to digress.[6]

Despite his admiration for Chardin, Diderot cannot possibly elaborate on his work because still life lacks *peripateia*. Still-life painting presents, in fact, the opposite of a pregnant moment: it is not a frozen moment in time, precisely because time does not seem to pass in the spectacle it puts on display. A basket with strawberries or a plate with peaches will remain just as they

are, and their staging assumes neither that there exists a moment "before" nor a moment "after." Still life presents objects in a purely deictic way, so the only thing that Diderot can say about them is that they are "there." Moreover, duration in still life is simultaneously a representation of what it endures, namely, time. Chardin's simple depictions of fruit and kitchen utensils present an image of time, as if they were painted stills, similar to a film still.[7] Whereas landscape painting shares with still life its non-narrativity, Diderot shows us that it fundamentally differs from still life because it does provide the viewer a space and a time in which to dwell. In a famous section, entitled "Promenade Vernet," Diderot gives himself over to a "walk"—for more than forty pages—"in" Vernet's landscape paintings. The fact that still life is purely descriptive and thus lacks any narrative does not suffice as an explanation for Diderot's remarkable silence with regard to Chardin. If he can create a story out of a non-narrative landscape, then what is it in still life that resists being forced into a temporal structure?

In literary theory, description often has been considered to be the handmaid of narrative.[8] Mieke Bal dismantles this logocentric hierarchy between narrative and description by arguing that every description is a narrative. She prefers to approach signs of the real not by assigning them to a category, such as description, but as elements within narration.[9] This tactic may indeed be applicable to non-narrative landscape painting. Diderot, however, reveals that the still-life genre resists Bal's argument by refusing to be turned into a narrative. The signs of the real cannot function within narration, because still lifes do not tell a story.[10] Indeed, while most descriptions in Diderot's *Salons* are turned into hieroglyphs and therefore contain a temporal structure that is reflected in the production of text, Chardin's still lifes actually arrest Diderot's continuing flow of words. Chardin's images are unchanging, they endure, and for that reason can neither be turned into a hieroglyph nor captured in a temporal narrative structure. Diderot's failing words betray that the complexity of still lifes resides precisely in the difficulty of saying something about them to begin with. I believe that what still lifes communicate is not a story, but a theory, that is, a form of thinking in visual terms.

Schopenhauer's Appetite

Half a century after Diderot's description of Chardin's still lifes, Schopenhauer discusses still lifes in an entirely different manner in *The World as Will and Representation*, but is likewise confronted with a truth in painting that disturbs him. He first mentions the Dutch still life as an example of pure objective observation. These still lifes encompass for the philosopher the

peacefulness and silence reminiscent of the mood of the artist, who must have lost himself in the reproduction of his own scrutinized observation of these objects. This peaceful silence elevates the viewer and offers him the opportunity to escape from his enslavement to the will by placing himself in a situation of pure knowing. The will is for Schopenhauer the impulse that slavishly drives human action and reason, imprisoning man in the suffering it causes. The only way out of human suffering is to free oneself from the will, an escape that is enabled by aesthetic contemplation.

In general, Schopenhauer seems to highly appreciate Dutch still lifes as ways of escaping from the enslavement to the will, yet he finds great fault with the representation of edibles typical of Dutch breakfast painting. Attempting to formulate the distinction between the beautiful and the sublime, Schopenhauer suggests that the sublime finds its genuine opposite in what he calls "the charming."[11] The charming lures the beholder away from pure contemplation (Schopenhauer's ideal state of mind) because it promises immediate gratification and thus agitates rather than elevates the will. Schopenhauer knows only two examples of the charming in the entire history of art. It goes without saying that the painted nude is an outstanding example of the charming, distracting the viewer from contemplating the beautiful by arousing feelings of lust. More surprisingly, however, Schopenhauer's second example concerns the breakfast still life:

> The one species, a very low one, is found in the still life painting of the Dutch, when they err by depicting edible objects. By their *deceptive appearance* these necessarily excite the appetite, and this is just a stimulation of the will which puts an end to any aesthetic contemplation of the object. Painted fruit is admissible for it exhibits itself as a further development of the flower, and as a beautiful product of nature through form and color, without our being positively forced to think of its edibility. But unfortunately we often find, *depicted with deceptive naturalness*, prepared and served-up dishes, oysters, herrings, crabs, bread and butter, beer, wine, and so on, all of which is wholly objectionable.[12] [italics mine]

The work of Claesz., Heda, and other painters of laid tables is here declared anti-aesthetic, because the dishes are so naturally rendered that they make Schopenhauer's mouth water in spite of himself. In his attempt plainly to dismiss these paintings as art, Schopenhauer explicitly compliments the artists on their ability to render their set tables with extreme realism. For Schopenhauer (who wrote his masterwork before the invention of photography), the truth he finds in breakfast still lifes is so strong that it directly

affects his body. It is not the edibles themselves, however, that arouse Schopenhauer's appetite so much as their "deceptive appearance."

The breakfast still life thus serves as the example par excellence of bad art, barricading the pathway to beauty by means of its realism. At the same time, other still lifes are foregrounded as instances of the peacefulness that an elevated mind can experience by means of an equal level of realism in portraying meaningless objects. Schopenhauer thus celebrates the realism typical of Dutch still life, but only insofar as it is a *painted* lifelikeness. When, in his perception, the realism of edibles seems to cross the border between the painted and the real, he despises their banality. This dualism in Schopenhauer's discussion both echoes the general opinion of art theorists of the seventeenth and eighteenth centuries and anticipates current art historical debates regarding the significance of realism and the dilemma of whether realistically, unmotivated objects in painting should be considered as real, or as symbols that mask meaning.

Early in the eighteenth century, the artist and art theorist Gerard de Lairesse, who shared Schopenhauer's preference for representations of fruit rather than of fish dishes, already addressed the dilemma of banal realism. In *Groot Schilderboek* (published in 1707), De Lairesse insists that a still life is not necessarily beautiful when it is skillfully rendered, but only when it also depicts beautiful things that please the eye. Flowers and fruit are worthy of representation (granted that they are both in perfect condition; otherwise De Lairesse has no "appetite" for viewing them), as well as musical instruments and treasures; but he firmly rejects images that display "dead fish" and other banal edibles. It is not merely the stimulation of the viewer's appetite that bothers De Lairesse, but the artist's lack of taste in presenting objects that would never be admired in reality, let alone in painting:

> As for cabbage, carrots and turnips, as likewise codfish, salmon, herring, smelt, and other such things; they are bad and awful decorations, not worthy of hanging in interiors, and we will pass over them: *whoever has a taste for them may go to the market.*[13] [italics mine]

What Schopenhauer and De Lairesse find so disturbing is a representation of food that is too realistically rendered. When De Lairesse refers everyone interested in cabbage and salmon to the market, to a certain extent he "confuses" painted edibles with real ones, just as Schopenhauer did when his mouth began to water.[14] Edibles belong to the realm of reality, not of painting.

In the context of my idea that these breakfast paintings present a form of thinking, it is tempting to refer to Heidegger's notion of thinking. In one of

his essays, he dissects the question "What calls for thinking?" by discussing various possible answers. He concludes with the statement: "What calls on us to think gives us food for thought. What gives us food for thought we call thought-provoking."[15] I believe that literally and figuratively speaking, breakfast still lifes give us food for thought, yet of an utterly different nature than De Lairesse and Schopenhauer had in mind. Schopenhauer in particular was unable to distinguish between painted food and food for thought, but, nonetheless, the breakfasts did provoke his thoughts by seriously disturbing both his appetite and his concept of the aesthetic.

Parerga's Resistance to Reading

In the introduction to *Looking at the Overlooked: Four Essays on Still Life Painting*, Norman Bryson aims at developing a critical discourse for still lifes in terms of current art theory. Art historical interpretation of early modern art has traditionally privileged a historical paradigm over a critical one.[16] Lacking narrative or iconographic meaning, the still-life genre in general has resisted interpretation within this historical paradigm, while at the same time it hardly has been discussed within critical discourse. Since painting is made of signs that produce meaning only in dialogue with the viewer, Bryson insists that the still life ought to be studied within twentieth-century critical theory. Since the publication of Bryson's work, many studies of the still life have been published. While the revival of interest in this topic certainly has deepened scholarly understanding of these depictions, a critical discourse in Bryson's terms has not yet been established. Unfortunately, those interpretative attempts that have been made scarcely dare to trespass beyond the confines of historical explanation, with the result that despite the extensive amount of writing on the topic, the still life has hardly been given a thought; it has not been *theorized*.

 In his well-known essay entitled "The Resistance to Theory," Paul de Man has stated that the resistance to theory is in fact a resistance to reading.[17] His argument follows from an analysis of the classical distinction between knowledge of language and knowledge of the world, between, respectively, the *trivium*, which consists of grammar, rhetoric, and logic, and the *quadrivium*, which encompasses the nonverbal sciences of numbers (arithmetic), space (geometry), motion (astronomy), and time (music). Traditionally, the connection between the two modes of knowledge has been formed by logic, which underlies the basic structure of the theory of language as well as of mathematics. De Man, however, detects a latent tension between grammar, the first of the *artes liberales*, and rhetoric. Whereas logic and grammar originate from the same structure, rhetoric strives for an effect and performs

a pattern of persuasion that is text-producing rather than text-analyzing. Rhetoric and grammar both partake in the process of reading, but for de Man a reading of a text never offers clarity regarding how it establishes a relation between the means of communication and its message. A grammatical reading (which for de Man includes semiotics to some extent) always "leaves a residue of indetermination"; textual elements that are not ungrammatical, but for which grammar and logic do not provide a method of analysis. De Man considers these textual elements rhetorical insofar as they produce an effect for which neither logic nor grammar can account. Rhetoric thus has a negative relationship to the other two *artes liberales*, for it exceeds their primary necessity and their claims on language. If we persist in the orthodox method of reading a text as a transparent message, we confuse, as de Man phrases it, "the materiality of the signifier with the materiality of what it signifies."[18] De Man pleads for a mode of reading that exceeds a strict referential framework, but he admits that, generally, such a reading encounters an opposition from the text that is often avoided rather than faced by readers. To a certain extent, we readers resist reading; this is, as de Man points out, a resistance to theory: "the resistance to theory is a resistance to the rhetorical or tropological dimension of language."[19]

In representational painting, belief in the transparency of visual language is even more complex since it is generally understood that the signifier does not have a symbolic relationship with its signified, as in language, but an iconic one. In narrative painting, visual language is employed to communicate a story. Yet Claesz.'s *Little Breakfast* is deprived of a narrative, leaving us with the visual language itself. If we resist reading still lifes within a critical or theoretical discourse, we resist reading visual language as such. And since the still life does not have anything else to offer aside from its pure imagery, the only possibility for interpretation is within a theoretical paradigm, as Bryson claims, or by evoking a rhetorical reading, as de Man proposes.

Translating de Man's ideas about literature to painting, we may start reading Claesz.'s still life literally, that is, within a strict referential framework, as a genuine recording of a seventeenth-century scene from daily life. Thus, Julie Hochstrasser argues within the context of the seventeenth-century Dutch economy that *Little Breakfast* can be understood as an ode to the flourishing trade and the great wealth of the Netherlands.[20] The edibles portrayed were among the primary products of Dutch trade. Fishing was mentioned in contemporary texts as one of the three pillars of the Republic's prosperity, while beer was a national beverage. Hochstrasser correspondingly turns Claesz.'s breakfast into a portrayal of patriotic chauvinism or an advertisement for national trade products. Surprisingly, she then

abandons the economical frame of interpretation when she concludes that the timeless message of this painting-turned-ode in fact communicates the art of representation itself, an idea she unfortunately does not elaborate.

Sam Segal likewise searches for meaning within a historical context when viewing Claesz.'s still life and opts for a Christian iconographical reading. He carefully points to the possible symbolism of the combination of fish with bread as a reference to the Eucharist.[21] Neither Hochstrasser's nor Segal's readings suffice because they remain too general, following interpretative methods that were initially developed for other kinds of painting. Simon Schama makes recourse to a cultural-historical method in order to speculate on the relation between the artlessness of Dutch cooking, of which foreigners often complained, and the plain description of a meal in breakfast painting. He emphasizes the delicate balance between objects and edibles in Claesz.'s compositions that point to the painter's talent at creating much from little. Schama's readings of paintings are always inspiring, but in the end his discussion of the breakfast remains a mere aspect of his larger argument.[22]

If we limit ourselves to a more formalist approach (which in de Man's terms would equal a grammatical reading), we can say that Claesz.'s composition is dominated by a rigid horizontal axis following the edge of the tabletop and a vertical one marking the contours of the glass. The knife, its handle slightly protruding out of the frame, indicates a slight diagonal that ends in the crust of the roll. The brushstrokes are smooth but not completely effaced, and there is no single light source but rather a hazy luminosity. Most notable in terms of pictorial technique is the monochrome color scheme of *Little Breakfast*. Claesz. adapted the monochrome style from landscape painters who initiated this trend in the first decades of the seventeenth century. During that time, more genres began to display mute coloring. As John Montias demonstrates, this monochrome style was not stimulated by a change in the "taste" of art collectors, but must be understood as a market innovation. At the beginning of the seventeenth century, the demand for paintings grew rapidly. Painters simplified their work methods and reduced the costs of the final product in order to attain a faster production and higher profit.[23] Monochrome paintings with only slight variations in composition, such as breakfasts, could be produced more quickly in order to meet the market's demand.

Remaining within the historical-economical approach but contesting Montias, Jonathan Israel sees the tonal trend not as motivated by marketing strategies, but as one aspect of a general tendency toward simplification.[24]

Israel detects in most genres from the 1620s to the mid-1640s a restricted palette that went hand in hand with a remarkable decrease in size and an interest in more modest themes. The market for expensive pictures collapsed during that period and forced painters to lower the costs of their production. After 1645, representations again became richer in all aspects: color reappeared in pictures that grew larger and contained more abundant topics. Israel argues that this tendency toward modesty was caused by the recession in the Dutch maritime economy immediately after the Twelve Years' Truce with Spain (1609–21). He convincingly demonstrates how the supply of certain pigments was prevented from reaching the Netherlands when the war with Spain continued in 1621. Painters were forced to turn to cheaper pigments and materials, which explains the monochrome trend that began roughly that same year. While Israel's arguments are supported by documents detailing the prices of pigments and paintings, his method does not account for the correlation between mute coloring and modest subject matter in the breakfast paintings.

These various readings of Claesz.'s *Little Breakfast* offer great insights into the art market, the production of paintings, and the economical situation in the Netherlands. While I acknowledge the importance of these types of historical research, I wish to point out, however, that these analyses tend to write "around" paintings rather than "about" them.[25] While each of the explanations I mentioned contributes to a fuller understanding of Dutch painting, they cannot do justice to the particularity of Claesz.'s *Little Breakfast*, consisting of the combination—rather than isolation—of subject matter, technique, and meaning. Indeed, a literal or a formalist reading does not exhaust the full impact of the image. There remains a residue of indetermination that emphatically manifests itself as an obscurity regarding what this painting is about. We may assume, on the basis of these observations, that the Dutch still life calls for a mode of looking that fundamentally differs from conventional methods originally designed for other genres.

It may be argued that a literal or grammatical reading of narrative painting always leaves a residue of pictorial elements that has no specific motivation with regard to the narrative. These elements reside in the margins of the picture, as well as of our visual field, as arbitrary or even meaningless signs. Barthes has argued that such details in literature produce "the effect of the real," a term that Bryson has tailored to painting by linking this effect to the presence of pieces of information that exceed the minimal schema we need for recognizing a picture's story.[26] Seventeenth- and eighteenth-century writers on art named such marginal elements *parerga* (by-works),

supplements to a painting's major topic that were often painted by pupils rather than by the hand of the master. A literal or grammatical reading of narrative painting would evidently leave such by-work out of the picture. If we isolate and frame these *parerga*, however, we would have a still life.[27] Still life can therefore be called the indeterminate residue of representational painting as such.

As a representation of *parerga*, still life has resisted interpretation. De Lairesse was among the first to vent his irritation about still-life artists who refused to motivate their painting of particular objects. More recent attempts at interpreting still-life painting, mentioned above, do not go beyond the limits of the historical paradigm. They remain literal readings that confuse the materiality of the signifier with the materiality of what it signifies, something Diderot and Schopenhauer did as well. By contrast, I will attempt to leave the realm of referentiality that Claesz.'s breakfast so easily evokes without disavowing the realism typical of laid tables. Following de Man and Barthes, I want to suggest that a belief in referentiality obscures the concept of realism in both literature and painting. A way out of having to choose between a referential and a historical paradigm (and these of course overlap extensively) is offered by close reading. I argue that a close reading of a still life may reveal a level of meaning that exceeds the context of its creation, leading to an interpretation in terms of our own time. An interpretation of still lifes, however, is not the major aim of this study. In my close analyses, I will instead read paintings as theories of visuality and of representation, issues that are raised by the paintings themselves. In their resistance to interpretation, laid tables indicate the limits of interpretative methods and thereby imply as well that there may exist a realm beyond interpretation. Art historical interpretation is, I believe, never an end in itself, but a means to provoke our thoughts concerning the complexities of vision, meaning, and representation. If that which makes us think is thought-provoking, as Heidegger argues, I suggest that, in resisting interpretation, the breakfast pieces present us with a form of thinking. They address specific issues on the nature of vision as well as their own representation.

I am particularly interested in two aspects concerning the realism of breakfast paintings by Claesz. and Heda. First, the breakfast pictures' shallow pictorial space and empty background contradict this realism by partly violating perspective's claim to truth as a view into pictorial depth. I will address this point below in the context of phenomenology. Second, I focus on the ways in which the emptiness characteristic of the work of Claesz. and Heda (and that of some of their followers) has been partly responsible for

producing an effect of realism in their creations. In chapter 2, I will discuss how this emptiness becomes a trope in the rhetoric of their images that convinces the viewer of the images' truthfulness.

I concentrate on laid table pictures by Claesz. and Heda because they privilege mere *parerga* on three distinct levels. On the general level of the genre (or kind or series of painting), still life can be categorized as supplemental to the greater tradition of painting. (De Lairesse and Van Hoogstraten would not have agreed more, given the low valuation of the still life in their treatises.) On the more specific level of representation, the still life isolates elements that are otherwise minor supplements in major paintings. Finally, within the still-life tradition itself, the breakfast as a subcategory has been treated as supplemental to the grand style of the banquet paintings of Willem Kalf and Jan Davidsz. de Heem, who brought seventeenth-century Dutch still life to its climax.

My attention to the *parerga*'s relation to the *ergon*, the major work, is heavily indebted to Derrida's analysis of Kant's notion of *parergon* as a supplement that is added to a major work in order to cover up an internal lack.[28] Derrida mentions the frame as one instance of the *parergon*, a hybrid of outside and inside that articulates and locates that which is missing from the *ergon*. He states that the *parergon* is both a product of and a production of the frame; it is itself a frame even as it frames. The still life, as a kind of painting rather than as a genre, has been particularly invested in the act of framing, since what it frames was traditionally labeled as the *parergon* in other kinds of painting. The still life lived a long life in the margins of painting before it was framed as an independent form of artwork.[29] While it was never outside the history of painting, it achieved visibility only when it was articulated within this history. My motivation for exploring still life lies in this specific aspect of its history. I believe that still life is able to pinpoint for us a site of painting that could not be seen until it was articulated and framed *as painting*. With regard to Claesz.'s *Little Breakfast*, we may say that it articulates a specific correlation between its realism and its shallow space. In framing an image that presents us with virtually nothing, *Little Breakfast* presents a truth on the basis of a painting built of *parerga*. Claesz. and Heda made this variety of truth the subject matter of their breakfasts.

Truth and Depth

In 1905 Cézanne wrote in a famous letter to his friend Emile Bernard, "I owe you the truth in painting and I will tell you."[30] In the introduction to *The Truth in Painting*, Derrida ponders the meaning of Cézanne's phrase. Cézanne's

expression might be a promise or an acknowledgment of debt. If the latter is the case, Derrida asks, then "what must truth be in order to be owed, even be rendered? In painting?"[31]

Derrida considers four possible translations of this "truth" in painting. The first translation refers to "true" truth without mediation or mask and resembling itself sufficiently. This kind of true truth precludes illusion. Truth can also be adequately represented in painting, as a faithful portrait. In this case, truth appears as its double. Painting can offer a good likeness of truth rather than truth itself: a representation rather than a presentation of truth. If truth is indeed the painter's model, then the artist has at least four possibilities for creating its image, Derrida argues: as a presentation of a presentation; as a presentation of a representation; as a representation of a presentation; or as a representation of a representation. This dazzling number of possibilities already performs the complexities of the problem, but Derrida has still two more translations in store. If we emphasize the final two words in Cézanne's expression, we may read it as referring to truth *in painting* and not in other modes of expression such as literature or poetry. Finally, a last meaning is truth as regards painting; a truth on the subject or in the domain of painting.[32]

The truth in painting that Cézanne owes Bernard may include all of these possible meanings, or none of them. If we read the phrase literally, the painter is not going to *paint* any one of these four truths, since he promises to *tell* the truth. Is Cézanne implying that truth in fact cannot be found in painting since he is going to tell it? Derrida leaves this question open, but he speculates about a potential painting without truth, without debt, no longer having anything to say, yet that still would not give up painting.[33] Derrida devotes his book to this kind of truth, or rather to this kind of painting. The truth in painting can never be properly restored, he suggests, but remains that which can only be owed, that to which the painter and the painting will forever be indebted.

Merleau-Ponty has said that Cézanne searched for truth all his life.[34] Apparently, the painter never found what he was looking for. He wanted to discover a truth in painting, yet he continued to pursue reality in painting by rejecting perspective as a means of attaining it. Bernard called this paradoxical strategy Cézanne's suicide: the search for truth in painting was in his eyes a matter of life and death. Contrary to Merleau-Ponty, Alberto Giacometti has stated that Cézanne sought depth all his life.[35] Can Cézanne's search for depth be equated with his search for truth? Is the search for both actually one and the same search, or are there in fact two quests ultimately leading to the same revelation? Is, for Cézanne, the concept of truth so closely

intertwined with that of depth that they virtually become the same, that is, *in painting*? Is the *debt* Cézanne acknowledges in his letter to Bernard the *depth* Giacometti named? Truth and depth are inextricably bound up in the configuration of perspective, and Cézanne's struggle acknowledges perspective's mediation between truth and depth. How "true" can depth in painting be, given that it is always the *illusion* of depth? And how "deep" can the truth in painting be, since painting is a two-dimensional surface? I will address these questions by analyzing Claesz.'s *Little Breakfast* in light of Merleau-Ponty's theory of depth.

Depth as First Dimension: Merleau-Ponty and Claesz.

Like his other breakfasts, Claesz.'s *Little Breakfast* possesses one characteristic that significantly differentiates it from other pictorial genres. The space depicted in this panel is shallow, a feature that is especially striking when compared to landscapes or genre paintings of the same period. In terms of the representation of depth, this breakfast seems to have more in common with the flat pre-Renaissance paintings of the trecento—their backgrounds filled with gold leaf—than with pictures of its own time. Certainly, perspective in breakfast pieces is correctly applied to the extent that objects appear to be extremely lifelike, yet their realism does not seem to entail the depiction of space even as shallow as a small table.

All objects in this shallow space are within reach of our viewing body. The glass, the herring, and the roll lie in such proximity that it is as if we could touch them were we to stretch out our hand. The knife and the plate project out of the frame, a well-known trick employed to blur the separation between the pictorial and the viewer's space, and enhancing the apparent nearness of the objects even more. The size of Claesz.'s relatively small panel (14.5 x 20 in.) makes it impossible to observe from a distance greater than five feet. The objects, a little over life-size, are near to us, indeed assume the vicinity of the viewer, who is invited to look from an arm's-length distance. This perspectival configuration anticipates not only a coming close, but a being close of the viewer. The viewpoint is located such that we are able to see the highlights on the herring and the plate. Participating in the intimacy of this breakfast for one is only possible at the cost of seeing "into" the painting. The space between us and the painting is not wider than the breadth of the painted table, and yet we are confronted with an insurmountable distance, an awareness that the space from which we look is not the space reflected in our eyes. We may say that the objects are *there, right in front of us*; they dwell within our perceptual field, but not within our space.

Claesz.'s modest panel is an outstanding example of the complexities of depth in our perceptual field as it has been discussed by Merleau-Ponty. We will see how this breakfast, through its staging of "nearness" and "thereness," also points to a differentiation Merleau-Ponty describes between the fields of perception and vision. In *The Phenomenology of Perception*, Merleau-Ponty argues against Kant's conception of space as the setting in which things are arranged. Kant draws a strict demarcation line between space as the form of all appearances of our senses, and things given within that space. "We can never represent to ourselves the absence of space," Kant writes, "though we can quite well think it as empty of objects."[36] Kant's strict separation between space and the appearance of things in space is untenable for Merleau-Ponty, since objects occupy a space that in turn enables them to be visible. On the contrary, Merleau-Ponty states that space cannot be seen as a container in which things are enclosed. It may be conceived as empty of objects, but it will always be filled with visibility. Neither an object itself nor visible, space is presupposed in every observation. We, as viewing subjects, enter a space that is more ancient than thought by way of our perception, Merleau-Ponty writes, and therefore perception and space represent the fact of the subject's birth.

Merleau-Ponty's main purpose in his *Phenomenology* is to come to an ontology of perception. His point of departure is, on the one hand, an empiricism that conceives of the world as objective and hence considers the subject as another object and, on the other hand, an intellectualism that stands for absolute subjectivism. Both methodologies simplify the subject-object relationship insofar as they refuse to acknowledge perception as that which makes the visible possible. Merleau-Ponty aims to revise this traditional subject-object relation by approaching perception as a *phenomenon*. Perception is always already "there" as a form of being in the world, preceding the subject-object relation and, as such, is simultaneously immanent and transcendent: immanent because the object that we see cannot be foreign to us since vision is always possessed by us, and transcendent because there is always more in a perception than is actually given.[37] The acquisitions of the philosophy of science imply the primacy of perception that should not, however, be understood as assuring a monopoly on truth but rather as the experience of "our presence at the moment when things, truths, values are constituted for us; . . . perception is a nascent *logos*."[38]

Merleau-Ponty finds the foundation for perception's primacy in the notion of depth. Traditional accounts of perception, formulated by Berkeley and Descartes among others, deny depth's visibility and hence declare the

three dimensions—height, width, and depth—to be indifferently inter-changeable. Depth has been defined as width viewed in profile. Merleau-Ponty firmly rejects the idea that changing one's viewpoint by rotating it ninety degrees would transform depth into breadth and vice versa, because it would provide the subject a sort of ubiquity. If we could see equally from all sides, we would ourselves turn into an omnipresence, and our surround-ings would become a purely objective space. Moreover, depth does not be-long to things around us but to our very perspective, possessed by us, sub-jects: perspective is always "ours." For that reason, Merleau-Ponty declares depth to be the most "existential" of dimensions. Length and height jux-tapose things by connecting them in front of us. By contrast, depth plays a different role in our perception by letting things overlap, constituting a relation between us and the visible objects around us, rather than merely between these objects. Depth forces us "to reject the preconceived notion of the world and rediscover the primordial experience from which it springs."[39] Neither a construction of the subject nor belonging to his or her thoughts, depth is a given, a possibility of the subject involved in the world, "a thickness of a medium devoid of any thing."[40]

The notion of depth as a certain "thickness" can be clarified by Merleau-Ponty's subsequent discussion of Cézanne's still lifes with apples, published at a much later date.[41] Painting and drawing sacrifice depth, according to the philosopher, because an outline encircling an object does not belong to the visible world but to geometry. A single outline turns an object into a surface that does not account for the object's place in space, its distance from our eyes, and, more importantly, the thickness of depth. For Merleau-Ponty, Cézanne's genius lies in his painting of apples, whereby the continuing con-tour has been replaced by various broken, sketchy lines in different shades indicating the thickness of space surrounding the apple rather than mark-ing its superficial shape. Cézanne's broad contours envelop the apples and thus show their position in depth.

Merleau-Ponty defines depth as "the dimension in which things or el-ements of things envelop each other, whereas breadth and height are the dimensions in which they are juxtaposed."[42] Elements have their place in space precisely because they overlap one another, an eclipse that occurs only in depth. We see things nearby and far away, both in their total exteriority and partly covered by other things, something that only happens in our per-ception and never in reality. This is what Merleau-Ponty calls the enigma of perception: the fact that it always contains more than is actually given, be-cause objects never appear as entities but only partially, overlapped by other

objects that "rival" before our sight, *yet only in our view.* Elaborating his notion of depth as the most "existential" of dimensions, Merleau-Ponty declares in his essay "Eye and Mind" that if depth is a dimension, it must be the first dimension instead of the third:

> Depth thus understood is, rather, the experience of the reversibility of dimensions, of a global "locality"—everything in the same place at the same time, a locality from which height, width, and depth are abstracted, of a voluminosity we express in a word when we say that a thing is *there.*[43] [italics in the original]

Saying that a thing is "there" maps out a spot where we cannot be. We can never take in the locus of the object at which we look, yet that we nevertheless reach with our gaze. As such, depth is conceived as the possibility of saying that a thing is "there," while this general deictic pronoun is the only means we have precisely to circumscribe a thing's place in our field of perception. The act of pointing to the spot where the thing dwells establishes our relationship to it, while at the same time the instance of indexicality declares that the thing is where we are not. That is why Merleau-Ponty describes vision as "the means given me for being absent from myself, for being present at the fission of Being from the inside—the fission at whose termination, and not before, I come back to myself."[44] The fission involves a split, a thickness or voluminosity of depth that serves as a connection rather than separation. Either depth is nothing, Merleau-Ponty writes, or it is some kind of a participation in a Being, a being of space that is beyond any point of view.

In *The Visible and the Invisible,* published posthumously in 1964, Merleau-Ponty redefines his concept of perception in terms of the visible and the invisible. The realms of the visible and the invisible are neither mutually exclusive nor are they separated by a distinction between the seen and the unseen or the perceived and the unperceived. Rather, they are complements that touch each other in the place the thing occupies, the place where the invisible is captured in the visible. Our perspective does not mark this separation between the visible and the invisible, and neither is our visual field marked by it, for we are not looking at only the visible but participate in both realms. We cannot see what is visible unless we are ourselves possessed by it, because we do not only see but are also seen. There is, however, a part of vision that we cannot see, for we cannot see ourselves seeing (or hear ourselves listening). Furthermore, our body includes parts that we cannot see, while as an entity, it is contained within the full spectacle of the world. We are visible *from elsewhere,* from a place in depth that is occupied by the things

surrounding us, a place that can nonetheless be "touched" by our gaze. The visible is not merely the sum total of all visible things, but a surface of an inexhaustible depth, in which things are enveloped *by our gaze*. The envelopment of the gaze unveils things in veiling them with the gaze.

In his earlier work, Merleau-Ponty proposes that the thickness of depth is distinct from any thing, but in *The Visible and the Invisible* this thickness becomes a tissue that "lines" things in the gaze that rests upon them. The thing opens in front of us while we are opening the thing by looking at it, and this twofoldness creates the possibility for opening up the tactile world with a look alone. In order to understand the far-reaching dimensions of this intertwining of the visible and the invisible, Merleau-Ponty suggests redefining his notion of depth as *flesh*. No longer labeled as the first dimension, depth as thickness is understood as a potential visibility:

> We understand then why we see the things themselves, in their places, where they are, according to their being which is indeed more than their being-perceived—and why at the same time we are separated from them by all the thickness of the look and of the body; it is that this distance is not the contrary of this proximity, it is deeply consonant with it, it is synonymous with it. It is that the thickness of flesh between the seer and the thing is as constitutive for the thing's visibility as for the seer's corporeity; it is not an obstacle between them, it is their means of communication.[45]

The visibility of a thing is not caused by its existence, but brings the thing into being. The means of communication between us and an object are generated neither by matter nor materiality but by the intertwining of vision and touch. We can actually see how things would feel. Merleau-Ponty's fundamental revision of the subject-object relation as it had been understood by the traditional philosophy of perception lies in their being separated as well as related by a certain distance that is, paradoxically, synonymous with proximity. When we touch something, it is simultaneously touching us, and additionally we are also touching the touch itself. A hand that touches is itself touchable, even as it can touch itself touching. Within the visible, the same reversibility occurs. While we share visibility with our own visual field, however, this reversibility remains incomplete given that we cannot see ourselves seeing, not even in the mirror, where we can see our face yet not our gaze. The visible and the tactile world interrelate by means of a chiasm: every tactile thing promises visibility and everything visible, Merleau-Ponty writes, is cut out in the tangible. The visible and the tangible cross over in each other's respective realms, mapped onto each other and forming each other's complement without ever merging.

Claesz.'s *Little Breakfast* may illuminate the complex structure of the visual realm that Merleau-Ponty maps out. Unlike Cézanne's contours, Claesz.'s outlines of objects are sharp and clear, albeit that the hazy, mute coloring does envelop the wafer glass and the pewter plate, making them radiate grayly. The ways in which this painting anticipates our participation in a scene that stages objects alone alludes to what Merleau-Ponty calls the enigma of perception. *Little Breakfast* exemplifies the complex intertwining between the visible and the tactile. We are called upon by this painting, but not as viewers who either accept or reject the point of view that is offered. In order for that to have happened, a deeper pictorial space, a more rigorous vanishing point, and a sharper division of the picture plane from the viewing space would have been necessary, in which case the traditional subject-object relationship would have been more rigidly maintained. *Little Breakfast* offers a viewpoint that is so close to the pictorial plane that the viewer's gaze crosses a boundary, or rather blurs the distinction between the space of the viewer and picture.

What we see seems to be within our reach and yet it is not. The ridges of the glass, the smoothness of the pewter plate, and the crust of the roll are executed by Claesz. so brilliantly that we can "see" their touch. We see how the texture of the bread or the knife feels without there being a texture other than the paint on the panel. We can feel the paint on the panel, while seeing the texture of the bread or the knife. Something is brought near to us, and yet it does not exist except in our vision. We see it there where it is not.

Merleau-Ponty writes that "the look can never overcome depth, it goes around it," and that is precisely what Claesz.'s panel evokes.[46] We look into an abyss of distance that seems so close, which makes us aware of missing something in our perception that is nevertheless "in" this painting. *Little Breakfast* displays a collection of surfaces, textures, and tissues of glass, bread crust, metal, fish skin, and so on, behind which the insurmountable depth of the indefinable backdrop yawns. To borrow Merleau-Ponty's words, we may caress the painted objects with our gaze, enveloping them with the thickness of depth and the flesh of the look, but we are not able to penetrate the shallow space with our eye. We see a distance that is near, indeed a distance that is synonymous with proximity, a glimpse of the flesh.

Heidegger's notion of nearness may assist in an even more subtle understanding of the subject's proximity in relation to objects. In his essay "The Thing," he delves into the notion of "nearness" in his attempt to answer the question of what the nature of a thing is. "Near to us are what we usually call things," Heidegger writes.[47] The character of a thing is what Heidegger calls

the thingness of the thing, a feature that remains, even in a scrutinized observation of the thing, concealed and forgotten. Heidegger uses as an example the jug—interestingly a thing that along with other types of containers often features in breakfast paintings—whose thingness resides insofar as it is exists as a vessel. A vessel's function is to hold, but its thingness does not lie in the material of which it consists or in the substance it may contain, but in the void or the emptiness that it holds. We never really see a thing, Heidegger states. When we place it in front of us, either in immediate perception or as representation, we watch its (re-)presentation rather than the thing itself. Whereas Kant does not distinguish between thing and object, seeing everything that surrounds us as mere appearance, Heidegger indicates that regardless of how far away or how close the object is to us, there is something in it that cannot reach us. This is what he calls the thingness of the thing. A thing, then, is *near* to us. Although *nearness* cannot be encountered directly, we can succeed in reaching it "by attending to what is near."[48] Nearness, however, must not be understood as an abolition of all distances, but is instead a "presencing" of the thing. Always already encompassing an insurmountable distance by its very appearance, representation fails in materializing the nearness of the thing. We can catch sight of the thing's character (concealed and forgotten) in the process of the thing bringing itself near to us. "The thing is not 'in' nearness, 'in' proximity, as if nearness were a container. Nearness is at work in bringing near, as the thinging of the thing," Heidegger concludes.[49] It is not that the thing is present, but is *presencing*. Strictly speaking, the essence of the thing is not concealed and hence invisible, but rather always in the process of bringing near. The bringing near is therefore not a permanent fixed state but a continuing process.

I cannot possibly argue that in Claesz.'s painting we can observe the thingness of the things presented—precisely because they have been represented; they have become objects whose essence cannot be materialized—but we do perceive, I believe, the bringing near. Not only are the objects proximate, but we have to come near ourselves, and it is in the process of bringing near that we become aware of the fact that these objects, and this painting, are within reach of our own body. The positioning of the painting on the one side and of us on the other is not a static but an active moment whereby we become proximate to each other, in the sense that we share the same space. Without any suggestion of movement, *Little Breakfast* is merely there, not caught in a particular moment, or rather caught in any moment except a pregnant moment. Opposed to any form of "cutout fragment," the nonsingular instance of the modest meal seems to extend itself into a temporal vacuum in which the objects present their thereness time and again.

Articulated by the indefinable beige-colored background, the shallow space presses the objects forward, virtually pushing them out of their frame. In this timeless vacuum of undetermined space, the objects foreground their presence rather than their objectness: *they are presencing*, bringing near their own nearness.

Heidegger's notion of presencing is related to Merleau-Ponty's concept of the chiasm in that they both deal with the insurmountable distance between the perceivable and the perceived. Heidegger finds the essence of the thing in the process of nearing, while Merleau-Ponty, not concerned with an object's essence but with the visual nature of its relation to the subject, incorporates in his notion of the flesh a similar kind of proximity. Both philosophers are confronted with the phenomenon of an invisibility that escapes the perceptual field: Heidegger names it the presencing of the thing that remains concealed (yet is able to be thought), while Merleau-Ponty conceives of it as the invisible flesh (which yet is visible in its absence). Building on these concepts, my reading of Claesz.'s *Little Breakfast* implies the possibility of alluding to the invisible within the visible, that is, within the visible of painting.

Is this the truth about this painting? If indeed there is something that escapes the perceptual field, an invisibility that is nonetheless "present" or "presencing" in painting, it follows that the perceptual field is contained within a larger field of vision. Merleau-Ponty clearly indicates with his notion of the invisible that these realms do not overlap. How then can we "see" the difference between these realms in painting, and what is the value of acknowledging this difference? One possible answer is offered by trompe l'oeil painting. This kind of painting potentially articulates the invisible within the visible on the basis of a discrepancy between vision and perception elaborated in terms of deception, an idea developed by Jacques Lacan in *Seminar XI*. Samuel van Hoogstraten's *Feigned Letter Rack Painting* (plate 2, c. 1670) is an excellent example in which we see how the complex correlation of realism and depth comes to its very surface. Correspondingly, my close analysis of this work will demonstrate that the discrepancy between vision and perception can be observed within a moment of deception. While optical deception is, in fact, the opposite of truth in painting, Van Hoogstraten's trompe l'oeil demonstrates that it may come close to a revelation of truth precisely because it is in the moment of deceit that our perception fails.

"The Things Look Back at Us": Van Hoogstraten and Lacan

Van Hoogstraten's *Feigned Letter Rack* displays a velvet-covered board, attached to a wooden wall, with strips of red ribbon fastened to it. Various

objects, such as a leather-bound book, scraps of paper, a letter, a penknife, a quill, scissors, combs, a golden chain with a dangling medallion, a pince-nez, and a brush are placed behind the ribbon. As flat as its real-life model, or as the canvas on which it is painted, Van Hoogstraten's letter rack purports to coincide with the objects it represents by concealing their being made of paint. In this picture, and others like it, Van Hoogstraten devoted all his attention meticulously to transforming the painting's surface into any material other than canvas. In the upper right corner, he even painted the handwritten text of a poem by the Austrian aristocrat Johann Wilhelm von Stubenberg, challenging anyone who doubts the legend of Zeuxis' masterful flat painted grapes to consider Van Hoogstraten's art, which has deceived the ruler of the whole world.[50] Van Hoogstraten's success has stood the test of time: his renderings of wood, velvet, leather, ivory, feather, bone, metal, and wax to this day are hardly distinguishable from real materials.

Apparently, modesty was not one of Van Hoogstraten's strengths. In *Artifice and Illusion: The Art and Writing of Samuel van Hoogstraten* (1995), Celeste Brusati brilliantly demonstrates how the letter rack motif is deployed by Van Hoogstraten as an instrument of self-promotion: one book, bound in red leather, is one of his own plays, while the other book behind the large comb is an essay from his hand. The wax seal reveals his initials, and the golden chain was given to him by Emperor Ferdinand III of Austria during Van Hoogstraten's stay at the court of Vienna. The chain is a token of the honor, fame, and wealth that a painter can enjoy through his art, displayed by Van Hoogstraten as a symbol of his position as celebrated artist.[51] According to Brusati, Van Hoogstraten's letter racks make a pictorial case for the ennobling power of art. She labels *Feigned Letter Rack* "the artist's pictorial tribute to himself and his achievements" and concludes that Van Hoogstraten's letter rack trompe l'oeils therefore should be considered self-portraits.[52]

Following Brusati's argument by taking it one step further, I propose that *Feigned Letter Rack*, particularly insofar as we understand it as a self-portrait, presents a self-contradiction. In his *Inleyding tot de hooge schoole der schilderconst* (1678), Van Hoogstraten repeatedly emphasizes that the artist's main task is to deceive the eye. Consequently, he has a high regard for the application of perspective in trompe l'oeils and in the so-called *doorzichten* ("seeing-throughs," life-size illusionist views of indoor spaces as if viewed from thresholds) because of the pleasurable deceit they allow.[53] Paradoxically, he also declares still life to be the lowest of pictorial genres, claiming that the painting of flat objects on a flat surface is among the simplest exercises for a pupil.[54] To this extent, *Feigned Letter Rack* is truly Van Hoogstraten's self-portrait, for it incorporates the double position that he occupies as painter

celebrated for his optical tricks, and as an art theorist who rejects such odd-
ities in favor of higher forms of art.

As a contradictory self-portrait, the picture may indicate that theory and
practice did not, by definition, go hand in hand in the seventeenth century.
Moreover, as Brusati mentions, *Feigned Letter Rack* makes a pictorial statement
that cuts across the traditional hierarchy positing history painting as the no-
blest and still life as the lowest form of painting, while nonetheless confirm-
ing the artist's own theory. At the same time, *Feigned Letter Rack* deceives us at
an additional level besides the strictly optical one by also breaking with the
art theory that the artist himself has formulated. Attempting to ennoble still
life and raise it to a higher level, Van Hoogstraten's trompe l'oeil points to
the more general contradictory valuation of this imagery. Both admired in
the seventeenth century for its display of the artist's virtuosity and insights
into optical effects and simultaneously disavowed (especially in later ages)
as a mere trick, trompe l'oeil has occupied a dubious position in the hierar-
chy of genres ever since.[55] Reading Van Hoogstraten's letter rack as a por-
trayal of the self thus confronts us with a problem inherent in seventeenth-
century trompe l'oeils. Because of their effect of deception, these images
challenge the conditions of painting formulated by art theorists through-
out the ages and hence also the criteria art history has developed for early
modern art. We may even argue that these images are characterized pre-
cisely by the absence of the conditions that traditionally have defined the
art of painting.

The trompe l'oeil shares with still life a lack of narrative as well as the
display of daily life objects, and as I have already indicated, this combina-
tion frustrates attempts at interpretation. Whereas *Little Breakfast* exhibits a
remarkably shallow depth of perspective, the vertical letter rack does not
allow for any space deeper than the curled edges of the letters that seem to
project out of the frame.[56] This lack of spatial illusion raises the question
of whether perspective has been applied at all in this picture. Absence of
pictorial depth is a serious shortcoming in Van Hoogstraten's painted letter
rack, particularly in light of painting's Renaissance comparison to a window
view, a prospect, or *doorzicht*. The ways in which these metaphors have been
used in art theory both assume realistic painting to be, by definition, per-
spectival and perspective to be the sine qua non of realism. *Feigned Letter Rack*,
however, undermines this traditional idea of perspectival space as the sine
qua non of realistic painting. Contradicting several pictorial presumptions,
Van Hoogstraten's rack therefore cannot be considered a painting in the
traditional sense without the addition of significant qualifications.

For instance, a trompe l'oeil insists on the bodily presence of the beholder in order for its deception to be enacted, and for that reason its effect cannot be caught in a photographic reproduction. Arguably, no artwork can be accurately reproduced, but a reproduction of a trompe l'oeil destroys precisely the primary effect of deception. Presenting a reproduction of Van Hoogstraten's painting thus problematizes my argument to the extent that the reproduction foregrounds its similarity with representational painting, rather than the major difference I am striving to establish. Jean Baudrillard remarks in his excellent essay on the topic that the trompe l'oeil is opposed to painting as the anagram is opposed to literature since the trompe l'oeil takes appearances by surprise, attacking the foundations on which painting has been built.[57] The trompe l'oeil transcends painting, he claims, going so far as to declare the trompe l'oeil not a representation but a "non-representation," a form of anti-painting that does not derive from painting but from metaphysics.[58]

Presenting itself as a radical departure from other realist genres, trompe l'oeil thus lacks the basic qualities that have shaped realistic painting: it lacks narrative, it lacks the presence of human beings, it presents the opposite of a pregnant moment without any suggestion of movement or the passage of time, and, finally, it lacks any indication of pictorial depth—realism's most profound condition. And if, despite all these absences, we still feel the urge to look at *Feigned Letter Rack*, then we, too, fall into the trap of deception.

Until recently, scholars have not felt the urge to consider trompe l'oeil paintings seriously, and the artful game that trompe l'oeil plays with visual language has never met with the same attention that other pictorial genres have been given—despite the fact that trompe l'oeil painters such as Van Hoogstraten and Gijsbrechts enjoyed great renown at the European courts.[59] Prior to the twentieth century, the relatively few discussions of trompe l'oeil that did exist were more often than not dominated by negative responses such that art critics who did mention illusionist pictures generally disapproved of them.[60] In recent years, however, initiated by the work of Celeste Brusati, Victor Stoichita, and Louis Marin among others, the trompe l'oeil has regained the interest of scholars in such a way that we may speak of a modest revival.[61] Literature on the topic that has seen the light in the last couple of decades can be loosely divided into two groups. On the one hand, Anglo-Saxon, German, and Dutch writings discuss the trompe l'oeil in the context of its history but generally refrain from speculating on its meaning or its larger significance within the history of art. On the other hand, French scholarly writings have widely discussed the trompe l'oeil within art history,

philosophy, and psychoanalysis as the ideal genre for examining the theoretical problems of illusion, mimesis, and deception.

Representative of the first group, Arthur Wheelock, for instance, argues that Neoplatonism, by increasing the appreciation of nature from the early sixteenth century onward, resulted in a revaluation of illusionist painting. Recording exact observations of God's creation, trompe l'oeil images could convey moralizing messages as well as constituting proofs of artistry. The primary function of the trompe l'oeil can thus be compared to that of history painting, Wheelock states, despite the important differences in the official rankings given the two kinds of images. Wheelock's argument is significantly weakened by its failure to address the specificity of trompe l'oeil paintings and by choosing instead to analyze it in the context of related kinds of pictorial curiosities such as anamorphic art, flower still lifes with deceptively realistic insects, and images created with the assistance of the camera obscura.[62]

In an essay entitled "Illusionism in Dutch and Flemish Art," Wheelock discusses the uses of the notion of deception in Dutch seventeenth-century literature. As the word "trompe l'oeil" had not been invented yet in the seventeenth century, and its Dutch equivalent, *oogenbedrieger*, was not coined until the beginning of the eighteenth century, the distinction between lifelike and illusionist paintings remains blurred in accounts of viewers who take images for actual objects. Wheelock points out that writers and theorists probably exaggerated the effect of deception for literary effect, as topoi of the powerful deceptive effect of images have been used since antiquity as a mark of artistic excellence. Although these anecdotes clearly demonstrate that visual deceptions were highly admired in the seventeenth century, Wheelock concludes that the reliability of enthusiastic accounts as to how the eyes of emperors, princes, and writers were deceived remains questionable. Regrettably, Wheelock refrains from elaborating on the double problem of deception that he presents. If contemporary viewers' accounts may be as deceitful as the images they describe and were employed for rhetorical effect, the issue of the rhetoric of the trompe l'oeil image is too obvious to avoid entirely.[63] Instead of confronting the nature of the difference between lifelike and illusionistic representation, or for that matter between documentary and fictional viewers' accounts, Wheelock shies away from the level of complexity that an analysis of these images and accounts demands.

A more interesting reading is offered by Louis Marin, an exemplary figure of the second group. In his essay "Mimesis and Description," he directly faces

the distinction between realism and illusionism when he asserts that deceiving the eyes is not the same thing as trompe l'oeil. Marin locates the trompe l'oeil at the margins of the immense domain of mimesis.[64] Partly indebted to mimesis, and partly differing from it by simulating rather than imitating reality, the trompe l'oeil's organization constitutes a pictorial experiment in representation conducted by a painting as such. For Marin, the trompe l'oeil interrogates representation by means of representation itself, pushing the codes and rules for imitation to the extreme.

In his response to Pierre Charpentrat's article "Le Trompe l'Oeil," Marin goes one step further when he follows Charpentrat in defining trompe l'oeil as a supplement to imitation. The existence of trompe l'oeil does not at all assist in establishing an order of representation as it relentlessly suppresses the distance between model and copy, a distance essential to representation. At once the excess of representation, trompe l'oeil also appears as its remainder or as its lack. In fact, what representation does, Marin writes, is convey an absent object into a "presence" as absence, all the while mastering the initial loss. The dominating power of representation manifests itself in the transformation of the displeasure of this absence into the pleasure of a presence. The instrument of this power and pleasure inherent in representation, as Charpentrat points out, is perspective. By perverting the rules of perspective, Marin writes, trompe l'oeil opens up an alternative line of questioning about perspective as an instrument of pleasure and power.[65] Victor Stoichita proceeds with Marin's line of questioning in proposing trompe l'oeils by Cornelius Gijsbrechts as examples par excellence of the self-awareness of the baroque image that interrogates the nature of its own representation.[66] Despite the fact that Brusati remains within a historical paradigm in reading Van Hoogstraten's trompe l'oeils strictly in the context of their production, her approach bridges the gap between the two groups, given her strong emphasis on the self-reflexivity of the image.

Contemporary literature of either group demonstrates that the trompe l'oeil has a long, unbalanced history of reception. On the one hand, visual deceptions have been admired at courts throughout Europe; they have been purchased as objects of curiosity and scientific interest for *Kunstkammer* collections, while trompe l'oeil artists were held in high regard. On the other hand, trompe l'oeils have a long tradition of scholarly disapproval, and despite the renewed attention they have recently enjoyed, a general lack of interest in theoretical or philosophical implications remains. The resistance to taking these playful images seriously has not been recognized as a flaw within (art historical) discourse but has generally been assumed to

derive from the trompe l'oeil's own inherent resistance to interpretation. We might argue, however, that it is *we*, art historians, who have fallen into the trap of deception by blaming our lack of interest on the image itself. This displacement has been partly caused by equating meaning with subject matter—a common problem in art history—and by the belief that meaning must always be found; discovered, that is, behind the depicted scene, as if one were conducting an archaeological excavation. While in other pictorial genres meaning may hide in the layered depth of the pictorial field, as it is symbolized by perspective, for the trompe l'oeil *there is no behind*. Van Hoogstraten's picture reveals how trivialities are flattened out against a vertical background that does not allow for any space "behind" the picture other than the wall on which it hangs and with which it appears to coincide.

Another reason why the trompe l'oeil may have been neglected as a serious pictorial category might lie in the strategies of discovery and revelation instigated by certain modes of looking that have characterized art historical writing, particularly on Dutch seventeenth-century art. Edgar Allan Poe's famous story "The Purloined Letter" is perhaps one of the most interesting instances where the trompe l'oeil functions as a pictorial trick (and a literary trope) that evokes strategies of concealment and investigation, as well as particular modes of looking. In an attempt to understand both the recent interest in trompe l'oeil, its resistance to interpretation, and the resistance in art historical writing to address the wider theoretical implications of this interest, I will read Poe's story as an allegory for art historical methods of research, one that opens up new directions for an analysis of the trompe l'oeil as an emblem of blindness within the act of looking. Poe's narrative points to the essential difference between representational and trompe l'oeil painting, as well as between the respective modes of looking that they solicit.

The Lure of the Letter Rack
In "The Purloined Letter," the minister has stolen from the queen a letter that he keeps hidden somewhere in his apartments. The reader is never given any clue about the contents of the letter, but we are to believe that publication of its message will heavily compromise the queen. The prefect in charge of the case secretly turns the minister's residence upside down for eighteen months, even checking underneath tabletops and in chair legs. Despite all his efforts, the letter is nowhere to be found. In despair, the prefect turns to the shrewd Dupin, who fathoms the minister's cunning game. He easily manages to find the letter by reasoning that the only place the prefect may have overlooked must be a spot excessively obvious. Dupin inspects the apartments by sight alone and immediately discovers the letter: it has been

turned inside out and carelessly put, as if it were a worthless piece of pa-
per, in an old letter rack hanging over the mantelpiece. On full display, the
document's exaggerated visibility had prevented the prefect from finding it.
Dupin secretly replaces the document with a facsimile, saving the reputa-
tion of both the queen and the prefect and misleading the minister with his
own act of deception.

In this story about deception and virtuosic game playing, another art-
ful game is played as well, involving an allusion to trompe l'oeil painting.
The minister's letter rack described in the story closely resembles those dis-
played in the seventeenth-century easel trompe l'oeils of Van Hoogstraten
or Gijsbrechts. Poe's subtle play with this pictorial allusion suggests that the
prefect was unable to find the document not only because he was blinded
by his conviction that it must be concealed but also because he confused the
minister's actual letter rack with a letter rack painted in a trompe l'oeil.

In the first half of the nineteenth century when this story was written,
the trompe l'oeil had been virtually forgotten, and "The Purloined Letter"
may in fact be partly responsible for the genre's revival by American painters
around the 1880s.[67] Poe incorporates the pictorial curiosity in his story as
much to make a visual pun of his own as to enable the minister's sly joke.
Quite craftily, he develops his allusion by first hinting at another kind of
painting before introducing the reader to the alluring letter rack. When
Dupin scans the minister's apartments in search of the most obvious hiding
places, his eye initially falls on the minister's desk. The presence of some mis-
cellaneous letters and musical instruments functions more like an *ekphrasis*
of typical seventeenth-century still-life paintings such as Jan Davidsz. de
Heem's *Still Life of Books* of 1628 (plate 3) than as a description of a typical
nineteenth-century desk:

> [Dupin] paid especial attention to a large writing-table near which [the min-
> ister] sat, and upon which lay confusedly, some miscellaneous letters and
> other papers, with one or two musical instruments and a few books. Here,
> however, after a long and very deliberate scrutiny, [Dupin] saw nothing to
> excite particular suspicion.[68]

Nothing excites "particular suspicion" because, within the framework of
Poe's playful pictorial allusions, the desk's description recalls a still life. Al-
though still lifes are often highly realistically rendered (we have seen what
level of naturalism they are able to achieve), they will never deceive the eye
as trompe l'oeils do. When Dupin finally rests his gaze on the letter rack, he
realizes why the prefect was unable to find the document: the location of the
letter rack, hanging over the mantelpiece like a painting, and the placement

of the letter within it made him believe that the rack actually was a painting because it resembled—and had been framed as—a trompe l'oeil. Poe brilliantly turns the metaphor inside out. In this case it is not a painted letter rack that pretends to be a real one, but a real letter rack that is disguised as a painting. Dupin's substitution of the facsimile for the letter is particularly cunning with regard to painted letter racks that contain documents closely resembling facsimiles, like the handwritten poem in Van Hoogstraten's picture. These, however, are never duplicates but images.

We may read Poe's story as a sophisticated version of Pliny's overquoted story of the rivalry between Zeuxis and Parhassius. Zeuxis created a highly realistic still life of grapes, so faithfully rendered that birds foolishly pecked at the painting in vain. Parhassius surpassed even this level of realism by deceiving the eye of the master rather than that of a bird. He painted a curtain in a trompe l'oeil that Zeuxis, blinded by the idea that a painting would lie behind it, tried to lift. Parhassius in Pliny's anecdote and the minister in Poe's story triumph over their opponents in their strategic deployment of the trompe l'oeil's rhetorical effect. Showing that which it wishes to hide, the trompe l'oeil reveals its fundamental difference from still-life painting as a difference in rhetorical effect. I suggest that on the basis of this difference, the trompe l'oeil—traditionally belonging to the genre of still life—must be singled out not merely as another genre *within* painting, but as a different kind of representation altogether.

The difference between still life (and representational painting in general) and trompe l'oeil, then, is the difference between realism and illusionism by virtue of the latter's radicalization of realism's premises. Despite their frequent conflation, these pictorial categories refuse to be conjoined. They are separated on the level of the surface by the rhetoric of foregrounding. Whereas *Feigned Letter Rack* foregrounds its two-dimensional surface, *Little Breakfast* or for that matter De Heem's *Still Life of Books* precisely deny their surface by effacing it. *Little Breakfast* wants us to believe that it is that which it is precisely not, namely, a window onto the still world of the kitchen table. Paradoxically, *Feigned Letter Rack* demonstrates that a painting never appears so real as when it presents itself as the two-dimensional picture plane that it actually *is*.

The way in which scholars have viewed both still lifes and trompe l'oeils is analogous to the search methods of the prefect, in contrast to those of Dupin. Whereas the prefect wanted to penetrate the surface of things with his in-depth, positivistic gaze, opening chair legs and so forth, Dupin's phenomenological look merely scanned the interior and in doing so let the backdrop against which the searching was performed come to the surface.

In addition, the prefect knew too well what he was looking for. His hunting for a secret to be disclosed made him an easy victim of deception. Ernst Gombrich remarks in his *Art and Illusion: A Study in the Psychology of Pictorial Representation* (1960) that it is the expectation of the beholder that creates illusionism.[69] I would like to add that illusionism may be created by the expectation that something *will be revealed*, that a painting will be revealed, as Zeuxis hoped, or that something hidden will be revealed, as art historians often expect.

Feigned Letter Rack may therefore be read as referring to the failure of perception that a search for revelation involves. Its effect is analogous to the schism between the eye and the gaze, described as a lure by Jacques Lacan in *Seminar XI*.[70] For Lacan, every act of looking engages in silent combat with the gaze that tyrannizes the eye, holding us as subjects firmly caught in its web of visual signifiers. "What I look at," Lacan says, "is never what I wish to see."[71] Beyond the restrictions of the eye and hence beyond the limits of the field of vision, an absence always manifests itself that can be circumscribed by the wish to see "more" behind or beyond that part of the visual—the perceptual field—that we presume to master with our eyes. The wish to see "more" emerges as an enigma of the art of looking that already occupied the minds of Diderot and Lessing, an enigma that they attempted to unravel by examining the moment that painting presents. By contrast, both Lacan and Merleau-Ponty use painting as a model to map out the visible in an attempt to articulate that which escapes it. Whereas Merleau-Ponty defines the visual field as a chiasm between the look of the perceiver and that which is visible, Lacan conceives of the visual field as governed by the gaze, where the intertwining of eye and gaze appears as a lure, an appealing misrecognition of sight. He thus defines the field of vision as a continuing process of deception. This deception is caused by the fact that our perception does not fully cover the field of vision, leaving an unseen residue that Lacan defines as a blind spot.

Lacan argues that the visual field is structured by the symbolic. The visual field encompasses something that cannot be seen, or grasped within the visual: a blind spot that in fact constitutes the foundation of the field of vision. We will never be able to see the entirety of the visual, just as we are incapable of expressing everything we wish to say. Our limitation designates a lack that is experienced in the visual field and in the symbolic as the idea of a beyond. Being and appearance are two different modalities within the visual field that correlate with the difference between vision and classical perception. The classical understanding of perception is in fact modeled after a pictorial perspective that is based upon geometrical space. A geometrical construction of space can be explained to a blind person, Lacan states,

by means of tightening strings in an empty room. The visual field, however, cannot be mapped out according to this model. It does not equate with geometrical space because there is something that eludes perception but that is nonetheless "present" in vision. The gaze situates itself in this lack, Lacan argues, but hides behind its own invisibility. We will always presume mastery over our visual field as long as we deny the presence of this blind spot that is visible only in its absence. We are therefore subordinated to a fundamental misrecognition of sight. Lacan therefore concludes that our perception does not cover the field of vision but leaves a residue. Painting, he suggests, visualizes the presence of this blind spot in our perception:

> Indeed, there is something whose absence can always be observed in a picture—which is not the case in perception. This is the central field, where the separating power of the eye is exercised to the maximum in vision. In every picture, this central field cannot but be absent, and replaced by a hole—a reflection, in short, of the pupil behind which is situated the gaze.[72]

Lacan's division between vision and perception is structured by an absence whose place is taken by a hole in a painting. This cryptic fragment only makes full sense if we realize that Lacan, without further notice, is referring here to a particular moment in the history of painting around 1425 when Filippo Brunelleschi discovered perspective by means of a peculiar experiment.[73]

Antonio di Tucci Manetti wrote a detailed account of how this discovery came about.[74] The very first view into pictorial space was produced, according to Manetti, by means of two panels. The first panel was a painting of the Baptistery as seen from the entrance of the Duomo in Florence. The sky in this panel was covered with reflecting silver-colored material. In the painting a hole had been carved in the middle of the pictorial horizon, exactly at the spot that we now call the vanishing point. Manetti describes how the carved hole was shaped like a pyramid, leaving an opening "as tiny as a lentil" in the painted surface. The second panel was a mirror of the same size as the picture. The illusion of depth was produced when the viewer held the back of the painted panel to her/his face, pressing her/his eye to the peephole. The mirror was located precisely opposite the painting, at roughly an arm's-length distance. Looking "through" the painted panel via the peephole, one would see in the reflection of the mirror an image whose realism was further enhanced by the reflection of the real sky in the silver material. "And of the point," Manetti writes, "it seemed that one was seeing truth itself."[75]

Knowing of Brunelleschi's first experiment with perspective, we are now able to understand Lacan's cryptic description. The "central field" mentioned in the fragment I quoted refers to the vanishing point that, by definition, is absent in a painting to the extent that it is vanishing. In Brunelleschi's panel, the peephole was located exactly at the vanishing point. Looking through the hole, one would see in the mirror a reflection of the painted Baptistery, except for the opening in the center ("as tiny as a lentil") where one would see a reflection of one's own pupil. In Brunelleschi's construction, the viewer is therefore being looked at *from within* the painting by his or her very own eye. One is seeing oneself seeing oneself.[76] This procedure is in accordance with Lacan's cryptic description. The hole in the picture is a blind spot, filled with the reflection of a pupil, which, in fact, is a hole *in* the eye. The vanishing "hole" stains the image even as the pupil reflected in the mirror literally looks back at the eye.[77] Hubert Damisch points out that if Brunelleschi's experiment does not mark the birth of Western painting, it should at least be considered the mirror stage of painting. A painting confronted by its mirror image, literally held up by the father of perspective, jubilates over its own existence as a coherent whole for the first time.[78]

Brunelleschi's experiment finally resulted in the discovery of linear perspective, a detailed procedure described by Leon Battista Alberti in *On Painting* in 1435. Alberti's method has been criticized, with Leonardo in the lead, for the ideal-yet-impossible position of the viewer, who has only one point at his disposal but looks at a picture with two eyes. Interestingly, Brunelleschi's experiment produces the illusion of perceptual depth if one looks through the peephole *solely with one eye*. Contrary to binocular vision, depth disappears from perception in monocular vision. Merleau-Ponty has pointed out that binocular perception is not constructed by means of two monocular perceptions surmounted but is instead of an entirely different order.[79] Therefore, the primal scene of depth's visualization within the two-dimensional plane of a painting may be of a different order than regular perception, having been enabled only at the expense of the third dimension itself.

Conclusion: Perspective Turned Inside Out

Lacan points out how Brunelleschi's experiment shows us that at the birth of Western painting something was made visible on a panel that was not actually perceptible. The laborious construction with the two panels creates the illusion of depth on condition that actual depth is excluded by making use of monocular vision. The first vision into pictorial space was, so to speak, *outside* of perceptual depth and resulted from the collapse of the viewpoint

into that of the vanishing point. After Alberti wrote down the procedures for creating linear perspective, the illusion of depth was produced by a separation of the vanishing point and viewpoint and never again by means of their fusion. One of the very few instances, however, where the vanishing point does collapse with the point of view, just as in Brunelleschi's panels, is trompe l'oeil easel painting. In Van Hoogstraten's *Feigned Letter Rack*, there is barely any illusion of depth. The vanishing point toward which our eye would be directed in all other kinds of painting is here significantly absent. Notwithstanding the absence of depth, perspective is not absent but is, so to speak, *turned inside out.*[80]

A schematic diagram illustrating the basic idea of perspective may illuminate the complexity of the perspectival organization of the trompe l'oeil (figs. 1a & 1b). In the classic construction of perspective, the sense of space is rendered through the use of two symmetrically determined points: the vanishing point located on the horizon of the picture and the point of view outside of the image where the beholder is presumed to stand. Ideally, these two points are connected by means of orthogonals, which fan out from the vanishing point into the picture plane, and from there converge in the point of view. In the diagram, the picture plane forms the axis linking the bases of two so-called visual cones or pyramids that mirror each other. Whereas the triangle lying "in" the picture depicts a truly mathematical space, the second triangle that actually should exist outside the picture has to be imagined within it.

In trompe l'oeil painting, these two triangles or pyramids are subjected to reversibility. The mathematical space that is supposed to be depicted *in* the picture has been hollowed out in a forward direction and has to be imagined *outside*, in the space of the actual viewer. In terms of the diagram, we can understand this operation by imagining the two visual triangles being folded onto one another until the vanishing point and the viewpoint merge with each other. The gaze of the viewer is no longer able to look "into" the painting but instead ricochets off the surface of the picture, bouncing back to the viewing eye, the place from which it originated. The blind spot of linear perspective, that is, the vanishing point to which the viewer's eye is directed, can never be reached—or, for that matter, seen—and collapses with the point view from which seeing is made possible. The dialectic of possible and impossible moments of seeing that coincide outside of the frame, in the beholder's eye, produces the optical effect of deception.

The inside/out structure of the perspectival organization in trompe l'oeil is used by Lacan as a model for mapping out the visual field as it is governed by the gaze. Assisted by his notorious diagrams, Lacan explains the structure

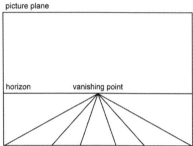

picture plane

vanishing point the viewer

picture plane

horizon vanishing point

FIGS. IA & IB. SCHEMATIC DIAGRAM OF THE
STRUCTURE OF PERSPECTIVE.

of the visual field by superimposing the Albertian onto the trompe l'oeil per-
spective. He illuminates this complex construction of the visual by referring
to Merleau-Ponty's metaphor for its organization.[81] If we turn the finger of
a glove inside out, its structure will remain exactly the same but will now be
articulated by its reverse side. Previously enveloped by the leather, the lin-
ing of the glove will emerge. Exteriority and interiority are reversed without
actually changing the structure of the glove. Elaborating on this metaphor,
we may imagine the tip of the glove's finger as a vanishing point that once
pulled out reveals the other side of the point, which normally falls beyond
the horizon. Moving the finger of the glove back and forth, we see how the
vanishing point can merge with the point of view when the structure within
which these points are normally separated is mapped out.

For Merleau-Ponty as well as Lacan, the field of vision has two sides, one
from which we see and another from which we are seen. The latter is lo-
cated beyond the scope of our perception. This other side is not simply out
of sight, but forms, like the lining of the glove, an expansion of the outside of
the visible that, as a screen, enables us to see.[82] Since we cannot see ourselves
seeing, we miss a part of vision, in the depth of our field of vision, where its
outside and inside—that is, where vision's exterior and lining—meet. We
miss this side of depth, which is not *what* we see, but what structures the
position from which we see, which can be described as a void. The effect of
the optical illusion in the trompe l'oeil painting offers just such a void, one
in which we find ourselves ignorant of what it is precisely that deceives us.

Is it the painting, which despite its hyperrealism presents its own flatness instead of the illusion of depth? Or is the optical deception caused by our own eye, which, assuming depth, is confronted with its own annihilation? The trompe l'oeil offers us the reverse side of our visual field, of the things that we do perceive. The things "look back" at us from a position we ourselves cannot occupy in order to see ourselves seeing.

In Van Hoogstraten's letter rack, we see that the depth, which is *not* in the picture, is extended in our eye, behind our pupil, there where we cannot see but from where our seeing is made possible. The lack in our visual field—the blind spot indicating a beyond behind the horizon—which the viewer always expects to be *outside* the limits of perception, actually resides *in* our eye. As Lacan states:

> I am not simply that punctiform being located at the geometrical point from which the perspective is grasped. No doubt, in the depths of my eye, the picture is painted. The picture, certainly, is in my eye. But I am in the picture.[83]

Certainly, the picture is painted in the depths of the eye, while the pupil is reflected in the vanishing point of the picture, constructing the mutual mirroring "through which" we see. We may say, with Merleau-Ponty, that this is the thickness, the depth of visibility that we share with things while looking at them. Indeed, we are "in" Van Hoogstraten's picture, while in between the letters and booklets no space is left, not even for our gaze. It seems as if the painted letters and booklets stare *at us* rather than the other way around, defeating our otherwise mastering look.

Van Hoogstraten's composition seems to be deprived of a human gaze, yet this absence betrays its existence *within* the painting in the abandoned eyeglasses that have been placed behind the red ribbon in the upper right corner.[84] The transparent lenses stare at us but do not see, like empty sockets in a skull, disavowing the viewer's look during the moment of deception. As a visual aid normally employed to focus blurred vision, this idle pince-nez confuses rather than clarifies, having lost its function but not quite its visual effect. On the contrary, the painting's glance is even underscored by another pair of "eyes" that mime the eyeglasses' effect. Appearing as the pince-nez's twin, the scissors seem to blink from the other corner of the picture. While we look right through those two pairs of staring hoops (it is in fact difficult to make out if there actually are lenses in the pince-nez), our eyes register for a brief second that the eyeglasses, the scissors, and the whole letter rack are real.

In trompe l'oeil painting, we are caught up in what we see by means of the rhetoric of deception; we exercise our vision even as we are also subjected

to the look of the objects staring back at us. Things are not just put on display, submitted to our look, but our look veils the objects in the process of seeing them. The gaze, residing on the side of the things that look at us, is not a panoptic eye, a device that can really see, but should be understood as Van Hoogstraten's eyeglasses in the trompe l'oeil, a mechanism through which the other side of vision can be turned inside out.[85] The perspectival configuration of the trompe l'oeil thus offers us a map of both sides of the visual field, which can be defined neither by the subject's perspective nor by the collective perspectives of all subjects but by a depth that is created by the absence of the gaze as such. That which enables us to "see" deception is located precisely there where our perception fails.

For Lacan, the division in the visual field is marked by the things that look at us: "On the side of the things, there is the gaze, that is to say, things look at me, and yet I see them."[86] In his explanation of the chiasm, Merleau-Ponty makes a similar claim when he writes that a certain visible or tangible entity "turns back upon the whole of the visible, the whole of the tangible," just as two mirrors facing each other produce an infinite series of mirror images that do not belong either to one surface or the other but form a "couple":

> Caught up in what he sees, it is still himself [that the seer] sees: there is a fundamental narcissism of all vision. And thus, for the same reason, the vision he exercises, he also undergoes from the things, such that, as many painters have said, "I feel myself looked at by the things."[87]

Through overexposure, the objects in Van Hoogstraten's letter rack produce an illusion that culminates in dis-illusion. Their deception consists of lies that tell the truth about their own appearance. Moreover, the letter rack betrays its two-dimensional surface as much as it betrays two-dimensionality itself. Alluding to what exceeds perception within the visual, the *Feigned Letter Rack* confronts us with a failure of perception. This awareness of things looking back at us is not without consequence, however. Our eyes are fooled: we do not know what we look at even while seeing it. The exposure to the picture's effect obstructs observation.

In the preface to Merleau-Ponty's *The Visible and the Invisible*, the translator Alphonso Lingis remarks that the invisible structure of the visible may be seen as the key to the unconscious structure of consciousness. In terms of structure, the invisible thus relates to the visible as the unconscious relates to the conscious.[88] Similarly, we can understand the invisible as structuring the visible in terms of its providing objects with latent visibility; this is not what we see, Lingis states, but according to which we see, just as grammar is not what we speak but what structures our speech.[89]

A grammatical reading in de Man's terminology that is supported by a belief in the transparency of Van Hoogstraten's rack will not suffice as long as we do not acknowledge that there is a part of vision that exceeds perception, and that can be found in painting. If we now attempt to use the blind spot in our eye as a sign pointing to an absence in perception that is visible in painting, we may find the meaning of this painting. Its meaning does not hide in the depth of the pictorial field but in a structure that, itself remaining invisible, enables the visible in painting. Perspective is just such a structure that hides behind its own invisibility as the painting's secret. It is a framework that signifies without revealing—in our perception—how its meaning comes about. Merleau-Ponty's description of meaning within the visual clarifies my point:

> Meaning is invisible, but the invisible is not the contradictory of the visible: the visible itself has an invisible inner framework, and the in-visible is the secret counterpart of the visible, it appears only within it, it is the *Nichturpräsentierbar* which is presented to me as such within the world—one cannot see it there and every effort to *see it there* makes it disappear, but it is *in the line* of the visible, it is its virtual focus, it is inscribed within it (in filigree).[90]

This may draw our attention as viewers and art historians to the idea that our methods of interpretation simply may overlook what trompe l'oeil paintings overabundantly foreground. Departing from the dominant story of Western art, where realism has developed in line with Albertian perspective, the trompe l'oeil has pursued a different direction, arriving at a form of realism precisely by eliminating any suggestion of pictorial depth. Illusionism is not a radicalization of realism's conditions, but a reversal of its premises; it does not comprise the subsequent step in the process of creating the ultimate copy of reality, but manages to reach a level of hyperrealism by falling back upon its own surface in all its flatness. The conditions of realism upon which representational painting has been built have been turned inside out, in carnivalesque fashion, just like the purloined letter in the hands of the minister.

The trompe l'oeil pretends to be a painted surface behind which lies neither truth nor meaning, but solely the back of the canvas. If, indeed, this is the only thing that trompe l'oeil paintings may tell us, then Cornelius Gijsbrechts has reached the ultimate limit of painting as such in his work *The Reverse Side of a Painting* (plate 4). This work presents everything that constitutes a painting: we see a wooden stretcher, held together by several nails that cast small shadows on the construction. The stretcher frames the back of a painted canvas, its frayed edges visible between the wooden slats. But

where is the image? Literally turning its back on painting as well as on its viewer, this canvas tends to be its negative, a clear instance of Baudrillard's statement that a trompe l'oeil is an anti-painting. If we follow our inclination to turn this canvas around in order to see what is represented on its front side, its shock effect would resides less in the deception, and more in the discovery that there is nothing there to see. Nothing, except for the same image, back as front.

Think of a kitchen table . . . when you're not there.
—Virginia Woolf, *To the Lighthouse*

TRUTH IN BREAKFAST PAINTING
Horror Vacui VERSUS THE VOID AND PASCAL'S
GEOMETRICAL RHETORIC

Introduction: A Supplementary View

Willem Heda's *Breakfast Still Life* (plate 5, 1634) is conspicuous, to say the least. The tabletop itself is not particularly exciting. Partly covered with white cloth, it stages the painter's favorite objects. The centrally placed *roemer* (rummer glass), a so-called Jan Steen pitcher, and a caudle glass accompany a cut meat pie on a pewter plate. In the corner, the ubiquitous lemon performs its supporting act. The only object that introduces a slight variation in the stylized chaos typical of Heda's oeuvre is a *torentgenslepel* (little tower spoon).

In sharp contrast to Heda's other breakfasts, however, where objects are projected against an empty ocher-colored background, in this still life a landscape arises behind the table, a picturesque luxurious garden furnished with white templelike buildings and a bridge, their architecture calling to mind English landscape gardens. This *Breakfast Still Life* is one of two paintings by Heda that offers a garden view.[1] A closer look reveals rough brushstrokes that separate the garden from the meticulously rendered arrangement on the table, underscoring the peculiar contrast between them. The landscape and the tabletop are two highly distinctive images sharing the same panel, as if two different paintings, rendered by two different hands, had been inserted within one frame as pieces of a puzzle. In fact, scholars have discovered that the garden scenery was indeed added to Heda's breakfast by an overpainter, identified as the French artist Francisque Millet (c. 1642–1679).[2]

Apparently, the fervent landscape artist was troubled neither by the break in style that his overpainting caused nor by the serious distortion of spatial continuity: the garden suggests that the table is located outside, yet

the original interior setting betrays its existence in the reflection of a cross window in the *roemer*. The overpainting destroys the illusion of an interior as well as of an exterior setting, a discontinuity that presumably did not occur to Millet since he conserved the window reflection in the painting. Without attempting to restore a balance between the display of a meal and the garden vista, Millet created a supplement that remains literally outside Heda's original.

The spatial distortion brings about a discontinuity in style as well. The early romantic landscape is reminiscent of Arcadian or pastoral scenery that dramatically breaks with the realistic sober tones of the somber breakfast in the foreground. The classical temple clashes with the simplicity of household effects. The final result of Millet's efforts may be called hilarious, if not ridiculous.

The table thus balances on the threshold between two "windows" into the different worlds of the outdoor garden that we see and the indoor space that we can only imagine through the reflection of the window in the *roemer*. Extending into depth, the classical garden reinforces a new horizon in the painting that correspondingly produces a second point of view. The "new" painting offers two conflicting directions for the viewer's eye to travel, either into the depth of the landscape where the vanishing point hides behind the white buildings, or toward the reflection in the *roemer* that substitutes for a vanishing point that, technically speaking, is absent.

We may assume that the vista was initially intended as an improvement. What, then, was the flaw in Heda's original that required correcting? Or was Millet motivated by purely aesthetic reasons? Considering the overpainting as supplementary to Heda's original work, the latter must have lacked something significant in the eyes of the overpainter, which needed to be covered irrespective of either aesthetic concerns (given the borderline that yawns as an abyss) or realism (given the discontinuity of space and style). Heda's original work consisted of mere *parerga* spread out on the tabletop, by-work promoted to an *ergon*, that is, to work as such. Apparently, Heda's *ergon* must have revealed a lack, evoked by a scene of unmotivated *parerga*, that Millet wished to complete. This lack must have been the absence of a view into depth that needed to be "filled" by means of the garden vista.

The supplementary garden thus attempts to restore what all breakfasts lack, namely, a *view*. Paradoxically, the very use of overpainting reveals the essential quality of breakfast painting. If, for Millet, the shortcoming of the *Breakfast Still Life* was indeed its lack of depth, we may argue that his motivation may have been a fear of empty spaces in painting, *horror vacui*. For the

overpainter, the spread-out flatness that Heda's breakfast initially exhibited demanded a suggestion of spatial depth that he generated by means of trees and buildings and, more importantly, by means of a horizon. With the supplementary (but not complementary) vista, however, a new lack surfaces. The garden opens up an incredible and impossible view: trying to look through it, our eyes seem to "bump" into a blind wall. The objects and edibles in the foreground are too close, while the landscape is too far away. Since the demarcation line is too apparent to be overcome by our gaze, we are unable to look into the distance that extends behind the foreground. We cannot "see" this landscape by keeping it at a distance (to use Merleau-Ponty's definition of seeing) now that the distance between foreground and background has been annulled by a borderline too visible to overlook. Rather than opening up the blind "wall" in Heda's panel, the vista fails as a genuine substitute for it and transforms into precisely that which it wanted to cover up, namely, a literal wall painting.

It is likely that Gerard de Lairesse would have disapproved of the supplementary vista. In his *Groot Schilderboek*, he recommends still-life painters to fill their background with nothing but the appropriate color, or place their attributes in a niche of nicely tinted material: dark gray for flowers, white and gray marble for fruits. Pictures including views would no longer belong to the category of still life that should represent only "immovable and inanimate things":

> 'Tis likewise improper, and against the Nature of Still-Life, to introduce, in any of the before-mention'd Choices [Flowers; Fruit; Gold, Silver and other rich Things; and Musical Instruments], *colour'd Back-works*, or *Vistos*, either close or open, that is, Landskip, Architecture, or any Kind of living Creatures; which would spoil the very Name of a Still-Life. . . . I say then, that the *Depth* of the Picture is only to be represented by a hanging Curtain, or Bass-relief of Wood or Stone, or such a Colour and Tint, as best suits the general *Decorum*; the one darkish, and the other somewhat lighter.[3] [italics in the original]

De Lairesse recommends that still-life artists avoid *any* suggestion of pictorial depth stretching out behind their arrangement of objects. Depth in still life is only acceptable when produced by reliefs or hanging curtains, yet these tropes, mostly recurring in flower paintings, occur *in the immediate foreground* of the picture plane. Particularly at the end of the seventeenth century, reliefs in marble or other materials appear on pots holding bouquets or are carved in marble pedestals on which they typically are placed. The other trope is the hanging curtain painted in trompe l'oeil that we often find partly covering a wealth of flowers, as for instance in the famous *Trompe*

l'Oeil Still Life with a Flower Garland and a Curtain of 1658 by Frans van Mieris and Adriaen van der Spelt at the Art Institute of Chicago. The kind of "depth" in still life of which De Lairesse approves occurs *on the surface* of the painting.

While we can call with De Lairesse the overpainting the destruction of what might have been a genuine still-life masterpiece, the overpainting does reveal how empty the backgrounds of breakfast pieces actually are. The supplementary garden also demonstrates that a view does not equal spatial illusion per se. Moreover, Heda's breakfast painting also visualizes how perspective, as a system of organizing space, configures a coherent whole that is destroyed when it is interrupted by an additional view. A new horizon in the depth of the garden does not smoothly transform Heda's breakfast into a new painting. Apparently, the breakfast contains "more" pictorial space than the objects, strictly speaking, occupy; indeed, space that does not represent an illusion of depth. If there is one thing that the supplementary garden has opened up to us, it is insight into the complexity of a void in painting.

Conquering the Void

Pieter Claesz. has been credited for inventing the empty background in breakfast pieces, a novelty that Heda, working in the same city of Haarlem, quickly followed. In the context of still life's history, the contrast between the intimate dressed table and the empty backdrop can be considered as another instance of the separation between foreground and background that stands at the origin of still life. As many scholars have pointed out, the independent genre of still life emerged as a result of a dramatic separation of already isolated objects and edibles, so-called still-life motifs, from the realm of history painting in which they initially appeared. Pictorial topics showing such a split include Madonna and child pictures of the early sixteenth century, market and kitchen pieces produced in Antwerp around 1550, the depiction of symbols of transience on the back of portraits dating back to 1480, and decorated margins framing small biblical scenes in fifteenth-century Books of Hours. Victor Stoichita has shown that still-life features in these pictorial traditions all appear at the border of representation, at its margins, on its frame or verso, in a word as *parerga*, which leads him to state that the genre was born as a result of a *cut*.[4]

Ingvar Bergström was among the first to point out that skulls and other *vanitas* symbols appearing on the versos of portraits are the earliest instances of the trend that separates customary religious symbols by giving them an

independent existence.[5] In such portraits, the face of death is painted behind that of the sitter, that is, on the other side of it, nonetheless remaining attached to it as two sides of a coin. This tradition of "anti-painting" reaches its ultimate end in Gijsbrechts's *Reverse Side of a Painting* (plate 4). In other forerunners of the genre, the separation within the representation between edibles and crockery arranged in the immediate foreground and the narrative scene in the background results from a contrast, or conflict, as Stoichita calls it. Early sixteenth-century devotional paintings featuring the Madonna and child by Joos van Cleve or Quentin Massys or market pieces and kitchen scenes that were created in Antwerp by Pieter Aertsen and Joachim Beuckelaer typically demonstrate this conflict. As I will point out in this chapter, this conflict between foreground and background does not reach its termination at the moment when the still life comes into existence around 1600, but continues to be a constant factor in the development of the genre in the Netherlands during the seventeenth century.

Joos van Cleve's *Holy Family* (fig. 2, c. 1513) is an early instance of this moment of conflict. We see Saint Joseph, who has just taken off his glasses to look at the Virgin nursing Christ, as the fulfillment of the text from the Gospel of Luke including the Magnificat (Luke 1:42, 46–50) on the scroll he holds in his hand. An opening in the wall behind Saint Joseph's head shows a view of the sky. The interior that the figures inhabit is separated from the viewer's space by a ledge upon which is placed a small arrangement of a plate with some fruit, half of a walnut, a knife, and a beaker of wine covered with a glass lid. The daily life objects are embedded in the narrative of the picture as Christian symbols, obvious rather than disguised, of the Eucharist (the wine), the church and Christ's Passion (the pomegranate), and Christ's divine and mystical nature (the grapes and the walnut). Van Cleve's careful placement of the symbols on the very edge of the table, however, where they fall partly inside and partly outside the picture's frame, renders the objects ambiguous. The ledge initially serves as an extension of the frame, raising a barrier between the viewer and the Virgin that has been disavowed by the objects' attempt to cross this barrier: the rim of the plate and the blade of the knife protrude out of the frame. Although in agreement with the larger image on the level of symbolic meaning, the plate and the knife seem to be in conflict with the position they occupy in the pictorial space, reaching out as far as they possibly can into the space of the viewer. Thus literally marginalized, the symbols seem to balance on the limit of painting, a feature that leads Stoichita to claim that the independent still life is "the limit become painting."[6]

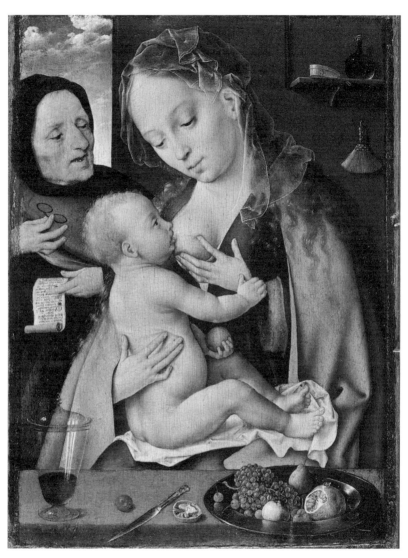

FIG. 2. JOOS VAN CLEVE, *The Holy Family* (C. 1513). COURTESY OF THE METROPOLITAN MUSEUM OF ART, THE FRIEDSAM COLLECTION, BEQUEST OF MICHAEL FRIEDSAM, 1931 (32.100.57).

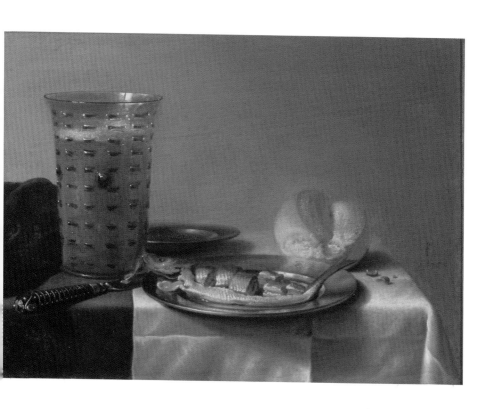

PLATE 1. PIETER CLAESZ., *Little Breakfast* (1636). COURTESY OF
MUSEUM BOIJMANS VAN BEUNINGEN, ROTTERDAM.

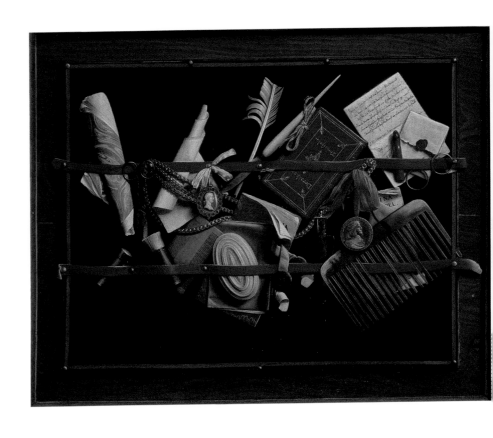

PLATE 2. SAMUEL VAN HOOGSTRATEN, *Feigned Letter Rack Painting*
(C. 1670). COURTESY OF STAATLICHE KUNSTHALLE, KARLSRUHE.

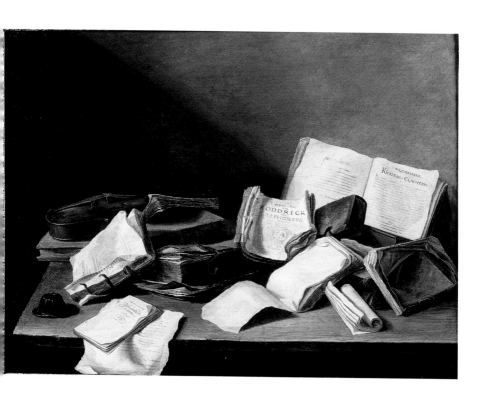

PLATE 3. JAN DAVIDSZ. DE HEEM, *Still Life of Books* (1628). COURTESY OF
THE ROYAL CABINET OF PAINTINGS, MAURITSHUIS, THE HAGUE.

PLATE 4. CORNELIUS GIJSBRECHTS, *The Reverse Side of a Painting* (C. 1670),
STATENS MUSEUM FOR KUNST, COPENHAGEN. PHOTO: SMK FOTO.

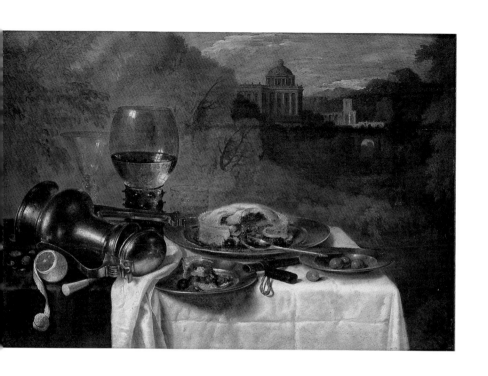

PLATE 5. WILLEM CLAESZ. HEDA, *Breakfast Still Life* (1634). COURTESY
OF MUSEUM VOOR SCHONE KUNSTEN, GHENT.

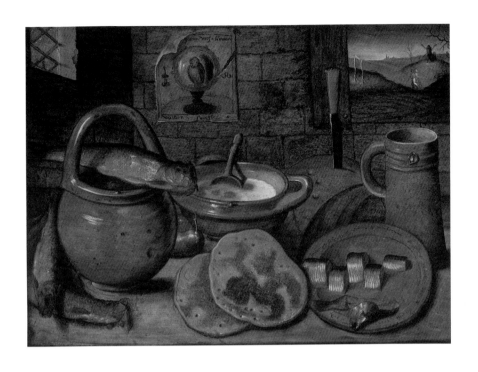

PLATE 6. HIERONYMUS FRANCKEN THE YOUNGER, *A Poor Man's Meal* (C. 1600).
COURTESY OF MUSEUM BOIJMANS VAN BEUNINGEN, ROTTERDAM.

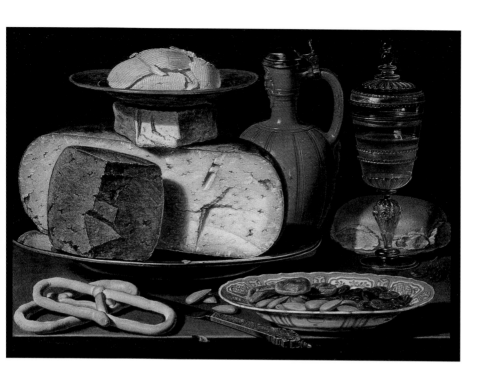

PLATE 7. CLARA PEETERS, *Still Life with Cheeses and Pitcher* (1612).
COURTESY OF THE RICHARD GREEN GALLERY, LONDON.

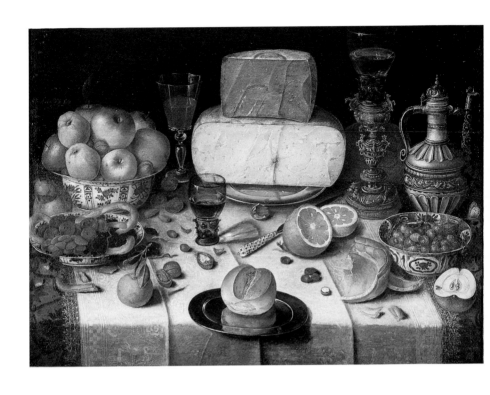

PLATE 8. NICOLAES GILLIS, *Laid Table* (1612), PRIVATE COLLECTION, UNITED STATES.

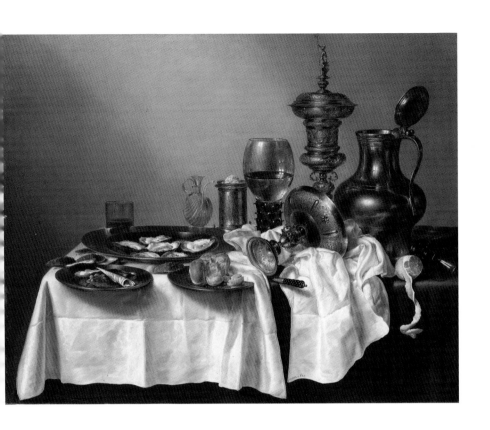

PLATE 9. WILLEM CLAESZ. HEDA, *Still Life with Gilt Goblet* (1635). © RIJKSMUSEUM, AMSTERDAM.

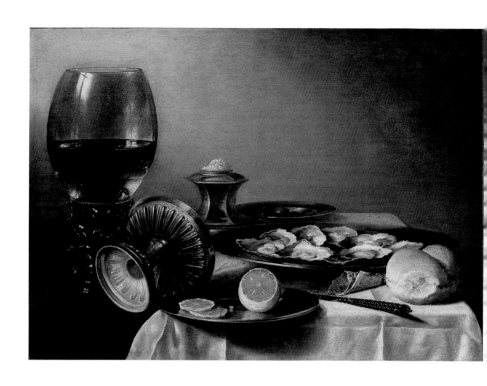

PLATE 10. PIETER CLAESZ., *Still Life with Wine Goblet and Oysters* (1630S). COURTESY OF THE
MUSEUM OF FINE ARTS, BOSTON. GIFT OF MRS. H. P. AHRNKE IN MEMORY OF HER GREAT-AUNT,
MRS. FRANCIS B. GREENE (56.883). PHOTOGRAPH © 2003 MUSEUM OF FINE ARTS, BOSTON.

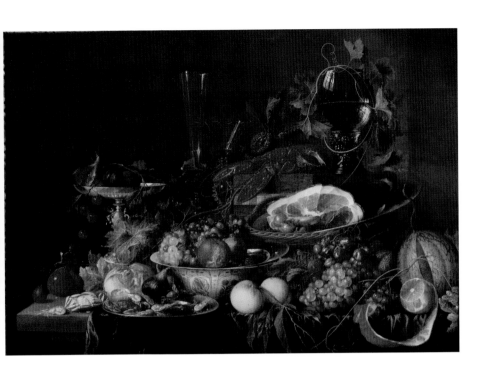

PLATE II. JAN DAVIDSZ. DE HEEM, *Pronk Still Life* (1648). COURTESY
OF MUSEUM BOIJMANS VAN BEUNINGEN, ROTTERDAM.

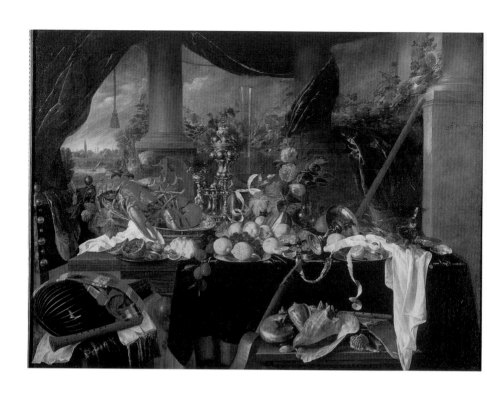

PLATE 12. JAN DAVIDSZ. DE HEEM, *Pronk Still Life with Shells* (1642), PRIVATE COLLECTION.

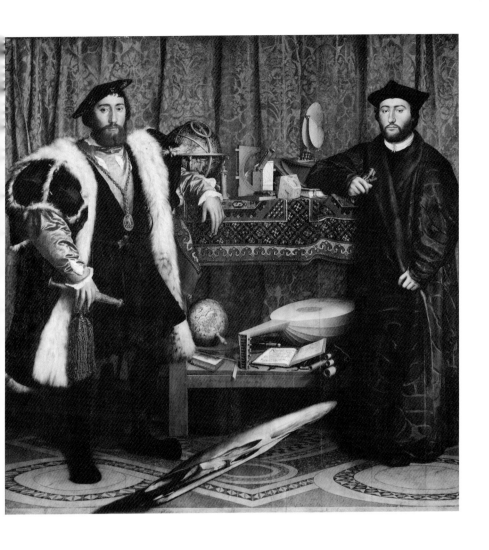

PLATE 13. HANS HOLBEIN THE YOUNGER, *The Ambassadors* (1533), NATIONAL
GALLERY, LONDON. PHOTO: ERICH LESSING/ART RESOURCE, NY.

PLATE 15. EMMANUEL MAIGNAN, *St. Francis of Paola* (1642). COURTESY
OF THE CLOISTER OF THE TRINITA DEI MONTI, ROME.

PLATE 16. EMMANUEL MAIGNAN, *St. Francis of Paola* (DETAIL) (1642).
COURTESY OF THE CLOISTER OF THE TRINITA DEI MONTI, ROME.

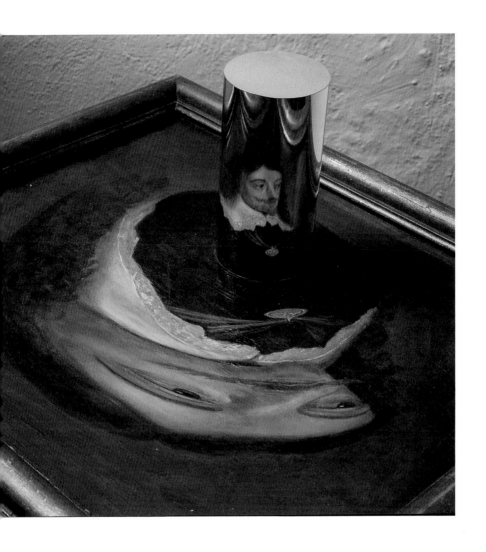

PLATE 17. ANONYMOUS, *King Charles I of England*, CYLINDRICAL ANAMORPHOSIS (C. 1660),
NATIONALGALERIE, STOCKHOLM. PHOTO: THE NATIONAL MUSEUM OF FINE ARTS.

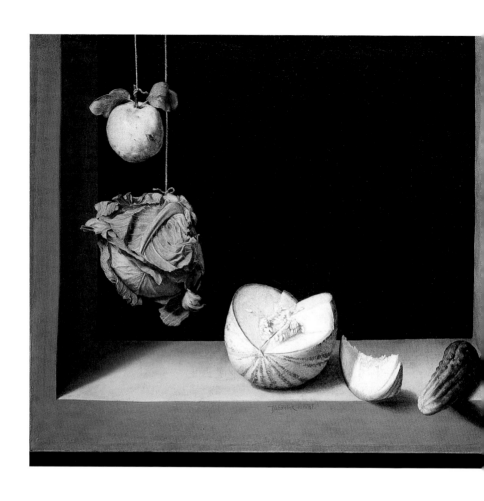

PLATE 18. JUAN SÁNCHEZ COTÁN, *Still Life with Quince, Cabbage, Melon and Cucumber*
(C. 1602), COURTESY OF THE SAN DIEGO MUSEUM OF ART (GIFT OF ANNE R. AND AMY PUTNAM).

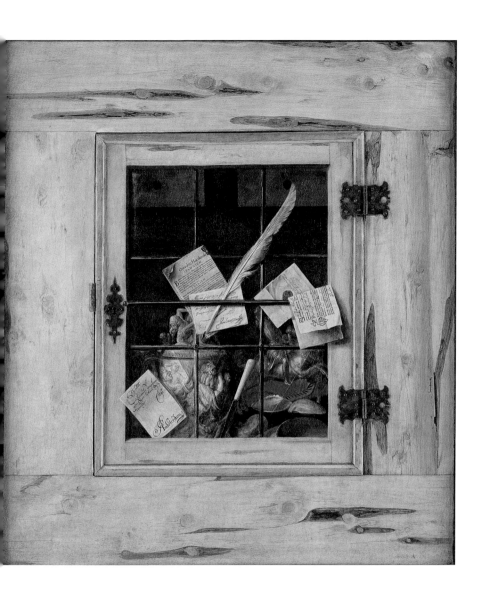

PLATE 19. CORNELIUS GIJSBRECHTS, *Trompe l'Oeil Cabinet of Curiosities with Ivory Tankard,*
RECTO (1670), STATENS MUSEUM FOR KUNST, COPENHAGEN. PHOTO: DOWIC FOTOGRAFI.

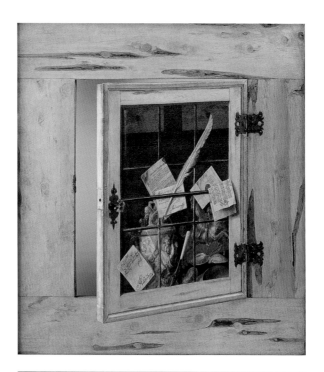

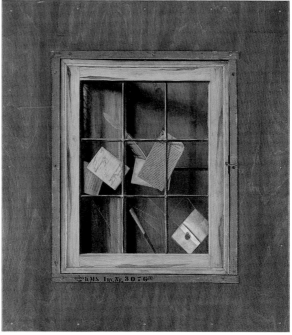

PLATE 20. CORNELIUS GIJSBRECHTS, *Trompe l'Oeil Cabinet of Curiosities with Ivory Tankard,* WITH OPEN DOOR AND VERSO (1670), STATENS MUSEUM FOR KUNST, COPENHAGEN. PHOTO: DOWIC FOTOGRAFI.

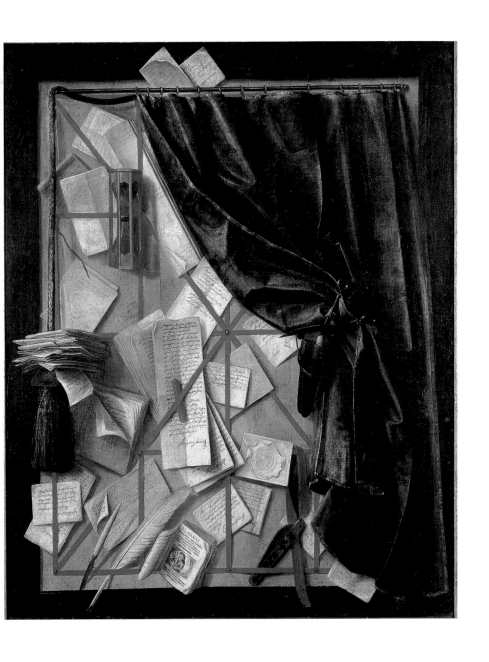

PLATE 21. CORNELIUS GIJSBRECHTS, *Trompe l'Oeil Letter Rack* (1668).
COURTESY OF MUSEUM VOOR SCHONE KUNSTEN, GHENT.

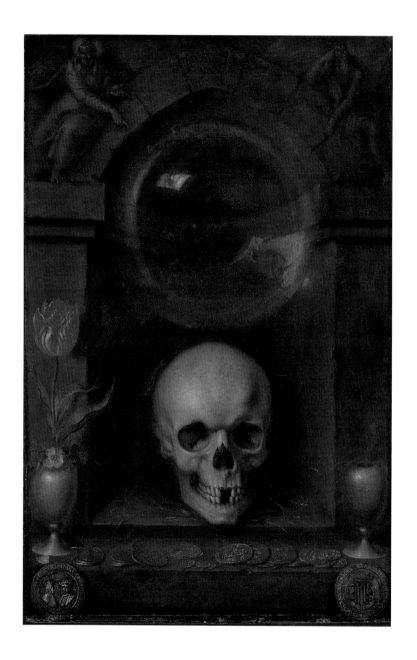

PLATE 22. JACQUES DE GHEYN, *Vanitas Still Life* (1603). COURTESY OF THE
METROPOLITAN MUSEUM OF ART, NEW YORK, CHARLES B. CURTIS, MARQUAND,
VICTOR WILBOUR MEMORIAL, AND ALFRED N. PUNNETT ENDOWMENT FUNDS,
1974 (1974.1). PHOTOGRAPH © 1984 THE METROPOLITAN MUSEUM OF ART.

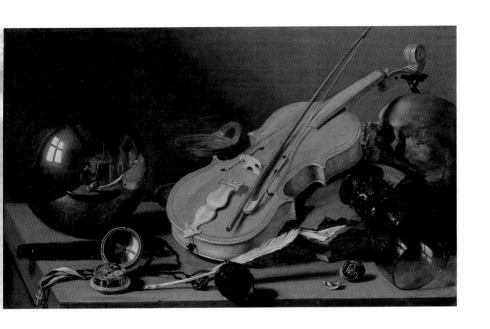

PLATE 23. PIETER CLAESZ., *Vanitas* (C. 1628). COURTESY OF
GERMANISCHES NATIONALMUSEUM, NUREMBERG.

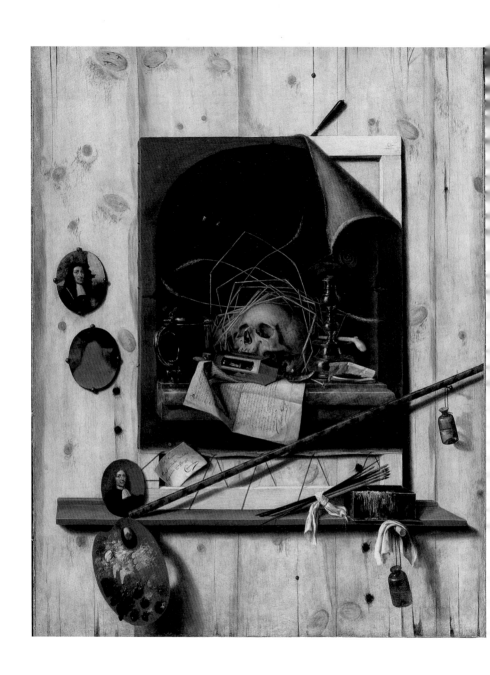

PLATE 24. CORNELIUS GIJSBRECHTS, *Trompe l'Oeil with Studio Wall and Vanitas Still Life*
(1668), STATENS MUSEUM FOR KUNST, COPENHAGEN. PHOTO: HANS PETERSEN.

A similar conflict between foreground and background resulting in a different relation between the two planes appears in market and kitchen pieces. In most of such paintings, the modest arrangement of Christian symbols in the Madonna pictures have been substituted for a gigantic display of fruits, vegetables, meat, and fish in the foreground consuming most of the picture's surface. For instance, if we look at Pieter Aertsen's often discussed *Christ with Maria and Martha* (fig. 3, 1552), the life-size objects and edibles, arranged on a table flanked by a cupboard, leave little room for the biblical scene of Christ, Mary, and Martha located near a fireplace in the background. The large joint of meat, probably lamb, resting on too small a plate seems to be in sharp contrast with the sacred scene, yet this contrast is in accordance with the theme of Luke 10, which precisely deals with the opposition between spiritual and earthly food, between the Word of Christ and the Flesh.[7]

In Van Cleve's painting, the fruit and objects are clearly motifs subordinated to the larger theme of the picture. In contrast, Aertsen's peculiar treatment of foreground and background planes serves as a deepening of the meaning of the biblical narrative, a deepening that emerges on the level of the split between the planes. The objects and edibles do not fall "outside" the painting, as in Van Cleve's *Andachtsbild*, but they visualize, or rather materialize, its theme by translating the word of the Gospel, enunciated in the background into an image. The strong connection between the two planes is further emphasized, as Stoichita remarks, by the strip of floor tiles on the left side of the painting, suggesting a continuation between the two spatial levels. Rather than balancing on the threshold of the pictorial realm, the large still life is in full command of its space, in the sense of having appropriated it: Aertsen's accumulation of objects stretches out from the lower to the upper frame in a two-dimensional rather than a three-dimensional direction, occupying a considerable part of the panel's surface rather than of its pictorial space. Indeed, Elizabeth Honig explains how the extension of the pig's ear and the sausage from the foreground over the larger view do not create but rather negate the illusion of depth.[8]

In his article on Aertsen's still-life conception, Reindert Falkenburg argues that the representation of edibles and objects in close-up is not the only compositional feature Aertsen's market pieces have in common with devotional images of the Madonna. The two traditions share a particular type of background structure as well. Falkenburg explains how, for instance, Van Cleve's *Holy Family* is a variation on a compositional type of devotional imagery whereby the interior space is closed off on the one side by a background wall including a view out of a window and on the other side by

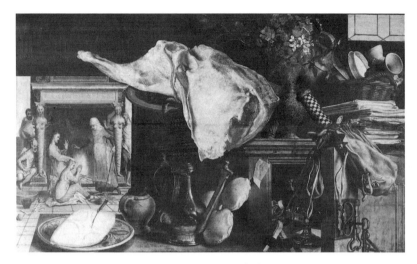

the close-up of daily-life features in the immediate foreground. Falkenburg
distinguishes a second type of composition whereby the Madonna is placed
against a view of a landscape that, divided by an arcade of columns, covers
the entire background.[9] Whereas Aertsen's composition of *Christ with Maria
and Martha* in which the narrative scene is reduced to an aperture in the back-
ground seems to be a version of the first type that Falkenburg distinguishes,
the second type underlies the composition of Aertsen's *Butcher Stall* (fig. 4,
1551), where the wooden posts of the butcher's stand fulfill a similar role as
the columns dividing the background view in the Madonna pictures. Partly
following Joachim Raupp, who has stated that Aertsen's pieces are satires,
Falkenburg argues that the "high" compositional type traditionally belong-
ing to sacred scenes has been used by Aertsen as a paradoxical *encominum*—
a figure of speech made popular by Erasmus's *The Praise of Folly* (1509)—for
painting pictorial eulogies of profane peasant life.[10]

Following Falkenburg to the extent that we shift our attention from the
foreground to the background of the precursors of still life, we see traces
of Aertsen's composition in one of the earliest northern European still lifes,
which is also the first known breakfast painting, entitled *A Poor Man's Meal*
(plate 6). This humble and rather clumsily rendered picture, of which sev-
eral versions are extant, was previously attributed to Aertsen but presently
is assumed to have been painted around 1600 by Hieronymus Francken the

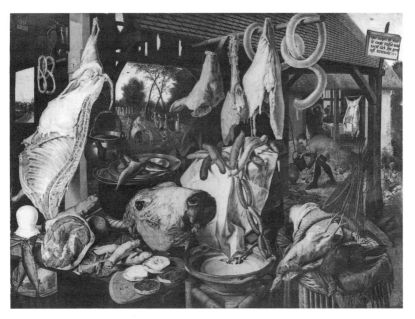

FIG. 4. PIETER AERTSEN, *Butcher Stall* (1551). COURTESY OF UPPSALA UNIVERSITY ART COLLECTIONS.

Younger (1578–1623).[11] In this picture, Francken laid out the basic elements of
the depictions of banquet pieces that soon thereafter became popular in the
Netherlands. We see a table dressed with a pitcher, a loaf of bread with a knife
stuck in it, a fresh herring cut into pieces, pancakes, and a bowl of oatmeal.
A print or drawing of an owl reflected in a mirror hangs on a wooden wall
while a window offers a view of dunes with two little figures, a mill, and the
contours of a village on the horizon.[12]

If we juxtapose Francken's *Poor Man's Meal* to Aertsen's *Butcher Stall*, we see
several striking similarities in the structure of the background and the fram-
ing of the "views." The location of the three views in Aertsen's picture—the
landscape on the left, the biblical scene of the Flight to Egypt in the center,
and figures at work in a butcher shop to the right—closely corresponds with
the location of the three "apertures" in *A Poor Man's Meal*: the window on the
left, the print of the owl in the center, and the view onto the dune landscape
on the right. Francken clearly has decided to follow Aertsen's design closely
by carefully copying the shape of his cutouts. The frame of the view onto a
landscape on the left in the *Butcher Stall*, its upper and lower borders receding
into depth, is literally taken over by Francken, albeit less convincing, while
the particular cutout of the biblical scene, its frame slightly curved by the

roof beams of the meat stall, is echoed in the detached upper left corner of the owl print.

This comparison demonstrates that in this simple early still life Francken did not merely catch within his frame still-life features that seem to have been spilling out of market stalls, but he also preserved the type of background composition against which these features were originally placed. His direct followers change this type of composition drastically when they start to raise the horizon of their pictures in such a way that no space for a background remains. *Horror vacui* seems to rule the works of the first generation of breakfast painters.

A breakfast piece by Clara Peeters, *Still Life with Cheeses and Pitcher*, of about a decade later (plate 7, 1612) displays a close-up that puts the viewer virtually face-to-face with the tabletop, leaving no room for a window view. A mound of cheese with a plate of butter on top; a jug; a porcelain plate with almonds, figs, and dates; a roll of bread; two *krakelingen*; and a knife with Peeters's signature inscribed in the handle are pressed together within a tightly cropped frame, containing them all in a space that is barely large enough. Peeters chose a composition in which the objects take up all of the picture's surface, leaving no room at either the top or the bottom of the frame, or behind the objects. In Peeters's painting, the stack of cheese, the pitcher and the glass, and the plate with figs and nuts are entirely on their own.

In the first decades of the seventeenth century, Peeters and her contemporaries Nicolaes Gillis (active 1601–1632), Floris van Dijck (1575–1651), Floris van Schooten (c. 1590–post-1655), and Roelof Koets (1592–1655) created tabletops that all seem to tip over, filled with a great number of objects surrounding mounds of cheese in the center. In Gillis's *Laid Table* of 1612 (plate 8), a prominent mound of cheese is flanked by a bowl with apples.[13] Unlike Peeters's austere meal of bread and cheese, Gillis dresses the table with rich damask, decorated with fine linen trimmed with lace. On the expensive fabric, he arranges precious glasses, a decorated pitcher, blue-and-white ceramic ware, and a wide range of fruits and delicacies. This is not an average breakfast, but a celebratory feast.

Gillis's picture reveals the same inclination toward *horror vacui* as that found in Peeters's painting. The tops of the glass and the *bekerschroef* in the background seem to reach for the upper frame, while potentially empty spaces between objects have been overcome by evenly sprinkling nuts and pieces of fruit around the table. The outer edges of the table, cut off by the frame, enhance the compact fullness of the pictorial space. The pewter plate

projects over the edge of the table, indicating here that the pictorial space can only extend forward, that is, out of the frame in the direction of the viewer, while extension backward is obstructed by the barricade of glasses and the pitcher. *Horror vacui* seems to have stimulated the first generation of painters of laid tables to "fill" their tables and hence their frames to the rim, a motivation that later may have pushed Millet to add his garden view to Heda's breakfast.

Characteristic of early breakfasts is that their objects rarely overlap in spite of their quantity. The extremely high viewpoint enables the artists to show complete outlines of most objects. Appearing as contour studies rather than realistic recordings, the early breakfasts display a high level of artificiality. The various objects are represented as they *are* rather than as they would appear to our eyes on a genuine table.[14] As we have seen in the previous chapter, Merleau-Ponty asserts that things never overlap in reality, but only in our visual field. Because we see the world from one particular point of view, the things surrounding us constantly overlap. In the course of looking, we change our viewpoint continually, whereby the foreground of our visual field persistently slides in front of the background. According to Merleau-Ponty, we see things *because* they overlap. A visual field where things do not overlap is an impossible one.[15]

In Merleau-Ponty's perspective, therefore, the laid tables of Peeters and Gillis present a pictorial reality without a view. While we see the entire form of most of the objects presented—and as many objects as possible are presented within the available pictorial space—they are not depicted the way we would see them. The high viewpoint does not correspond with our point of view in the visual field.

A shift occurs in the still young tradition of breakfast painting around 1630, when Claesz. and Heda begin to radically simplify the standardized composition. J. M. Montias, Michael North, and Jonathan Israel, among others, have explained this simplification in terms of market strategies and a shortage of supplies.[16] In the early seventeenth century, the art market in the Netherlands was dominated by merchant collectors, who expressed an interest in specific genres rather than specific pictures. Responding to the growing interest in still lifes, Claesz. and Heda, like their colleagues, specialized in one particular topic and attempted to create a new type of painting that would be familiar enough to attract buyers, while being original enough to become their own specialty. They adjusted the characteristics of their artworks to the quickly expanding art market in order to keep up with the demand and aimed at a higher production rate by limiting themselves

to modest themes, rendered through the application of simple techniques. Influenced by the Haarlem landscape painters, such as Van Goyen, Claesz. pioneered working with mute colors and designed a color scheme that enabled him to work much faster. Heda contributed the strategy of fixed composition, compulsively repeating his arrangements to such an extent that to this day it remains difficult to discern whether a specific work is an original or a copy by his own hand. Together, Claesz. and Heda established a distinct direction in the painting of still lifes, one that was modest, monochrome, serene, and, so to speak, virtually empty.

Unlike Gillis's creation of colorful, fancy cookies, candies, and other delicacies, Heda's *Still Life with Gilt Goblet* of 1635 (plate 9) displays the strict repertoire of objects and edibles in monochrome colors that are also typical of his other works. Contrary to Gillis's table that is horizontally captured within a painting's frame, Heda's table is situated in an indefinable space, the edges fully visible. The table appears as if it subjects itself to the rules of gravity, carrying what might be the leftovers of an actual meal, while Gillis's stiffer arrangement almost slides out of the frame.

The dimensions of the two painted tables are similar, yet the quantity of objects in Heda's painting is radically reduced. Paradoxically, not one of the objects is fully visible (except, perhaps, for the omnipresent lemon), but instead every outline is interrupted by the contours of another element. The tablecloth, for instance, partly covers one of the pewter plates, and although another small plate on the left appears as if it presents its whole surface, Heda delicately places an oyster on its rim, thus obscuring it from full view. This strategy of overlapping results in the appearance of a void. Behind the table a space arises, invisible in early breakfasts, that covers virtually one-third of the picture plane. While the walls of seventeenth-century paintings often are marked by details such as nails casting small shadows or holes and cracks in the plaster that produce the effect of the real, Heda (like Claesz.) never leaves such traces.[17] His background is intentionally left empty. Apart from shades of ocher reflecting light, the background is a beige color field against which objects are projected: a genuine void in painting.

Not afraid of empty spaces, Claesz. and Heda allow a void to appear in a genre where *horror vacui* once ruled. There is no compensation for this emptiness. The part of their compositions that *is* covered with painted objects consequently seems to be even more emptied out. The oeuvre of both artists exhibits little variation, and their images do not appear to communicate a clear meaning. Indeed, the slightest reference to Christian symbolism, still apparent in the work of Peeters and Gillis, has disappeared. Even more remarkable

is the way in which color has been drained from the picture plane. In other words, the void rules over these pictures at multiple levels, including those of composition, the selection and arrangement of objects, depth suggestion, color scheme, and iconographic meaning.

The radical lowering of the viewpoint is the primary source of these changes in breakfast paintings, whose result is that the tabletop sinks, along with the horizon, subsequent to which the objects shift in front of each other while the background emerges behind them. Interestingly, both artists decided to leave this background untouched. Their decision may have been motivated by market strategies or the increasing price of supplies, as Montias and Israel have argued. Contrary to this historical-economical explanation, however, I will read this void as a commentary on the complexity of spatial representation.

Rembrandt versus Claesz.

Claesz. and Heda were not the only artists who enabled a void to emerge in the process of modifying the traditional compositions of previously developed genres. In *Das Holländische Gruppenporträt* (1902), Aloïs Riegl describes what I call the void in terms of an opening up of free space ("Freiraum") within the picture plane of Dutch group portraiture.[18] Until the beginning of the seventeenth century, groups of people were portrayed in static rows, placed one above another in such a way that they tightly filled the frame. In the 1630s, Riegl suggests, a new compositional structure was introduced in Rembrandt's *Anatomy Lesson of Dr. Nicolaes Tulp* (fig. 5, 1632). Rembrandt decided to paint Dr. Tulp and his colleagues in a more naturalistic way by arranging them around a corpse in the appropriate setting of a dissecting room, while Dr. Tulp demonstrates the workings of the hand muscles. Though not an entirely original composition (in 1619 Thomas de Keyser had created a similar composition with a skeleton), Rembrandt's painting represents for Riegl a newfound balance between space, figures, depth, and composition by a unification of what he calls "external" and "internal" coherence. An example of art that creates an "external coherence" is Aertsen's *Butcher Stall* in which various isolated scenes seem to be unrelated to each other. The connection between the figures and their surroundings needs to be imposed on the picture by the viewer. Riegl speaks of "internal" coherence when a work of art appears complete in itself, calling for such attention of the viewer that s/he becomes involved in the scene. Unlike earlier group portraits, where the figures' heads appear as a visual inventory of members, Rembrandt places Tulp's colleagues loosely behind and next to each other

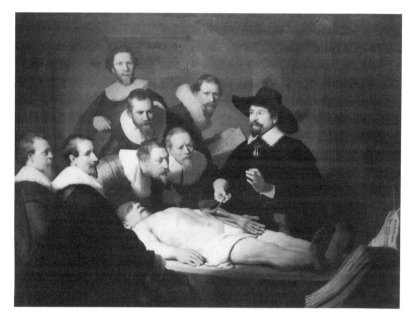

FIG. 5. REMBRANDT VAN RIJN, *The Anatomy Lesson of Dr. Nicolaes Tulp* (1632). COURTESY OF THE ROYAL CABINET OF PAINTINGS, MAURITSHUIS, THE HAGUE.

in a pyramidal construction, as they all attentively follow the doctor's autopsy. With regard to attentiveness, Riegl detects a "dual subordination" of the group to the dominant figure of Dr. Tulp, and of both to the viewer. In addition, Rembrandt's novelty is brought about by a "double unity" in composition by integrating the two-dimensional effect of the triangular composition in the three-dimensional arrangement. Symmetry and pyramidal shapes, however, are only relevant to the artist as constituting aspects. For Riegl, Rembrandt's real challenge "was the illusion of depth in the free space between the figures." [19] The artist wanted his viewer to focus as much on the free space between the figures as on the figures themselves.

Recognizing the profundity of Rembrandt's challenge, Riegl acknowledges that space, distance, and depth are not interchangeable, even in painting. While the use of a pyramid construction as well as the abandonment of strict symmetry in favor of a centralized composition had been performed earlier, *The Anatomy Lesson* marks for Riegl a breakthrough in enabling these contrasting elements to reinforce one another. Rembrandt manages to suggest a depth that truly encompasses the figures by leaving free space among them. *The Anatomy Lesson* is a milestone in group portraiture as well as in

Dutch painting in general, because for the very first time it makes an interior space within a painting visible *as space*.[20]

In *A Modest Message as Intimated by the Painters of the "Monochrome Banketje,"* N. R. A. Vroom applies Riegl's argument regarding the emergence of free space in group portraiture to laid table still lifes. Vroom is less interested in Rembrandt's problem of how to transform space between figures into the suggestion of depth than in the area on the right side of *The Anatomy Lesson* that is left "untouched."[21] Around the same time that *The Anatomy Lesson* was created, Claesz. and Heda experimented with compositions similar to Rembrandt's. Inspired by Riegl, Vroom compares kitchen pieces and militia banquets with the breakfast pieces of Claesz. and Heda, something his purely formalistic discourse allows him to accomplish successfully.

Comparing Claesz.'s *Toebackje* (Little Tobacco) (fig. 6, 1633), which is strictly speaking not a *banketje* (little banquet), with Rembrandt's *Anatomy Lesson*, Vroom demonstrates how Riegl's argument also holds for laid table pieces. Just as for Riegl, Rembrandt's painting indicates a break with tradition, so Claesz.'s modest *Toebackje* marks the shift from an early laid table piece to its final resolution. Vroom even speaks of a "solidarity" between the glass, brazier, and smoker's utensils that expresses a spiritual tension similar to Rembrandt's gathering of Tulp's fellows. According to Vroom, the displacement of the focal point from the center of the picture plane to the left, brought about by the pyramid construction, is responsible for the naturalism in both artworks. Although I do not agree with Vroom's argument that Claesz.'s *Toebackje* exemplifies a breakthrough similar to Rembrandt's *Anatomy Lesson*, Vroom's comparison demonstrates how the laid table piece is very much part of a general development in painting. To this extent, the better-documented tradition of portrait painting does provide a new insight in the largely disavowed category of laid table pieces.

In terms of the organization of the picture plane, Rembrandt's *Anatomy Lesson* reveals striking similarities with Claesz.'s *Toebackje*. The look they solicit, however, is fundamentally different. Looking *at* Claesz.'s painting largely differs from looking *through* Rembrandt's *Anatomy Lesson*. Despite the resemblances in composition, form, and tradition, as well as both paintings' success in opening up the pictorial space, the two instances of free space do not represent the same thing. Rembrandt's free space provides his painting with more depth, while Claesz.'s void does not enhance the illusion of space in the least. If the free space in *The Anatomy Lesson* represents a depth of space, as both Riegl and Vroom suggest, then what does the void in Claesz.'s *Toebackje* stand for?

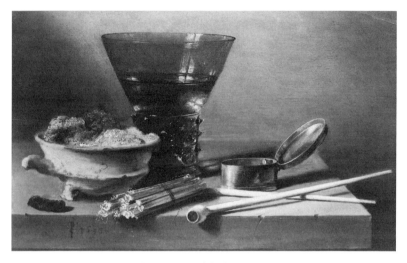

FIG. 6. PIETER CLAESZ., *Toebackje* (LITTLE TOBACCO) (1633), PRIVATE COLLECTION.

A Fly's-Eye View

Let us look again at Heda's *Still Life with Gilt Goblet* (plate 9) for a possible answer to the question of what the void in breakfasts may represent. Among Heda's regular objects—such as the *roemer*, the silver tazza, the pewter pitcher, and the elegant condiment bottle—an unusual gilt goblet proudly stands out at the back of the table, on its cover a little soldier whose spear rises far above the other objects. The presence of the goblet significantly changes the calm and cool atmosphere typical of Heda's other breakfasts into a more sumptuous mood that still, however, is painted in sober tones. If we read this painting in the traditional way from the lower left to the upper right corner, the goblet literally and metaphorically constitutes the climax of the picture. Heda carefully ensured that the diagonal running along the edge of the table ends exactly at the goblet's cap, just touching the figure's spearhead.

The table is placed at such a distance that we see how the edges of the white linen do not fully cover the green velvet cloth underneath. The somewhat chaotic arrangement suggests that this meal of oysters and bread was prematurely abandoned. Only half the oysters have been eaten, probably with some of the pepper that is wrapped in a sheet of paper from an almanac or with some of the salt piled on the silver pedestal, vinegar from the condiment pitcher, or lemon juice. The bread has hardly been touched. While

luxurious, the chaos on the table is also quite disciplined and ingeniously composed. In particular, individual elements were paired by Heda to give the messy arrangement a well-balanced harmony. A glass half filled with red wine occupies one corner of the table while an empty one lies on its side in another. The *roemer* with white wine as well as the pitcher with its cover ajar flank the goblet and the tipped tazza. The elegant vinegar bottle reaches with its spout toward the salt cellar. The two small pewter plates both extend over the edge of the table, as do the knife handle and the lemon peel. One tablecloth neatly covers the left half of the table, while a second one of the same color and material, evidently used as a napkin, lies crumpled on the table.[22]

Though the meal in the painting may appear abandoned, it has not yet been abandoned by its viewers. The chaotic state of the table, however, suggests that this after-dinner (or after-breakfast) scene and its display of leftovers was not meant to be seen. It is as if we see the world just at the moment when no one is there to look at it, as Bryson puts it.[23] Indeed, what we see before us is what we never look at in reality; in everyday life we always leave such scenes before we have taken time to observe their abandoned state, our last action that of throwing the crumpled napkin on the table even as we turn away.

Heda presents this scene that we normally only register vaguely, from the corner of our eye, from a rather unusual point of view. While we see the food from nearby, it is not as potential diners and what it offers us is certainly not a feast for the eye. It is not entirely clear from what imaginary spot this picture must be viewed; indeed, it looks as if nobody will ever think it worth a glance. Yet we are neither sitting at the table nor standing in front of it, but rather "approaching" it. While we are offered an overview of the table as if it were a landscape, the proximity of the objects and their many details disrupts this notion of having an overview. Neither a bird's- nor a frog's-eye view—neither occupying a diner's position nor being offered the viewpoint of a fixed viewer—our looking is suspended at an angle relative to the tabletop that we normally would never experience. Persisting with animate metaphors, we could say that we view the table from a fly's point of view.

Following Vroom in his comparison between different genres, we can juxtapose Heda's *Breakfast Still Life* to a landscape painting, for instance, Jan van Goyen's *Cottages and Fishermen by a River*, also produced in Haarlem around the same time (fig. 7, 1631). Like group portraiture, landscape painting of the 1620s reveals a similar shift in composition in terms of a new propor-

tional relation between sky and land. As I indicated earlier, breakfast still lifes have more in common with landscape painting of the same period than with group portraiture, both being non-narrative and monochrome. A comparison between them may consequently better articulate the particularity of breakfasts than did Vroom's juxtaposition of Claesz. and Rembrandt.

As Heda's tabletop displays the leftovers of a meal before our eyes, Van Goyen's landscape offers us an overview of trees, a river, and cottages in which the proportional relation between sky and earth is identical to the one between Heda's table and backdrop. In formalist terms, the outlines of both compositions are virtually the same: the hanging tablecloth functions in a similar way to the river; and the diagonal in Heda's painting that runs from the edge of the table to the goblet is comparable to the diagonal moving from the two treetops in Van Goyen's picture. The edge of Heda's table that encourages our eye to look beyond it echoes Van Goyen's river stretching out toward the horizon; and the dimensions of empty space, whether indefinable background or sky, are in both pictures the same. Like Heda's picture, Van Goyen's landscape invites us to take a closer look, promising details and small surprises.

Van Goyen's open sky, however, serves quite another purpose than Heda's ocher background. While a landscape such as Van Goyen's river view can be admired in reality, Heda's table will only be observed in a painting, since few people will pay attention to an abandoned breakfast. The space in Van Goyen actually opens up, not only because its emptiness represents the openness of the heavens (which are empty by definition), but because its infinite vanishing point exists in real space. The problem with infinity is, of course, that it can never be seen but only imagined; we can apprehend it without necessarily comprehending it. Van Goyen's infinite void is recognizable *as sky* while Heda's vacuum is unexpected and disrupting.

Whereas our eyes can travel the same paths in both pictures—wandering over the river and across trees as if between plates and oysters, flying from the peaks of the goblet to the lower parts of the table as if gliding from the peaks of trees to the water's surface—in Heda's landscape of leftovers, our visual mobility is ultimately restrained. It is enclosed by the sides of the picture frame as well as by the triangular ocher color field. Indeed, Van Goyen's painting offers a *view* in more than one sense.

Whereas *Cottages and Fishermen by a River* presents in an Albertian sense a look into a space that extends in depth, Heda's void is imaginary in that it does not portray anything outside purely pictorial space. His space is defi-

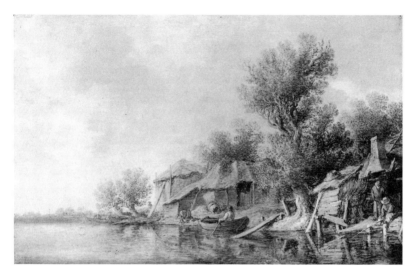

FIG. 7. JAN VAN GOYEN, *Cottages and Fishermen by a River* (1631). COURTESY OF THE GLASGOW MUSEUMS.

nitely *flat*. The picture's vanishing point gestures toward a point of infinity that is *not* included in the painting, but must be imagined beyond the panel and even beyond the painted color field.[24] That is, Heda's background does not refer to any space outside the frame, but rather signifies a void *in painting* that is devoid of *painted* objects. We may assume that the horizon in Heda's picture runs along the edge of the table, but in contrast to the horizon of Van Goyen's picture, it cannot be *seen*. *Still Life with Gilt Goblet* offers us a scene without a clear horizon or a defined vanishing point, treating a kitchen table as if nobody is present to look at it. Paradoxically, we *are* looking at this picture but in such a way that it appears as if *we are looking from an empty point of view*.

A viewpoint is never simply offered to us; it *enables* us to see. Because it is the very place from which we view, this point itself can hardly be scrutinized. Viewers themselves can be watched and analyzed relatively effortlessly, yet the viewpoint from which seeing is made possible is difficult to picture. As I have explained in chapter 1, trompe l'oeils demonstrate that their—fixed—point of view is *not* the point of perception. The breakfast still life confronts us with the paradox that the point of view is not entirely there. How to imagine a world or an image without a point of view?

Heda comes close to visualizing this internal paradox by showing a world deprived of a human gaze. Through the void, he makes something visible

that is invisible in Van Goyen's landscape, precisely because the latter offers us a view. The opening up of pictorial space in *Cottages and Fishermen by a River* conveys the infinite depth of heaven. In Rembrandt's *Anatomy Lesson*, we have seen how the "free space," as Riegl calls it, signifies a depth that encompasses Dr. Tulp and his fellows. The question arises what Heda's void represents. Neither referring to actual space nor to pictorial depth, the void is a mere beige field, its color a result of mixing all the pigments of a palette. Does the beige color field simply represent nothing at all, or does it signify nothingness as such? The prominent visibility of the void leaves no doubt about its importance in the painting, and for that reason it requires us to take a decided standpoint regarding its presence. As pure flatness, it represents the opposite of regular pictorial space, while as a representation of nothingness, it refers to the opposite of painting as such. Heda's empty field thus necessitates a rethinking of perspective's relation to pictorial space, depth, and empty space. We may ask ourselves whether the empty triangle does not fall under the sovereignty of perspective, given that it does not follow its rules for creating either an illusion of depth or space, or a view. I suggest that through its very emptiness, Heda's beige triangular field reveals perspective's own empty geometrical structure.

From within a pictorial tradition traditionally dominated by *horror vacui*, Claesz. and Heda birthed the void in the late 1620s, only to have it suffocated by their immediate successors.[25] After an absence of barely twenty years, *horror vacui* was reintroduced most emphatically in the so-called *pronk* still lifes, whose most prominent exponent is Jan Davidsz. de Heem. Within the tradition of laid tables, therefore, the empty background in breakfast paintings stands out as a unique phenomenon. If we juxtapose the breakfasts with the *pronk* still lifes into which the former ultimately developed, it is possible to see how the void functions on a rhetorical level within a discourse of austerity and abundance.

The Art of Persuasion: Claesz. and De Heem Compared

Jan Davidsz. de Heem initially started as a painter of breakfasts done in the manner of Claesz. One of De Heem's earliest known creations is a monochrome *banketje* from 1629 that strongly recalls Claesz.'s typical simplicity. He quickly distanced himself from the monochrome style, however, by introducing bright red lobsters and richly decorated silver and mother-of-pearl nautilus cups in warm and bright colors, elements that hardly appear in the work of Claesz. and Heda. Along with adding both costly objets d'art and delicacies, De Heem enlarged the average size of the still life. He widened the

genre's narrow borders to include more pleasurable objects in the pictorial space, without ever allowing the newly acquired space to remain empty.

The differences between the two categories, however, easily overshadow their structural link. In *Still Life with Wine Goblet and Oysters* (plate 10, 1630s), Claesz. repeats his well-known repertory. The always-present *roemer* is placed in the far left, right next to a silver tazza tipped on its side. A plate with oysters is flanked by two smaller plates, one with olives and one with the ubiquitous lemon, this time without its curled peel. A salt cellar stands in the back, while in the lower right corner pepper spills from a cone made of an almanac sheet located near a chunk of bread and a knife with a checkered handle. The plane is dominated by diagonals, the primary one running from the upper left to the lower right corner, dividing the image into two triangles. The lower triangle displays the styled disorder of the objects on the table, while the upper one allows the void to appear. A dark shadow is cast over the lower left corner and resonates with the dusky upper right corner, while a shaft of light—like a spotlight—runs from the impeccable white tablecloth in the lower right corner to a hazy sparkling of light just above the *roemer* in the upper left corner.

De Heem's *Pronk Still Life* (plate 11, 1648) has far more to offer in staging a genuine delight for the senses, gustatory and visual alike. Breaking with its breakfast predecessors, the image thematizes its abundance. If Claesz.'s simplicity of form and choice of object may be connected to a working-class aesthetic, and if Heda's objects represent the wealthy middle class, De Heem's taste is definitely aristocratic, as was his clientele.[26] Rich in color and abundant in composition, *pronk* still lifes present diverse delicacies and costly objects and can therefore easily be considered the opposite of Claesz's *Still Life with Wine Goblet and Oysters*. Like Claesz.'s painting, however, the design of De Heem's composition still is structured by diagonals. The stack of foodstuffs forms a sharp triangle with the *roemer* on top, as always in the dominant position, the center around which the composition is arranged. From the *roemer* downward there is a complex three-tiered construction. The highest level consists of a basket on which a pewter plate with a ham has been placed. One level down, there is a porcelain bowl covered with another plate replete with fruit, and below, on the table, stands a third plate with some *fruits de mer*. A tazza with figs and prunes along with some (Venetian) glasses form the back row, while a melon, bunches of grapes, two peaches, and a lemon are placed up front. De Heem's entire arrangement is decorated with garlands of leaves that give it an artificial touch, as well as creating an effect of fullness. This is a feast for the eyes: the colors are warm and bright, the red of the

lobster perfectly matches the deep red-brown of the chestnuts next to it, the glasses sparkle, the grapes are translucent and glimmering, the peaches are velvety, and the bone emerging from the ham shines with grease. One can easily imagine how these treats of nature taste. The still life's overall effect, especially when placed next to Claesz.'s panel, is overwhelming, breathtaking, and mouthwatering.

With De Heem's magnificent banquets, *horror vacui* returns to rule the laid tables, operating now on the level of seduction rather than being deployed in order to render the outlines of the objects faithfully, as did the early masters of laid tables. De Heem maintains the lower viewpoint and the horizontal position of the tabletop that Claesz. and Heda introduced. The empty background that resulted from this low viewpoint, however, has been covered up. De Heem's inventiveness in this regard is admirable. As we have seen in his *Pronk Still Life*, he creates towers of food and dishes, stacking fruit-filled plates, baskets, and bowls on top of each other in order to have large parts of the otherwise untouched plane overlap. He is also fond of draping curtains behind the table or providing his still lifes with a view from a window, a reference to the earliest meal pictures by Hieronymus Francken, as well as their predecessors. As soon as De Heem fully established the sumptuous banquet as his hallmark, the void in meal painting disappeared, never to return in seventeenth-century painting.

The comparison between Claesz. and De Heem may easily lead to formulations of the differences between them in terms of oppositional styles generated by divergences between the northern and southern parts of the Netherlands (De Heem moved to Catholic Antwerp in 1635), focusing most notably on Calvinism versus Catholicism and the plainness of the word versus the theatricality of the image. Once, however, the different aspects of cultural history, geography, religion, and stylistic qualities have been pointed out—as many studies of still-life painting have done so admirably—there still remains a certain critical dissimilarity for which none of these factors can account.[27] This quality may best be described as a difference in *effect*. In the footsteps of de Man, I suggest that a formulation of differences in terms of effect calls for a rhetorical reading rather than a historical or formalist one.[28] Whereas in monochrome breakfasts, the void goes hand in hand with depicting austerity, in De Heem's *pronk* still lifes, *horror vacui* produces a sumptuousness and fullness that clearly attempts to seduce the viewer. As pictorial elements, *horror vacui* and the void are thus implicated in a discourse that separates abundance from moderation, seduction from persuasion, and desire from restraint, topics that these paintings each address

on a thematic level. In terms of painting, this discourse depends, to a certain extent, on that perspectival organization of space with which the tropes of *horror vacui* and the void are heavily involved.

In the late 1650s, Blaise Pascal addressed the complex relationship between rhetoric, seduction, truth, and geometry in his two-part essay "The Mind of the Geometrician" and "The Art of Persuasion."[29] Created for the instruction of pupils at Port-Royal, the monastery to which he had retired, the text presents the usefulness of geometry as the basis for a reliable form of argumentation in ordinary as well as scientific language. This essay is useful for examining the different rhetorical strategies in the work of Claesz. and De Heem because it deals with key notions such as truth, pleasure, superfluity, and reduction within the context of a geometrical rhetoric. Furthermore, Pascal's idea of a geometrically based rhetoric may have an equivalent in painting. I believe that perspective, a geometrical system as well as a method of "convincing" us of the reality of a painting, is analogous to Pascal's geometrical rhetoric.

Geometry as a Model for Rhetoric

Pascal begins his study of truth and rhetoric with the following claim: "We have three fundamental aims in the study of truth. First to discover it as we search for it; secondly, to demonstrate it when we have it; lastly, to distinguish it from falsehood when we examine it."[30] His main focus in this essay is on the second aim. Pascal proves how a geometrically based rhetoric will perfectly demonstrate a truth. According to Pascal, there are two gateways through which arguments are received, the understanding and the will, to which two separate rhetorics appeal. The art of persuasion is directed toward understanding and operates through reason and truth, while the art of seduction appeals to the will and seduces through pleasure.

The starting point of Pascal's treatise is the difference he observes between nominal flexible definitions that make truth claims and need to be proved by the geometrician and real definitions that are in fact not definitions but derivative propositions. If nominal definitions alone are admitted to discourse, then argumentation in the manner of geometry becomes epistemologically reliable. The art of persuasion, modeled on geometry, offers two simple rules. First, one should never use terms whose meaning has not been explained beforehand, and second, one should never state propositions that cannot be demonstrated by truths already known. Pascal explains at length the absolute necessity for defining terms but simultaneously stresses the idea that "primitive words," such as "time" or "space," should be left

undefined since an attempt to describe them will ultimately cloud rather than clarify their meanings. While geometry cannot define these "primitive words" that are its principal concern, their resistance to definition implies their extreme clarity and is therefore a mark of excellence rather than a defect:

> It is not due to any obscurity of these things but rather to their extreme clarity which is such that, although it does not carry the conviction of demonstrations, nevertheless it does afford the same full certainty.[31]

Pascal is most concerned with securing a clarity of argumentation that in and of itself is able to annihilate even the slightest sense of ambiguity. The crystal-clear system of geometry guarantees the eradication of obscurity, Pascal promises, provided that, first, one never leaves obscure terms undefined; second, that one should always regard axioms as things that are in themselves perfectly evident; and finally, that one ought to prove propositions only by means of obvious axioms. Use of this method ensures the absence of ambiguity and consequently demonstrates truth. One condition this method stipulates is a stripping of useless and superfluous definitions that may confuse the argument and, hence, prevent it from being convincing. Pascal suits his actions to his words by holding his eight rules for the definition of terms, axioms, and demonstrations to the same standard. By way of example, he systematically removes all excess information, reducing the list to five essential rules that manifest themselves as indispensable, absolutely necessary, self-evident, and, therefore, obviously true. The extreme clarity that geometry can thus produce, Pascal claims, "convinces reason more strongly than does argumentation."[32]

Significantly, Pascal implies with this statement that the clarity of an argument's presentation is more convincing than the argument itself. He insinuates, I am suggesting, that an argument's clear presentation—regardless of its content—should be used as a device that convinces effectively while exceeding argumentation. This moment in his text is important for what follows: the success of clarity as a device is not based on reason, but in fact operates by means of seduction.

Pascal is very much troubled by the art of seduction because its principles are never "firm or stable"; in other words, they are ambiguous. Seduction operates by virtue of confusion, since it is founded on a desire whose object constantly changes. Since ambiguity poses a great threat to a geometrically based rhetoric, Pascal takes pains to distance himself and his method from the fallacies of seduction. He explains how man almost inevitably tends to be persuaded by pleasure rather than by proof, a weakness that he underscores

by referring to the biblical story of the golden calf. The mode of seduction, Pascal admits, is incomparably more difficult, more subtle, and more admirable than that of conviction. For that reason, he ultimately decides to leave the issue of seduction untouched.

Yet, instead of dismissing the issue and continuing on his way, Pascal now presents numerous reasons why he does not wish to discuss the art of seduction. Having argued the necessity of cutting off superfluous information in order to establish a clear argument, Pascal undermines his own rhetoric by providing redundant justifications for his refusal to address the issue of seduction. He explains that he considers himself totally unsuited to the job, that there are people who can address the issue much better than he can, and finally asserts that man's pleasures vary greatly, not only between men but also within man himself. The more reasons Pascal formulates, the weaker his argumentation becomes, enacting precisely the fallacy that a geometrically based rhetoric should prevent. Had he in fact followed his own rhetoric of persuasion, he would have succeeded in excluding ambiguity from his argumentation rather than exposing it. As it is, not one of Pascal's arguments yields any clarity about the true reason for his reluctance to discuss the rhetoric of seduction. It does not escape notice that he is trying very hard to absolve himself of seduction. This situation gives rise to the suspicion that this part of his text serves another goal: it itself functions rhetorically as proof of Pascal's overall sincerity. Seduction poses such a threat to geometry's coherence and perfectionism that even an attempt to justify his avoiding the topic nonetheless seriously undermines his argument.

As Pascal points out, the problem lies in the relation between discourses of truth and of seduction, which only coincide in cases where a man has been convinced by what is true and good. This state of affairs, however, rarely occurs. Most of the time, persuasion and seduction fail to cooperate, and transform into opposites. Men are governed so much more by caprice than by reason, Pascal writes, that they are inclined to follow the course of seduction rather than of persuasion, notwithstanding reason's resistance to pleasure. The essence of the problem is that seduction can be stronger than reason, and the outcome of the resulting psychomachia is often dangerous:

> A dubious balance is effected between verity and voluptuousness [truth and pleasure], and the knowledge of the one and the consciousness of the other wage a combat whose outcome is very uncertain.[33]

The general threat that Pascal perceives in this dialectical moment, itself inconclusive, turns into a premise that jeopardizes the very possibility of a rhetoric based on geometry. If this dubious balance is a property of rhetoric

in general, as he suggests, then a distinction between the two rhetorical methods is untenable, with the result that reason will always be defeated when it finds itself challenged by seduction. Although he so strongly wishes to distance himself from seduction, Pascal finds himself confronted with its rhetoric and the corruption it engenders in the art of persuasion through its perpetually inconsistent principles of pleasure. His struggle with the rhetoric of seduction, or rather with the impossibility of avoiding it, results in contradictions, confusions, and obfuscations. Such convoluted argumentation is uncharacteristic for such a brilliant mathematician and logician as Pascal, especially just at the moment that he is making his case for a geometrically based rhetoric. His text evidently has encountered an impasse, entangling Pascal in the complexities of truth as opposed to seduction. If we return to our comparison of Claesz. and De Heem, Pascal's difficulty with seductions will take on clearer contours by being read against the two paintings.

The Truthful Void: Seductive *Horror Vacui*
De Heem and Claesz. faithfully render their laid tables through different rhetorical strategies that are comparable to the two rhetorical modes Pascal distinguishes. Claesz.'s panel deploys the rhetoric of persuasion, based on a demonstration of truthful representation by means of reduction, while De Heem's banquet piece plays with registers of seduction, exploiting the typical baroque trope of excess.

Claesz. chooses the trope of simplicity, which carries connotations of innocence implying a direct tie to truthfulness. His panel does not merely offer a truthful representation of what could have been a real breakfast, but also aims at a faithful presentation of truth as such. He accomplishes his task by exhausting the concepts of simplicity and plainness. Since there is so little to see in *Still Life with Wine Goblet and Oysters*, it follows that what is represented must be the whole truth and nothing but the truth. Indeed, just as Pascal recommends, Claesz. accomplishes truthfulness by eliminating redundant information. He strips painting to its bare essentials. The use of monochromatic colors, the prominent empty background, the extreme unpretentiousness of the objects, and the deliberate artlessness of their representation produce an effect of self-evidence that touches on naïveté. The picturing of simplicity, however, is so elaborate and eloquent that we may call it hyperbolic. By pushing the reduction of artificiality and ornament to extremes, absence turns into a trope that itself stands for "truth" rather than *signifying* it. This absence constitutes an internal logic that postulates a transcendental truth in terms of purity, formulated in Claesz.'s *Still Life*

as an absence of superfluity. As we have seen, Pascal explains how an argument's clear presentation may convince us more strongly of its truth than the argument itself. Claesz.'s panel provides an outstanding example of this strategy in painting. The elaborate presentation of emptiness becomes transparent—literally see-through—with the result that we easily forget that the clarity of this presentation strategically functions as a *sign*. The void in Claesz.'s *Still Life with Wine Goblet* absorbs the different aspects that contribute to representing the scene's truthfulness. The monochrome colors, the flatness of the depicted space, the little that there is to see all contribute to Claesz.'s strategy of reduction. The void turns into a mark of excellence, a sign of the success of Claesz.'s rhetoric. It functions as a rhetorical trope of truth, essentially without becoming manifest as such.

In his overwhelming depiction of splendor, delicacy, and wealth, De Heem rather than Claesz. is the one who, in fact, is more straightforward. Far less subtle than Claesz., he does not operate on the level of proof, but on the level of seduction by displaying objects of desire in all their colorful richness. The elements refer directly to a sensuality of taste, touch, smell, and vision, tinged with a sexual overtone. His *Pronk Still Life* is a celebration of the beauty of food and therefore of the pleasures of looking rather than of eating, for there are no indications that this food has been touched by anything else than the brush. De Heem's theatrical setting and artificial composition fully explore the registers of visual seduction, turning his viewer into a voyeur who can freely enjoy the accumulation of pleasurable objects that the painting gives us to see. Simultaneously, his retreat from proof toward seduction accompanies a renewed interest in filling up the entire picture plane. That which Pascal fears, namely, the ambiguity generated by superfluous information, De Heem quests after. He does not opt for clarity but for a dazzling jumble of color and line, of fruit and fish, of taste and vision. For him, hunger is not the best icing on the cake, but rather lusciousness, with the result that *horror vacui* is reintroduced in his banquet pieces after an absence of only twenty years. The carefully created void of the breakfast pieces is abandoned in favor of a fresh desire to fill in any form of emptiness. De Heem's use of curvatures and round shapes, the full colors, the sprigs of ivy and other leaves, the leveled composition, and the diversity of food all function to thoroughly saturate the picture plane.

De Heem's famous banquet piece of 1642, *Pronk Still Life with Shells* (plate 12), generally considered his magnum opus, celebrates the reappearance of *horror vacui*: a set of velvet curtains *and* a view onto a garden fill in the background. The view, however, appears to be the least realistic part, framed by columns

wrapped in curtains with golden cords suspended from it that call to mind the awnings of a theater stage. In this theatrical setting, the window view serves as a mere backdrop rather than as a realistic view.

De Heem's still life in fact contains multiple still-life compositions. The enormous exhibition of food and *pronk* objects on the table—four times the size of a regular breakfast table—is accompanied by an isolated shell still life in the lower right corner and a separate arrangement of musical instruments also on the right. De Heem flaunts his virtuosity with three still lifes plus a landscape staged in a theatrical setting. This image of excess includes multifarious foods and objects, as well as absorbing some of still life's subgenres, becoming a still life of still lifes. For De Heem, boundaries are never limits, but instead are to be exceeded: not a single corner of this painting remains empty, offering a visual spectacle that seduces us to look everywhere; every surface hides a reflection, every fruit skin tempts us to touch it, every color is rich and deep.

Horror vacui directed De Heem to add as many elements as could possibly fit within his chosen frame. Yet it could not prevent some well-hidden voids from appearing. The spiraling lemon peel in his 1648 *Pronk Still Life* and the curtains in his banquet of 1642 circle around voids, as all curls do, in an attempt to cover up an emptiness that is not supposed to be there. In such curvatures, De Heem reveals himself as an authentic artist of the baroque. Christine Buci-Glucksmann has pointed out that baroque art always curls around a void.[34] She suggests that the baroque is characterized by what she calls an optical fold, a dialectic of seeing and gazing most clearly exemplified by the look that anamorphic art solicits. De Heem's picture does not invite an unorthodox mode of looking in the same way that, for instance, anamorphosis does, but it does offer an excessive vision of things that results in a vertigo effect. Gilles Deleuze explains, in his discussion of Leibniz, how baroque's specific language of form is the fold that falls in infinite curves and circles, unfolding one void while folding in another. In all its extensiveness, the fold can only include, never leaving anything outside.[35] The impetus of *horror vacui* underlying De Heem's creations is indeed directed toward inclusion. His strategy of seduction operates by means of offering too much to see: presenting a buffet with too much food, a painting incorporating multiple compositions, and reflections enclosing too much space. The final result is an image whose meaning is wrapped up, convoluted, and endlessly folded. The fear of empty spaces manifests itself as an underlying structure for this banquet while remaining well concealed behind the excess of information that also, simultaneously, veils the banquet's indebtedness to breakfast painting. The curls and curvatures in De Heem's images corre-

spondingly relate his fear of empty spaces to a perspective that anticipates a specific baroque look.

We have seen in De Heem's painting how the baroque fold includes space that is wrapped in texture. What, then, is the meaning of the void in breakfast painting, given that it represents neither space, nor depth, nor an inclusive fold? The void in Claesz.'s *Still Life with Wine Goblet* does not have a similar dazzling effect on our eyes as De Heem's banquet, nor does it confront us either with unorthodox modes of looking or with a typical baroque look. The void in breakfast paintings, however, is not simply present. It is *staged*, in the same way as De Heem's theatrical setting stages *horror vacui* as its opposite. Reading Pascal's text in relation to these paintings, we see how *horror vacui* correlates with a pleasure and an abundance that result in ambiguity. The void serves as a device for convincing us of a painting's truthful appearance, while also generating space for ambiguity: the clarity of the nothingness that it presents persuades us more strongly of the truthfulness of the image than the objects as such ever can. Claesz. deploys the emptiness of the background as a truth more clear than the edibles themselves.

What De Heem's compact fullness hides, Claesz.'s void—visible in all its nothingness—reveals in the empty viewpoint it offers us. The visible emptiness in breakfasts points to another type of void, likewise present yet invisible in every painting, namely, the vanishing point. The central point around which perspectival space evolves, the vanishing point is itself nonspatial, lacking as it does all qualities of space. Not representing a specific spatial location—given that it is a mere *point*—the vanishing point is at the very heart of pictorial space, while simultaneously falling *outside* that very space. Albeit a central point of spatial illusion in painting, the vanishing point represents the infinite as a finite entity within space.

The vanishing point has a similar status in perspectival painting as the zero has in the numerical system. In his analysis of Pascal's "Reflexions," de Man explains that the mathematical system of numbers depends on the existence of zero, a non-number, or rather a number that lacks all the properties of a number.

> The coherence of the system is entirely dependent on the introduction of an element—the zero—that is itself entirely heterogeneous with regard to the system and nowhere a part of it. . . . [I]t is a principle of radical heterogeneity without which it cannot come into being.[36]

De Man concludes that at the heart of the rhetoric of persuasion there is an element that lacks every real definition (in Pascal's sense, differing from nominal definitions). *Horror vacui*, the driving force behind De Heem's

paintings, is a reaction to the anxiety provoked by the confrontation with the nothingness that grounds the system of perspective. Like the over-painter of Heda's *Breakfast Still Life*, De Heem's inventiveness in overloading his laid tables is directed not only at covering all potential emptiness of space but at enfolding the infinity that lies behind it.

The moralistic dimension of painting has to be understood in relation to this anxiety. De Man argues in his reading of Pascal's "Réflexions" that the essay is particularly interesting for enabling an understanding of Pascal's work, especially with regard to his development of infinitesimal calculus, since the text

> spells out, more explicitly than can be the case in the apologetic and religious context of the *Pensées*, the link between this central principle [infinity] and the geometrical or mathematical logic of which it is actually a version.[37]

The infinite, a mathematical principle, is, of course, closely connected with theological implications in Pascal's work. Indeed, the anxiety generated by the infinity of emptiness in space, and the ambiguity it causes, directs the void in breakfasts and *horror vacui* in banquets to visualize the moral dilemma of reason as opposed to the pleasure that these paintings communicate on a thematic level.

A Moral Dilemma as a Rhetorical Problem

The battle between these forces of proof and pleasure is not merely illumi-nated when the Claesz. and De Heem still lifes are juxtaposed, but is con-tained as an internal dilemma within each individual painting that consti-tutes its very theme. The paintings perform this conflict, as Pascal unwit-tingly has shown, as a *rhetorical* problem. The seventeenth-century still life is generally considered to be the carrier of a moral message about the dyad re-lations between abundance and moderation, restriction and excess, framed by the religious imperative warning that choosing one means struggling with the other. Calvinism taught very strict rules about living an austere life with sober meals, simple dress, and contemplation of God's word. With the profit of their flourishing trade not siphoned off by a money-consuming court, Dutch citizens could experience living standards that directly con-flicted with this seventeenth-century morality.

Both the Claesz. and the De Heem paintings, as different as they are, carry the same meaning according to the dominant tradition of still-life iconogra-phy. They teach the moral message of moderation, a warning against glut-tony, lust, and sensual indulgence. These paintings, and others like them, thematize the moral dilemma of body versus soul, the evil attraction of

wealth versus the peace of poverty, a life of ambition versus one of contem-
plation. In prosperous yet Calvinistic Holland, moderation was expounded
by means of a strong imperative not to consume. Although he lived in Cath-
olic Antwerp for many years, De Heem's pictures nonetheless embody this
Calvinist idea of moderation, according to many commentaries.[38]

If De Heem's painting intends to convey this message of temperance and
moderation, it masks it masterfully in the image's abundance. Indeed, it is
hard to believe that this blatant display of objects of desire actually com-
municates a warning *against* rather than a celebration of the pleasures these
objects provide.[39] If Claesz.'s panel contains this message, it may be trans-
lated through the presence of bread and wine, referring to the Eucharist.
This symbolic reading, however, still admits voluptuousness: next to the
bread and wine we find a plate with oysters, symbolizing lust, sex, and se-
duction. The iconography of the oysters as aphrodisiacal disrupts the sim-
ple and innocent-looking breakfast, a disclaimer difficult to disavow. The
discourse of truth cannot be mastered completely by the rhetoric of persua-
sion, but here betrays signs of pleasure. The presumed opposition between
truth and pleasure within rhetoric, and between prosperity and Calvinism
in seventeenth-century Holland, apparently go hand in hand *in painting*. The
portrayal of plenitude and seduction may have been compensated by un-
earthing moral messages promoting austerity, for example, in De Heem's
paintings; but the extensive art production of the period confirms that both
wealth and the possession of picture collections were enjoyed all the same,
and that breakfast and banquet still lifes alike were in great demand. More-
over, in Calvinist Holland seduction ultimately won out over reason as far
as actual eating habits were concerned. As has been pointed out repeatedly,
the Dutch were widely reputed to be terrible gluttons.[40]

In still-life painting, I suggest, the conflict between reason and desire is
played out as a battle, though not between two opposed lifestyles (austere
versus decadent) or two paradoxical meanings (warning against or cele-
brating abundance in De Heem; promoting austerity as a warning against
abundance in Claesz.) but between two rhetorics. As the void in breakfasts
demonstrates, painting always presents elements that refuse to fit within
the larger scale of assumed meaning, elements that according to de Man
are always rhetorical.[41] Pascal's text partly explains that this "indeterminate
residue" may be the result of the intertwined discourses of truth and plea-
sure, which despite their opposed aims are partially interdependent.

Pascal's struggle with seduction reveals how ambiguity may slip through
the rigid grid of geometrical rhetoric. In this context, perspective is an ex-
ample of a perfect, ideal, and geometrically based rhetoric, just as Pascal

imagined it, hiding its strategies behind the clarity of its presentation. Indeed, perspective only betrays its operation when it fails to convince us of the image it presents. As long as representations are perfectly realistic, or illusionistic, perspective's rhetoric operates magnificently, staging elements in a naturalizing way, making it appear as if no argument has been made. Such an operation is analogous to Pascal's art of persuasion that also aims at demonstrating truth on the basis of arguments that appear to go without saying. The essence of Pascal's argumentation lies in the presentation of propositions so clear and transparent that one is convinced of the truthfulness of the argument *because of* the transparency of the presentation. Perspective pursues the same aim in painting. Its staging of objects in space, on the picture plane, is so clear that both its method (its presentation) and the image (its "argument") become transparent. As I mentioned earlier, perspective literally means "seeing through." Because we see through it, we are unaware of its operating system, so we look at objects that appear within this system as if they are truth itself.

Despite their mutual geometrical foundation, both perspective and Pascal's art of persuasion allow for confusion—as Pascal was forced to admit regarding his argumentation theory. Perspective produces ambiguity because it persuades us of its clarity as much as it seduces us to look through it. This ambiguity does not merely manifest itself on the spatial level, but also on the level of meaning. The illusion of three-dimensional space that perspective opens up, ironically, permits superfluous elements and redundant information to appear in that space. The excess of information that Pascal wished to eliminate finds, in painting, a place within the perspectival configuration whose clear intent is to convince us of the reality of the scene. Yet precisely this reality effect often leads to confusion about a picture's meaning.[42] Perspective thus produces a truthful image of reality at the cost of maintaining clarity of meaning, and consequently causes another "moral" dilemma regarding the truth and seduction of interpretation.

The Pleasure of Interpretation
Still-life paintings are at the heart of a debate on interpretation that circles around the rhetoric of moderation and speculation. In iconographic discourse of the past three decades, much attention has been paid to considering the limits of interpretation. Dutch art historical discourse, specifically, has attempted to limit interpretations of still lifes to analyses based on seventeenth-century literature, predominantly Jakob Cats's famous emblem books. Edibles often operate as moral pointers in such emblem books,

and therefore have been deployed within art history as both proof and ulti-
mate limitation of the possible significations of banquet and breakfast paint-
ings. The use of literary references as evidence regarding the meaning of a
still life often ends in the question of how far one can go with this method
of interpretation. Whether it is even necessary to draw borderlines around
interpretation, or to find ways of formulating strict rules, has been an is-
sue of debate for decades.[43] These debates have not exclusively concerned
still lifes (genre painting, for instance, evokes the same problem), but with
this genre, meaning is not determined by a narrative that to some degree
limits signification. Especially with banquet pieces, there has been a fear of
what is called "overinterpretation," a danger that—primarily Dutch—art
historians believe should be avoided at all costs, in the process performing
the same anxiety that Pascal expressed toward ambiguities of meaning or,
in other words, toward the pleasures of interpretation. Only an imagined
seventeenth-century viewer (who was "trained" in reading Cats's specula-
tive emblems) may be seduced by the pleasures of interpretation, but never
today's scholar.

These debates are grounded in a method of argumentation based on
proof. An excess of evidence supporting a particular meaning is a sign of
excellence (especially given that source documentation is scarce and lim-
ited). Speculation about meaning, however, is easily accused of enacting
overinterpretation and, as such, is unacceptable. Regardless of the message
that paintings like Claesz.'s *Still Life with Wine Goblet* or De Heem's *Pronk Still
Life* may communicate according to these debates, a balance between mod-
eration and excess at the level of interpretation is hard to find.

It is no coincidence that the debate concerning the appropriate limits
of interpretation emerges in relation to the larger issue of the meaning
of still-life painting. In fact, the paintings themselves anticipated these de-
bates when they thematized the "dubious balance" between moderation
and excess. The modes of looking that paintings by Claesz. and De Heem
solicit have influenced—and even predicted—their interpretation and the
problems related to such interpretation.[44] Current (Dutch) art historical
discourse on still lifes involves, to a certain extent, a continuation of the
dilemma these paintings address. As such, the discourse of interpretation
becomes an allegory of the image. The dilemma of seduction and persua-
sion that breakfasts and banquets raise on several levels is echoed in the
failure of interpretation. This failure is produced by the fact that the object
of interpretation is, in Pascal's words, "not fixed and not stable" and because
it refuses, as a result of this inconsistency, to be nailed down in one truthful

and reliable argument. Indeed, the paintings may predict certain modes of looking and interpretation (and we have seen how much they overlap in these particular cases), but the images themselves remain unpredictable. The rhetoric of these still lifes operates on several levels, incorporating contradictory claims and tropes for which a method of interpretation based solely upon historical evidence, or watertight argumentation, cannot account. If, in interpreting these images, we cling to a rhetoric of persuasion that is based on proof, à la Pascal, we act out of the same weak denial as he did in excessively disavowing seduction. If De Heem's paintings portray seduction, and if Claesz.'s breakfasts literally open up space for speculation, we may want to adjust our methods of interpretation to the challenges these paintings propose. I do not believe, however, that interpretation is the ultimate goal. The infinite void in breakfast painting breaks open a realm beyond interpretation, a realm where possibly the thought of painting resides.

Conclusion: Structured Emptiness

The history of still life demonstrates that the conflict between foreground and background in the predecessors of the genre ultimately resolved in *horror vacui* as one of the dominant factors in the development of its composition. Within this history, the breakfast still lifes stand out as a unique phenomenon when the void takes over and rules their design for only a couple of decades. Breakfast still lifes by Claesz. and Heda make visible to us something that can be seen precisely because there is so little to look at; that is, they reveal how the rhetoric of the image is structured by perspective. Since its discovery, perspective has been used to create the illusion of depth and has carried within it a secret that has never really been disclosed. Perspective's secret is that it never *added* a dimension to painting, as we are inclined to think, but *removed* one while persuading us to believe, through the illusion of depth, that an addition had taken place.

Jean-Luc Marion, who follows Merleau-Ponty and to a lesser degree Lacan, makes this claim in *La croisée du visible*.[45] According to Marion, painting is situated at the intersection of pictorial perspective and of "our" perspective. For Marion, pictorial perspective is structured emptiness, a void in painting that, however, is not synonymous with the invisible despite the fact that it does not add anything to our visible reality. Perspective is therefore fundamentally paradoxical because it makes us believe that it added a dimension to painting while the flat image of the real that it produces actually attests to the removal of depth. I suggest that the void in breakfast painting displays traces of the removal of the third dimension. The void points to a field within the picture frame that refers neither to depth nor to space, but to the

empty structure of perspective as such. In contrast to all visible objects, the realism of which breakfast paintings strive to convince us, the simultaneously visible and invisible void is a genuine space in painting that only exists where we see it. It is in this picturing of nothingness that the "true" truth in painting can be found. That is, the nothingness of the void signals the arrival of something other than a visual third dimension. I am suggesting, in fact, that perspective *did* add a dimension to painting, namely, a *rhetorical* one.

The meaning *is* the location within a definite space, in or on some of the countless definite spaces; it is the site, the orientation, the proximity, the limit and the pullulating complex of the relations which set them. It is, for instance, the proportion of this woven and closed space, where such and such element sets up as statue and throws a vector towards this open space, to some space and to the intricate lines stretching to it. Space swarms with meaning. . . .

—Michel Serres, *Carpaccio*

THE RHETORIC OF PERSPECTIVE
PANOFSKY, DAMISCH, AND ANAMORPHOSIS

Introduction: *Perspective Correction*

In the 1960s the Dutch minimalist artist Jan Dibbets made a series of black-and-white photographs entitled *Perspective Correction*. Each of the pictures displays an interior or exterior space where a square figure has been constructed, drawn on a wall, laid out with ropes on a meadow, and so forth. One photo, *My Studio I*, shows a corner in an empty room with a wooden floor and whitewashed walls (fig. 8, 1969). A pipeline running along the baseboard directs our eye into the depth of the studio toward the window. Along with the pipeline, the lines that follow the edges between wall, floor, and ceiling all run in the direction of the vanishing point in the window, structuring a clear perspectival configuration. On the wall, a square has been drawn, divided by two diagonals into four triangles. As in every picture in the series, the square disrupts the spatial coherence of its environment. It appears as if it does not fit in the photograph at all; as if it was drawn on the photograph's glossy surface rather than on the studio wall. Our eyes are confused because we see the geometrical figure as if standing directly in front of it, while we throw an oblique glance—between its lines—at its ground, the wall behind it. What we see is not simply a drawing of a square, but an anamorphic figure; that is, it appears as a square only at the point from which the photograph was taken and from which we view it. Naturally, we cannot observe it from any other location than the one presented to us. Though we may hold the picture itself at different angles, we can never change our angle to the wall in the picture. We can only imagine how the figure would look when actually seen from the front. It would reveal itself as a trapezoid, the two horizontals diverging slightly on the

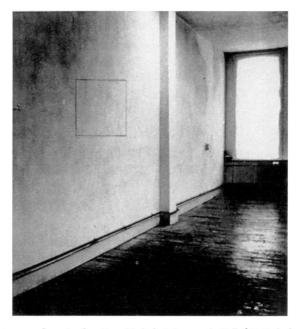

FIG. 8. JAN DIBBETS, *Perspective Correction—My Studio I, Square on the Wall of My Studio* (DETAIL) (1969), COLLECTION OF THE ARTIST. BLACK-AND-WHITE PHOTO AND PENCIL ON PAPER, 50 X 65 CM. COURTESY OF BARBARA GLADSTONE.

left side. Contrary to baroque disfigurations, Dibbets's "perspective correction" is an anamorphosis presented in reverse. Sixteenth- and seventeenth-century anamorphoses always entail an element of surprise, when the image emerges from its distortion, a trick that is absent in Dibbets's picture. Instead of discovering a perfect image in a chaos of lines and colors, the distortion as such needs to be discerned. Dibbets reduces anamorphosis to its pure structure. If we were to call trompe l'oeil a visual practical joke, anamorphosis might be compared to a cryptogram that requires optical acrobatics.

Dibbets's square has a long history as leitmotiv in perspectival and theoretical treatises. As early as Leonardo da Vinci, it figured as a paradigmatic example in debates about marginal distortions, a discussion topic energetically elaborated in future centuries as well, including in the twentieth century by Panofsky, Gombrich, and Nelson Goodman, among others. We should remember that anamorphic art gives the impression of radically breaking with linear perspectival conventions, even as it is created strictly according to perspectival rules. Unlike perspective's initial promise to enable the creation of lifelike or illusionist pictures, anamorphic art uses perspective's own weapons against it in order to pursue its opposite: rather than showing images, it hides them. Whereas we always gain unmediated access to realist

images as an effect of perspective, the sneaky glance that anamorphosis so-
licits radically undermines such access.

With regard to the title of Dibbets's series, *Perspective Correction*, we may ask
what exactly has been corrected in this picture? Is the square a correction
relative to its original trapezoidal form? Or does the square itself require cor-
rection? If we want to answer these questions, we arrive at a paradox. Do we
have to understand that the deformation—which in the photo appears as a
perfect geometrical figure—is inferior to its origin, the imperfect trapezoid?
Or does the photograph itself perhaps need correction with regard to the
drawing on the wall? Is an oblique point of view a correction of the regular
frontal one or vice versa? Dibbets's photograph raises questions that point
to the paradox that perspective contains. If anamorphosis indeed presents
a visual cryptogram, then Dibbets's photograph is a genuine brain teaser.
Which or whose perspective must be assumed the correct one, to which
the others must adjust? According to Dibbets's picture, the only way out of
the impasse that the perspectival paradox creates is to realize that looking
straight (at the photograph) and looking awry (at the square) may occur
simultaneously in one moment of perception, but only on condition that
we accept the resulting confusion and ambiguity as part of our visual field.
Dibbets's photograph addresses perspective's influence on perception and
invites us to reflect upon the imperfections and deceptions that deform the
image we have of our visual field.

Despite the playful nature of the whole series, Dibbets is making a seri-
ous statement about linear perspective's dominance within our visual field.
The slightly alienating effect of his photograph foregrounds the persuasive
power of perspectival images. Our confusion indicates how well our eyes
are adjusted to the hegemony of linear perspective as it maps our field of
vision, organizing pathways that lead from our point of view into the as-
sumed depth of the picture, a pattern that we eagerly adopt. Dibbets claims,
however, that we can take the paradox inherent in perspective as a point of
departure. We as spectators are not merely subjected to perspective but are
able to look at its operation from a different angle. Leaving the standardized
point of view will provide us with the capacity to unearth the distortion
within this picture as well as in our perception. On the basis of Dibbets's pic-
ture, we may conclude that we have two options: either our own perspective
is correct, and hence the images around us are deformed; or our perspective
needs correction, in which case our visual field may include imperfect views
of things.

Does Dibbets consider his correction an actual improvement? After all,
the square appears as that which it is not: it is not a perfect geometrical

figure, and it is not drawn on the surface of the photograph. The improvement, if there is one at all, must be made by the spectator rather than be discovered in the picture. In the process of observing *My Studio I*, we realize that our vision is not as reliable as we assume, and hence that orthodox perspective is not as self-evident as we expect it to be. Dibbets's "correction" complicates the status of perspective in relation to our perception. According to his picture, perspective is itself an anamorphic construction. Disfiguration may be a form of correction to the same extent that proper perspective may be a form of distortion. *My Studio I* is an invitation to look at perspective from a different point of view and to observe it from the point proposed by anamorphosis.

In this chapter, I will take up Dibbets's suggestion to view linear perspective *from the point of view that anamorphosis proposes.* In my investigation of orthodox perspective, I will attempt to look *at it* instead of *through it.* As I have indicated in the previous chapter, we are unable to observe perspective directly because our position is always already implicated in its configuration, something that Dibbets's photograph effectively demonstrates. Therefore, we need to find an alternative position from which we can "see" the ways in which perspective operates as a system that manipulates our vision. Anamorphic images teach us that it is possible to look at the margins of our own visual field, insofar as we are willing to marginalize our point of view. Moreover, anamorphic art itself is marginalized within the history of art. In fact, since the late eighteenth century, the genre has been virtually forgotten. Having rarely been looked at for several centuries, such art possesses the rare quality of being able to disrupt or even shock our accustomed ways of looking and of laying bare the prejudices such looking involves.

Looking Awry

> I believe that the Baroque return to the play of forms, to all manner of devices, including anamorphosis, is an effort to restore true meaning of artistic inquiry; artists use the discovery of the property of lines to make something emerge that is precisely there where one has lost one's bearings or, strictly speaking, nowhere.
>
> —*Jacques Lacan*, Seminar VII

The most famous example of anamorphosis dates from 1533. Hans Holbein the Younger included in his portrait of two ambassadors to the French king François I a hidden image of death (plate 13). The young men flank a table displaying objects that symbolize the liberal arts and sciences. In front of these privileged aristocrats, Holbein painted a floating beige-colored shapeless figure that, when viewed from an oblique angle, reveals itself as a skull.

Since so many scholars have written on the meaning of the skull in relation to the highly complicated iconographic program of the painting, I will not elaborate on *The Ambassadors*. Later, however, I will return to this painting to consider the connection between allegory and anamorphosis that Holbein's picture makes visible.[1]

We can speculate about whether Shakespeare, who is said to have been fascinated by perspectival disfiguration, had actually seen Holbein's portrait when he used anamorphosis as a metaphor in *Richard II*:

> For sorrow's eye, glazed with blinding tears
> Divides one thing entire to many objects
> Like perspectives, which, rightly gaz'd upon
> Shew nothing but confusion; ey'd awry
> Distinguish form.[2]

When Shakespeare wrote his *Richard II*, the term "anamorphosis" had not yet been invented. In 1657 a German Jesuit named Gaspar Schott (a pupil of the scholar and anamorphic artist Athanasius Kircher) coined the term in his work *Magia universalis naturae et artis*. Schott was convinced that all natural and technical marvels were manifestations of the supernatural.[3] Mathematics, physics, and optics belonged to the magical sciences that he divided into three categories: natural, artificial, and satanic. Anamorphic perspective he assigned to the second category (although it also includes satanic features) because Schott considered it a method of deformation based upon geometry, which he called "anamorphic magic." This neologism is based on the Greek *morphe*, which means "form," and the preposition *ana-*. In classical Greek, *anamorphosis* literally translates as "distortion," while in modern Greek *ana-* functions both as the English prefixes *dis-*, as in "distortion," and *re-*, as in "reformation." *Anamorphosis* can thus be understood as "that which lacks a proper shape," and as simultaneously signifying the "restoring of that which has been out of shape." Its meaning creates a double bind, pointing to the product, the actual image, as well as to the process of its reshaping, that is, the viewer's search for the right point of view.

In 1751 Diderot and d'Alembert incorporated the term in their *Encyclopédie*. They introduced it to the French-speaking community as follows: "In painting, anamorphosis means a monstrous projection or a deformed representation of an image rendered on a surface which from a certain point of view appears with regular proportions."[4] The entry is not limited to simply a definition but also provides a method for creating anamorphoses. Artists are encouraged to turn the "monstrous projection" of chaotic, elongated lines and colors into a more pleasing image. The *Encyclopédie* includes an example

of how the unsightly appearance of a satyr's face can be disguised as a river landscape with soldiers marching along the shore. An engraving created around 1530 by Erhard Schön, a student of Albrecht Dürer, partly matches the scene described in the *Encyclopédie*. Schön created what he called *Vexierbilder* (secret images) in which not the face of a satyr but four profiles—of Charles V, Ferdinand I, Pope Clement VII, and François I—are hidden in a landscape where little figures walk on the shores of blurry lakes (fig. 9). The linear chaos of the picture traces the elongated portraits underneath, and the little figures on the shores in particular provide a clue to the engraving's riddle. A secret never comes alone, it seems: the four concealed faces are accompanied by political messages related to each of the powerful men portrayed. A scene depicting soldiers who are taking a horse away from a battlefield covers the portrait of Charles V. An oriental figure with a camel, along with the personification of Justice, recalls the Turkish relations of François I. A miniature siege of Vienna, often represented by Schön, masks Ferdinand I.[5]

Anamorphoses were often used to conceal dangerous political messages, as in Schön's engraving, or erotic imagery. The immanent structure of disguise and revelation also served as an allegory of God's omnipotence as it manifested itself in or behind all natural phenomena. The chaos of the world was compared to the jumble of lines and colors behind which a perfect order was assumed to hide. For the one who truly sees, this perfection would become visible. Anamorphosis's logic of concealment, therefore, invests in revelation as much as in obfuscation.

Although an anamorphic perspective could be employed to hide secrets, it was also itself labeled a secret part of perspective. Daniele Barbaro describes anamorphosis as "una bella e secreta parte di Perspettiva" (a beautiful and secret part of perspective). During his second visit to Italy in 1506, Dürer wrote a letter from Venice to his friend Willibald Pirkheimer that included the famous words: "I shall ride to Bologna where someone is willing to teach me the secrets of perspective [die Kunst in geheimner Perspektive]." This line is generally interpreted as indicating that Dürer intended to learn the secrets of linear perspective, since he was not yet completely familiar with its rules of construction.[6] In *Anamorphoses* Jurgis Baltrušaitis suggests, however, that in the context of the growing interest in anamorphosis, Dürer's words are ambiguous.[7] He could also have been writing his friend that he planned to learn one specific aspect of perspective, namely, "geheimner Perspektive," a method for concealing images. Whether or not Dürer was finally initiated into the tricks of the trade is not entirely clear, but thirty years later his pupil

FIG. 9. ERHARD SCHÖN, *Vexierbild* (WOODCUT, C. 1530), KUPFERSTICHKABINETT, STAATLICHE MUSEEN ZU BERLIN. PHOTO: BILDARCHIV PREUSSISCHER KULTURBESITZ/ART RESOURCE, NY.

Schön applied secret perspective flawlessly in his *Vexierbilder*. The application of a strict set of mathematical rules could now function to camouflage an image rather than reveal it, making the image into a secret and the method itself into a magical art.

The Anamorphic Eye

There is no exquisite beauty without some strangeness in the proportion.
—Francis Bacon

At the origin of anamorphosis stands the eye.[8] Leonardo da Vinci was the first to draw some simple sketchy lines, elongated forms of a baby's face and of an eye, in his *Codex Atlanticus* (plate 14, c. 1483–1518). It was a single eye that looked at the origin of perspective, one we earlier saw peeping through a hole in Brunelleschi's panel, looking at "the truth itself."[9] A similar single eye also marks the starting point of the first violation of these newly developed rules for representation. From the moment it was invented, anamorphosis was on occasion called "reversed perspective" (not to be confused with medieval inverted perspective); but its structure is more radical than a mere flexibility of perspectival rules and lines would indicate.[10] If we bend

over Leonardo's page in order to discover what the sketchy lines may mean, we see the eye slowly assume its correct shape as we try out different points of view, moving back and forth in correcting our gaze. During the process of moving our head, the eye transforms into a vision that exceeds the limits of the drawing and obtains, as we stare at Leonardo's staring eye, the shape of our own gaze. Indeed, the subject of anamorphosis is vision rather than representation.

Leonardo not only drew the first anamorphic image, but also wrote down the first description of how to look at an anamorphic image:

> The observer should situate himself with his eye at a small aperture, and then through this hole the perspective will be well displayed. But because many spectators will strive to see at the same time the one work made in this manner—and as only one can see well how such perspective functions—all these other people will find it confusing.[11]

Leonardo uses the anamorphic construction to introduce the problem of the mixing of what he calls accidental perspective, "that made by art," with natural perspective ("our" perspective). In well-made perspectival images, accidental perspective ought to blend harmoniously with natural perspective, but there are many instances where this ideal situation does not occur. This problem was later called "marginal distortion" and has been widely discussed.[12] If a wall is viewed from a certain point of view, its surface will look different at different distances. For instance, if we stand close to a wall, we will have the illusion that the outer parts of the wall, barely visible from the corner of the eye, are curving around us. The artist who wants to paint a fresco on a wall, composing it according to the rules of accidental perspective, will have to take into account the diminution of that wall in natural perspective; otherwise, Leonardo states, objects will appear "monstrous." The defects of such "monstrous forms" can be concealed if the artist manages to mix accidental with natural perspective. The artist has to slightly modify the ideal geometrical system, since *perspectiva artificialis* generates deficiencies despite itself that are actually unacceptable within its configuration. Leonardo does not care to address the dilemma about whether mistakes are corrections or genuine errors (or both). He recommends that artists not work with this mixture of natural and accidental perspectives that is supposed to cancel out each other's distortions (and that he labels "compound perspective"). Instead, he advocates a "simple perspective" that requires artists to enlarge the perpendicular distance of the viewpoint to the picture plane to such an extent that distortions no longer will be noticed.

Leonardo then gives an example of a foreshortened square that, when viewed from the side, appears as a parallelogram, and includes guidelines for avoiding this perspectival distortion. Significantly, Leonardo's square that appears as a parallelogram, illustrating the mixing of natural and accidental perspectives, is similar to Dibbets's *Perspective Correction*. The only difference between the two is that the mixing itself remains visible in Dibbets's photograph. The small aperture Leonardo mentions, through which the correctly proportioned image must be viewed, is also present in Dibbets's image: present in absentia, that is, for of course it is the camera's aperture through which we "peep" into the studio space. Dibbets's perspective correction has "solved" Leonardo's problem: his photograph has made it possible for more than one viewer to see the proper image at the same time.

At the top of Leonardo's drawing of the eye are small vertical divisions, indicating that he probably worked with a system that would, eventually, be described in the seventeenth century. During the sixteenth century, however, anamorphoses were still composed according to empirical methods. Barbaro describes in his *Practica della prospettiva* (1559) how an image must be perforated and subsequently positioned in front of a light source so that the spots of light falling through the pinholes project a deformed image onto a wall, which then can be traced. In the beginning of the seventeenth century, a group of French mathematicians belonging to the Minim mendicant order in Paris developed new perspectival theories. In addition to Descartes and Marin Mersenne, the mathematicians included Emmanuel Maignan and the mathematical prodigy of the group, Jean-François Nicéron (1613–1646). Their approach was not empirical, but geometrical.

Whereas some mathematicians, such as Samuel Marolois or Simon Stevin, included discussions of anamorphosis in their perspectival treatises, Nicéron was the first to devote an entire work to what he called "curious perspective."[13] In 1638 he published *La perspective curieuse ou magie artificiele des effets merveilleux*, followed by an expanded Latin version in 1646, entitled *Thaumaturgus opticus*. Nicéron was of great importance for the development of anamorphic art because he perfected already existing ideas about creating such art by adjusting them to a geometrical system based on the *costruzione legittima* of the Renaissance perspectivists. His work provides the most extensive reference source concerning different anamorphic techniques.

Nicéron distinguishes three categories of anamorphic construction, depending on the position of the viewer and his or her viewing direction: optical, when the viewer looks in a horizontal direction; anoptical, when one looks upward; and catoptical, when one looks downward, as in conical or

pyramidal mirror anamorphosis. In the common optical constructions, the viewpoint has been displaced from its position in front of the picture plane to one that is virtually on the same level with the picture but just outside its frame. The result is that the horizon and the central axis now are at an extremely small angle relative to each other. Not all categories of anamorphosis are based on a central perspective. Nicéron's method for creating images that reflect in conical and cylindrical mirrors is based on a transfer of coordinates from one system to another, as for instance from Cartesian to polar coordinates.[14] The method itself is rather simple: every point in one system must be assigned an equal corresponding point in the other. The result is a projection of points that can be connected by drawing lines between them.

Nicéron also created anamorphic murals of Sainte Madeleine and of Saint John writing his gospel in the Minim cloister at the Place-Royale in Paris, which were later destroyed. Such anamorphic murals were highly popular in the seventeenth century. They often fully covered one wall and were constructed so that one caught a glance of the proper image solely upon entering the room. The viewpoint thus lay on the threshold, in the doorway, where one would see the image literally in passing. The construction of these site-specific murals adds a metaphorical dimension to the definition of anamorphosis. Unlike the unmediated access the viewer always has to a painted image, an anamorphosis of this kind has, in fact, the temporal logic of a snapshot. It shows in a split second an otherwise "moving" image, to the extent that here it is the viewer who makes the image move. Its perfectly frozen condition is never contemplated, since one always crosses rather than remains on a threshold. In both the snapshot and the mural, the fleetingness of time has been contained in one single moment. Unfortunately, very few murals are still extant.[15] *St. Francis of Paola* by Emmanuel Maignan has survived the ravages of time (plates 15 & 16, 1642). Here, the fact that the moment of revelation occurs in passing is underscored by the fact that Saint Francis has been painted on the long wall of a corridor. When one enters the corridor, the image of Saint Francis emerges. Maignan's mural is a good example of the double-masking of anamorphic images that the writers of the *Encyclopédie* promote. If we stand in front of Maignan's image, we see in the elongated lines of Saint Francis's habit the Strait of Messina, with tiny ships floating on the sea, where the saint performed one of his miracles by walking over water.

In the late seventeenth century, anamorphoses lost their status as magical art when small versions began to be enjoyed by a large public who viewed

them in the private sphere. The shift from magical to popular culture coincides with the introduction of the mirror in the study of anamorphic art. Fit to be presented at the salon tables of the leisure class, mirror anamorphoses have a different approach to the logic of concealment. The most common version is the cylindrical or semi-cylindrical mirror that is placed on plates with circular deformations. Collections of plates often consisted of hand-colored prints especially produced for this purpose, and generally of bad quality. They were executed on paper and subsequently glued to cardboard. A more durable version was made by attaching prints or drawings on paper to wooden panels. In addition to the (semi-)cylindrical mirrors, there were catoptical conical and pyramidal ones. In the case of pyramidal mirrors, the plates consisted of four different images that transformed into a single one when reflected in the pyramid.

A whole different category concerns prismatic mirrors. These mirrors have four facets that form part of a decahedron. Accompanying prints no longer showed unrecognizable, blurry messes, but clear images grouped around a center in which the prismatic mirror was placed. With this type of diversion, the trick did not lie in the surprise of sudden revelation but in the demonstration of new scientific discoveries about the relation between image and movement. If we look into one of the four facets and slowly move our eyes to the next, we see, for instance, how a dancing woman changes clothes, or how a priest who listens to a confession suddenly happens to peep into a lady's bedroom (Haarlem, Teylers Museum). The effect of this anamorphic category is fundamentally different from the others in that it contains a gradual rather than a radical transformation from one visible image into another.

The Teylers Museum in Haarlem possesses a box full of optical instruments, one of which is a tool described in the 1790 *Inventory* as "a glass with many polished facets in a brass barrel or so-called Anamorphosis-viewer."[16] While it looks similar to a kaleidoscope, this instrument has been used to view so-called magic pictures. Unfortunately, not a single example of these amazing optical masterworks survives. Nicéron is said to have painted a magic picture, which when viewed with the naked eye displayed fifteen portraits of Turkish sultans that turned into a portrait of Louis XIII when seen through an anamorphosis viewer. Apparently, Nicéron's picture was not even that impressive compared to the one that Amadeus Vanloo exhibited at the Salon of 1759. His picture displayed an allegory of the Virtues with their respective attributes that transformed into a portrait of Louis XV when seen through an anamorphosis viewer.[17] Interestingly, portraits of kings featured frequently in anamorphoses. An early English example from

the sixteenth century is the well-known portrait of the young Edward VI (1546, London, National Portrait Gallery). More lugubrious versions (which circulated illegally among partisans) show the head of Charles I after he was decapitated (*Secret Portrait of Charles I*, 1649, London, Coll. Anthony D'Ottay). Another plate for a cylindrical mirror shows a portrait of Charles I, with a small skull in the center, on the spot where the mirror must be placed (plate 17, c. 1660).[18]

As is implied in Nicéron's title, which Baltrušaitis adopted for the first version of his book, anamorphosis is a technique or a trick that is clearly deployed by artists as a manipulative device for the sake of effect: "The Curious Perspective, the Artificial Magic of Marvelous *Effects*." The descriptions and procedures that Nicéron presents in his work, if properly applied, promise optical effects rather than representations. At the height of scientific interest in its workings, its greatest theoretician thus presents anamorphosis as a geometrically based rhetorical figure.

The rhetorical effect of anamorphic art was so powerful that it has been connected with (black) magic, alchemy, and demonic forces. The possibility that unreadable images could hide horrifying messages between the lines of innocent-looking landscapes was tremendously disturbing. Positioned opposite the crystal-clear (Renaissance) mode of analogy, anamorphic art in fact reveals the dark side of representation. The terrifying haunting that anamorphosis may entail—Holbein's skull says it all—returns long after its vulgarization and final decline in the eighteenth century in Edgar Allan Poe's story "Ligeia" (1838). As we have seen in chapter 1, Poe proved himself a master in reviving virtually forgotten pictorial curiosities by incorporating them in his tales. In "Ligeia" the anamorphosis Poe describes in the drapery of a room functions as a metaphor for the clue of his story narrating the fantastic transformation of one woman into another, of dead into living, and of reality into a dream.

"Ligeia" is written as the confession of a man who is haunted by the memories of Lady Ligeia, his deceased beloved. The month after he remarries, his second wife also falls ill and dies in their nuptial chamber. The story recounts how the man, during the wake, witnesses the remarkable transformation of his second wife's dead corpse into Ligeia's living body. Typical for Poe, it remains unclear whether the transformation actually happens or is a result of the man's vivid imagination, or even of "an immoderate dose of opium." It may very well be that the entire story is just a dream. What does become clear is that the transformation of the second wife into the first mimics another transformation, namely, of the woven patterns in

the drapery of the nuptial chamber where the sinister substitution of one woman for another also occurs:

> It [the drapery] was spotted all over, at irregular intervals, with arabesque figures, about a foot in diameter, and wrought upon the cloth in patterns of the most jetty black. But these figures partook of the true character of the arabesque only when regarded from a single point of view. By a contrivance now common, and indeed traceable to a very remote period of antiquity, they were made changeable in aspect. To one entering the room, they bore the appearance of simple monstrosities; but upon a farther advance, this appearance gradually departed; and step by step, as the visitor moved his station in the chamber, he saw himself surrounded by an endless succession of the ghastly forms which belong to the superstition of the Norman, or arise in the guilty slumbers of the monk.[19]

What thus emerges from the drapery when it is seen from a single point of view are pagan motives from a primitive era of long ago, visions that occur during the *guilty* slumbers of a monk or belong to Norman superstitions. In short, the visions are not of this world but are derived from the unconscious of the dreamer, and so horrific that they chase the man in this story, imprison him, and haunt him as a secret desire. The man's chimerical memories give reason to believe that he longs for his second wife's death in order to allow his fantasy of eternal love and sexual fulfillment to appear. The succession of events step-by-step becomes more ambiguous, whereby the story's structure itself seems to adopt the shape of the drapery's pattern. Unlike the drapery's anamorphosis, the man's confessions remain blurry and impenetrable, regardless of the reader's point of view, and eventually do not betray their secrets.

The "contrivance" Poe mentions is, of course, perspective, and he seems to suggest that the specific perspective responsible for the transformation of the arabesque figures marks the demarcation line between antiquity and modern times, between paganism and Christianity, between the proper and the perverse viewpoint, and even between the conscious and the unconscious. The phantasmagoric effect of the changing arabesques evokes terror, guilt, and secret desires that are all incorporated in the patterns, including nontextile ones, that surround us. The effect that Poe assigns to anamorphosis is so powerful that it reveals visions that defy death, reason, and even Christianity.

Despite its great hallucinatory effect, the anamorphosis in Poe's story has a distinctly reduced status relative to its sixteenth-century predecessor.

Originally an art close to magic or a symbol close to divine revelation, the anamorphosis has adapted itself to the passing of time; after its vulgarization, it returns as a mere wall decoration, its effect comparable to that of an opium dream.

The Rhetoric of the Anamorphic Gaze

A single eye continues to mark the history of anamorphosis. Mario Bettini includes a print of an eye for a mirror anamorphosis in his *Apiaria universae philosophiae mathematicae*, a work devoted to optical peculiarities published in 1642 (fig. 10). This single eye is not alone. It has its deformed twin, still recognizable in a formless mass that bears similarities with a small pool on the ground. The "reflected" eye stares at us with authority, yet it does not look. Unlike Leonardo's eye, this one belongs to an individual, namely, Cardinal Colonna, archbishop of Bologna in the early seventeenth century. Bettini's print recalls the story of Cardinal Colonna, whose enlightened view reformed the government of Bologna, thereby saving many poor souls who had been misled by the abusive church. The "wrong view," symbolized by the deformed eye, led the people of Bologna astray, while the proper eye signifies the literally reformed as well as reforming view of the cardinal, under whose inspiring leadership the "right" perspective in the church was reinstated. The ambiguous form of anamorphosis thus makes it possible to blur distinctions on a rhetorical level between metaphorical and literal language, mixing up these styles of speech just as different perspectives were visually jumbled. This mixing is played out in the legend about the cardinal, which precisely concerns reforming views, visual and moral alike. Nonetheless forming a unity, the reformed and the deformed eye underscore the complexity of the ambiguous and multiple levels of representation and rhetoric inherent in anamorphic art.

In *La folie du voir: De l'esthetique baroque*, Christine Buci-Glucksmann uses Bettini's parable image of the cardinal's eye to visualize what she claims to be fundamental to baroque aesthetics, the double structure of baroque vision. Baroque aesthetics occupies a double position, as it is scientific as well as rhetorical. This double structure is reflected in the baroque in the way in which perspective departs from its rigid Renaissance framework and starts to generate play rather than proof, illusion rather than reality, effect rather than resemblance, by incorporating optical tricks into a science of vision. Buci-Glucksmann sees anamorphosis as the best representation of the intertwining of scientific and artistic modes of vision. The baroque eye can be defined as an *anamorphic gaze*. Still highly structured, the chaotic form deliberately incorporates a level of complexity in vision that had not been

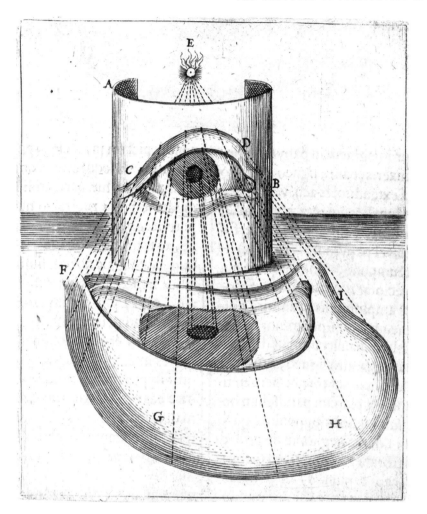

FIG. 10. MARIO BETTINI, *The Eye of Cardinal Colonna*, FROM *Apiaria universae philosophiae mathematicae* (BON-ONIAE, 1645–55), VOL. I. PHOTO: SCIENCE, INDUSTRY & BUSINESS LIBRARY, THE NEW YORK PUBLIC LIBRARY, ASTOR, LENOX, AND TILDEN FOUNDATIONS.

there before.[20] It contains a principle of uncertainty that is not merely *in* the image, but must be located at its foundation. The destiny of the baroque form, Buci-Glucksmann writes, is directed toward an always unstable and ephemeral state, which constantly solicits a double and doubling gaze, such as the one we see in Bettini's print. One eye is correctly and scientifically drawn, the other is deformed, swollen, almost fluid. Buci-Glucksmann demonstrates with Bettini's print a dialectics of seeing and gazing, similar to the schism between Lacan's gaze and the eye. For Buci-Glucksmann, the anamorphosis is an allegory of Vision with a capital V, an allegorical picture

of Vision's "longue-vue," which functions as representative for baroque aesthetics.[21] Typical for anamorphosis as well as for all baroque forms are instability and chaotic deformations that almost but not quite become catastrophic. These apparently imbalanced compositions nevertheless remain highly structured. According to Buci-Glucksmann, this dualism within the baroque form, which is—despite its chaotic emergence—secretly structured, circumscribes the unconscious of the baroque gaze. I would like to append to this idea the suggestion that if there does exist such a thing as the unconscious of the baroque gaze, it must be structured like perspective. The question then arises how perspective itself is structured.

The Structure of Perspective

> The term perspective is generally misunderstood. The theory of projection on a transparent picture
> plane to a station-point is a Renaissance discovery that is properly called artificial perspective. The
> theory of the ambient optic array from an environment to a point of observation should be called
> natural perspective and is not at all the same thing.
> —James Gibson, The Ecological Approach to Visual Perception

How is perspective structured? In addition to reading the countless treatises that have been written since Alberti's *Della pittura* (1436) and the enormous number of publications on this topic that have appeared since Panofsky's famous essay *Perspective as Symbolic Form* (1927), the only means that the art historian has at her or his disposal is the practice of tracing perspectival lines. This so-called "reconstruction" of perspective ("deconstruction" would have been a more appropriate term) is meant to uncover the underlying foundations of this system of representation. The method is simple: if one follows the orthogonal lines of the omnipresent floor pattern in Renaissance paintings by laying a ruler across the picture, and does the same with any of the lines used to build the boxlike elevation of the scene, a blueprint of the picture's perspectival configuration appears. What do we wish to see, or to find, when drawing these lines? In the last chapter of his book *The Poetics of Perspective* (1994), James Elkins attempts to answer this question by developing an "iconology of tracing." On the basis of his own and other "reconstructions" of Renaissance perspectives (Elkins uses the plural), he observes that general reconstructions tend to be more uniform than the Renaissance perspectives they wish to trace. Apparently, fervent tracers tend to be more accurate than the painters themselves ever were, unconsciously "correcting" some of the artists' "mistakes." The results of tracing, if done properly, hardly ever reveal such well-known, perfectly geometrical configurations as the Albertian diagrams in textbooks, but instead portray

a poor derivative, full of irregularities and mistakes. Virtually all paintings, Elkins argues, contain such serious perspectival errors, an opinion that contradicts the common view of Renaissance paintings as expressing an obsession with symmetry, balanced proportions, and mathematics. Elkins manages to prove (through the same practice that he partly criticizes) that some of these errors are intentional and therefore not entirely wrong.

Elkins is correct in observing, by means of his reconstruction, that Giorgione intentionally abused perspective in his *Castelfranco Altarpiece* (Chiesa Parrocchiale, Castelfranco, 1505) in order to achieve a more correct and realistic view of the enthroned Madonna with saints.[22] Giorgione's mistake turns out to be not a mistake, but its opposite, a conscious correction of one. It is not that Giorgione did not master linear perspective, but that he mastered it too well. His awareness of marginal distortions made corrections unavoidable, even if they violated the rules of the game. Elkins finally concludes that it is almost impossible to find a painting whose perspective perfectly matches the Albertian geometrical system; nevertheless, we continue to assume that an ideal structure lies behind it.[23] What Elkins reveals in discovering Giorgione's error is, in fact, art history's shortsightedness. Every "reconstruction" does not generate an insight or a discovery but, on the contrary, further problematizes the function of perspective as it increasingly appears not to be the coherent system that we assumed produced realistic pictures.

Although I do not endorse Elkins's viewpoint in all aspects, I do think that the explicatory textbook diagrams and related notions of an ideal and perfect geometrical configuration have greatly influenced the perceptions of line-tracing art historians, among others. I use the term "influenced" and not "informed," as Marx Wartofsky does, because the latter term seems to suggest that we are aware of the transference of knowledge.[24] As I will demonstrate, we are not merely ignorant of the impact of linear perspective on our perception, but we are inclined to deny it firmly. The practice of tracing within art history tends to say more about the discipline's methods of interpretation and about art historical perception than it reveals crucial information about particular paintings. Other than confirming that paintings contain perspectival errors and supporting explanations that perceive these to be deliberate choices made by the artists, there is less to "see" in the blueprint than one wishes.

Panofsky's *Perspective as Symbolic Form*

What *do* we see in the blueprint; what exactly is perspective?[25] I would like to take a look at two monumental works that deal with this question:

Panofsky's thought-provoking essay *Perspective as Symbolic Form*, initially presented as a lecture in 1924, and Hubert Damisch's *The Origin of Perspective* (1987). Panofsky's lecture was published afterward with additional notes that, true to art historical tradition, cover more pages than the body of his text. Without constant reference to these notes, the reader may find the essay too dense and its complicated argument too difficult to follow. Though full of irregularities and clear mistakes, the essay enjoyed great success because it initiated a debate on perspective at a level distinct from strict psychological or geometrical approaches. The fundamental importance of Panofsky's essay does not rely on issues of curvilinear or fishbone perspective. More significant is his implied yet pervasive starting point positing that while linear perspective, both in terms of its form *and* its idea, has greatly influenced perception, this impact has hardly been acknowledged, let alone studied.

Panofsky opens his essay with the first concrete problem that arose directly after the new rendering of space was discovered in relation to marginal distortions, of which anamorphosis originally was said to be a part. His starting point is not perspective's origin, but its first critique. The difference Leonardo observes between perspectival images and perception supports Panofsky's belief in the possibility of curvilinear perspective (Damisch, rejecting this idea, blatantly calls it "fantasy perspective").[26] He assumes that distortions of this kind are caused by a discrepancy between the retinal image, which is slightly curved, and a perspective that conforms to Euclidian mathematics, which is constructed of straight lines. Following Guido Hauck, Panofsky is convinced that perspective should thus be adjusted to our retinal image by substituting slightly bent lines for straight ones. While untenable, this peculiar argument has attracted much attention, perhaps because, by advocating this idea, Panofsky exceeds the boundaries of his profession and abandons his explanatory art historical discourse in order to take up a position in the long tradition of perspectival treatises. No longer simply analyzing perspective's lineage but promoting his own version of curvilinear perspective, Panofsky for the moment forgets that he is an art historian in order to become a perspectivist. Speaking on two registers, he strives for the double aim of being inscribed in two discourses simultaneously.

Fascinated with distortions rather than perfect forms, Panofsky studies perspectival errors in the checkerboard floor patterns that emerged in pre-Renaissance painting and discovers an interesting pictorial trick. Because late medieval artists lacked knowledge of geometry, their methods often resulted in conflicting moments in painting where attempts to create an impression of recession were betrayed by the flatness of the picture. Panofsky claims that obvious errors were usually covered up:

Already in antiquity, but then above all in the late Middle Ages, when this construction [the checkerboard pattern] was revived in many parts of Europe, such awkward discrepancies were concealed by an escutcheon, a festoon, a bit of drapery or some other *perspectival fig leaf.* (40) [italics mine]

Panofsky's use of the term "perspectival fig leaf" is remarkable. His choice for this particular phrase demonstrates clearly what he, and Elkins's line-drawing art historians, yearns to discover: the hidden, or if you like, private parts of the painting that, censored by the painting's own construction, contain the clue to its secret. Panofsky implies that the meaning of a painting can be defined as that which always lies behind the painted surface. His notion of disguised symbolism that he later develops perfectly complements his theory of perspective. In both cases, he wants to penetrate the painting by looking at what lies underneath, hoping thereby to catch a glimpse of precisely that which always remains invisible. For meaning is indeed invisible, as Merleau-Pony has pointed out, and to a certain extent it shares this invisibility with perspective.[27]

We may even say that the term "perspectival fig leaf" is also applicable to the practice of art history. Elkins points out that perspective's most familiar image, the crystal-clear Albertian figure, has influenced scholars to such a degree that it so to speak "covers up" perspectival errors, *in the perception of these scholars,* in order to present the perfect coherence of geometry. The diagram can thus be said to function itself as a perspectival fig leaf, a concealment that displays an aspect of the unifying fallacy of art history.[28]

This unifying fallacy sacrifices irregularities of any kind for the ideal of coherence. Panofsky's keyword is "unity," perspective being for him the process of pictorial synthesis par excellence. Wishing to unify the retinal image with pictorial representation by means of curvilinear perspective, his ultimate aim is to demonstrate the correspondence between linear perspective and worldview: perspective as symbolic form.

But if perspective is not a factor of value, it is surely a factor of style. Indeed, it may even be characterized as (to extend Ernst Cassirer's felicitous term to the history of art) one of those "symbolic forms" in which "spiritual meaning is attached to a concrete, marginal sign and intrinsically given to this sign." (41)

Panofsky quotes here from Cassirer's magnum opus, *The Philosophy of Symbolic Forms,* published between 1923 and 1929.[29] Critiquing the narrow conception of the notion of objectivity within transcendental analytical philosophy, a shortcoming Kant himself acknowledges, Cassirer attempts to transform Kant's critique of reason into a "critique of culture." Kant suggests that the

relation between cognition and the object has to be radically modified. Previously, ontological metaphysics had aimed at defining the universal qualities of being. Kant, however, insists that we should not solely "know" an object, but also understand it. In order to establish the more sophisticated concept of objectivity that this requires, he introduces the concept of judgment, whose foundations must be fully analyzed before such objectivity can become conceivable. While Cassirer rejects understanding an object purely on the basis of its logical attributes, he does not want to position himself against Kantian philosophy, but instead wishes to refine some of its methodological aspects. Dismissing the traditional investigation of isolated objects, he is interested in the way in which these objects function in the broader context of their specific cultural realm. "The crucial question," Cassirer writes, "is whether we seek to understand the function by the structure or the structure by the function," a question he answers by affirming that "we must seek to understand . . . the function of mythical and religious thinking, and the function of artistic perception."[30] Cassirer proposes the primacy of an object's function and understands structure by means of this function. An object is never a naked thing, but embedded in scientific discourses. The fundamental concepts that belong to such discourses have been regarded, Cassirer states, as passive images of given information, while they should be considered as *symbols* created by the intellect itself. Produced by the diverse functions of human actions (they do not exist a priori), these symbols function as vehicles by means of which the sciences reflect on and describe reality. They should therefore be surveyed as a whole and no longer studied as isolated fragments. Cassirer's purpose is to reveal symbolic forms such as language, art, and myth, as various manifestations of the same basic human function.[31]

Within the context of Cassirer's philosophy, Panofsky's hypothesis of perspective as a symbolic form sounds plausible. Perspective is produced by an interaction between optics and art; it is a vehicle by means of which artists are able to reflect upon reality as well as describe it; and it is a structure in which many objects may be embedded, whose function says something about culture as a whole (the Renaissance). Unfortunately, Panofsky refuses to explain his notion of perspective as a symbolic form any further. His idea that it is an expression of a worldview is not only a little naive but also partly in conflict with Cassirer's definition of symbolic form as something that can never itself be an expression of anything, but must be understood as a device through which certain expressions about reality are enabled.

Panofsky easily transgresses the conditions of Cassirer's definition when he claims that certain scientific achievements were anticipated by the artistic

practice of using perspective. While many scholars have taken the edge off this bold claim, we have to admit that Panofsky introduces his argument convincingly. Belonging to the first generation of line-tracing art historians, he follows some of the orthogonal lines of the floor tiles in Ambrogio Lorenzetti's *Annunciation* (1344, Siena, Pinacoteca), demonstrating that they actually meet at one point in the very center of the panel. Eighty years before Brunelleschi, Lorenzetti already made "his" point: for the first time, Panofsky claims, all orthogonal lines of the ground plane are oriented toward a single point, designed "undoubtedly with full mathematical consciousness" (57), and marking the discovery of the vanishing point. Lorenzetti's remarkably systematic recession of floor tiles shows that the concept of infinity is, in 1344, still in the making. Panofsky optimistically argues that projective geometry, which was developed in the seventeenth century by the same Parisian circle of mathematicians that was so intrigued by anamorphosis, emerged from perspectival endeavors such as Lorenzetti's tour de force. At least as crucial and indispensable as the point of view, the vanishing point has nevertheless remained less theorized and (thus) more problematic. Yet it is precisely this point that represents a concept that to a certain extent can be called the opposite of its companion, the point of view, or even its denial or its annihilation. Infinity excludes everything that concerns the point of view, namely, a well-defined location in the center of a comprehensible space. At the same time, it includes everything that is beyond view, placement, or even measurement.

The discovery of the vanishing point is, according to Panofsky, "the concrete symbol for the discovery of the infinite itself" (57). Two problems arise with Panofsky's seductive argument. First, as Damisch observes, the lines Panofsky traced in the *Annunciation* reveal a vanishing point that does not manifest itself *as a point* because the convergence of orthogonal lines happens behind a wooden column in low relief that is part of the painting's gilded frame.[32] An essential part of the frame, the column has been incorporated in the painting and stands firmly, with a little pedestal, on the painted floor tiles, sharing the same space that the angel Gabriel and the Virgin inhabit. Its status is highly ambiguous: both material and immaterial, both part of the scene and of the viewer's space, both imaginary and real. It cuts the picture symmetrically in half, while simultaneously uniting the two halves by fading away against the golden background. The vanishing point as such is not visible; it does not even *appear* in the painting. In his discussion of this section of the essay, Damisch asserts that the column functions like a mask or screen that covers up the point toward which the orthogonal lines converge; but it is also, he writes, "the lynchpin" of a contradictory structure in

which the column's flattening effect conflicts with the recession of the floor tiles. Damisch concludes that Lorenzetti's first construction with the implied vanishing point must have been so suspect that it could not be openly acknowledged, but instead had to be masked.[33]

If this vanishing point was indeed such a compelling yet contradictory discovery, then why does Panofsky call it a "concrete symbol" of this discovery? If he is so bold as to claim the emergence of projective geometry from such artistic achievements as Lorenzetti's, why does the appearance of the vanishing point not anticipate, or mark, the discovery of infinity itself? As infinity cannot be visualized in any way, the point in Lorenzetti's painting hidden behind the column is as much infinity's image as the mathematical symbol that was later designed for it. If infinity could not yet be mathematically thought or theorized in Lorenzetti's time, it follows that it could not be symbolized either, or that it could only be symbolized. For different reasons, Damisch proposes to consider this point not as a symbol of infinity, but as its *sign*.[34] For him, this point as sign, inscribed on the canvas or panel, marks the initiation of a history of geometry to which the art of the perspectivists certainly contributed; not to the extent, however, that Panofsky claimed was the case.

The concept of infinity was the result of a reinterpretation of Aristotle's doctrine of space by the Scholastic philosophers. The evolution of perspective, from which the revolution of the Renaissance arose, carries with it all the achievements of the past centuries. The revolutionary moment that heralded the Renaissance, Panofsky suggests, came when a new method of representation emerged, as well as a "modern" worldview, and when scientific and artistic developments converged and synthesized. It seems as if, for Panofsky, history moves backward as much as forward. In section 3 of the essay, there is a rhetorically problematic moment when Panofsky, tracing back the history of perspective, finds himself in the midst of his own narrative of argumentation, anticipating his own point of departure, which is also the same point of convergence he seeks to approach.

> At this point [when infinity is conceptualized in the late Gothic period] we can almost predict *where* "modern" perspective will unfold: where the northern Gothic feeling for space . . . seizes upon . . . forms preserved in fragments in Byzantine painting, and welds them into a new unity. (54) [italics mine]

The perfect locus where two evolutions might merge resides in a vanishing point that has not yet come fully into existence, a point that, in painting, is never entirely there. Panofsky's own investment is expressed by the open-

ing phrase. The deictic expression "at this point" functions as a knot on the basis of which we can predict not *how* modern perspective will unfold, but *where* this will happen. What Panofsky has in mind, like Lorenzetti's vanishing point, is a location, a place, that will function as a site of unification. In this conspicuous fragment, he in fact has chosen Lorenzetti's vanishing point—that had not even properly emerged yet—as his point of view from which he looks at the revolutionary moment to come. The moment of revolution and revelation that Panofsky is after must be found in a point that has come into view with Lorenzetti, but which still, in 1344, is located at the horizon of history and painting alike. If perspective does indeed have a symbolic form, as Panofsky claims, its symbolism becomes nowhere so clear in his essay as it does here. The inversion of view and vanishing points that, as I will demonstrate, is inherent in perspective's construction manifests itself here on a symbolical level. Indeed, for Panofsky, perspective's range reaches far beyond the frame of the painting. Within the scope of his essay, however, he merely manages to imply his thoughts more than he explains them, failing to elaborate further on how perspective can be defined as a symbolic form.

One statement in particular that remains implied in the essay is Panofsky's conviction that perspective influences perception. In the first section, he explains how Johannes Kepler initially denied that the objectively perceived straight tail of a comet could be a curve because he had been schooled in linear perspective (34). Panofsky's original argument that perspective symbolizes or expresses a worldview is in fact undermined by this example of Kepler, who unwittingly used linear perspective as a paradigm for his vision. In Kepler's case, linear perspective *produced* his view of the comet's tail, and thus his perception of the world (and of the universe), instead of being an expression of a worldview. Developments in the study of perspective often have had repercussions on (theories of) visual perception, including, for example, on the unifying fallacy.[35] Just as Jacob Burckhardt's account of the Renaissance perfectly resembles paintings of that period, which, in their turn, prove him right, I think perspective has shaped an image of our visual field that we assume must be correct when we find proof of it in painting and in photography.[36] Hence, perspective has provided us with a model of looking and, consequently, with a mode of interpretation, whose consequences we, unlike Kepler, do not quickly recognize. It is important, moreover, not to underestimate the effect of linear perspective on our perception precisely because our "vision" of things exceeds the limits of our perceptual field, with the result that it ultimately sustains something that, if it is not interpretation, might be called thinking.

Damisch's *Origin of Perspective*

Damisch considers Panofsky's essay "a kind of textual threshold that must be crossed before one can undertake to 'go beyond' it" (4). He indeed manages "to go beyond it," considering the more than four hundred pages of his comprehensive work and the complexity of his version of perspective's history.[37] The title of his work, *The Origin of Perspective*, may not immediately reveal that Damisch is in fact more interested in the philosophical question of the origin and its relation to history than he is in perspective per se. As he mentions himself, perspective has provided art historians with a well-defined semi-scientific object of study, the history of which seems as coherent as the outline of its form. He also takes this seemingly coherent object as the focus of his own study. Unlike art historians, however, he is not so much interested in fully understanding the artistic rendering of space as in writing its plural histories. Seeking the origin, Damisch demonstrates that it is marked by absence, or disappearance: as we have seen in the first chapter, the vanishing point in Brunelleschi's panel, the first indication of a geometrically systematic perspective, was a hole. The panels themselves have not survived, with the result that perspective has lost its prototype. "By what title," Damisch asks, "within what optic, if not within what perspective, can a demonstration conducted in accordance with the ways and means of art . . . acquire the status of an origin?" (157). This hypothesis has less to do with perspective as such and more with the *position* that the tradition assigns to Brunelleschi's invention or discovery. Damisch is interested in this position because it corresponds to the moment when practical interest is inverted into theoretical interest, which according to Husserl constitutes the condition of science in the European world (157).

Although he labels Panofsky's essay and its appendix of notes "labyrinthine," Damisch himself is not entirely free of a similar meandering structure of writing; his style is verbose and repetitive, full of digressions and intermezzos, and constructed of extremely long Proustian sentences. The two monumental works on perspective turn out to be partly inaccessible and equally difficult to penetrate, and as such their styles contradict their topic, which itself ought to generate transparent, unobtrusive viewpoints. Historically speaking, however, the understanding of the operation that provides such clear views has been hindered by the level of mathematics, blurred by the many instances in which it has been reformulated, and eventually obfuscated by the philosophical issues related to realism that its invention generated. Damisch does not pursue a clarification of these complications, but instead offers a full account of the complexities and far-reaching philosophical consequences of the development of perspective since its invention. In

that sense, he is a true follower of Panofsky, whose pioneering essay staged the first attempt to problematize perspective rather than to clarify it.

Assuming for the moment that perspective is a symbolic form, Damisch aptly wonders of what it is a symbol (14). I would like to link this question with Panofsky's idea that the convergence of lines in Lorenzetti's picture is a *concrete* symbol for the discovery of infinity itself. What is so concrete about this symbol, and why does he consider it a symbol to begin with? What form can perspectival elements adopt, whether or not symbolic, if perspective itself has not yet been fully invented?

Damisch does call perspectival configuration symbolic, yet he means, in the precise Lacanian sense of the term, a singular paradigmatic structure that is ruled by determinants that are symbolic (19). Inspired by Emile Benveniste's language theory, Damisch concludes that artificial perspective provided the painter with a formal apparatus like that of the sentence. Deictic features, which for Benveniste form the foundations of language, are also shared by the perspectival configuration given that its structure is designated by view, vanishing, and distance points. Simultaneously it also determines the location of specific points within the pictorial space such as here, there, and elsewhere, thus construing a geometry of the sentence (446).[38]

The point of view that opens the possibility for a subject to see can be considered as a sign, like an apostrophe, a direct address that has meaning and existence only within the space of the visible (442). The subject is *the effect* of perspective. More precisely formulated, its position is an effect of the vanishing point since it determines the very place of the point of view within the geometrical system. If the viewpoint and the vanishing point are companions partly because they share the same perpendicular line that connects the viewer's space with the pictorial space, we must conclude on the basis of Panofsky's suggestion that the invention of the vanishing point *precedes* that of the point of view. While Lorenzetti let his diagonal lines converge, he did not know how to connect the point of convergence with a horizon, something that Brunelleschi was able to accomplish only later. When the vanishing point was given a "point," a spot, the viewing subject had not yet been placed, his location had not yet been implied in the construction of the painting. Within perspectival configuration, it is consequently the vanishing point that determines the position of the viewer, and not vice versa. The result is that precisely the locus that the subject can never possibly reach effects the point from which the subject is to view the image, thereby inscribing the partial elision of the subject in the construction. In other words, this vanishing point is the sign of the *elision* of the subject (in the Lacanian sense, not to be confused with the "absence" of the subject).

Following Pascal's thoughts concerning infinity, Damisch explains that
the viewpoint and vanishing point do not in fact designate points, but a line
on which they both lie. This line connects the eye of the subject with infin-
ity, which, in a painting, the eye will never comprehend, or for that matter
perceive. Although infinity's sign is located on the horizon in the picture,
its meaning must rather be found *behind* it. Similarly, the line of vision does
not end in the viewer's eye, but stretches out beyond his or her head, just as
the concept of infinity goes beyond one's comprehension. There is not one
infinity, as geometry teaches us, but two: the infinitely big and the infinitely
small. The image of both can be found to a certain extent in painting, as first
Pascal and after him Damisch claim (385).

The subject inscribed in the system is interpellated by the painting as
much as s/he interpellates it, since s/he can only engage with the painting by
becoming lost in it (389). Once one takes a position within this system, there
is no escape, as there is no escape from the symbolic order, or from language.
The perspectival paradigm is therefore similar to the formal apparatus of a
sentence because

> it assigns the subject a place within a previously established network *that gives*
> *it meaning*, while at the same time opening up the possibility of something like
> a statement in painting: as Wittgenstein wrote, words are but points, while
> propositions are arrows that have meaning, which is to say direction. (446)
> [italics mine]

With regard to this fragment, Damisch's definition of the perspectival con-
figuration accords with that of Panofsky to the extent that it shares fea-
tures with Cassirer's notion of symbolic form. Neither Cassirer nor Panof-
sky, however, assigned a position for the subject within their systems, while
Damisch claims that this is a fundamental condition for the perspectival
paradigm.

Following Damisch, and along with him Lacan and Benveniste, we may
claim that perspective can be said to give meaning to the place of the subject
within its established network, while it also opens up the possibility of mak-
ing "something like a statement in painting" (446). If perspective can make
a statement, then it must be a signifying system, indeed a network that *gives*
meaning rather than a sign that *means* something. For Panofsky, perspective
means something; it is an expression of a worldview by means of a symbol
that stands for something else. For Damisch, perspective *gives* meaning; it
is not a symbol but a structure, a paradigm. If perspective indeed is able to
make something like a statement in painting, this statement would be fun-
damentally paradoxical if only for the reason that it does not *say* something,

but *shows* it. How can perspective either mean or show something if it itself remains invisible? We will see how this paradox operates most emphatically in one of Juan Sánchez Cotán's still lifes.

Perspective *Shows* . . . Sánchez Cotán and Gijsbrechts

Around 1602 Sánchez Cotán painted his remarkable *Still Life with Quince, Cabbage, Melon and Cucumber* (plate 18). The perspective in this picture certainly cannot be traced as it can in a Renaissance painting, yet the appearance of the picture is in all respects determined by geometry. Two rectangular, virtually square figures shape the shallow space, one tracing the size of the niche and another outlining the black background. Within this cubic space, the edibles, illuminated as if a spotlight has been placed on them, emerge as a study in mathematical forms.[39] The quince is a sphere turning around its axis; the cabbage's circular leaves folded in upon one another recall the mathematical figure of the cardioid; the melon seems to have an ellipsoid as its basic form, with a segment cut out; and the cucumber slightly echoes the shape of a cone. From the quince suspended by a thread to the cucumber protruding out of the stone niche, the five elements trace a perfect curve, a hyperbola. The coordinates of this hyperbola are not two dimensional, but three dimensional. The curve formed by the fruits and vegetables gradually moves forward while reclining toward the right. Within the depicted space, the cabbage and the quince have been pushed backward compared to the melon. Its slice has been placed slightly in front of it, and the cucumber has been pushed forward so far that it projects out of the frame.

The visibility of the edibles, geometrically fixed and almost scientifically presented, contrasts strongly with the darkness against which they are portrayed. Like Claesz. and Heda, Sánchez Cotán decides to leave half of his painting untouched and devoid of painted objects. Whereas in the breakfast paintings the emptiness remains "visible" because of the beige color, Sánchez Cotán's background is painted so dark that its ground has become invisible under the color, turning the void into a black hole of nothingness. The threatening darkness yawns like an abyss, virtually transforming the artificially made niche into a subterranean cave. This painting's perspectival configuration has lost its vanishing point in the darkness of the void. It designates a "depth" that nonetheless is incapable of adding anything to the space in the painting. Not making the niche any deeper, the black background manifests a depth that extends itself without any ground existing. If we try to see beyond the fruits and vegetables, we become aware of the fact that the capacity of perspective to structure space is in fact a capacity to structure *emptiness in space*. Whether in reality or in painting, perspective

never adds anything to already existing space but merely organizes it; it is empty in and of itself.

Naturally, there has never been just one perspective, but always two. *Perspectiva artificialis* (or *accidentale* as Leonardo suggested) and *perspectiva naturalis* have always been distinguished as two separate sides of the same coin. Yet in art history the latter tends to be underestimated, having been reduced to the point of view. *Perspectiva naturalis*, "our" perspective, is evidently invisible, while actually it is the primary condition of *perspectiva artificialis* to remain invisible.

In *La croisée du visible*, Jean-Luc Marion states that both perspectives are staging devices that open up pathways for our gaze in a space that, ordered by the three dimensions, forms our visual field. The dimensions never measure this boundless space that is like a depth without ground. Directed by perspective and invisible in itself, our gaze must penetrate a space devoid of things, a structured emptiness, in order to see. Informed by Merleau-Ponty's *The Visible and the Invisible*, Marion states that this void is not synonymous with invisibility, but must be understood as an emptiness within the visible whose mise-en-scène is perspective. In painting, this mise-en-scène results in a space that is ideal *and* visible, while in reality the staging of things is real but invisible, a proposition that leads Marion to state that perspective is a condition prior to experience. Brunelleschi's experiment must therefore be considered a discovery rather than an invention. Painting can be understood as the site where the visible and the invisible intersect, a crossing that is mediated by perspective. Elaborating on Alberti's definition of painting as a planar intersection of our visual cone, Marion claims that perspective is a paradox as much as it exercises one.

In Sánchez Cotán's painting, we can see how perspective is ruled by this paradox. The edibles are staged in a sober yet theatrical way in the niche that indeed opens up a space; a space that is, as the curve indicates, mathematical and therefore ideal. Although the curve has been presented three-dimensionally by slowly coming forward and moving out of the frame, its reference to topology firmly states its two-dimensionality. Sánchez Cotán clearly demonstrates that he is well aware of having *removed* a real dimension in the process of creating his painting.

More importantly, our perspective has been blocked off by the composition of the background. Covering up the ground of the painting, the black square manifests a hollowness, an infinite depth that we cannot really see. Standing in front of this painting, our perspective, structuring a depth without ground, intersects at a direct angle with the picture plane that consists of a ground without depth. The black void emerges as a black hole, which

offers a mise-en-scène for the fruits and vegetables' appearance; it also, however, makes visible the emptiness of perspective itself. This painting presents itself not as the intersection of the visible and the invisible, but of two voids *within* perspective. The void through which our eyes are constantly traveling encounters here a void in painting that grounds our perspective. In the course of the viewing process, Sánchez Cotán's black background functions as a dark empty screen against which the fruits and vegetables are projected, and in which our gaze becomes lost. If Damisch proposes that perspective can make something like a statement in painting, I would suggest that in Sánchez Cotán's painting perspective states that it *shows*.

In his article "Tableau," Gérard Wajcman maps out a part of the Lacanian topology.[40] He connects the three Lacanian "dimensions" with the three spaces they design, and the three graphic representations that inscribe three specific spots. The symbolic structures the symbolic space where the *graphe* inscribes the place; the imaginary space has a scheme that figures as the map of the image; and finally the space of the real has the tableau that presents the sites. The symbolic graph speaks for itself: it is a written sign that tells what it means, and simultaneously it is something that can be told. The major function of the imaginary scheme is to represent; it is something that can be seen. And the tableau, the picture, does not tell or see; it *shows*.

In the second part of *Seminar XI*, Lacan searches for the function of vision.[41] In his well-known story of the sardine can, he finds the condition enabling his structure of the visual field, which is the reversibility of seeing and being seen. We have seen that the point of view, as it is defined by perspective, does not strictly function as merely a position from which the subject sees, but also from which it is seen by the gaze. Lacan realized this inversion because of a joke he did not fully understand. Once, when he was out on a boat trip, one of the fishermen pointed to a sardine can floating on the water that was reflecting the sunlight, saying: "Do you see that can? Do you see it? Well, it doesn't see you!"[42] Lacan could not for the life of him figure out what was so funny, while the fisherman found his own joke rather amusing. Lacan's discomfort made him aware that notwithstanding his being on the boat, he was rather "out of place in the picture."[43] Unable to understand the joke, he definitely did not get the picture, even as he remained a part of it in the reflection of the sardine can that "photo-graphed" him. Arguably, class differences may have played a role in creating the situation, as Lacan implies. I am interested, however, in the fact that he lost his grip on the situation because of a joke, which forms the basis of every trompe l'oeil. The deception in trompe l'oeil is caused by the joke that what one sees is not the picture one gets.

The structure of the visual field that Lacan establishes in his *Seminar XI* of 1964, with the schism between the eye and the gaze, is elaborated in his 1966 seminar and becomes the basis of his topology. The gaze thus starts to take a most important position, its function no longer restricted to the realm of vision. Its task is to reformulate, once again inspired by Merleau-Ponty, the relationship between subject, object, and the world. As Lacan's notorious diagrams demonstrate, the realm of the gaze has been visualized by the intertwining of two perspectives that indeed can be named in accordance with the tradition, *perspectiva artificialis* and *perspectiva naturalis*. Although Marion draws different conclusions, his crossing of the visible and the invisible can be compared to Lacan's perspectival cones, which, when superimposed, imply a similar crossing. We should not forget, however, that Lacan's crossing is more of an encounter and generates a split, the schism. Furthermore, the void, which is for Marion that which renders possible the mise-en-scène of the visible, has the form of a hole in Lacan's diagram, a hole in which the *objet petit a* resides.

The operation of inversion is mediated by what Lacan calls the screen (*l'écran,* translated as "image-screen" in the English text). There have been many interpretations as to how this notion of the screen should be understood, since it combines connotations as various as film screen, mask, cultural coding, and Alberti's veil. My interest in the notion of the screen is that it is fundamentally paradoxical because it is constructed by means of superimposing two contradictory parts of the perspectival cones. It includes Albertian features typical of a picture as well as the features of a glass window, presenting a ground and a view alike whereby the image veils the screen. While the structure of the gaze falling through and filtered by the screen is not a metaphor but real (Lacan's structures are always real), the screen is merely a function, a mise-en-scène if you like. As image as well as veil, the screen shows as much as it hides. More importantly, in bringing these contrasting concepts together, they cancel each other out (to show means not to hide, to hide means not to show) with the result that the Lacanian screen neither hides nor shows, but is instead transparent. Wajcman adds that the screen first and foremost is a support; it is the surface of the painting, its ground:

> Underneath the image, underneath that which can be seen, it is hidden by the image, in revealing, the image veils the screen as that which hides, it veils the veil; underneath the letter [support de la lettre], it is shown as that which hides an opaque emptiness; "ground" of the object ["support" de l'objet], it shows what it hides, *it is pierced.*[44] [italics mine]

If we look at Gijsbrechts's *Trompe l'Oeil Cabinet of Curiosities with Ivory Tankard* (plate 19, 1670), we may better understand how the different layers of the screen enfold us, all the while remaining transparent. This picture must certainly not be understood as an example of the screen, but it may illuminate its ambiguous status and function in the visual field. The painting presents a cabinet door with windows of leaded glass through which we see the contents inside the cabinet: an ivory tankard, the small figure of a horseman, and some shells. Framed by panels of painted wood, the door has real hinges and can be opened just like any other door. A painted iron bar runs across the window, with a quill pen and some letters placed behind it, confusing our eye because it has a stronger realistic effect than the real metal lock and hinges themselves have on us.[45]

It goes without saying that Gijsbrechts's picture is literally a "support de la lettre," but evidently denotes something completely different than Wajcman had in mind. Yet this particular window both shows and hides simultaneously: what we see behind the window—items of a *Kunstkammer* collection whose sole function is showing, and showing off—is partly covered with letters revealing only a few readable sentences. Other paintings by Gijsbrechts, such as the first picture he made for the Danish king Frederik III, the *Trompe L'Oeil Letter Rack* of 1668 (plate 21), may present a better example of the screen veiling both the image and its ground, along with veiling the veil itself, in a typical baroque fold. Both paintings bear references to Alberti's description of the veil:

> Nothing can be found, so I think, which is more useful than that veil which among my friends I call an intersection. It is a thin veil, finely woven, dyed whatever color pleases you and with larger threads [marking out] as many parallels as you prefer. This veil I place between the eye and the thing seen, so the visual pyramid penetrates through the thinness of the veil. This veil can be of great use to you. Firstly, it always presents to you the same unchanged plane. Where you have placed certain limits, you quickly find the true cuspid of the pyramid.[46]

In both the letter rack paintings and the cabinet door, Gijsbrechts's reference to such a grid as a pictorial device is conspicuous. The red ribbon in the letter racks and the division of the window in the cabinet door fulfill similar roles as Alberti's veil, keeping the letters in place just as Alberti's intersection keeps the objects seen through the veil in place. The cabinet door doubles the reference to Alberti by being both a grid *and* a window, the glass of which is slightly colored, blurring the view the same way a veil would.

Gijsbrechts's door may assist us in understanding the structure of the

screen because it hides an ingenious surprise within. Just as the screen works both ways, the gaze being filtered through it as well as the subject of representation, Gijsbrechts's picture likewise works in both directions. Unlike most paintings, his door has a behind: its verso, the inside of the cabinet door, also contains a painting that remains concealed as long as the door is closed (plate 20). The verso represents the exact back of the image: we see the reverse side of the letters pressed to the glass, the quill pen protruding a bit. Gijsbrechts's breathtaking virtuosity demonstrates its ultimate greatness in a deception that misleads even the most scrutinizing observer: the glass in the window is partly broken. A sharp fracture line cuts the lower right window in half, the upper part being a little lighter than the lower part, indicating that part of the glass has been removed.

Wajcman indicates that the screen, the " 'support' of the object, shows that which it hides, it is pierced." While the "glass" in Gijsbrechts's cabinet door already enables our gaze to pierce what looks like the first layer of the picture, this layer itself displays a puncture, facilitating our desire to peep in. But then, the double disillusion reveals itself dramatically. There is no difference between the glass and the hole; that which shows itself behind it is of the same order as the window; that is, the window is not a window at all, notwithstanding the fact that it shares all its major features, even incorporating a view from the reverse side. Indeed, the screen mediates a crossing of the gaze and the eye, since it can be looked at from both sides. While the subject's eye is able to see through the screen, however, the gaze that pierces it from the other side is incapable of seeing, and consequently only shows itself. In Gijsbrechts's construction, the other side of things is made visible on the verso, yet not for anybody to see. Unlike other pictures with painted versos, the sides Gijsbrechts has united are inextricably linked by being each other's reverse side. We are able to see that which is always invisible in regular paintings as well as in our perception, namely, how things would look when seen from the other side, from the point toward which we direct our gaze, but from which we cannot see.

Conclusion: The Profile of Perspective

For a full understanding of the impact of perspective on the visual field—as Panofsky's essay anticipated, and as Lacan tried to formulate with his notion of the gaze and Marion attempted with his notion of the crossing—we have to return to anamorphosis.

Neither Damisch's monumental *Origin of Perspective* nor Panofsky's *Perspective as Symbolic Form* discusses anamorphosis. Although the subject evidently does not fit within the scope of Panofsky's essay, Damisch's bulky

Origin of Perspective ought to have paid it some attention, especially given the book's theoretical foundations, rather than merely mentioning it in passing.[47] Elkins, too, only refers to anamorphosis in relation to his (incomplete) discussion of Lacan's notion of the gaze.[48] I am determined to fill in this lack because I believe that anamorphosis provides a model of vision, which, unlike the perspectival model, deliberately plays with a logic of secrecy. While perspective also hides as much as it shows, stimulating the complexities I have detailed, the model of vision that it offers remains unproblematic, clear, and unambiguous. In my search for the truth in painting, I pursue, if not truth, then at least a moment of revelation that may involve an alternative point of view. If I want to catch a glimpse of the operation of perspective in the visual field, I will have to look at painting from the place I cannot see, that is, from the side of painting itself. This place, I think, is proposed by anamorphosis.

In order to illustrate that he felt neglected, on the one hand, and, on the other hand, caught in a perspective he could not grasp, Lacan provides the example of Holbein's anamorphosis embedded in his painting *The Ambassadors*, where this negation, or annihilation, has been made visible.[49] Already in *Seminar VII*, Lacan uses anamorphosis as a metaphor for the highly rhetorical game of courtly love. He mentions that the inverted perspective that structures anamorphic art marks a turning point in the history of painting, when the artist completely reverses the use of spatial illusion by transforming it into a support for hidden reality. Anamorphosis, too, hides and shows at the same time; it also, however, makes a significant contribution to the complexities of perspective's function in the field of vision. Whereas Gijsbrechts's trompe l'oeil illuminates the function of the screen in the schism between eye and gaze, whose effect of deception Lacan called a triumph of the gaze over the eye, anamorphosis proposes a refined location for the always-elusive gaze.

We have seen how the point of view is ordered by the vanishing point that precedes it. There is, however, a third point that emerges later in the history of perspective, developed more than a century after Alberti's treatise, first by Sebastiano Serlio and later by Giacomo da Vignola and Vincenzo Danti. This point more precisely determines the distance between the subject and the picture plane and is simply called the distance point (or lateral point). Perspectival configurations with additional distance points were developed in the second half of the sixteenth century, although there are indications that they already had been used much earlier.[50] Distance points lie on the horizon of the picture plane, outside its frame, making the interval between the vanishing point and the distant points equal to the one between the eye

and the picture plane. The point of view is now completely fixed within the system, produced by the line perpendicular to the vanishing point as well as by the intersection of two verticals that run through the distance points. A further sophisticated revision of perspectival configuration was that with the assistance of distance points, the intersections of orthogonal and horizontal lines could now be plotted precisely rather than estimated (fig. 11).

The distance points thus stipulate measurable distances and fix the point of view within the perspectival configuration, all the while remaining literally out of the picture. They fall outside of the picture's frame, determining its structure but themselves remaining invisible. Unlike the point of view, which is likewise invisible, a distance point will neither be occupied nor looked at by a spectator.

Wajcman demonstrates, on the basis of the distance-point construction in painting, how we can understand the schism between the eye and the gaze that structures the visual field. The subject in front of a painting is determined by two "eyes," the first being that of the vanishing point, which Lacan calls the eye in the picture (see chapter 1), and the second being the "eye" of the Other. This eye of the Other always remains outside of the picture in the broadest sense, located where one never looks, while providing visibility from, and especially through, its distance. Wajcman considers the distance point to be the locus of the gaze. The lateral point as gaze is here introduced as the third term: while the vanishing point addresses the viewer, becoming a kind of a second person, the lateral point functions here—in line with Damisch's theory of perspective as a sentence—as a third person who remains invisible. The gaze as distance point "looks" at both the spectator *and* the painting from the side of the painting, at an oblique angle.

In his *Phenomenology of Perception*, Merleau-Ponty explains his difficulty with defining depth. George Berkeley never thought of depth as a separate dimension but understood it as width viewed in profile. As we have seen in chapter 1, Merleau-Ponty opposes this idea because if we consider the first and the third dimension interchangeable, we disavow the distance between our eyes and the object, which is, according to Merleau-Ponty, the fundamental condition for sight. Furthermore, the moment one attempts to observe width from an oblique angle, it transforms into depth and vice versa, indicating that depth as such cannot be seen. Berkeley's directive is as impossible for a spectator to follow as looking from the distance point is. I believe, however, that anamorphosis introduces within its structure such an impossible lateral view.

Within the geometrical construction of anamorphic perspective, the viewpoint has been moved to the side of the painting, approximately on

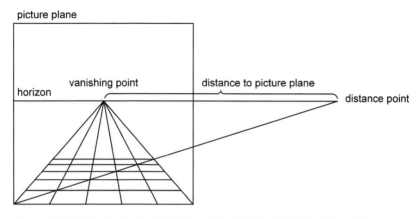

FIG. II. SCHEMATIC DIAGRAM OF PERSPECTIVE CONFIGURATION WITH DISTANCE POINTS.

the level where we normally find a distance point. Occupying this peculiar point, we simultaneously see the creation from two sides: with a lateral view we look at its ground, from which emerges the image that is presented as if it is right in front of us. Anamorphosis solicits the double view that Buci-Glucksmann claims to be typical of the baroque. We no longer occupy a position that literally is diametrically opposed to the painting in which image and ground coincide, but we stand by the painting's side; we have moved to its level, and look, so to speak, from the painting's point of view. What we see when we arrive there is an image that is not a given, that is not presented to us, but appears in the process of unfolding. It is as if not the image, but perspective itself, unfolds itself and shows itself. The search for the right point of view reveals perspective's operation by means of which we do not see "truth itself" but a variation of truth, one emphatically shaped by perspective rather than one that merely emerges from it. As Deleuze says:

> The point of view is not what varies with the subject, at least in the first instance; it is, to the contrary, the condition in which an eventual subject apprehends a variation (metamorphosis), or: something = x (anamorphosis). For Leibniz, for Nietzsche, for William and Henry James, and for Whitehead as well, perspectivism amounts to a relativism, but not the relativism we take for granted. It is not a variation of truth according to the subject, but the condition in which the truth of a variation appears to the subject. This is the very idea of Baroque perspective.[51]

Baroque perspective can be understood as a response to the pictorial regime of the Renaissance, whose representative is anamorphosis. Indeed, the "truth of a variation" is precisely that which anamorphosis reveals. This

possibility of variation that generates an ambiguity in meaning and vision alike is opposed to orthodox perspective. We are seldom aware of the fact that perspective is the mise-en-scène for the objects we see in painting. Anamorphosis does not simply offer such a mise-en-scène. On the contrary, it must be conquered. Lacan called trompe l'oeil painting a triumph of the gaze over the spectator's eye. Comparing anamorphosis to "regular" painting, the influence of perspective manifests itself in the difference between conquering and being conquered. What an anamorphic look at a perspectival configuration teaches us is how we are snared within its system. We even have appropriated its strategy of clarity and coherence, guidelines that partly organize our perception as well as our modes of (art historical) analysis. Since the foundation of the discipline of art history, anamorphosis has never managed to leave its marginal position, a disavowal that has a long history.

Galileo, for instance, expresses his aversion to Torquato Tasso's "allegorical" poetry by comparing it to anamorphosis. In allegorical poetry, the "current narrative, originally plainly visible and viewed directly," has adapted itself "to allegorical meaning seen obliquely, and implied," which "extravagantly obstructs it by chimerical, fantastic and superfluous figments." These characteristics of allegorical poetry are similar to the features of anamorphosis, showing

> a human figure when looked at sideways and from a uniquely determined point of view but, when observed frontally as we naturally and normally do with other pictures, displays nothing but a welter of lines and colors from which we can make out, if we try hard, semblances of rivers, bare beaches, clouds, or strange chimerical shapes.[52]

Like Pascal, Galileo abhors any form of ambiguity that obstructs clear views. Allegory and anamorphosis share the same secret and coded discourse that celebrates ambiguity as the very means through which they communicate.[53] Anamorphosis does not necessarily have to be allegorical, yet it is very hard not to understand a deliberately deformed image, hiding behind its distortion, as an allegory. For Buci-Glucksmann, anamorphosis is an allegory of baroque vision that unifies some of baroque's most important features: its inclination toward ambiguity and confusion, its high level of rhetoric, its concentration on play, and, above all, its fascination with vision. The peculiarity of anamorphosis and allegory, their complexity and secrecy, and the aversion they often evoke demonstrate how natural and normalized their opposites have become. Allegory and anamorphosis solicit a particular mode of looking that entails a mode of reading that can also be productive if

used for regular images. The anamorphic gaze, like the allegorical mode of reading, is still marginal with regard to direct, plain, and unobtrusive modes of looking. The truth that perspective as a geometrically based system claims to show must be different from the meaning that an allegory conceals.

Allegorical painting finds its opposite in realist painting, just as an allegorical mode of reading is the opposite of a literal one. They can, however, coincide and complement each other as well. The obvious rhetorical structure of allegory remains more implied but just as powerful in realistic painting. If anamorphosis is allegorical, and therefore fundamentally rhetorical, it follows that orthodox perspective can be understood as likewise allegorical in terms of its visualization of natural perspective as mise-en-scène. I would suggest that perspective can be understood as an allegorical form rather than a symbolic one, starting from the condition that perspective is as anamorphic as anamorphosis is perspectival. Panofsky's proposal to consider perspective as a symbolic form has had far-reaching consequences, not for the understanding of perspective as such, but for the way in which art history has approached problems of signification. Greatly influenced by Panofsky's ideas, a symbolic reading of painting prevails over an allegorical one. Now I have found a point of view from the side of a painting and an anamorphic gaze that offers me the possibility of looking at a painting differently. Therefore, I would like to investigate the consequences of these different conditions of analysis for the meaning proffered by painting as well as for art historical methods of interpretation, while following Michel Foucault's suggestion: "Instead of analyzing the ostensible elements of form that refer to meaning, instead of treating form as being significant in its frontal function, we look at its hidden face, the point where it faces dissolution, from which it comes and in which it will be lost again."[54]

I will look at perspective's hidden face in still-life painting, which in itself conceals so little, in order to discover how it can give meaning rather than mean something. What will be the result of a fundamentally anamorphic mode of analysis for understanding the rhetoric of perspective? Is that which it hides and shows indeed a truth (or a variation of truth), and how does it differ from meaning? I will attempt to answer these questions in the next chapter, "Perspective as Allegorical Form."

The object of philosophical criticism is to show that the function of artistic form is as follows: to make historical content, such as provides the basis of every important work of art, into a philosophical truth.
—Walter Benjamin, *The Origin of German Tragic Drama*

PERSPECTIVE AS ALLEGORICAL FORM
Vanitas PAINTING AND BENJAMIN'S ALLEGORY OF TRUTH

Introduction: A Decapitated Portrait

To grasp the precise character of allegory, we might return first to the cylindrical anamorphosis of Charles I that I briefly mentioned in the previous chapter (plate 17, c. 1660). This portrait, made by an anonymous artist after the king was decapitated, demonstrates ways in which the allegorical structure manifests itself in form as well as in content. In the center, on the spot where the cylindrical mirror must be placed, the plate displays a small skull surrounded by a fan-shaped jumble of lines and colors. Once the skull is covered by the cylindrical mirror, Charles's face emerges. The macabre contrast between the portrait (of Charles when he was alive) and the skull (the hidden face of death), between Charles's head and his beheading, is emphasized by the anamorphic perspective. We are unable to see the skull and the portrait simultaneously because the distortion has internalized the split between the image and its appearance, a split as definite as the final blow that divided the king's head from his body. The shift in perspective articulates the irreversibility of the death of the king.

In Holbein's *Ambassadors* (plate 13), we see a similar shift in perspective that connects the faces of the portrayed with the face of death. The anamorphic skull in the foreground has a counterpart in a skull in relief located on the small brooch that Jean de Dinteville, standing on the left, wears on his beret. The two skulls in Holbein's picture are divided by a visual abyss that is generated by two perspectives. The viewer is able to see one of the skulls on condition that the other fades away. As such, death's uncanny inaccessibility is doubly presented in Holbein's painting. Death cannot be grasped within the limits of our regular field of vision—the only perceiving mode that we have at our disposal.[1] Both Holbein and the anonymous artist of Charles's

portrait employ an anamorphic technique to stress that the shortcoming of our perception is a structural one. It is the very limitation of our own vision, spatial as well as temporal, that is allegorized in the anamorphic distortion. We cannot see beyond the point of death, just as we cannot see beyond the limits of our visual field.

We may assume that this "hidden" portrait has been created as part of a mourning process for the king's tragic death on the scaffold. His visage probably would have appeared many times before the melancholic gaze of his still-devoted subjects. The repetitive act of placing the mirror on the skull—as if one wished to screen it—may have been guided by nostalgia for the past. A substitute for the genuine image of the skull, Charles's portrait remains a mere reflection that fades away when its ground, the mirror, is removed. The anamorphic construction marks the contours of the abyss of time that renders past and present incompatible. The anamorphosis of Charles I can be considered an allegory of the nostalgia of an era that ended abruptly with the death of its king. By means of its structure of distortion and reflection, the anamorphosis more generally thematizes the incapacity of a representation to be a substitute for that which is forever lost.

In his essay "The Allegorical Impulse," Craig Owens, who closely follows Walter Benjamin, describes allegory as being able "to rescue from historical oblivion that which threatens to disappear."[2] In this anamorphosis, it is the remembrance of the king's likeness that, reflected in the cylindrical mirror, is rescued from oblivion, and continues to be rescued every time one repeats the act of putting the cylinder on the skull. As an act of mourning, this gesture is in fact a variation of the *fort-da* game described by Freud. The gap between present and past thus remains forever foreclosed, just as the shift in perspective prevents the portrait and the skull from coinciding.

Through its distorted form, which enhances its content, the anamorphosis of Charles I points to what is most proper to allegory: its capacity to give meaning by failing to overcome the distance between signifier and signified, a fissure that is overshadowed by the notion of that which is no longer there. Just as the king's portrait is masked by its anamorphic distortion and is unable to fully coincide with itself because its visibility is never permanent, allegory is never saturated with meaning. And just like the portrait, allegory remains imperfect and incomplete as it continues to speak of something other than it represents. The term "allegory" is a contraction of *allos*, which means "other," and *agoria*, "to speak." The allegorical sign stands at a distance from its meaning, which is marked by a constant deferral. This deferral is not a progressive but a regressive process: the allegorical sign refers to another sign that precedes it, but with which it will never be able to coincide.[3] The

distance of sign to meaning is a deferral in time. The allegorical sign reaches back to a previous stage and in this constant attempt at return incorporates a structural distance from its own origin, a constitutive temporal relation that it never manages to overcome. In the anamorphosis of the king's face, the "other" of which the image speaks is the ultimate otherness of death expressed in the head versus a death's-head. While a head eventually transforms into the skull that it already carries within, a skull can never return to its previous stage when it was still camouflaged by the flesh of a face. The abyss between the sign and its origin can be compared to the discontinuous connection between face and skull. For Benjamin, the "face" of a death's-head is emblematic of history as the story of natural decay; it is a fossil or ruin of what history has become:

> In allegory the observer is confronted with the *facies hippocratica* of history as a petrified, primordial landscape. Everything about history that, from the very beginning, had been untimely, sorrowful, unsuccessful, is expressed in a face—or rather in a death's head.[4]

A residue that itself will turn to dust, the skull is a highly meaningful fragment by which history can be portrayed. As such, it has been used by poets as well as painters as a constructive element for orchestrating allegories that always deal with the passing of time in contrast to the plentitude of time in eternity. Similar to the anamorphic skull that contrasts with Holbein's portraits in *The Ambassadors*, the anamorphosis of Charles I is—besides an instrumental mourning process—an allegory of the fragility of life, indeed a *vanitas* image. In making the skull the emblem of decay, *vanitas* images thematize precisely those characteristics that allegory uses as its structuring principles. Allegory has been defined by Paul de Man, Benjamin, and Owens, among others, as that which emerges under the melancholy gaze, expresses itself in ruins, establishes a distance to its own origin that it never reaches, and desires to fix the ephemeral in an image. Within this conception, *vanitas* images can be understood as allegories of allegories. Correspondingly, in order to fully understand the allegorical function, we have to turn to *vanitas* imagery.

Jacques de Gheyn's Allegory of Allegories

> *Curiosity is only vanity.*
> —Pascal, Pensées

Vanitas images intend to combine the complexities of the ontological difference between being and nothingness with the impenetrable passing of time

and the inevitability of death. In Christianity, death means both the instance at which biographical time stops and a transitory stage on the way to the continuum of eternity where time does not exist. A reminder of the brevity of life, the *vanitas* message warns against the human weakness of indulging in earthly pleasures, all the while reminding the viewer of the consoling possibility of living on, either through Christian salvation in eternity, or through fame on earth. *Vanitas* imagery confronts the viewer with the paradox that if "all is vanity," as the Preacher says in Ecclesiastes, vanity marks the world with indifference; it is precisely indifferent to the human perspective that differentiates between being and nothingness.[5] In the Preacher's view, present being means nothing, hence the history of life is not a progressive development of man (or of the world) toward being, but toward nothingness. The beauty of nature as God's creation, however, can be enjoyed and contemplated, nonetheless, and the lust for life that man is able to experience seems incompatible with the nothingness to which life will deteriorate. This *vanitas* paradox has been extended, in fact, by painting, which proves that the nothingness of being can be contradicted by the act of creating as such. An artwork is able to survive its maker and guarantee his or her fame, as a famous *vanitas* maxim expresses: *Vita brevis ars longa*, "Life is short but art endures." A painting can challenge the process of decay by copying and thus maintaining nature's beauty; for instance, by eternally freezing a blossoming flower in time. Furthermore, in order to visualize the complexities of time and its ontology, the only device the painter has at his or her disposal is the allegorical form, which because of its signifying structure of temporal deferral itself partly contradicts the message that *vanitas* images communicate. Insofar as it is visualized in painting, the *vanitas* paradox is a double one.[6]

The earliest *vanitas* images display skulls depicted frontally and extinguished candles set in niches. They can be found on the versos of fifteenth- and sixteenth-century portraits, where the face of death is literally hidden behind the face of the sitter. These *vanitas* images are the first instances of still-life painting, and it is therefore not a coincidence that the picture that is now known as the earliest example of independent Dutch still-life painting is *Vanitas Still Life* by Jacques de Gheyn (plate 22, 1603). De Gheyn's painting marks the point of origin of a new genre and does not renounce its historical background. De Gheyn maintained the *vanitas* topos of the niche as the setting for the skull, which he still represented frontally. Seventeenth-century *vanitas* painters who came after him abandoned the frontal composition of the skull and generally placed it on its side. As we will see, the frontal depiction has a particular function in the elaborated *vanitas* program that De Gheyn designed.

Resting on some broken straw and ears of corn, the skull is flanked by two identical vases, one containing a tulip, an expensive flower that only blooms for a short time, while smoke spirals from the other vase, conveying that life goes up in smoke. In the upper left and right corners, the sculptured figures of the ancient philosophers Heracleitus and Democritus express two contradictory views of the world. Democritus, the skeptic, laughs at the absurdity of life, whereas Heracleitus, his head resting on his hand in a moment of melancholy, weeps over the human condition. Both figures actively point to the large bubble that floats over the death's-head as the cause of their emotions. Through these gestures, De Gheyn extends the meaning of the transparent sphere, which traditionally referred to *Homo bulla*, "Man is a soap bubble," by merging this original motif with the image of a terrestrial globe.[7] Both the fragility of man's short life and the transience of the world as such are here represented through the bubble motif. This extremely insubstantial *mappa mundo* contains within it reflections of objects symbolizing infirmity and human weakness. Subjected to the ravages of time, these reflections have been slowly fading away and today are barely visible. The painting's own decay, revealed in the transformation of already vague and translucent reflections into nearly invisible ones, unwittingly adds an extra dimension to De Gheyn's *vanitas* painting. The reflections display drinking glasses, dice, and playing cards that represent earthly pleasures. A heart with a dagger driven through it symbolizes the burning desire of earthly love. War insignia and a crown and scepter in the center stand for the hollow trophies of worldly power, and coins falling from a money bag point to wastefulness. A wheel of torture, medical flasks, and a rattle used by lepers to warn others of their arrival indicate the fragility of the body. On the edge of the niche, below the skull, a row of coins has been laid out, riches that man cannot take with him to the grave. On both ends of the row, we see the obverse and the reverse side of the same gold ten-ducat coin with the imprint of Joanna and Charles V.[8]

Unlike most of the genre of Dutch seventeenth-century still-life painting that this painting initiated, De Gheyn's prototype has a strictly symmetrical composition. A central axis divides the image into halves, a division to which the skull, the bubble, and even De Gheyn's signature immediately below the skull's chin have been subjected.[9] This prototypical symmetrical composition is highly revealing for understanding the logic and structure of allegory. In fact, the construction provides us with a blueprint, even a definition, of the allegorical form.

Although a symmetrical composition often functions as a unifying device, in De Gheyn's painting it is also used as a structural principle of

disjunction. Always involving a doubling of some sort, the principle of disjunction governs on the basis of a range of mirroring or chiasmic elements. The central axis in the painting separates a left, "positive," side from a right, "negative," one. On the "positive" side, we find the laughing Democritus, who is accompanied by the tulip that—despite its quick decay—is an example of pure natural beauty. In the sphere, most of the symbols signifying earthly pleasures—such as the dice, the drinking glasses, and the burning heart—are also placed on the left side. The opposite of each of these elements determines the right side: we see a weeping Heracleitus, who points to the rattle and the wheel of torture, which stand for illness and pain, the negatives of pleasure, in the right half of the sphere. The vase from which smoke curls indicates that even pure natural beauty will eventually turn to ashes. Pleasure and beauty, on the one hand, and pain and decay, on the other, thus coordinate two poles. These poles, however, are not simply opposite extremes but rather stages in the same gradually developing process of life and its decline. By opposing the signs of pleasure to those of pain, De Gheyn enforces the meaning of both concepts, while deliberately refusing to let them become resolved in a perfect balance.

The little wild rose that forms a small bouquet with the tulip in the vase reveals that De Gheyn composed a more complex mirroring system than the "positive-pleasure" and "negative-pain" sides suggest at first sight. Having lost a tiny petal, the wild rose has already started its decay, a decline that does not enter the realm of pleasure from outside but is here presented as a weakening force from within. Beauty carries its own rotting process within it, as a living human being carries its skull. De Gheyn turns to litotes in order to highlight the fundamentally paradoxical essence of *vanitas*. Reducing the rigid contradictions by stating their negatives, De Gheyn undermines the very idea of opposition by showing, in fact, mutually exclusive moments within the same individual process leading from being to nothingness. Exhibiting the beauty of a blossoming flower simultaneously with the first traces of the decay to which it is subjected, De Gheyn explores the dynamics of reversal in order to demonstrate that the exact moment of transformation when blossoming turns into decay is impossible to determine. The two phases of a flower's life that reflect two moments in the same gradually developing process are connected with the philosophers who present two mutually exclusive perspectives on the same human condition. The ears of corn, symbols of resurrection, De Gheyn places on the "negative" side. Death and resurrection, and blossoming and decay, are here positioned not so much as opposites but as two sides of the same coin, a figure of speech that is literally represented in the inclusion of the obverse and reverse sides

of the same ten-ducat coin. In order to emphasize that the link between the coin's obverse and reverse sides exceeds the painting's obvious symbolism and forms a clue to the sophisticated mirroring construction, the horizontal row of coins, interrupting the vertical composition, connects the two sides of the ten-ducat coin as well as the two sides of the painting.[10]

The rigid separation of the composition, along with the subtle play with reversals within temporal processes, reveals a clear image of the structure of allegory. Allegory's structural principle is disjunction, since the allegorical sign never contains its own meaning, but refers to other signs in a discontinuous temporal relation. De Gheyn's crafty composition visualizes the structure of allegory. On the one hand, disjunction rules while, on the other, the opposed elements speak against their contradictions, undermining their referent in such a way that the meaning of each of them transforms into something else. Benjamin points out that the allegorist is a kind of alchemist who possesses the power to transform meanings by combining fragments of images into a whole. The allegorical image is neither coherent nor complete, because the relation of the combined fragments to their meanings remain arbitrary; yet arbitrariness, Benjamin states, is an instance of "the most drastic manifestation of the power of knowledge" (184).[11] And he continues:

> In [the allegorist's] hands, the object becomes something different; through it he speaks of something different and for him it becomes a key to the realm of hidden knowledge; and he reverses it as the emblem of this. (184)

De Gheyn can be said to be such an alchemist of meanings. He has heaped up motifs and fragments in a seemingly orderly composition that suggests a control over the intended meaning that the image cannot possibly realize. Through the weakening and strengthening of contradictions, De Gheyn's painting continually speaks of something else, which serves, as Benjamin says, as a "key to the realm of hidden knowledge," that is revealed in the double paradox of *vanitas* without ever being disclosed. De Gheyn does not merely reverse this "key" as an emblem, but he turns the process of reversal itself into an emblem, as the representation of both sides of the ten-ducat coin visualizes.

Furthermore, De Gheyn's *Vanitas* literally presents the reverse side of painting as such, since it is the first among (*vanitas*) still lifes to detach itself from its previous location on the back of portraits.[12] Wittingly or unwittingly, De Gheyn allows his very painting to partake in the allegorical structure by turning the *vanitas* topic that hitherto has been reserved for versos into a subject worth being presented independently, on the front of a painting.

The repetitive process of reversal of meaning results in inconclusiveness. Treasuring its paradox by foregrounding friction rather than denouement, the painting itself does not take sides. The paradox has the last word. The final inconclusiveness of De Gheyn's picture, however, does not prevent the essential theme from filtering through the hollowness of the niche, through the transparency of the sphere, through the hole in the set of teeth, and, most emphatically, through the empty sockets of the death's-head. *Vanitas* literally means "emptiness," and in spite of the fact that this painting is filled with symbols, contradictory or not, the void of its setting and the monochrome colors that only brighten up in the flowers underscore the painting's central focus in the empty stare of the skull. De Gheyn's painting holds up a mirror to the viewer's face, who, viewing the skull at eye level, recognizes in the empty, unseeing eyes a reflection of what will become of him or her when s/he is no longer there to look. Forgetting its origin, even as the allegorical signs continue to reach for it, the allegory lives on by looking backward, exemplified by the skull's empty sockets that without looking nonetheless cross the viewer's gaze. De Gheyn's allegorical image expresses the incomprehensible concept of pure emptiness as much as it paints visibility; it lets the disappearing appear, notably by means of the vague reflections in the transparent sphere, which will eventually fade away.[13] It seems as if this painting intends to prove that the maxim *Vita brevis ars longa* is a function of allegory by also letting the disappearing *reappear*. For ages, this *vanitas* painting was attributed to an obscure master named J. Heyn. In the 1960s, after the painting had been cleaned, the rediscovery of a D and a G transformed the painting into a masterwork by De Gheyn. The painting thus survived itself, by once again becoming a De Gheyn. In his description of the life of Jacques de Gheyn in his *Schilder-boeck*, Karel van Mander mentions a picture with a *dootskop*, a "death's-head," that is probably identical with this *vanitas* still life.[14] The completion of the signature, itself an inscription, thus initiated a rewriting of a history already written: Van Mander's description of De Gheyn's painting suddenly gained visibility now that it coincided with the image to which it referred. De Gheyn's name and fame were rehabilitated by means of a painting that so precisely articulates the impossibility of anticipating its own history, that is, the history of its own decay.

At the crux of the *vanitas* paradox stands allegory in its capacity to rescue from oblivion that which threatens to disappear, and for which fame proves the success of such a rescue operation. Being an allegory as much as visualizing allegory's very structure, De Gheyn's painting has proven itself to be an outstanding example of such an operation.

With the intention of dismissing allegory, Schopenhauer gives an example that exactly pinpoints the issue of fame as it continues to involve *vanitas* images and allegories. According to Schopenhauer, one can become equally excited when seeing an allegory by Annibale Carracci, entitled *Genius of Fame* or viewing the word "fame" written in large letters on a wall.[15] Benjamin, who quotes Schopenhauer at length (162), disagrees with him in this respect, but uses his example to indicate that the philosopher's motivation for disregarding allegory manifests its essential quality as a form of writing. The claim that allegory is essentially a written form is one of the core arguments of *The Origin of German Tragic Drama*.

A conventional system of signs, the allegorical image always partly rewrites an earlier text, becoming a palimpsest without origin that allows the elements that it confiscates to shine through, as De Gheyn demonstrates, for example, with his refiguration of the bubble.[16] As has been argued by many thinkers (Diderot, Hegel, and Johann Joachim Winckelmann, among others), allegory is static, repetitive, arbitrary, conventional, and unmotivated, and shares all these qualities with script. For these reasons, allegorical language has been compared to the similarly indecipherable hieroglyph that was assumed to be one step removed from the word and one step closer to the image. Hegel, for instance, defines personifications as empty forms of subjectivity, whereby the term "subject" should be understood, he insists, purely in grammatical terms.[17] Benjamin asserts that allegory is a form of script, in painting as well as in literature, because like writing and speech, it is a form of expression.

> The allegory of the seventeenth century is not convention of expression, but expression of convention. . . . [A]t one stroke, the profound vision of allegory transforms things and works into stirring writing. (175–76)

As a blueprint of the allegorical structure, De Gheyn's painting underscores this connection between allegory and writing by means of the obvious inscription in the arch of the niche, *Humana Vana*, "Man (man's life) is empty." This phrase supposedly serves as an explanation of the painting's general theme; it partly goes above this task, however, to the extent that De Gheyn's collection of symbols alone already makes the subject matter abundantly clear. The *vanitas* vocabulary consists of a handful of obvious symbols familiar to everyone who attended church on a regular basis in the seventeenth century. The withering flower, the watch, the hourglass, the books and musical instruments, the smothering wick, and the soap bubble always appear in various combinations, facilitating the identification of these pictures as

vanitas images. In addition, the prominent skull hardly ever is absent from such scenes. Although De Gheyn's painting was the first independent *vanitas* image, the symbols it presents had circulated for centuries. And yet most of the *vanitas* images contain inscriptions such as *Memento Mori, Homo Bulla,* or *Vita Brevis Ars Longa,* jotted on shreds of paper that are attached in trompe l'oeil fashion to tablecloths, carved out in stone, or printed in volumes conveniently opened to the proper page. In general, inscriptions appear significantly more often in *vanitas* images than in any other Dutch seventeenth-century genre. Precisely because they are superfluous, the presence of the mottoes reveals the fundamental allegorical form of *vanitas* images.

If all is vanity, then nothing can possibly escape vanity, not even De Gheyn's own creation. De Gheyn failed to succeed in fulfilling the message of his painting precisely because his creation did accomplish allegory's aims. For something *did* escape from the collective nothingness and was rescued from oblivion (at least until the present time): the painting itself, of course.

The Vanity of Painting

In the course of the seventeenth century, *vanitas* artists addressed, developed, and complicated the *vanitas* paradox from within its allegorical structure, that is, as representation. I would like to discuss two variations on *vanitas* imagery by Claesz. and Gijsbrechts, respectively, that address the double paradox and specifically foreground a rescue operation that the *vanitas* doctrine forbids but allegory permits.

Claesz. initially began his career as a *vanitas* painter before he decided to devote his attention predominately to breakfast painting. Immediately prior to creating his first breakfast, Claesz. designed a *vanitas* image (plate 23, c. 1628) in which we see a variation on De Gheyn's reflecting bubble. At a corner of a table, some of the most obvious *vanitas* symbols are brought together in styled chaos. A violin rests on a small pile of books and papers. A watch with a blue ribbon, a feather quill and its holder, a cracked nut, and a *roemer* on its side are lined up in the foreground. As counterpart to the skull, painted in profile and partly covered by the violin on the right, a spherical mirror is placed on the left that reflects a painter sitting in front of his easel, caught in the act of creating the picture that we see. Still-life artists often employed reflective devices in order to include self-portraits.[18] Most of those reflective portraits are either too small or too vague to discern facial characteristics, with the result that it remains difficult to decide whether or not the image in a reflection is a genuine self-portrait. The figure in Claesz.'s painting does not reveal facial characteristics and wears a large brown hat, has a white collar, and holds a palette in his hand. Although it is quite seductive to assume

it is a self-portrait of Claesz., within the allegorical *vanitas* setting, however, the figure in the orb may also function as a personification of the artist as creator.

Including a creator in the act of creating the painting we see within the pictorial scene itself, as a permanent reflection in an orb that refers to *Homo bulla* as well as to the *mappa mundo*, Claesz. expresses the self-contradiction inherent in all *vanitas* painting. "Creation is subjected to vanity," Paul says (Rom. 8:20), and yet a painter may live on through his creation. Claesz.'s picture as such is most vain, not because of its subject matter but by means of what it, regardless of its "message," aspires to achieve *as creation*. *Vanitas* images never manage to coincide with the message they actually attempt to communicate insofar as the creation survives the creator. They have deployed the distance between signifier and signified by forcing their own creation within it, under the auspices of the motto *Vita brevis ars longa*. The gap between being and nothingness, the nothing of all being, is suspended, and rather than attempting to resolve this fatal contradiction, *vanitas* images transform this difference into pure indifference. *Vanitas* images are therefore allegories on the process of allegory. Although it is impossible to step out of the self-contradictory complexities of these pictures, I believe that Claesz., supported by the format of allegory, has attempted to rescue his painting as creation from the irrevocable destiny that time maps out for it. Furthermore, the figure of the painter in the mirroring sphere also points to the reversibility of seeing and being seen, called the chiasm by Merleau-Ponty and constituting an element of Being. Claesz. has added to the objects that he himself saw, as he painted, what those things saw of him. The reflection functions as a camera that sees—without eyes—how Claesz. observes the objects he creates.[19]

Shortly after he completed this painting, Claesz. took the daring step of expressing the essential idea of *vanitas*—emptiness—without the assistance of symbolic attributes. Erasing obvious motifs such as the skull and the orb, expensive objects such as musical instruments, books, and feather quills, he substituted banal and meaningless plates, glasses, and food for them, arranged on a tabletop in a typical *vanitas* composition. The elements he decided to place on the table do not in the least reflect the *vanitas* idea. More strongly formulated, the greater part of the objects do not carry any (iconographic) meaning at all.[20] In terms of signification, they are as empty as the background surrounding them. The void reigns in Claesz.'s breakfast paintings, which is visible at the level of representation by virtue of the paintings' empty backgrounds, and invisible at the level of signification. The objects are neither beautiful nor expensive, a lack of visual attractiveness, however,

that makes them even more vain in Pascal's view. Under the caption "Vanity" in his *Pensées*, he writes: "How vain painting is, exciting admiration by its resemblance to things of which we do not admire the originals!" [21] This famous utterance is more applicable to the banality of Claesz.'s objects than to, for instance, the costly objet d'arts in the banquet pieces of De Heem or Kalf. Contrary to Pascal, Goethe once exclaimed, after having seen one of Kalf's *pronk* still lifes, that in case he had to choose between the painting or the valuable objects it represented, he would definitely take the painting. [22] Apparently, he was not interested in the original but in its representation, a duplicate that had become more important than the model after which it had been created. The painting itself became for Goethe, a typical Romantic, the object of value, and his expression marks the slow shift from (allegorical) painting as a mode of rescuing that which threatens to disappear from oblivion to painting itself as the object that needs to be rescued.

Gijsbrechts's Self-Aware Image

Victor Stoichita declares at the end of *The Self-Aware Image* that Gijsbrechts's work, especially his *Reverse Side of a Painting* (plate 4), marks the end of the baroque era, during which art began to be considered as a problem. In an attempt to define its aesthetic boundaries, the art of painting deliberately began to show its own nothingness by raising issues of framing, cataloging, creating, and authorship as its actual subjects. With Gijsbrechts, Stoichita claims, "painting has become fully aware of itself, of its being, and of its nothingness." [23] Within the context of *vanitas* as an allegory on allegory, Stoichita's analysis reveals how Gijsbrechts elaborates the *vanitas* paradox as a conflict on the level of representation. In Gijsbrechts's *Trompe l'Oeil with Studio Wall and Vanitas Still Life* (plate 24, 1668), we see how the friction of being and nothingness takes shape in a *vanitas* image that is surrounded by the instruments of its own production in a trompe l'oeil. Gijsbrechts used the traditional *vanitas* topos of a skull placed in a niche and situated the entire image in a conspicuous setting. Still mounted on its stretcher, the freshly finished canvas has been placed on a shelf against a studio wall. On the shelf itself are a bundle of brushes and a paint box daubed with paint. A palette, still dripping, hangs from one of the shelf's supports, a bottle with liquid from the other. Two oval portraits, one of Emperor Leopold I and another empty one, are nailed to the board partition. A third, unknown portrait rests on the shelf next to a slip of paper tucked between the threads of the stretcher with Gijsbrechts's signature on it. [24]

Bypassing issues of either death or time, Gijsbrechts's *Studio Wall* confronts the most profound self-contradiction of *vanitas* painting *as represen-*

tation. He pushes the *vanitas* theme to its limit in an attempt to visualize its paradox, namely, that it cannot be visualized. Since the very act of creating speaks against an ontology of nothingness, Gijsbrechts takes a different path by shifting the focus from the paradox inherent in *vanitas* images to the ambiguity of vision itself. As flat as this painting may appear in terms of physical space, our eyes plunge into the depths of illusionist confusion. It is not the deception alone that produces the confusion, but the inconsistency of the illusionist levels that Gijsbrechts piles up ceaselessly. If we label *vanitas* images as allegories of allegory, then Gijsbrechts can be said to explore the boundaries of the allegorical form by creating a trompe l'oeil of a trompe l'oeil. *Studio Wall* is a genuine example of the allegorical intention as Benjamin understood it:

> As those who lose their footing turn somersaults in their fall, so would the allegorical intention fall from emblem to emblem down into the dizziness of its bottomless depths, were it not that, even in the most extreme of them, it had so to turn about that all its darkness, vainglory, and godlessness seems to be nothing but self-delusion. (232)

Not only does the frayed corner of the *vanitas* canvas effect a moment of disillusion with regard to the trompe l'oeil niche, but the "canvas" betrays its appearance by presenting itself not as a painting, but as its opposite, a painted painting so to speak. Framing the *vanitas* still life with the blank wooden trompe l'oeil planks, Gijsbrechts instigates a continual alternation between illusion and disillusion in a process that never ends in a moment of revelation. The relations between referent and reference on the level of realism, and signifier and signified on the level of meaning, remain blurred. Trompe l'oeil touches on trompe l'oeil in this dazzling picture-within-a-picture for which our eyes find no solution: what is painted, what is real, what is supposed to appear as painted, and what must look more real than reality? A climax in this canvas that veils illusion with illusion is reached in the marbled maulstick that runs across the lower right corner of the *vanitas* painting. Does it touch the "canvas" or does it lean against the marble shelf of the niche?[25] The marble shelf looks more real than the imitation marble of the maulstick, whose intention nevertheless is to appear more lifelike in contrast to the "canvas." Stoichita asserts that the abandoned maulstick in this image is involved in an antithetical dialogue with the frayed corner. As an instrument used to make a painting, the maulstick challenges the fraying, detached canvas, a sign of un-making. Stoichita thus concludes that Gijsbrechts's creation challenges the art of painting in this *representation of a painting*.[26] I think that, in addition to posing a challenge for the art of painting

in general, this painting first and foremost challenges the perception of its viewers. Gijsbrechts manages to intertwine figurative and literal pictorial language, allegory and realism, and entangles them to such an extent that they cannot be unraveled, at least not by the eye of the viewer. *Studio Wall*, a painting that knows itself to be a painting, is therefore also a challenge to (the limitations of) vision, a challenge for the viewer rather than a provocation directed at the art of painting as such.

In the previous chapter, I argued that if perspective adds any dimension to painting, it must be a rhetorical dimension. I think that Pascal's geometrical rhetoric finds its clearest example in perspective. According to Pascal, geometry possesses such a crystal-clear logical system, that the clarity of its logic alone makes an argument forceful and persuasive. Perspective, insofar as it is a geometrical system, does provide truthfulness by means of its very clarity, that is, by means of its transparency. If we agree with Pascal that one can use geometry as the foundation for rhetoric, then perspective proves it; or rather it "shows," and in showing, it convinces. So clearly striving for the effect of fooling the eye, trompe l'oeils evidently deploy perspective rhetorically. But Gijsbrechts demonstrates how perspective not only functions rhetorically (as it, in fact, always does), but that it can be included in a painting as a rhetorical device that *gives* meaning.

Whereas Claesz. removes all symbols that may be connected with *vanitas* in order to come closer to its essential idea, Gijsbrechts uses the allegory of allegories as a trope in his allegory of the truth of vision. He literally places the *vanitas* in *a different perspective*. He has literally *added* a perspective to a painting by framing the "canvas" with a trompe l'oeil border. The trompe l'oeil perspectival configuration, which as we have seen is a turning inside out of orthodox perspective, is here deployed as an allegorical form.

In an attempt to define the nature of the distinction between the function of grammar and of rhetoric in the process of reading, Paul de Man argues that any narrative is an allegory of its own reading.[27] Reading the narrative, the reader will always find him- or herself confronted with incompatible meanings. When the reader decides one reading to be true (that is, not false), another possible reading will impose itself that declares the first one null and void. De Man states that the process of reading is thus always an allegory of the impossibility of reading. Although rhetoric allows for two incompatible points of view, eliminating the question of whether a text is to be read literally or figuratively, what remains fundamentally incompatible are grammar and meaning. The strong relation between grammar and logic is considered relatively unproblematic, yet the rhetoric of a sentence that is

generated by grammar "suspends logic and opens up vertiginous possibilities of referential aberration."[28]

Gijsbrechts's ambiguous and ambitious play with referentiality in his *Studio Wall* produces an allegory of the impossibility of reading this image realistically. The picture allows for (at least) two points of view that at the level of referentiality are mutually exclusive, creating an ironical distance between the "canvas" and its trompe l'oeil border, between the "canvas" and its ground (the stretcher), and between the entire board partition and the actual canvas on which it is painted. *Studio Wall* does not merely stress the practical joke that the picture we see is not the picture we get, but in this case we have to ask the question of whether the pictures we see will ever coincide enough to form a single coherent picture that we can "get." The allegory that we regard turns into an allegory of our own looking, narrating the impossibility of ever getting this picture right.

Perspective is not merely a rigid system that represents space, but has been used by Gijsbrechts as a trope, or rather as a framing device. Situating the *vanitas* image within a supplementary framework in trompe l'oeil, he transforms the mise-en-scène of the *vanitas* "canvas" into a *mise-en-abîme*. The two perspectives are supplements that enhance each other's effect and undermine each other's referentiality. The additional perspective that designates the studio wall creates a distance with regard to the "canvas" that is suddenly forced to stress its status as a painting instead of appearing as a niche. The "canvas," which itself bears the features of a trompe l'oeil, is reduced to a mere painting insofar as the "studio wall" appears more real. Gijsbrechts lets his double perspective tear apart "canvas" and "studio wall" as separate images and thus generates a friction between the form and content of his painting. For this perspective not only captures the "canvas," but also liberates it to the extent that we, as viewers, see it as a canvas, even while it is no such thing. The "canvas" is doubly painted (in reality, and in the trompe l'oeil setting of the studio wall), presenting canvas upon canvas as an illusionary abyss without ground. For where has the "real" painting gone? Does it appear or disappear under the eyes of the confused viewer? By means of the allegorical form, Gijsbrechts here truly exhausts the idea of the vanity of painting. The *mise-en-abîme* of the wooden planks transforms the *vanitas* canvas into a "meta-*vanitas*," which as much narrates its own destruction as its incapacity to represent its paradox within the limitations enforced by pictorial mimesis. The "meta-*vanitas*" opens up the possibility of analyzing itself, and in this analysis, it does not merely speak *about* painting, but proceeds with it. The discourse of this "meta-*vanitas*" does not refer to reality; it *is* the

reality, one of doubling and reversal, where no original can be found: for the "canvas" that appears to be a real painting turns out, in its double form, to be the least original. Which part of this painting do we have to "read" as real, in the sense of referring to reality, and which part should be understood as allegorical? Is looking a fundamentally allegorical act? How can we distinguish between pictorial reality and allegorical meaning? Which is, in other words, the "correct" point of view from which we ought to view this painting? What distance should we keep between our eyes and the canvas so that we can distinguish the illusion from self-delusion?

In one of the fragmentary notes that he compiled under the title "Vanity" in his *Pensées*, Pascal connects the doctrine of *vanitas* with the discovery that two extremes, two infinities, are separated by a vast field of inconsistency and indetermination.

> If we are too young our judgment is impaired, just as it is if we are too old. Thinking too little about things or thinking too much both makes us obstinate and fanatical. If we look at our work immediately after completing it, we are still too involved; if too long afterwards, we cannot pick up the thread again. Thus paintings, seen from too far away or from too close; and there is only one indivisible point that is the truthful spot: the others are too close, too distant, too high, too low. Perspective designates [this point] in the art of painting. But who designates it in truth and ethics?[29]

In his mathematical writings, Pascal works on the notions of the infinitely big and the infinitely small, which he translates to everyday experiences. His question is how we are ever able to determine the proper position from which to make a judgment about, or interpret, what we see. From which point of view will we manage to distinguish between true and false without being blinded by looking from too near or being distracted by observing from too far away? In painting, however, Pascal asserts that contrary to all other situations of judgment, the point of view is fixed: it is the truthful spot, the indivisible point designated by perspective. He presents perspective, a mathematical system, as a model for understanding how deceit enters our field of vision and influences our judgment of what we see, or what we decide to regard. A distance between extremes in age (too old or too young) or in terms of attention (too involved or too distracted) is made literal in his example of pictorial perspective, which functions to demonstrate that there must be a right point of view, that is, a right point of judgment. Yet it is precisely in painting (despite the "truthful spot" that perspective designates) that the notion of truth is questioned, and where the seduction of mimesis provokes our thoughts concerning the reliability of our optical capacities.[30]

Gijsbrechts's painting challenges the solution that Pascal assigns to perspective. Whereas, for Pascal, perspective can be understood as an allegory of truthful vision that offers reliable conditions for a viewer to judge what s/he sees, Gijsbrechts proposes perspective as an allegorical form. The point of view that Pascal calls indivisible remains an indivisible spot for Gijsbrechts where two different perspectives collapse into each other. Within the notion of "point of view," the "point" remains indivisible, so to speak, but it is the "view" that has been split in his painting.

Damisch claims that Pascal was the first to explore the theoretical and philosophical implications of perspective as a paradigm. And these implications, especially with regard to truth, are tricky:

> The idea that truth, insofar as it can be historical, is itself somehow perspectival, entails a redoubled cleavage. A cleavage between, on the one hand, a knowledge that chops away at this point which is indivisible . . . and a vision . . . that is strictly determined, as the apex of a cone can be, and, on the other, a truth to which no knowledge corresponds.[31]

I would like to proceed from the proposition that truth is itself somehow perspectival, as Pascal implies, and that perspective is somehow allegorical, as Gijsbrechts demonstrates. Perspective is understood as a symbolic form by Panofsky, and despite his indebtedness to Cassirer's theory of symbolic forms, he remains close to the Albertian metaphor of the window on the world. Considering it as a *Weltanschauung*, perspective is for Panofsky a unifying and unified view onto the world, a method that produces an objectified image of a vision of the past that itself remains unquestioned in its frozen state. Since Panofsky himself claimed that "the Renaissance would interpret the meaning of perspective entirely differently from the baroque, and Italy entirely differently from the North,"[32] I assume that I will not violate his ideas if, from this moment in time, I propose to understand perspective as an allegorical form. Although, in what follows, I will address the symbol-allegory dichotomy, I by no means intend to supplant Panofsky's symbolic notion of perspective with an allegorical notion. Rather, I will detail the ways in which his understanding of perspective as symbolic form has influenced current art historical modes of looking that cause a symbolic reading of early modern art to prevail over an allegorical one. I am less interested in perspective as a unifying pictorial system of representation and more in how perspective functions as an instrument of fissure that in painting generated a differentiation rather than a unification between meaning and appearance. To consider perspective as an allegorical form allows for the possibility of investigating it in a way that differs from understanding it

as a system that merely produces realistic painting. Moreover, it gives me the opportunity to relinquish modes of looking that perspective, understood as a coherent and unifying system, has shaped. As we have already seen, allegory permits chaos, arbitrariness, paradox, and fissure, elements not easily accepted within either a simple notion of perspective, a realistic reading, or a historical interpretation.

Walter Benjamin's Theory of Allegory versus Symbol

The distinction between the concepts of allegory and symbol became a central problem in Romantic aesthetics. In his "Versuch einer Allegorie, besonders für die Kunst" (1766), Winckelmann labels every image that contains meaning an allegory, a term he considers synonymous with iconology.[33] In the second half of the eighteenth century, a reversal took place whereby the notion of symbol moved toward the position that Winckelmann assigned to allegory and slowly began to denote all figurative language, including that of allegory. In the 1790s Goethe and Schelling distinguished between the concepts, a major issue in their discussions of art, and treated them as antithetical. They considered allegory as a discursive sign that refers to something else and essentially deals with content. By contrast, they argued, the symbol deals with form and really is that which it represents. They conceived the symbol as a representation of an idea, through which the particular expresses the universal, while they understood allegory as the representation of a concept that deploys universal signs to voice the particular. Conceptualized as a unity of representation and meaning, the symbol, originally a sacred sign that connected the earthly with the divine, now gained supremacy over allegory. Consequently, the latter was dismissed by the Romantics as a rational sign, a mere reflection that referred to a meaning that it itself did not contain. The influence of the Romantics was so successful that for almost two centuries allegory was devalued and sidetracked, only to be rediscovered by postmodern art and criticism in the last decades of the twentieth century. One of the few exceptions that disputes the Romantic privileging of the symbol prior to postmodernism's rediscovery of allegory is Benjamin's *The Origin of German Tragic Drama.*

Benjamin returns to the symbol-allegory dichotomy of the Romantics in an attempt to revalue the notion of allegory as the basic form of baroque expression. This approach to revaluating allegory's theoretical significance, a philosophical and not an aesthetic one, in turn will form the basis for my own explorations of perspective as an allegorical form. In order to understand the range and consequences of Benjamin's rethinking of the symbol-allegory dichotomy, we have to consider his ideas in the larger context of

his philosophical project, particularly as it is enunciated in the "Epistemo-Critical Prologue."[34]

The Origin of German Tragic Drama is a discourse on critical method. Benjamin's starting point is the question of the task of philosophy. He states in his prologue that philosophy should not be used as a method for acquiring knowledge, but must instead strive for the representation of truth (28). The object of knowledge is not identical with truth. Knowledge is something that can be possessed and presented, whereas truth does not consist of a content to be possessed but finds its primary characteristic in its being absent. Given the impossibility of making truth present in a philosophical inquiry, it can only be grasped in the representation of ideas. The genuine task of the philosophical treatise is therefore to *represent*:

> [The philosophical treatise's] method is essentially representation. Method is digression. Representation as digression. . . . The absence of an uninterrupted purposeful structure is its primary characteristic. Tirelessly the process of thinking makes new beginnings, returning in a roundabout way to its original object. (28)

Truth, for Benjamin, has an integral unity and resides in the realm of ideas (in a Platonic sense), which are pre-existent. The self-representation of truth in a philosophical inquiry therefore evolves through the representation of ideas. Whereas for knowledge representation always remains secondary, "for truth [its method] is self-representation, and is therefore immanent in it *as form*" (30, italics mine). Truth does not *contain* a content, but its content *is* the form. Hence, its representation is not an end product but, as a digression, as an *Umweg* (which also means "detour"), it takes shape in the process of following a method, which is synonymous with the process of writing a philosophical treatise. Although lacking an "uninterrupted purposeful structure," the method of the philosophical treatise is, according to Benjamin, itself an allegorical form in its constant effort to return to its starting point. What the method thus represents, through the digression, is an allegory of truth. The mode of being in the world of appearances differs from the being of truth, which is without intention and beyond phenomenality. While decades later, Hans-Georg Gadamer, in *Truth and Method*, claims that truth is precisely that which eludes method, Benjamin asserts by contrast that truth must be considered the form of the method. "Philosophy participates in truth insofar as its form, not its content, represents the configuration which constitutes the realm of ideas" (114). The concept of truth shares allegory's inaccessibility, its inconclusiveness, its absence, and hence the fact that it can only visualize itself through representation.

The importance thus assigned to allegory explains Benjamin's critique of the notion of the symbol that supplanted allegory in Romanticism. For more than a hundred years (Benjamin wrote in 1925), the symbol governed the realm of aesthetics and subsequently dominated modern art criticism. Part of my argument in this chapter is that Benjamin's criticism, now almost eighty years old, still holds for the interpretation of early modern art. In contemporary art and criticism, theorists have labeled the last quarter of the twentieth century an allegorical age—Craig Owens speaks of "the allegorical impulse"—and the notion of allegory as opposed to symbol has been paid much attention in art historical writing. Notwithstanding this expanded general interest in allegory, it has not been noticeably recuperated in mainstream readings of early modern art. This is the case despite allegory's implicit significance and direct relation to such art as a result of its "origin" (in the broadest sense of the word) residing in the very same era. Moreover, such neglect is all the more remarkable because, for Benjamin, allegory does not merely reside in an image (either visual or textual) but defines a point from which to view objects. It is precisely this view of things that counts. Benjamin states that the allegorical emblem (the outstanding example of which is the ruin, the fragment, or, as we have seen, the skull) evokes an allegorical way of seeing. Insofar as allegory is essentially a form of writing, the allegorical attitude is confirmed as also entailing a truly allegorical mode of reading; a reading of the image, and of the history that stands between the image and the viewer.[35]

In his chapter "Allegory and *Trauerspiel*," Benjamin polemicizes against a philosophical discourse of art that, under the influence of the Romantics, blindly accepts the predominance of the symbol as an expression of an idea; a construct that unifies form and content, and beauty and the divine, into an unbroken whole.[36] This indivisible unity contrasts sharply with allegory, particularly in its function as an illustrative technique, an abstract expression of a concept. Refusing to repeat the Romantic opposition of the two tropes, which he considers the source of allegory's negative appreciation, Benjamin argues that the concept of the symbol is fundamentally misconstrued. The result of this misconception is that allegory's qualities have been misunderstood, and even mistrusted, as a form of ambiguity (176–77). In fact, the way in which both concepts are defined fails to do justice to their interrelation. The symbol was originally a religious construct that was meant to connect worldly things with the divine. Classicism transformed this sacred construct into a profane symbol and provided it with a speculative allegorical (ambiguous, fragmentary) background against which the bright world of the symbol, as a clear unity, stood out (160–61).

Benjamin attempts to reassess the position and significance of allegory because he sees in the artificial and emblematic German *Trauerspiel* a history of the sufferings of the world. In the *Trauerspiel,* history itself becomes the setting of the play and demonstrates the process of decay to which history, and man, is subjected (177). "In the process of decay, and in it alone, the events of history shrivel up and become absorbed in the setting" (179). A play of representation upon representation, the *Trauerspiel* makes a spectacle out of the display of ruins and fragments from the history of mourning and melancholia. In addition to the significance of the *Trauerspiel* as the baroque allegorical form par excellence, the negative appreciation of this type of theater simultaneously marks the origin of modern art criticism. Under the influence, first, of the prejudices of classicism and, second, of the dismissal of allegory during Romanticism, the baroque *Trauerspiel* came precisely to represent the virtually forgotten mourning for the past that Romanticism so strove to neglect. Outdated because of its allegorical form and disavowed by German literary criticism, the *Trauerspiel* contains for Benjamin the shock that reveals that it "is incapable of emanating any meaning or significance of its own," an idea he later expands in this theory of the aura.

For Benjamin, time is the decisive category for distinguishing between symbol and allegory. As we have seen, time is expressed in allegory as petrified nature, while history appears only in fragments and ruins. From the point of view of allegory, one can only contemplate nature in retrospect. In the symbol, however, the transcendental makes itself present in what Benjamin calls "the mystical *Nu*," an instant in which the empirical and the universal coincide in a moment of revelation.

Proceeding partly from Benjamin's insights, de Man approaches the distinction between allegory and symbol in terms of referentiality. Whereas Benjamin places allegory in the realm of the visual and the theatrical— stressing his notion of an allegorical way of looking, and mentioning baroque emblem books among his examples—de Man analyzes the functioning of the two tropes within the context of (de Saussurian) structuralism. In the symbol, de Man claims, representation and substance do not differ in their being but only in their extension and are thus able to coincide. For the allegorical sign, the reference to its meaning has become of secondary importance. The relation between sign and meaning is discontinuous. The distance between the signifier and signified opens up and provides the allegorical sign not with meaning, but with another sign that precedes it. Differentiated from its literal meaning, the allegorical sign creates a distance that functions as the thematization of this difference. In accordance with Benjamin's definition of allegory: "any person, any object, and relationship can

mean absolutely anything else," and with his claim that time is the decisive category for distinguishing symbol from allegory (175), de Man concludes that

> whereas the symbol postulates the possibility of an identity or identification, allegory designates primarily as distance in relation to its own origin, and, recounting the nostalgia and the desire to coincide, it establishes its language in the void of this temporal difference.[37]

Indeed, in the void of this temporal difference, the *vanitas* image resides. In the fragments of petrified nature that they present, the allegory takes the shape of a pathway toward truth, or rather a detour (an *Umweg*, as Benjamin would have it) that does not lead to an end, a moment of revelation, a formulated meaning, but maintains a distance to its own origin. "Truth is not a process of exposure which destroys the secret, but a revelation which does justice to it," Benjamin states (31). Perspective has indeed revealed truth in painting, without destroying its secret.

Perspective as Allegorical Form

In the fourth chapter of *Art and Illusion*, entitled "Reflections on the Greek Revolution," Ernst Gombrich attempts to grasp the relation of pictorial to perceptual conventions by comparing Greek naturalism to Egyptian hieroglyphs. Recalling Heinrich Wölfflin's statement that people not only see differently but see different things, Gombrich wonders whether Egyptian representations were the result of a different perception of the world, or of a limitation in artistic skills, or were never meant to be realistic to begin with.[38] "We must never forget," Gombrich cautions, "that we look at Egyptian art with the mental set we have all derived from the Greeks."[39] The influence of the Greek revolution in representation on our perception of art is similar to another revolution that occurred in the nineteenth century with the invention of photography. Since we are accustomed to looking at images as if they are photographs, Gombrich writes, and to interpreting them as a reflection of "an actual or imaginary reality," we are too eager to identify the molded reliefs in Egyptian tombs as scenes from daily life.

Whereas the Egyptian artists were concerned with *what* was represented, the Greeks were interested in *how* the representation was rendered. They looked at the Egyptian figure "from the aspect of an art which wants to 'convince,' [and the Egyptian figure] undoubtedly raised the question why it looks unconvincing."[40] Gombrich suggests that the intention to create naturalistic art coincides with a rhetorical awareness. The Greeks, who thus viewed Egyptian art from a rhetorical point of view, correspondingly inter-

preted the hieroglyphs differently, Gombrich asserts. A gigantic pharaoh who attacks tiny enemy figures on a tomb relief signifies, within Egyptian conventions, the high importance of the pharaoh. The Greeks, who "were in fact inclined to read the pictograms of Egypt as if they were representations of an imagined reality," would have probably perceived a story about a giant among pygmies, reading the larger size of the pharaoh symbolically as a sign of his greater strength. Gombrich's argument is disputable, but it does introduce the interesting claim that the mistake the Greeks made was caused by reading allegorical signs as symbolic representations.

Despite his warning that our eyes are trained by looking at Greek art, Gombrich does not recognize the consequences of his own insight and the circularity of his argument for the remainder of his own book.[41] He forgets that his eyes have undergone the same training in looking at Greek art or at photography. In his chapter on the ambiguities of the third dimension, he, much like the Greeks, considers paintings precisely as representations of daily life, that is, as exact recordings of what the artist actually saw. After the Greek revolution and after the invention of photography, a third revolution in representation, the discovery of perspective, has trained our eyes as much as the Greek's naturalism shaped theirs. Although Gombrich extensively discusses perspective and its effects, he does not apply the same brilliant argument he presents with regard to Greek viewers to his own perceptions of art. He quotes J. J. Gibson, who claims that the visual field "is simply the pictorial mode of visual perception," and although I agree with Gombrich that such a vision is somewhat naive, I do not endorse his counterargument that while some flat pictures really look like the world, the world certainly does not resemble a picture.[42] It is not the world itself that looks like a picture, but our vision of the world is "pictured" (to use Joel Snyder's term) in painting. Paintings thus picture vision rather than depict reality.[43]

Gombrich's statement about the way in which our perception may become accustomed to certain systems of representation, whether Greek naturalism or photography, facilitates my claim regarding perspective's impact on perception. Indeed, just like the Greeks in Gombrich's example, we may read, or misread, allegorical signs as symbolical representations as a result of a perception that has been shaped by the "naturalism" of perspectival images. If perspective has been read at all, it has been read symbolically as a form, as a *Weltanschauung*. I believe that the double perspective in Gijsbrechts's *Studio Wall* demonstrates how perspective shapes our looking at this painting to the extent that it renders impossible an uninterrupted perception of what this picture shows. If we therefore consider Gijsbrechts's *Studio Wall* not

as an actual recording of a studio wall but read it as a treatise on the nature of its own representation, then a comparison with Benjamin's conception of method as an allegory of truth will be possible.

The additional perspective constitutes a border that frames the "canvas" as well as forming the picture's background; it is a support that on the level of perception simultaneously undermines what it foregrounds. This additional perspective that Gijsbrechts's painting throws upon itself serves as a method by means of which Gijsbrechts investigates the complexities of pictorial representation. Framed by and presented through this method, the image he decides to use as a case study is not just an image. It is a *vanitas* that through its double paradox itself raises ontological issues. We regard this *vanitas* in the "context" of the painter's personal perspectival framework that directs and guides our gaze as much as it blurs and confuses our perception by interrupting an otherwise purposeful structure. Instead of merely "showing" the image (in the sense of staging, or providing a mise-en-scène), the additional perspective forces our eyes to search for an original that we cannot find. In accordance with Benjamin's definition of the task of the philosophical treatise, whose method is representation and digression, our looking at the *Studio Wall* becomes a tireless process that does not lead to interpretation, but to a process of thinking. *Studio Wall* refuses to reveal a meaning or a truth about its being, yet it is thought-provoking, it gives us to think, to borrow Heidegger's terms.[44]

By using perspective as a rhetoric, Gijsbrechts establishes his argument about the complexities of referentiality with regard to optical illusion, or rather it *is* his argument. Indeed, as Stoichita states, we are looking at "a representation of a painting." The perspective frame provides the conditions for this painting to represent nothing but itself; it analyzes itself and arrives at a truth about its being, and its nothingness. The truth about this painting is self-representation, and it is immanent in his painting as form. Gijsbrechts clearly seeks the truth in painting: he wraps it up in his virtuous play with framing devices; he lays it out in front of our eyes in all its variations of representation, invariably without giving away its secret.

Can we assume that perspective is always an allegorical form, an allegory of truth? And is this proposition in accordance with Pascal's thoughts, rephrased by Damisch, concerning the question of whether truth is itself somehow perspectival? What are the consequences of an understanding of perspective as allegory? Benjamin writes that allegory "immerses itself into the depths which separate visual being from meaning" (165). If we apply his expression to painting, Gijsbrechts's painting demonstrates precisely this separation of visual being from meaning. The double perspectival config-

uration of the studio wall divides the frame-as-sign from what it eliminates and disperses the meaning of the painting from its apparent being. The "canvas" is indeed as detached as its frayed corner suggests, a detail that, as a condensed sign, points to what the *Studio Wall* finally implies: the separation of meaning and being as it is brought about by the perspectival configuration. The multiple framing devices could have given the viewer at least one stable frame of reference, but instead they constantly undermine and contradict each other. A realist reading of this image is therefore out of the question because it remains impossible to distinguish the real from the painted, or the original from its copy. As I have indicated, the additional trompe l'oeil perspective of the studio wall "border" tears the "canvas" away from its background. The painting and the painted painting are indistinguishable, and their difference can only be defined in terms of the distance of the material sign to its meaning. This distance is *not* visible in the painting at the level of spatial illusion (which accounts for the confusion it generates).

Gijsbrechts's painting exaggerates what perspective has generated from the multiple points of its origin: a distance between an object's appearance *qua* image and its meaning, between signifier and signified (or referent and reference), and between the viewer's and the painting's respective perspectives. The problematic separation of visual being from meaning that perspective forced upon the pictorial has been formulated by Panofsky in *Early Netherlandish Painting* as the dilemma of whether realistic objects that enhance the realism of a scene are disguised symbols or still-life features devoid of meaning. Panofsky observes in fifteenth-century Flemish painting a transition in modes of representation, from pictures with obvious symbolism, in which every element is recognizable as a symbol, to images where the rhetorical device of disguised symbolism has been employed. Disguised symbolism has often been misunderstood, but according to Panofsky, paintings with disguised symbolism are precisely those in which the separation between meaningful and meaningless objects is crystal clear. He uses the *Mérode Altarpiece* by Robert Campin as an example of this transition from obvious to disguised symbolism, wherein the latter was not yet been perfected. Panofsky suggests, without being explicit, that Campin's use of the principle of disguised symbolism "has not yet crystallized into a perfectly consistent system" because his perspectival configuration had not yet been perfected either:

> The Master of Flémalle's reality, not as yet completely stabilized and coherent, with tables threatening to tip over, benches extended to incredible length, interiors still combined with exterior views, could not absorb

symbolical content so completely that there remained no residue of either objectivity without significance or significance without disguise.[45]

Panofsky implies that Campin's lack of skill in the application of perspective is partly responsible for the fact that a demarcation line cannot be established between meaningful and meaningless objects. Too much involved in (or blinded by, as Benjamin would have it) the Romantic connotation of the symbol, he seeks meaning as the expression of coherence, determination, and consistency. Unfortunately, Panofsky did not elaborate on perspective's impact on the relation of objects to their meanings, and I believe that his devotion to the symbol and his exclusively symbolic definition of meaning are partly responsible for this. The genuine object of all Panofsky's inquiries has always been the symbolic form as a manifestation of the underlying principles of a culture.[46]

Roland Barthes addresses the complexities of being versus meaning in his famous essay "The Reality Effect." He investigates what he labels a "useless detail" in descriptive passages in realist literature, which is the literary equivalent of Panofsky's still-life feature, insofar as both elements denote an objective view of concrete reality. Barthes goes one step further than Panofsky, however, when he asks what ultimately the significance is of the insignificant. He dismantles the pure and simple representation of the real as a sign that appears to be resistant to meaning. Suspicious of whether it is at all possible to have a real referent that represents reality, Barthes proposes that if the useless detail carries meaning, it must depend on conformity to the cultural rules of representation rather than to its real-life model. The concrete, realistic detail, therefore, is constituted by a collusion of referent and signifier and produces what he calls "referential illusion." Although it seems that these details denote reality, what they actually do is *signify* this reality within a system of cultural, or rhetorical, rules of representation. The absence of a signified that characterizes these details transforms them into signifiers of realism (and not of reality). This process of signification Barthes calls the "reality effect."

The category of breakfast painting offers a clear pictorial translation of Barthes's theory. As I pointed out in chapter 1, Claesz.'s *Little Breakfast* (plate 1) solely stages what Panofsky would have called still-life features, or what Barthes would label useless details. This breakfast presents a small and humble collection of objects that denote reality in a mode that is so uncomplicated it touches on naïveté. They are clearly resistant to meaning, merely making themselves present without motivation: a perfect example

of Barthes's referential illusion. Compared to Gijsbrechts's *Studio Wall*, this painting is indeed transparent, for the very same reason that the *Studio Wall* is not. The problem with Gijsbrechts's illusionism is that the details in his painting—for instance, the painter's instruments or the frayed corner of the "canvas"—do not behave like Barthes's useless details. Instead of creating "referential illusion," they undermine it by refusing ultimately to reveal whether they denote reality or signify realism.

The problem with the signification of still-life painting in general is that its objects paradoxically maintain an instability between subject and accessory. In the context of its fifteenth- and sixteenth-century predecessors, still-life painting can be considered a descriptive component cut out of narrative painting or as a collection of symbols that used to appear in religious pictures. Ultimately, the question whether breakfast paintings display objects' afterlife as symbols that have forgotten their previous appearances as sacred constructs, or whether they have a background as excessive pieces of information in narrative painting, is not important. In both cases, the principle of disguised symbolism is no longer applicable to these images, neither as a rhetorical device deployed by painters nor as the category of signs that opens up speculation about the underlying cultural principles upon which Panofsky built his own version of iconology.

What remains important, however, is how Panofsky's dilemma, along with his notion of perspective as symbolic form, has influenced art historical modes of looking and interpreting early modern art. His understanding of perspective as symbolic form and his three-phased mode for analyzing the iconology of images separate the appearance of objects in painting from their meaning, which is defined in pure symbolic terms. Indeed, not perspective itself, but the pictures to which it is applied provide a *Weltanschauung*. As much as he distances himself from Panofsky's iconology, Gombrich's idea that paintings essentially represent true recordings of reality seen through the eyes of an artist is derived from a similar belief in the coherence of images that reflect actual perceptions. Gombrich's psychology of art and Panofsky's iconology are two separate approaches that circle around the same blind spot that perspective produces. The vanishing point is probably the clearest instance of this blind spot. Perspective, notwithstanding the fact that it provides a "seeing through," is *not* a transparent channel to a past world that both Panofsky and Gombrich consider the origin toward which their searches direct them. The vanishing point that appears in painting as the point to which our eyes are directed, the central locus or zero-point that makes pictorial space possible, falls outside this space, as the zero falls

outside the numeric system, even as it is its foundation. The vanishing point is not a symbol of our destiny, but signifies its absence: if it is at all a symbol, it is of infinity, of the very idea of the unreachable.

Perspective produces the illusion of a purposeful structure that directs our eyes and guides our scholarly curiosity to something hidden behind the horizon. Yet what lies concealed there is nothing safe, but a mere point that, like a zero, is empty. The idea, developed within art history, that perspective is a symbolic form is itself an allegory of the impossibility of interpreting painting as having "lost" its original meaning, a meaning that can be rediscovered in the historical context we attempt to reconstruct.

In its play on the vanity of painting, Gijsbrechts's *Studio Wall* narrates the impossibility of reading, articulated by its trompe l'oeil border. The additional perspective that literally frames the image clarifies how the "truthful spot" that perspective designates does not necessarily guarantee mastery over a painting. For the frame is within the painting as much as it frames it; it provides us with a map, or guidelines about how to look at this painting. Simultaneously, however, these guidelines are themselves part of the painting, and part of making the painting, as the painter's tools indicate. The method according to which we should look at this painting, specified by the painting itself, is what we consider. We are embedded in the picture's double manifestation of perspective.

Because of its geometrical form, perspective is a topology, a form of mathematical writing, itself empty in structure, that can be used as rhetoric. Pascal argued that geometry perfectly teaches the demonstration of truth and therefore can function as the basis of rhetoric. As I argued in chapter 2, in painting, perspective can serve as an equivalent to Pascal's geometrical rhetoric that indeed provides us with a watertight argument about the truth of what realistic painting tells. As a form of mathematical writing, which writes between the lines, perspective is a method, not of representation, but of visual argumentation. Benjamin takes the definition of allegory as writing literally when he declares that the written form of the philosophical treatise is an allegory of truth. The treatise is not about truth, but the method philosophy employs—its written form—represents truth. Truth can never be presented, for it is that which always eludes, but in writing it represents itself in a form that is allegorical, referring to a meaning that it itself does not contain.

Translating Benjamin's theory to painting, perspective serves to represent truth in painting by functioning as the foundation of a rhetoric of the image. Truth can thus be allegorically represented by means of the rhetoric of perspective. In painting, perspective separates the appearance

of objects within the configuration not only from *their* meaning, but also from the meaning the configuration itself produces. Benjamin claimed in a similar way that allegory "immerses itself into the depths which separate being from meaning." In art historical discourse, the separation between the meaning of the perspectival configuration, on the one hand, and the meaning of the represented objects, on the other, has often remained unrecognized or otherwise confused. In Anglo-Saxon art history, the meaning of images is largely defined as the meaning of the objects within its framework, neglecting the significance of a painting's method of representing itself, which is perspective.

The collision between objects within the picture frame and the structure that fixates them there—giving them their place as well as their visibility—proves exactly how successful perspective as rhetoric is. To use Pascal's terms, perspective's statement is so crystal clear that the form of presentation—and not the content of its statement—convinces us of its truthfulness. That is, perspective's method *is* its content, in the same way as, according to Benjamin, the philosophical method is philosophy's content. Itself remaining invisible, perspective makes us forget its structure, and even its presence, only to reveal what it makes visible: a view into the depth of the picture where the vanishing point marks the blind spot as the ultimate moment of illusion.

Perspective is therefore a threshold (to borrow Bryson's term) not only between the meaning of objects and their "being there," but also between two confusing methods of presentation and representation. As geometrical system (or topology), perspective *presents*: its structure is real and not metaphorical. The emptiness of its form neither refers to something else nor resembles something other than what it is. Especially the vanishing "zeropoint," around which the emptiness of perspectival space evolves, does not stand for anything but infinite nothingness; it does not have a reverse side where meaning may hide. Perspective therefore does not demonstrate, but "monstrates" (in a virtually Catholic sense of the word). As staging device, however, perspective simultaneously displays the objects within its grid that "fill in" the empty pictorial space it structures.

As we have seen, breakfast still lifes reveal the emptiness of perspective's rhetorical paradigm in showing the void as a painted surface that represents neither depth nor space. In showing nothingness, it lays bare the structure of its trope. Because the void itself does not make anything visible excepting the brownish color of its field, perspective suddenly gains visibility, just at the moment when space emerges that is not "ruled" by perspective—but that is, however, still "in" the painting.

Anamorphoses reveal another aspect of perspective's rhetoric in revealing its structure as highly manipulative, while trompe l'oeils expose the insurmountable distance between objects and their meaning. These examples, and especially Gijsbrechts's *Studio Wall*, point to the idea that perspective can never be a symbolic form, in the sense of producing unified views of coherent images. These paintings disrupt such coherent views when they, each in a different way, disclose perspective's operation. What they share, however, is the impossibility of finding either an origin—as Gijsbrechts's "canvas" or anamorphosis demonstrates—or an original meaning (as in the breakfasts).

Conclusion: The Original Lack of Perspective

The (Anglo-Saxon and especially the Dutch) historical method of art history attempts to return to the place of origin where the work of art was born. It seeks to find the conditions under which it came into being, the contemporary meaning it is supposed to contain, the underlying motivation for its creation, and/or the historical context of which it is a result. These methods of investigation express a longing to return to the time when the artwork was produced, as if its original context would provide the background into which the artwork would perfectly fit. This yearning to see the artwork in its own time is synonymous with a desire to see it as a whole, or as a perfect cutout fragment of the larger historical view. Indeed, this is how Panofsky describes perspective:

> For us perspective is, quite precisely, the capacity to represent a number of objects together with a part of the space around them in such a way that the conception of the material picture support is completely supplanted by the conception of a transparent place through which we believe we are looking into an imaginary space. *This space comprises the entirety of the objects in apparent recession into depth, and is not bounded by the edges of the picture, but rather only cut off.*[47] [italics mine]

Perspective cuts off a view of pictorial reality that otherwise would have extended beyond the picture frame. The view outside the frame is in fact the historical context. Perspective thus models the historical paradigm as much as the historical paradigm is modeled on perspective. As *Weltanschauung*, it provides us with a schematic picture of this search for a painting's origin that lies behind the horizon of the painting, and that symbolizes the horizon of our visual field behind which history lies buried. Yet, as Damisch declared in his search for the origin, perspective lacks a point of origin in several respects. To begin with, it lost its prototype when Brunelleschi's panels disappeared, with the result that it has multiple histories instead of one point

of origin. Furthermore, the vanishing point that could have been a point of origin falls outside of the pictorial space: just as the zero falls outside of the numeric system but is nevertheless fundamental to the system's existence; or just as the gaze as *object a* always exceeds the visual field, structuring a lack. Perspective's multiple histories circle around a lack of origin that connects them. Historical modes of looking deny this lack, maintaining the ultimate illusion of perspective, namely, as synthesis. In doing so, these modes of looking deploy perspective as a rhetoric for the method of interpretation that accords with it. The attempt to interpret paintings exclusively within a historical paradigm—defining meaning in symbolic terms in a gesture of nostalgia for a period that painting may reflect, but that art historical research never manages to retrieve—is in fact an allegorical mode of looking. Moreover, clinging to coherence is itself an allegory of the fact that historical truth cannot be found where we have been looking for it.

I claim that still-life painting in particular calls for an allegorical mode of looking because it calls attention to its two-dimensionality, thus undermining perspective's promise of depth. As these paintings' resistance to interpretation has shown, the art historical methods for interpretation that have been based on a perspectival model ultimately do not work fully when applied to still lifes. Therefore, I hope to have demonstrated that these images do not so much involve interpretation, but indicate something beyond interpretation, namely, a form of thinking in visual terms.

CONCLUSION
THE LOOK OF PAINTING

Around 1827 Joseph Nicéphore Niépce made the very first genuinely "truth-ful" recording of reality by taking a photograph, entitled *Set Table* (fig. 12). A table covered with a white cloth has been set for a solitary meal. In the middle of the tabletop stands a bowl on a plate, with a knife and a spoon, a glass, and a piece of bread; in short, we see a photographic recording of a breakfast still life. The origin of "truthful" recording of reality echoes the scene familiar from breakfast paintings in an attempt to capture the same "moment," or rather the same "place" of a set table. Like the breakfast still life, *Set Table* reveals a preoccupation with rendering a scene that looks as if no one is there to see it: uncannily, the first photograph ever made is devoid of human figures and therefore of a human gaze. Every viewer of this photo "meets with a start his own absence," as Ann Banfield declares.[1] Niépce's photograph, so reminiscent of still-life compositions, looks famil-iar to us—and for precisely that reason, because it is *not* a painting, is un-canny. The first photograph does share with painted still lifes an image of eyeless sight, this time photographed by the empty gaze of the camera. Yet the well-known topos of reflection in still life—functioning as a camera that "records" a painter caught in the act of creating the scene we see or gener-ating an endless mutual mirroring among objects—is absent from Niépce's scene. It misses the polish and the finesse of the appearance of things. Or, in Roland Barthes's words: "Still life painters like Van de Velde or Heda always render matter's most superficial quality: sheen."[2] The superficiality that lies on the surface of objects in still life, and therefore on the surface of the pic-ture plane, does not enter Niépce's picture in a similar way. It seems as if his photograph only has one surface, one layer of material, while the breakfasts

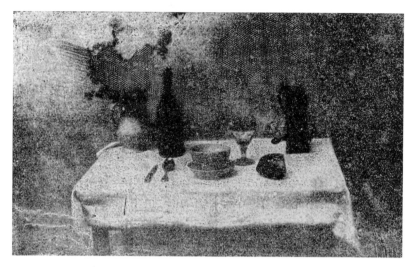

FIG. 12. JOSEPH NICÉPHORE NIÉPCE, *Set Table* (C. 1827). PHOTO: SOCIÉTÉ FRANÇAISE DE PHOTO-
GRAPHIE, PARIS.

and, for that matter, the letter rack trompe l'oeils display numerous layered textures and surfaces.

Indeed, Svetlana Alpers considers the Dutch still life to be an example of a mode of recording multiple surfaces that is modeled after microscopic vision. According to Alpers, the still life underscores the Dutch scientific practice of dissecting insects, plants, and so forth, and scrutinizing them under a microscope, in order to reveal the different sides and layers of things. Alpers notices that still-life painting is characterized by a similar dissection of edibles: cheeses and herrings are always sliced in pieces, pies are cut open to expose their filling, lemons are peeled, nuts are crushed, vessels and glasses are turned upside down, meat is carved to reveal as much flesh as skin, and so on: that is, to reveal the inside or underside of each object's principle form. "Each thing exposes multiple surfaces in order to be more fully present to the eye," Alpers writes.[3] Correspondingly, the still life dissects objects, just like Dr. Tulp performed an autopsy on a corpse in Rembrandt's *Anatomy Lesson*, or as Gijsbrechts paints the reverse sides of letters and other paraphernalia in his two-sided trompe l'oeils.

Alpers relates the dissection of objects in still lifes to a new method of classifying knowledge that consists of discriminating between things instead of drawing them together, a method of taxonomy modeled on scientific experiments with optical technology.[4] In his account of Dutch painting in *The Eye Listens*, Paul Claudel also notices the opening up of objects in still

lifes, but, in contrast to Alpers, he offers a less temperate interpretation. He sees Dutch still lifes as disturbing images of a world on the verge of falling apart. For Claudel, the repetitive composition of objects on a tabletop that is placed against a stable, motionless background displays "an arrangement in imminent danger of disintegration." Objects are off balance or about to fall, napkins are on the point of unrolling, knife handles are ready to become detached, edibles are voluntarily falling into slices, and plates are on the point of tumbling to the ground. "It is something at the mercy of time," Claudel writes.[5]

In Claudel's view, the dissecting of objects and edibles in still lifes springs not from a new, coherent ordering of things that results from scientific practice, but instead reflects the very image of material objects as they are crumbled by time. It is not the penetrating look of the microscope, hoping to reveal a thing's essence, that directs the still-life composition. Rather, the dissection of banal elements abolishes the very idea of coherence by confronting the notion of eternity with the (potential) destruction of all material elements over the course of time.

Possibly relying on Claudel's observations, Barthes states that Dutch still-life painters do not aim to rid an object of its qualities in order to reveal its essence, but that they "accumulate the secondary vibrations of appearance, for what must be incorporated into human space are layers of air, surfaces, and not forms or ideas."[6] For Barthes, objects in still lifes are presented as utilized entities, always showing themselves as destroyed, closed substances: edibles are peeled, and glasses or knifes have been picked up and put back, turning the still life setting into a human space. "What can be the justification of such an assemblage, if not to lubricate man's gaze amid this domain, to facilitate his daily business among objects whose riddle is dissolved and which are no longer anything but easy surfaces?" Barthes wonders.[7] What we see of these objects are circumstantial states, not their principle forms. Dutch painting shows the world as object, contrary to art that

> . . . has only two dimensions, that of the work and that of the spectator,
> [which] can only create platitudes, since it is no more than the capturing of
> a shop-window spectacle by a painter-voyeur. Depth is born only at the mo-
> ment the spectacle itself slowly turns its shadow toward man and begins to
> look at him.[8]

I believe that, in still life, depth is born in its shallow space as a result of the spectacle's starting to view the viewer, rather than the other way round. Still life does show the dissection of objects, as Alpers suggests, but not merely as the result of scientific modes of vision that aim to uncover the different

surfaces of things. Instead, I propose, the various surfaces of the still-life object are not created by a penetrating, scientific gaze, but point to another gaze that answers our gaze. If our model of representation is based on vision, we overlook the fact that painting also offers its own perspective: not in representing the objects we see, but in picturing us looking. Still life shows us a world of objects deprived of a human gaze in which only objects "look." And it is this "look" of the objects that reveals to us the other side of our perspective, and that gives the still life its depth, despite its ostensible flatness. Merleau-Ponty describes it as follows:

> Pictorial depth (as well as painted height and width) comes "I know not whence" to alight upon, and take root in, the sustaining support. The painter's vision is not a view upon the *outside*, a merely "physical-optical" relation with the world. The world no longer stands before him through representation; rather, it is the painter to whom the things of the world give birth by a sort of concentration or coming-to-itself of the visible. Ultimately the painting relates to nothing at all among experienced things unless it is first of all "autofigurative." It is a spectacle of something only by being a "spectacle of nothing," by breaking the "skin of things" to show how the things become things, how the world becomes world.[9]

The still life demonstrates how the "breaking of the skin of things" gives birth to depth in painting. The various surfaces of the small world of the kitchen table in breakfasts and the piling up of various layers of texture in Gijsbrechts's letter racks offer us "spectacles of nothing," of nothing but surfaces laid out before us. The flatness of the pictorial space does not allow for a meaning that hides behind the objects; more importantly, the objects themselves have nothing more to conceal or unfold. If there is meaning in these paintings, it does not have to be excavated, because the excavation has already been done by the paintings themselves. The objects reveal themselves as already being revealed. If truth resides in the essence of things, however, it is precisely the essence, as Barthes points out, that is not exposed. What is exposed is the perspective that the things throw upon themselves in the flatness of their display. In the deception of Gijsbrechts's trompe l'oeils, as well as in the void of the breakfast paintings by Claesz. and Heda, perspective reveals itself as unfolding the objects' visibility, and not their mere representation. As an instrument of dissection, perspective is deployed as a rhetoric of the image that fully exposes all the objects on the picture plane. What these paintings, or rather their perspectives, ultimately dissect, however, is not only the objects they represent, but the gaze of the viewer that for a moment is itself analyzed in the display of multiple surfaces. Within the

pictorial space, therefore, perspective does not operate merely to *represent* objects but to *present* itself as an empty structure that "shows." As I have attempted to point out in this study, perspective's paradox resides in the double function of its structure. As a method for creating images of the world, its function is to *represent* objects within the space it renders. Insofar as it is geometrical, its structure is real, however, and can only be *presented*. This double function, fundamentally paradoxical, has wide-ranging consequences for understanding our perception of both the visible and the invisible, as I have sought to demonstrate in my close readings of still-life imagery. In still life, I believe, we can see how the plurality of pictorial space manifests itself as the intersecting of different perspectives that ultimately reveal a world subject to a gaze that returns our look. As Eliane Escoubas so insightfully remarks:

> The pictorial space is plural. It lays in the work conditions of the visible according to historical modalities—and not conditions of the reproduction of the real—and therefore it is never fully and uniquely figurative. . . . [T]he pictorial space is never a part of space: it is a mode of emerging. Birth and rise of a world under the gaze—under a gaze that is not the gaze of a person—that is the enigma of painting.[10]

NOTES

INTRODUCTION

1. Martin Heidegger, "The Origin of the Work of Art," in *Poetry, Language, Thought*, trans. Albert Hofstadter (New York: Harper & Row, 1971), 77.

2. Erwin Panofsky, *Early Netherlandish Painting: Its Origins and Character* (New York: Harper & Row, 1971), vol. 1, esp. 131–48.

3. *Doorzichtig* means "transparent," while *doorzicht* is "seeing through."

4. Jacques Derrida, *The Truth in Painting*, trans. G. Bennington and I. McLeod (Chicago: University of Chicago Press, 1987), 1–14.

5. Paula Findler discusses the role of jokes and playfulness in seventeenth-century scientific discourse in "Jokes of Nature and Jokes of Knowledge: The Playfulness of Scientific Discourse in Early Modern Europe," *Renaissance Quarterly* 43 (1990): 292–331.

6. Maurice Merleau-Ponty, "Eye and Mind," in *The Primacy of Perception, and Other Essays on Phenomenological Psychology, the Philosophy of Art, History, and Politics*, trans. James M. Edie (Chicago: Northwestern University Press, 1964), 175.

7. Jean Baudrillard states that the trompe l'oeil transcends painting. See "The Trompe-l'Oeil," in *Calligram: Essays in New Art History from France*, ed. Norman Bryson (Cambridge: Cambridge University Press, 1988), 53–62.

8. See Mieke Bal, *Reading "Rembrandt": Beyond the Word-Image Opposition* (Cambridge: Cambridge University Press, 1991), chap. 6, "Textuality and Realism," 216–46.

9. See for instance, Sam Segal, *A Prosperous Past: The Sumptuous Still Life in the Netherlands, 1600–1700*, ed. William B. Jordan (The Hague: SDU Publishers, 1988), 31ff.

10. The aesthetic debate about Van Gogh's *Pair of Shoes* began with Heidegger's use of this painting to illustrate his idea about the thingly character of the thing in his essay "The Origin of the Work of Art." Meyer Schapiro replied with an article entitled "The Still Life as a Personal Object," after which Derrida responded to both texts in *The Truth in Painting*. Meyer Schapiro, "The Still Life as a Personal Object—A Note on Heidegger and Van Gogh," in *Theory and Philosophy of Art: Style, Artist, and Society* (New York: Braziller, 1994), 135–42. Many reactions followed, by Stephen Melville, among others.

11. Claudia Swan, "*Ad vivum, naer het leven*, from the Life: Defining a Mode of Representation," *Word and Image* 11, no. 4 (October–December 1995): 353–72.

12. Celeste Brusati explains how Van Hoogstraten's classification of pictures is not derived from rhetoric, but from natural history. Van Hoogstraten further distinguishes paintings according to their artistic merit, which gives him the opportunity to rank an excellent still life higher than a poorly executed history painting. *Artifice and Illusion: The Art and Writing of Samuel van Hoogstraten* (Chicago: University of Chicago Press, 1995), 237–39.

13. Samuel van Hoogstraten, *Inleyding tot de hooge schoole der schilderkonst, anders de zichtbare werelt* (Rotterdam, 1678), 75: "Maer deze Konstenaers moeten weten dat zij maer gemeene Soldaeten in het veltleger van de konst zijn." With regard to the notion of *parerga*, see 76.

14. Franciscus Junius, *The painting of the ancients in three bookes* (London, 1638). This work was first published in Latin in 1637, and a Dutch translation followed in 1641. For Junius's influence on Van Hoogstraten, see Andrea Gasten, "Dutch Still-Life Painting: Judgments and Appreciation," *Still-Life in the Age of Rembrandt*, ed. Eddy de Jongh, exhibition catalog (Auckland: Auckland City Art Gallery, 1982), 13–25. For an overview of the still life's position in seventeenth-century art theory, see Guido M. C. Jansen, " 'On the Lowest Level': The Status of the Still Life in Netherlandish Art Literature of the Seventeenth Century." In *Still-Life Paintings from the Netherlands, 1550–1720*, edited by Alan Chong and Wouter Kloek, exhibition catalog (Zwolle: Waanders Uitgevers, 1999), 51–57.

15. Gerard de Lairesse, *Groot Schilderboek* (Haarlem: Johannes Marschoon, 1740), 259–98.

16. I will elaborate on the notion of still life as a collection of *parerga* in chapters 1 and 2.

17. Brusati, *Artifice and Illusion*, 159.

18. Gerard de Lairesse, *The Art of Painting, in All Its Branches . . .* , trans. John F. Fritsch (London, 1738), 548; reprinted in Charles Harrison, Paul Wood, and Jason Gaiger, eds., *Art in Theory 1648–1815: An Anthology of Changing Ideas* (Oxford: Blackwell, 2000), 307.

19. The term *ontbytje* or *ontbijtje* was used in the seventeenth century to describe paintings displaying arrangements of food and objects on a tabletop before the term *stilleven*, or still life, was first coined in the Netherlands around 1650 and remained in use thereafter. *Ontbytje* literally means "little breakfast" and refers to taking a small "bite," to have a light meal at any hour of the day, in the sense of a snack. In the late Middle Ages, the word was already in use as referring in particular to the morning meal.

20. Brusati has convincingly argued that the trompe l'oeil letter racks of Samuel van Hoogstraten reveal strategies of self-representation. His images present the crafting of self and art as a totality and can be understood as a form of self-portraiture. Since there are many parallels between the work of Van Hoogstraten and Gijsbrechts, a similar claim might be made for Gijsbrechts's trompe l'oeils. Whereas his images do contain numerous references to his person, such as letters addressed to himself, an analysis limited to examining Gijsbrechts's artistry does not do justice to the complexities of his work. Brusati, *Artifice and Illusion*, 138–68. I elaborate on trompe l'oeil's ability to reveal strategies of self-representation or comment on their own representation in chapter 1.

21. Several explanations for repetitive oeuvres in the seventeenth century will be discussed in chapter 1.

22. Eliane Escoubas, *L'espace pictural* (La Versanne: Encre marine, 1995), 15–35. Influenced by Merleau-Ponty and Heidegger, Escoubas attempts to integrate phenomenology and aesthetics in her analyses of painting. The pictorial space is not a space of representation, she argues, but of manifestation.

23. Merleau-Ponty, "Eye and Mind," 160.

24. Maurice Merleau-Ponty, "Cézanne's Doubt," in *Sense and Non-Sense*, trans. Hubert L. Dreyfus and Patricia Allen Dreyfus (Evanston: Northwestern University Press, 1964), 9–25. For an account of Merleau-Ponty's indebtedness to painting regarding his theory of space and perception, see Brendan Prendeville, "Merleau-Ponty, Realism and Painting: Psychophysical Space and the Space of Exchange," *Art History* 22, no. 3 (September 1999): 364–88. The ways in which a perception of painting turns into a thinking about seeing for Merleau-Ponty has been explored by Jacques Taminiaux, "Le penseur et le peintre: Sur Merleau-Ponty," *La Part de l'Oeil* 7 (1991): 39–46.

25. Merleau-Ponty, "Eye and Mind," 14.

26. Ibid., 167, 169.

27. Hubert Damisch, *The Origin of Perspective*, trans. John Goodman (Cambridge, MA: MIT Press, 1995), xiii, 49, 446.

28. Michael Ann Holly, "Witnessing an Annunciation," in *Past Looking: Historical Imagination and the Rhetoric of the Image* (Ithaca: Cornell University Press, 1996), 149–69.

29. Roland Barthes, "The Reality Effect," in *The Rustle of Language*, trans. Richard Howard (Berkeley: University of California Press, 1989), 141–49.

30. Norman Bryson, *Vision and Painting: The Logic of the Gaze* (London: Macmillan Press, 1983), 37–66.

31. See also Bal's criticism of Bryson's denotation-connotation model in *Reading "Rembrandt,"* 230–31.

32. Damisch, *Origin of Perspective*, 287.

33. Andrzej Warminski, "Introduction: Allegories of Reference," in *Allegories of Reading: Figural Language in Rousseau, Nietzsche, Rilke, and Proust*, by Paul de Man (New Haven: Yale University Press, 1979), 1–33.

34. De Man, *Allegories of Reading*, 131.

35. Ibid., 7.

36. Ibid., 131.

37. Walter Benjamin, *The Origin of German Tragic Drama*, trans. John Osborne (London: Verso, 1998).

38. Blaise Pascal, "The Mind of the Geometrician" and "The Art of Persuasion," in *Great Shorter Works of Pascal*, trans. E. Cailliet and J. C. Blankenagel (Philadelphia: Westminster Press, 1948), 198–211.

39. Martin Heidegger, *An Introduction to Metaphysics*, trans. Ralph Manheim (New York: Doubleday, 1961), 100.

40. A well-balanced overview of the debates on Dutch realism is the following anthology, which includes classical essays extended with recent studies in the field: Wayne E. Franits, ed., *Looking at Seventeenth-Century Dutch Art: Realism Reconsidered* (Cambridge: Cambridge University Press, 1997).

41. Eddy de Jongh, "The Interpretation of Still-Life Paintings: Possibilities and Limits," in *Still-Life in the Age of Rembrandt*, ed. Jongh, 27–38.

42. A prominent exponent of this approach within the Dutch art historical community is Peter Hecht, whose catalog on the Fijnschilders intensified the debate on realism: *De Hollandse Fijnschilders: van Gerard Dou tot Adriaen van der Werff* (Amsterdam: Maarssen, 1989). Hecht, who is fervently opposed to (iconographic) interpretation, previously discussed his discontent in "The Debate on Symbol and Meaning in Dutch Seventeenth-Century Art: An Appeal to Common Sense," *Simiolus* 16 (1986): 125–36. More recently, he has reaffirmed his position in "Dutch Seventeenth-Century Genre Painting: A Reassessment of Some Current Hypotheses," in *Looking at Seventeenth-Century Dutch Art*, ed. Franits, 88–97.

43. For an overview of the materialist approach, see Elizabeth Honig, "Making Sense of Things: On the Motives of Dutch Still Life," *Res* 34 (Autumn 1998): 166–83.

44. Simon Schama, "Perishable Commodities: Dutch Still Life Painting and the 'Empire of Things,'" in *Consumption and the World of Goods*, ed. John Brewer and Roy Porter (London: Routledge, 1993), 478–88; Hal Foster, "The Art of Fetishism: Notes on Dutch Still Life," in *Fetishism as Cultural Discourse*, ed. Emily Apter and William Pietz (Ithaca: Cornell University Press, 1993), 251–65; Julie Hochstrasser, "Life and Still Life: A Cultural Inquiry into Seventeenth-Century Still-Life Painting" (Ph.D. diss., University of California, Berkeley, 1995).

45. Simon Schama, *The Embarrassment of Riches: An Interpretation of Dutch Culture in the Golden Age* (New York: Vintage Books, 1997).

46. Since J. M. Montias's *Artists and Artisans in Delft: A Socio-Economic Study of the Seventeenth Century* (Princeton: Princeton University Press, 1982), research in commerce and the art market has grown extensively. Closely following Montias, Michael North's *Art and Commerce in the Dutch Golden Age*, trans. Catherine Hill (New Haven: Yale University Press, 1997), examines several aspects of the still-life art market.

47. John Loughman, "The Market for Netherlandish Still Lifes, 1600–1720," in *Still-Life Paint-*

ings from the Netherlands, 1550–1720, ed. Alan Chong and Wouter Kloek (Zwolle: Waanders Uit-gevers, 1999), 87–102.

48. Georges Didi-Huberman, *Devant l'image: Question posée aux fins d'une histoire de l'art* (Paris: Editions de Minuit, 1990); Louis Marin, "Signe et représentation au XVIIe siècle: Notes sémio-tiques sur trois natures mortes," *Revue d'Esthétique* 4 (1971): 402–36.

CHAPTER ONE

1. Denis Diderot, *Diderot on Art.* Vol. 1, *The Salon of 1765 and Notes on Painting,* ed. and trans. John Goodman (New Haven: Yale University Press, 1995), 61.

2. Norman Bryson, *Word and Image: French Painting of the Ancient Régime* (Cambridge: Cam-bridge University Press, 1981), 154ff. For Diderot's use of hieroglyph and *peripateia,* see Marc Eli Blanchard, "Writing the Museum: Diderot's Bodies in the *Salons,*" in *Diderot, Digression and Dis-persion: A Bicentennial Tribute,* ed. Jack Undank and Herbert Josephs (Lexington, KY: French Fo-rum Publishers, 1984), 21–36; Michael Cartwright, "Diderot's Discursive Eye: Peripatetics and the Search for Harmony," in ibid, 72–84; and Bernard Vouilloux, "La description du tableau dans les *Salons* de Diderot: La figure et le nom," *Poétique* 73 (1988): 27–50.

3. Gotthold Ephraim Lessing, *Laocoön: An Essay on the Limits of Painting and Poetry,* trans. Ed-ward Allen McGormick (Baltimore: Johns Hopkins University Press, 1989), 19. For the rela-tion between Lessing's "pregnant moment" and Diderot's "hieroglyph," see Roland Barthes, "Diderot, Brecht, Eisenstein," in *Image-Music-Text,* trans. Stephen Heath (New York: Noon-day Press, 1977), 69–78; and Victor Burgin, "Diderot, Barthes, Vertigo," in *The End of Art Theory: Criticism and Postmodernity* (London: Macmillan, 1986).

4. Diderot, *The Salon of 1765,* 223.

5. Lessing, *Laocoön,* 19. As the instant right before the climax or catastrophe, the "pregnant moment" designates a lack that the viewer fills in by seeing.

6. See Bryson, *Word and Image,* 154–79.

7. Gilles Deleuze, *Cinema 2: The Time-Image,* trans. Hugh Tomlinson and Robert Galeta (Minneapolis: University of Minnesota Press, 1997), 13–18.

8. George Lukacs states that narration establishes proportions, while description merely creates levels. Description transforms people into conditions, into components of still lifes. He disapproves of leveling descriptive moments in novels, which he considers instances de-prived of all human significance. "Narrate or Describe?" in *Writer and Critic, and Other Essays,* ed. and trans. Arthur D. Kahn (London: Merlin Press, 1970), 110–48.

9. Bal, *Reading "Rembrandt,"* 216ff.

10. According to Lawrence Goedde, non-narrative still lifes should be read analogously to *ekphrasis.* "A Little World Made Cunningly: Dutch Still Life Painting and Ekphrasis," in *Still Lifes of the Golden Age,* exhibition catalog (Washington, DC: National Gallery, 1989), 35–44.

11. For a general discussion of the charming in breakfast painting, see Dale Jacquette, "Schopenhauer on the Antipathy of Aesthetic Genius and the Charming," *History of European Ideas* 18, no. 3 (May 1994): 373–85.

12. Arthur Schopenhauer, *The World as Will and Representation,* trans. E. F. J. Payne (New York: Dover, 1969), vol. 1, 208.

13. De Lairesse, *Groot Schilderboek,* 260 (my translation); see also 267. Part of the section on still-life painting has been reprinted in English in Harrison, Wood, and Gaiger, *Art in Theory 1648–1815,* 306–7.

14. In Emile Zola's *Le Ventre de Paris,* the opposite attitude toward food is expressed by the painter Claude (modeled after Cézanne), who wanders through the market and sees the mountains of vegetables not in terms of food to be eaten, but as objects to be painted. For him, the vegetables turn out to be too difficult to paint.

15. Martin Heidegger, "What Calls for Thinking?" trans. Fred D. Wieck and J. Glenn Gray, in *Basic Writings,* ed. David Farrell Krell (San Francisco: HarperCollins, 1993), 369–91. The pun on "food for thought" holds for the English translation of Heidegger's essay only. The original German version reads: "Was uns denken heisst, gibt uns zu denken. Wir nennen Solches,

was zu denken gibt, ein Bedenkliches." *Was Heisst Denken?* (Tübingen: Max Niemeyer Verlag, 1997), 85.

16. Norman Bryson, *Looking at the Overlooked: Four Essays on Still Life Painting* (Cambridge: Cambridge University Press, 1990), 10.

17. Paul de Man, "The Resistance to Theory," in *The Resistance to Theory* (Minneapolis: University of Minnesota Press, 1986), 3–20.

18. Ibid., 11.

19. Ibid., 17.

20. Julie Berger Hochstrasser, "Feasting the Eye: Painting and Reality in the Seventeenth-Century 'Bancketje,'" *Still-Life Paintings from the Netherlands, 1550–1720*, ed. Alan Chong and Wouter Kloek (Zwolle: Waanders Uitgevers, 1999), 73–86. See also Hochstrasser's dissertation, "Life and Still Life."

21. Segal, *A Prosperous Past*, 128. Joseph Lammers discusses the table pieces and their potential Christian symbolism more elaborately in: "Fasten under Genuss; Die Angerichtete Tafel als Thema des Stillebens," in *Stilleben in Europa*, ed. Gerhard Langemeyer and Hans Albert Peters, exhibition catalog (Münster: Staatliche Kunsthalle, 1979), 402–30. See also Annaliese Mayer-Meinstschel, "Die Welt auf einem Tish; Das Stilleben und sein Gegenstand," in *Das Stilleben und sein Gegenstand*, ed. Irina Antonowa et al., exhibition catalog (Dresden: Staatliche Kunst-sammlungen, 1983), 15–20.

22. Schama, "Perishable Commodities"; and idem, *The Embarrassment of Riches*, 160–61.

23. J. M. Montias, "Cost and Value in Seventeenth-Century Dutch Art," *Art History* 10 (1987): 455–66. Marten Jan Bok offers a similar argument in *Vraag en aanbod op de Nederlandse kunstmarkt, 1580–1700* (Utrecht: Universiteit Utrecht, 1994); and Michael North, "Art and Commerce in the Dutch Republic," in *A Miracle Mirrored: The Dutch Republic in European Perspective*, ed. C. A. Davids and Jan Lucassen (Cambridge: Cambridge University Press, 1995).

24. Jonathan I. Israel, "Adjusting to Hard Times: Dutch Art during Its Periods of Crisis and Restructuring (c. 1621–c. 1645)," *Art History* 20, no. 3 (September 1997): 449–76.

25. Bryson makes this claim in the introduction to *Calligram: Essays in New Art History from France*, ed. Norman Bryson (Cambridge: Cambridge University Press, 1988), xvi.

26. See Bryson, *Vision and Painting*, 37–67.

27. The connection between *parerga* and still life has been made several times in seventeenth-century literature of art. See Van Hoogstraten, *Inleyding*, 76. Andrea Gasten notes that Van Hoogstraten borrows the term *parerga* from Franciscus Junius's *The painting of the ancients* in her article, "Dutch Still-Life Painting."

28. Derrida, *Truth in Painting*, esp. 15–82. See also Victor Stoichita, *The Self-Aware Image: An Insight into Early Modern Meta-Painting*, trans. Anne-Marie Glasheen (Cambridge: Cambridge University Press, 1997), 3–16, 53–64, and on the still life as "para-ergon," 23; Louis Marin, "The Frame of Representation and Some of Its Figures," in *The Rhetoric of the Frame: Essays on the Boundaries of the Artwork*, ed. Paul Duro (Cambridge: Cambridge University Press, 1996), 79–95.

29. Stoichita, "The Birth of Still Life as an Intertextual Process," in *Self-Aware Image*, 17–30.

30. Derrida, *Truth in Painting*, 14.

31. Ibid., 4.

32. Ibid.

33. Ibid., 9.

34. Merleau-Ponty, *Primacy of Perception*, 178.

35. Merleau-Ponty, *The Visible and the Invisible, Followed by the Working Notes*, ed. Claude Lefort, trans. Alphonso Lingis (Evanston: Northwestern University Press, 1968), 211.

36. Immanuel Kant, *Critique of Pure Reason*, trans. Norman Kemp Smith (New York: St. Martin's Press, 1965), 68.

37. Merleau-Ponty, *Primacy of Perception*, 16.

38. Ibid., 25.

39. Maurice Merleau-Ponty, *The Phenomenology of Perception*, trans. Colin Smith (London: Routledge, 1994), 256.

40. Ibid., 266.

41. Merleau-Ponty, "Cézanne's Doubt," 9–25.

42. Merleau-Ponty, *Phenomenology of Perception*, 265.

43. Merleau-Ponty, "Eye and Mind," 180.

44. Ibid., 186.

45. Merleau-Ponty, *Visible and the Invisible*, 135.

46. Ibid., 215.

47. Martin Heidegger, "The Thing," in *Poetry, Language, Thought*, trans. Albert Hofstadter (New York: Harper & Row, 1971), 166.

48. Ibid., 166.

49. Ibid., 178.

50. For the complete German text and an English translation, see Brusati, *Artifice and Illusion*, 163.

51. Ibid., 160ff.

52. Ibid., 167.

53. "De Perspectiven en doorzichten zijn, om haere aengenaeme bedrieglijkheyt, altijts en overal in hooge agting geweest." (The perspectives and seeing-throughs have been highly respected, always and everywhere, because of their pleasurable deceit.) Van Hoogstraten, *Inleyding*, 275.

54. "Hier komt de speelende Schilderjeugt haest met gemeene dingen na 't leven gekoleurt, en uitgesneden, of met brieven en kammen te voorschijn: en vind gemak in iets vlaks op een vlakte te verbeelden." (Here appears the playful youth of painters with general [banal] things, colored from life, and cut out, or with letters and combs: and they find it easy to represent something flat onto a flat surface [my translation].) Ibid., 218.

55. Michel Foucault mentions that the Renaissance, as an age of resemblance, left nothing behind but games once it was over. He calls the seventeenth century "the privileged age of *trompe l'oeil* painting, of the comic illusion, of the play that duplicates itself by representing another play; . . . it is the age of the deceiving senses; it is the age in which the poetic dimension of language is defined by metaphor, simile, and allegory." *The Order of Things: An Archaeology of the Human Sciences* (New York: Vintage Books, 1973), 51.

56. Gerald Fremlin elaborates on the significance of the distinction between "seeing something in a painting" and "seeing something on a map." He points to the connection between mapmaking and trompe l'oeil painting, an idea that again indicates that the trompe l'oeil is a kind of representation fundamentally different from painting. "What Kind of Thing Is a Map? Not a Globe; Maybe a Picture" and "A Close Relative of Maps: Letter Rack *Trompe l'Oeil*," *Cartographica* 35, nos. 1/2 (Spring and Summer 1998): 25–34, 35–36.

57. Jean Baudrillard, "The Trompe l'Oeil," in *Calligram*, ed. Bryson, 53–62.

58. Pierre Charpentrat claims that trompe l'oeil substitutes transparency for a "Presence," with the result that it violates the rules of painting as well as a game. "Le trompe l'oeil," *Nouvelle revue de psychanalyse* 4 (Autumn 1971): 161–68.

59. The literature on trompe l'oeil is still marginal. I mention here the major overview works: Martin Battersby, *Trompe l'Oeil = The Eye Deceived* (New York: St. Martin's Press, 1974); Sybille Ebert-Schifferer, ed., *Deceptions and Illusions: Five Centuries of Trompe l'Oeil Painting*, exhibition catalog (Washington, DC: National Gallery of Art, 2002); Fabrice Farbé and Dominique Chevé, "Les tableaux de trompe l'oeil ou la dénonciation de l'illusion," in *Le trompe-l'oeil de l'antiquité au XX siècle*, ed. Patrick Maurières (Paris: Editions Gallimard, 1996), 169–250; Olaf Koester, ed., *Illusions: Gijsbrechts, Royal Master of Deception*, exhibition catalog, trans. W. Glynn Jones (Copenhagen: Statens Museum for Kunst, 1999); Michaela Krieger, "Zum Problem des Illusionismus im 14. und 15. Jahrhundert—ein Deutungsversuch," *Bruckmanns Pantheon* LIV (1996): 4–18; Miriam Milman, *Trompe l'Oeil Painting: The Illusions of Reality* (Geneva: Skira, 1982); M.-L. d'Otrange Mastai, *Illusionism in Art: Trompe l'Oeil, a History of Pictorial Illusionism* (New York: Abaris Books, 1975). Regarding the problem of representation in relation to illusion, see Richard Allen, "Representation, Illusion, and the Cinema," *Cinema Journal* 32, no. 2 (Winter 1993): 21–48.

60. For instance, Eileen Reeves points out that Galileo Galilei disapproved of trompe l'oeil as well as of anamorphosis because such images appear as something else than what they are. *Painting the Heavens: Art and Sciences in the Age of Galileo* (Princeton: Princeton University Press, 1997), 7, 18. Much later, John Ruskin argues against the trompe l'oeil for the same reason. See, for instance, Caroline Levine, "Seductive Reflexivity: Ruskin's Dreaded *Trompe l'Oeil*," *Journal of Aesthetics and Art Criticism* 56, no. 4 (Fall 1998): 367–75. Often cited as a counterexample of the typical negative view of the trompe l'oeil is Roger de Piles, who mentions a portrait of a servant leaning out of a window painted by Rembrandt, which, placed in an actual window, deceived the eyes of passersby. *Abregé de la vie des peintres . . .* , 2nd ed., rev. and corr. (Paris, 1715), 423.

61. Among obvious instances of this revival are the 1999 exhibition *Master of Illusion*, on the work of Cornelius Norbertus Gijsbrechts and Franciscus Gijsbrechts (Copenhagen, Statens Museum for Kunst, and London, National Gallery), and the 2002 overview exhibition in the National Gallery in Washington, *Deceptions and Illusions: Five Centuries of Trompe l'Oeil Painting*.

62. Arthur K. Wheelock Jr., "*Trompe-l'Oeil* Painting: Visual Deception or Natural Truths?" in *The Age of the Marvelous*, ed. Joy Kenseth, exhibition catalog (Hanover, NH: Hood Museum of Art, 1991), 179–91.

63. Arthur K. Wheelock Jr., "Illusionism in Dutch and Flemish Art," in *Deceptions and Illusions*, ed. Ebert-Schiffrer, 77–90.

64. Louis Marin, "Imitation et trompe l'oeil dans la théorie classique de la peinture au XVIIe siècle," in *Rencontres de l'Ecole du Louvre* (Paris: Documentation française, 1984). A similar argument is formulated in his "Mimesis and Description," in *On Representation*, trans. Catherine Porter (Stanford: Stanford University Press, 2001), 252–68.

65. Louis Marin, "Representation and Simulacrum," in *On Representation*, 309–19.

66. Stoichita, *Self-Aware Image*, 276–79. See also Bryson, *Looking at the Overlooked*, 140–45.

67. Among the best-known American trompe l'oeil painters are William Harnett (1848–1892) and John Peto (1854–1907). Doreen Bolger points to the similarity between the minister's letter rack and letter rack trompe l'oeils, however, without drawing further conclusions. "The Early Rack Paintings of John F. Peto: 'Beneath the Nose of the Whole World,' " in *The Object as Subject: Studies in the Interpretation of Still Life*, ed. Anne Lowenthal (Princeton: Princeton Univiversity Press, 1993), 4–32.

68. Edgar Allan Poe, "The Purloined Letter," in *The Fall of the House of Usher* (New York: New American Library, 1960), 96.

69. Ernst Gombrich, *Art and Illusion: A Study in the Psychology of Pictorial Representation* (Princeton: Princeton University Press, 1972), 204.

70. My understanding of Lacan's text is informed by Joan Copjec, *Read My Desire: Lacan against the Historicists* (Cambridge, MA: MIT Press, 1994); Jacqueline Rose, *Sexuality in the Field of Vision* (London: Verso, 1996); and Kaja Silverman, *Male Subjectivity at the Margins* (New York: Routledge, 1992), and *The Threshold of the Visible World* (New York: Routledge, 1996).

71. Jacques Lacan, *The Four Fundamental Concepts of Psychoanalysis*, ed. Jacques-Alain Miller, trans. Alan Sheridan (New York: Norton, 1981), 103.

72. Ibid., 108.

73. In *The Origin of Perspective*, Hubert Damisch—who quotes the same passage from *The Four Fundamental Concepts* in his discussion of the first view into perspectival space—notes that apparently Lacan did not have any knowledge of Brunelleschi's experiment, which I find hard to believe given his description of a vanishing point as a hole in the picture. Damisch, *Origin of Perspective*, 129.

74. Antonio di Tuccio Manetti, *The Life of Brunelleschi*, trans. Catherine Enggass (University Park: Pennsylvania State University Press, 1970), 44.

75. Ibid., 42. I use here the translation that is quoted in Damisch, *Origin of Perspective*, 116.

76. Damisch claims that the eye in the mirror does not see itself seeing since "there is someone there who looks at it, and whom it does not see." I agree with Damisch to the extent that the moment of recognition of the blind spot that resides in our eye as much as in our

vision happens precisely when one suddenly becomes aware of seeing oneself seeing. A similar moment of such awareness occurs in the deception effected by trompe l'oeil paintings.

77. Manetti describes the openings of the pyramid-shaped carving in Brunelleschi's panel as being the size of a ducat on the back side and of a lentil on the front. While peeping through the hole, one would see in the mirror a notch the size of a lentil in which one, technically speaking, would see a reflection of the pupil of the peeping eye. The current word for lens derives from the word "lentil" (*lens, lentis,* in Latin). In French the word for pupil and lentil is identical, namely, *lentille.* It is interesting in this context to note that the Arab perspectivist Alhazen (965–1039) explains the anatomy of the eye in his *Book of Optics,* which was translated into Latin around 1200 as *De aspectibus.* He was the first to describe the surface of what he calls the "uvea" (which is perforated by the pupil) as being shaped like a lentil (book 1, 5.9). The Renaissance perspectivists, including Leon Battista Alberti and Lorenzo Ghiberti were conversant with *De aspectibus.* Ghiberti used a copy of Alhazen's text (now in the Biblioteca Apostolica in the Vatican) as the framework for the third book of *Il commentarii,* and Alberti may have used it as well as one of his sources while writing *Della pittura.* Alhazen compares the slightly convex surface of the uvea with the shape of a lentil whereas Manetti uses the lentil to indicate the size of the hole. However, we may consider the possibility that Manetti refers to Alhazen's text, given the fact that the eye should rest in the carving in Brunelleschi's panel such that the pupil would fill up the lentil-sized hole. For Alhazen's description in Latin and English, see A. Mark Smith, *Alhacen's Theory of Visual Perception: A Critical Edition, with English Translation and Commentary, of the First Three Books of Alhacen's* De aspectibus, *the Medieval Latin Verson of Ibn al-Haytham's* Kitab al-Manazir, 2 vols. (Philadelphia: American Philosophical Society, 2001), 1:12, 2:349.. See also David C. Lindberg, *Theories of Vision from al-Kini to Kepler* (Chicago: University of Chicago Press, 1976), esp. chap. 4, "Alhazen and the New Intromission Theory of Vision," and chap. 8, "Artists and Anatomists of the Renaissance."

78. Damisch, *Origin of Perspective,* 121.

79. Merleau-Ponty, *Visible and the Invisible,* 7.

80. Baudrillard argues that perspective in trompe l'oeil is turned inside out in his essay "The Trompe l'Oeil," 53–62.

81. Lacan, *Four Fundamental Concepts,* 121; Merleau-Ponty, *Visible and the Invisible,* 213.

82. For a clear description of the complexities of Lacan's notion of the screen, see Silverman, *Threshold of the Visible World,* chap. 4, "The Gaze," chap. 5, "The Look," and chap. 6, "The Screen."

83. I have slightly modified the English translation offered by Alan Sheridan. In his translation, the last sentence of the quoted fragment reads: "But I am *not* in the picture," while the original French sentence reads, "Mais moi, je suis dans le tableau." Kaja Silverman comments on this difference in translation in *Threshold of the Visible World.*

84. Bryson describes still-life paintings as images of how the world would look if there were no one to see it. He describes Van Hoogstraten's *Feigned Letter Rack* as having the look of a dead man's clothes. *Looking at the Overlooked,* 144.

85. Lacan, *Four Fundamental Concepts,* 109.

86. Ibid.

87. Merleau-Ponty, *Visible and the Invisible,* 139.

88. A clarification of the relation between the visible and the invisible may also be found in the analogous structure of Lacan's notions of the symbolic and the real. The real structures the symbolic by marking an absence in it, around which the symbolic organizes itself. The symbolic is established on the basis of something that is subtracted from it, which forms a hole in the symbolic causing a failure of signification. The real designs this structural emptiness, whereby it provides the symbolic of a grammar, a structure. See the introduction of Copjec, *Read My Desire.*

89. Alphonso Lingis, "Translator's Preface" to Merleau-Ponty, *Visible and the Invisible,* li.

90. Merleau-Ponty, *Visible and the Invisible,* 215.

CHAPTER TWO

1. In *A Modest Message as Intimated by the Painters of the "Monochrome Banketje,"* 2 vols. (Schiedam: Interbook International B.V., 1980), N. R. A. Vroom mentions one other painting by Heda, signed and dated 1654 (no. 379a, location unknown), that contains a view of a landscape in the background. According to Vroom, several copies of this breakfast existed, of which he names two (379b and 379c). See 1:56 and 2:78.

2. According to Vroom, M. J. Friedländer makes this suggestion in *Mededeeling in de Archief van den Kunsthandel P. de Boer te Amsterdam*, n.d, n.p.

3. De Lairesse, *Groot Schilderboek*, 259–98. A section of De Lairesse's chapter on still life including the passage I quote has been reprinted in *Art in Theory 1648–1815*, ed. Harrison, Wood, and Gaiger, 307.

4. Stoichita, *Self-Aware Image*, 23.

5. Ingvar Bergström, *Dutch Still-Life Painting in the Seventeenth Century*, trans. Christina Hedström and Gerald Taylor (New York: Hacker Art Books, 1983), 14.

6. Stoichita, *Self-Aware Image*, 26.

7. Ibid., 3–16.

8. Elizabeth A. Honig, *Painting and the Market in Early Modern Antwerp* (New Haven: Yale University Press, 1998), 30. Also, Charlotte Houghton compares Aertsen's innovative composition to collages of the 1960s such as Richard Hamilton's *Just What Is It That Makes Today's Home So Different, So Appealing?* Houghton demonstrates how Aertsen's *Meat Stall*, like in collage, is structured deliberately to frustrate attempts at a unitary reading. "This Was Tomorrow: Pieter Aertsen's *Meat Stall* as Contemporary Art," *Art Bulletin* 86, no. 2 (June 2004): 277–300.

9. For example, in Van Cleve's *Virgin Mary and St. Anne* (Modena, Galleria Estense).

10. Reindert L. Falkenburg, " 'Alter Einoutus': Over de aard en herkomst van Pieter Aertsens stillleven-conceptie," *Nederlands Kunsthistorisch Jaarboek* 40 (1989): 41–66. Falkenburg makes a similar statement in "Matters of Taste: Pieter Aertsen's Market Scenes, Eating Habits, and Pictorial Rhetoric in the Sixteenth Century," in *The Object as Subject: Studies in the Interpretation of Still Life*, ed. Anne W. Lowenthal (Princeton: Princeton University Press, 1996), 13–17. Margaret A. Sullivan criticizes Falkenburg's argument in her essay "Aertsen's Kitchen and Market Scenes: Audience and Innovation in Northern Art," *Art Bulletin* LXXXI, no. 2 (1999): 236–66. Keith Moxey has argued against an interpretation of Aertsen's market and kitchen pieces as allegories that need to be deciphered but partly agrees with reading them as social satires. "Interpreting Pieter Aertsen: The Problem of 'Hidden Symbolism,' " *Nederlands Kunsthistorisch Jaarboek* 40 (1989): 29–39. See also his *Pieter Aertsen, Joachim Beuckelaer, and the Rise of Secular Painting in the Context of the Reformation* (New York: Garland, 1977). See also Ethan Matt Kavaler, "Pieter Aertsen's *Meat Stall*: Divers Aspects of the Market Piece," *Nederlands Kunsthistorisch Jaarboek* 40 (1989): 67–92.

11. Bergström presents *A Poor Man's Meal* as one of the first breakfast paintings but attributes it to an anonymous follower of Pieter Aertsen and dates it in the second half of the sixteenth century. Bergström, *Dutch Still-Life Painting*, 26. Sam Segal mentions a work by Nicolaes Gillis as the first still life in oil, dated 1601. He tentatively dates Francken's *Poor Man's Meal* to 1599. See Segal, *A Prosperous Past*, 39 and cat. no. 1.

12. The barely visible gallows in the lower left corner of the window may be a moral warning, especially when connecting them to the image of the owl in the mirror, above which is written the greeting "good day, brother." The image is a rebus on the name Tyl Uilenspiegel, a notorious thief and hero of German satirical tales popular at the time. The rebel's last name literally translates as "owl mirror," and the inscription *Vuilen-Spieghel* written underneath the image is a pun on his name and means "dirty mirror." Although one can barely speak of a narrative, the print in the center of the background could be an attempt at attaching a moral message, whether satirical or not, to the rather clumsy depiction of the humble breakfast in the foreground. For an extensive iconographic analysis of the potential moral message of this painting, see Segal, *Prosperous Past*, 39–45.

13. For the meaning of these piles of cheese, see Joshua Bruyn, "Dutch Cheese: A Problem of Interpretation," *Simiolus* 31 (1997): 201–8.

14. Van Hoogstraten points out that objects should look as if they are copied from reality rather than as reality. Hoogstraten, *Inleyding*, 25.

15. See chapter 1.

16. Israel, "Adjusting to Hard Times"; Montias, "Cost and Value"; North, *Art and Commerce*.

17. This is surprising considering the high level of realism with which the breakfasts are executed. Most still-life painters (Jan Jansz. den Uyl [1595–1640] is a notable example) never fail to "decorate" the walls in their paintings with irregularities such as cracks, nails that cast small shadows, or nail holes, in order to reinforce their pictures' realism.

18. Riegl's work has been published in English as *The Group Portraiture of Holland*, trans. Evelyn M. Kain and David Britt (Los Angeles: Getty Research Center, 1999).

19. Riegl, *Group Portraiture*, 259.

20. "In Rembrandt's anatomy lesson, the interior is defined as never before. . . . [T]he space is delimited not only at the sides but also at the top. . . . There is no doubt about it: this room, filled with spatial shadow that flows into every corner, makes us realize as never before that the figures in the scene before us are enveloped in free space. The painting leaves one conscious not only of the figures, which had always dominated until now, but also of the free space that flows around them." Ibid., 263.

21. Vroom, *Modest Message*, 123.

22. Heda created a similar painting in the same year, *Banquet Piece with Mince Pie* (Washington, D.C., National Gallery), where analogous pairs surround a gilded goblet that is situated on the left side of the painting, virtually mirroring the composition of *Still Life with Gilt Goblet*, so that the two paintings themselves become twins.

23. Bryson, *Looking at the Overlooked*, 121.

24. Paul Claudel sees still lifes as dedicated to a transcendental beyond that lies outside of the painting's frame, and perhaps even outside painting as such. "Introduction to Dutch Painting," in *The Eye Listens*, trans. E. Pell (New York: Philosophical Library, 1950), 1–52.

25. Epigones of Claesz. and Heda, such as Jan Jansz. den Uyl, largely maintained the simple table arrangement but began to add nails and niches to the background, transforming the void into a wall. One of the few exceptions to this trend includes Harmen Steenwijck, who designed *vanitas* arrangements on a tabletop placed against an empty background but abolished the monochrome palette in favor of bright pinks and greens.

26. Segal, *Prosperous Past*, 35ff.

27. See, for instance, Bergström, *Dutch Still-Life Painting*; Segal, *Prosperous Past*; and C. Sterling, *Still Life Painting: From Antiquity to the Twentieth Century*, trans. J. Emmons (New York: Harper & Row, 1981).

28. See chapter 1.

29. In the past, these two texts were considered separate essays instead of two sections of one work. Citations here are from "The Mind of the Geometrician" and "The Art of Persuasion." My discussion of Pascal's text is largely based on Paul de Man's essay "Pascal's Allegory of Persuasion," in *Aesthetic Ideology*, ed. A. Warminski (Minneapolis: University of Minnesota Press, 1996), 51–69.

30. Pascal, "The Mind of the Geometrician," 189.

31. Ibid., 195.

32. Ibid., 191. Interestingly, Pascal provides as an example of the absurdity of defining self-evident words the word "light": "There are some people who go to such absurd lengths as to explain a word by the same word. I know of some who have defined light as follows: *Light is a luminary motion of luminous bodies*, as if we could understand the words *luminary* and *luminous* without the word *light*." His example thus becomes as clear as the meaning of the word he uses as an example. Ibid., 192.

33. Ibid., 187.

34. Christine Buci-Glucksmann, *La folie du voir: De l'esthétique baroque* (Paris: Editions Galilée,

1986). See also Michael Ann Holly, "Imagining the Baroque," in *Past Looking: Historical Imagination and the Rhetoric of the Image* (Ithaca: Cornell University Press, 1996), 91–111.

35. Gilles Deleuze, *The Fold: Leibniz and the Baroque*, trans. Tom Conley (Minneapolis: University of Minnesota Press, 1993), chap. 3, "What Is Baroque?"

36. De Man, "Pascal's Allegory," 59.

37. Ibid., 57.

38. Sam Segal, *Jan Davidsz de Heem en zijn kring* (The Hague: SDU Publishers, 1991). One of De Heem's paintings carries as its title an inscription found in the painting: "Not How Much, But How Noble" [Niet hoeveel, maar hoe e'el]. Johannes Torrentius's enigmatic still life *Emblematic Still Life with Flagon, Glass, Jug and Bridle* (1614) shows a sheet of music with this text: "What exists beyond measure (order) / in over-measure (disorder) will meet a bad end." [Wat buten maat bestaat / int onmaats qaat verghaat.] For a beautiful discussion of Torrentius's painting, see Zbigniew Herbert, *Still Life with a Bridle: Essays and Apocryphas*, trans. John and Bogdana Carpenter (New York: Ecco Press, 1991), chap. 5, "Still Life with a Bridle."

39. The history of the display of abundance can be traced back to the market pieces of Aertsen and Beuckelaer, whose stacks of food may have been exaggerated for rhetorical effect. In the context of Raupp's and Falkenburg's interpretations of the market piece as satire, or paradoxical *encomium*, we may consider the possibility of reading a slight irony into the abundance that De Heem displays.

40. Schama, *Embarrassment of Riches*, chap. 3, "Feasting, Fasting and Timely Atonement."

41. See chapter 1.

42. Bryson, *Vision and Painting*, chap. 3, "Perceptualism.".

43. The discussion of iconography and the limits of interpretation intensified with the publication of Svetlana Alpers's *The Art of Describing: Dutch Art in the Seventeenth Century* (Chicago: University of Chicago Press) in 1983 and with Peter Hecht's exhibition of works by the Fijnschilders (Fine Painters) a few years later, reinforced by an accompanying catalog. As formalists, though in quite different ways, Alpers and Hecht both depart from the iconological approach spearheaded by Eddy de Jongh. See, for instance, de Jongh's "The Interpretation of Still-Life Paintings" and "Some Notes on Interpretation," in *Art in History, History in Art: Studies in Seventeenth-Century Dutch Culture*, ed. David Freedberg and Jan de Vries (Santa Monica, CA: Getty Center Publiction Programs, 1991). More recently, the problem has been reconsidered in Anne W. Lowenthal, ed., *The Object as Subject: Studies in the Interpretation of Still Life* (Princeton: Princeton University Press, 1996). See also my introduction.

44. I am following Michael Ann Holly's argument in "Witnessing an Annunciation" that pictorial strategies may anticipate—or even predict—particular methodologies of looking and interpretation.

45. Jean-Luc Marion, *La croisée du visible* (Paris: Presses Universitaires de France, 1996), 1–46.

CHAPTER THREE

1. Holbein's skull is today the best-known instance of anamorphosis, in large part because Lacan uses this picture in *Seminar XI* to illuminate his understanding of the schism between the eye and the gaze. If it were not for Jurgis Baltrušaitis's excellent work, the history of this curious art form most likely would have remained virtually unknown. His now classic *Anamorphoses; ou, Thaumaturgus Opticus; Les Perspectives Dépravées* (Paris: Flammarion, 1996), published for the first time in 1955 and revised in 1984, has preserved the peculiarity and the many varieties, stages, and meanings of anamorphic art that otherwise would have been forgotten or would have remained at least inaccessible. Apart from primary texts on perspective, hardly any documentation on the topic exists before 1955, while publications that have appeared after this all name Baltrušaitis's book as the fundamental and almost exclusive source, as do I. Research on anamorphic art is still marginal. Most of the articles that have been published lack the profundity and brilliance of Baltrušaitis and hardly contribute to what he already has presented. See, for instance, Brigitte Burgmer, "Studies on Holographic Anamorphosis: 500 Years After," *Leonardo* 22, nos. 3/4 (1989): 379–82; Daniel L. Collins, "Anamorphosis and the

Eccentric Observer: Inverted Perspective and the Construction of the Gaze I and II," *Leonardo* 25, no. 1 (1992): 73–82, no. 2 (1992): 179–87; Salvatore Naitza, "Tra regola e licenza: Considerazioni sulle prospettive anamorfiche," in *La Prospettiva rinascimentale: Codificazioni e trasgressioni*, ed. Marisa Dalai Emiliani (Florence: Centro Di, 1980): 487–99; and Kim H. Veltman, "Perspective, Anamorphosis and Vision," *Marburger Jahrbuch für Kunstwissenschaft* 21 (1986): 93–117.

2. William Shakespeare, *Richard II*, act II, sc. 2, quoted in Erwin Panofsky, *Galileo as a Critic of the Arts* (The Hague: Nijhoff, 1954), 14.

3. Baltrušaitis, *Anamorphoses*, 118.

4. "En peinture, anamorphose se dit d'une projection monstrueuse ou d'une représentation défigurée de quelque image qui est faite sure un plan et qui néanmoins, à un certain point de vue, paroit régulière et faite avec des justes proportions." Denis Diderot and Jean Le Rond d'Alembert, *L'Encyclopédie* (Paris, 1751), 1:404, quoted in Baltrušaitis, *Anamorphoses*, 164.

5. Baltrušaitis, *Anamorphoses*, 15.

6. Martin Kemp, *The Science of Art: Optical Themes in Western Art from Brunelleschi to Seurat* (New Haven: Yale University Press, 1990), 54–55.

7. Baltrušaitis, *Anamorphoses*, 51.

8. Although Baltrušaitis quotes a passage from Plato's *Sophist* asserting that some images are beautiful only from a certain point of view—which Baltrušaitis considers a possible reference to antique anamorphic art—Leonardo's sketches of an eye and of a baby's face with closed eyes are generally considered to be the first anamorphoses.

9. See chapter 1.

10. Lomazzo, *Traité de la Peinture* (1584), chapter XIX of book VI, quoted in Baltrušaitis, *Anamorphoses*, 35.

11. Martin Kemp, ed., *Leonardo on Painting: An Anthology of Writings by Leonardo da Vinci with a Selection of Documents Relating to His Career as an Artist*, trans. Margaret Walker (New Haven: Yale University Press, 1989), 60.

12. Erwin Panofsky carefully outlines the state of this discussion around 1927 in *Perspective as Symbolic Form*, trans. Christopher S. Wood (New York: Zone Books, 1991), 78–81n. 8. This discussion has known an extended afterlife, continuing until the early 1970s as a debate between two camps, the one headed by Ernst Gombrich and the other by James Gibson. For the debate on marginal distortions, see, for instance, James J. Gibson, *The Ecological Approach to Visual Perception* (Boston: Houghton Mifflin, 1979); Ernst Gombrich, "The Sky Is the Limit: The Vault of Heaven and Pictorial Vision," in *Perception: Essays in Honor of James J. Gibson*, ed. Robert B. MacLeod and Herbert L. Pick Jr. (Ithaca, NY: Cornell University Press, 1974), 84–94; M. H. Pirenne, *Optics, Painting and Photography* (Cambridge: Cambridge University Press, 1970); Norman Turner, "Some Questions about E. H. Gombrich on Perspective," *Journal of Aesthetics and Art Criticism* 50, no. 2 (1992): 139–150; and Marx Wartofsky, "Visual Scenarios: The Role of Representation in Visual Perception," in *The Perception of Pictures*, vol. 2, ed. M. A. Hagen (New York: Academic Press, 1980).

13. I have based this section on Baltrušaitis, *Anamorphoses*, chap. 5.

14. See Hans Holländer, "On Perspectives," *Daedalus* 11 (1984): 84.

15. In recent years, some murals have been rediscovered behind a layer of paint that had covered them for centuries. Among them are Andrea dal Pozzo's anamorphosis of circa 1680 on the wall of the Casa Professa of the Jesuit order in Rome and an anonymous painting of Saint Peter on the walls of the salle Saint-Pierre in the Jesuit church in Aix-en-Provence, probably painted in the early eighteenth century. On the latter mural, see Pascal Julien, "L'anamorphose murale du college jésuite d'Aix-en-Provence: Jusqu'à Lisbonne par la barbe de saint Pierre," *Revue de l'Art* 4, no. 130 (2000): 17–26.

16. *Catalogus van Psijsische Instrumenten in Teijlers Museum*, Teijlers archief, no. 196, p. 72. "Een glas met vele fasetten geslepen in een koperen buis of zoogenaamde Anamorphus-kijker." See also E. Lefebvre and J. G. de Bruijn, eds., *Catalogus van psijsische instrumenten in Teijlers Museum van Martinus van Marum*, vol. IV (Haarlem: Teylers Museum, 1973), 285–86.

17. Jacques Ozanam, *Récréations mathématiques et physiques* (Paris, 1694), trans. Charles Hutton (London, 1803). See also Lefebvre and de Bruijn, *Martinus van Marum*, 286.

18. I will elaborate on a cylindiral anamorphosis of Charles I in chapter 4.

19. Edgar Allan Poe, "Ligeia," in *Great Short Works of Edgar Allan Poe*, ed. G. R. Thompson (New York: Perennial Library, 1970), 186.

20. Buci-Glucksmann, *La folie du voir*, 41.

21. Ibid., 47.

22. James Elkins, *The Poetics of Perspective* (Ithaca, NY: Cornell University Press, 1994), 234–35.

23. Ibid., 217ff.

24. Wartofsky, "Visual Scenarios." See also Damisch, *Origin of Perspective*, 31.

25. An explanation of perspective, reduced to its bare essentials, is offered in G. ten Doesschate, *Perspective: Fundamentals, Controversials, History* (Nieuwkoop: De Graaf, 1964). For a standard bibliography, see Kim H. Veltman, "Literature on Perspective: A Selected Bibliography (1971–1984)," *Marburger Jahrbuch für Kunstwissenschaft* 21 (1986): 185–207.

26. See for instance Ten Doesschate, "Marginal Distortions" and "Anamorphosis," in *Perspective*, 39–45.

27. See also Erwin Panofsky, "Reality and Symbol in Early Flemish Painting: 'Spiritualia Sub Metaphoris Corporalium,' " in *Early Netherlandish Painting: Its Origins and Character* (New York: Harper & Row, 1971). Panofsky establishes a connection between the somewhat inconsistent system of disguised symbolism and the inadequate application of perspective in Robert Campin's *Mérode Altarpiece*. See also chapter 4.

28. A preoccupation with wholeness, as it manifests itself within art history, necessarily entails blindness. See, for instance, Mieke Bal, "Textuality and Realism" and "Blindness or Insight, Psychoanalysis and Visual Art," in *Reading "Rembrandt."*

29. For an elaborate discussion of Cassirer's influence on Panofsky's ideas, see Michael Ann Holly, "Panofsky and Cassirer," in *Panofsky and the Foundations of Art History* (Ithaca, NY: Cornell University Press, 1984).

30. Ernst Cassirer, *The Philosophy of Symbolic Forms*, trans. Ralph Manheim, 3 vols. (New Haven: Yale University Press, 1955), 1:79.

31. Ibid., 1:77.

32. Damisch, *Origin of Perspective*, 80–81.

33. Ibid.

34. Ibid., 81.

35. For the way in which theories of vision changed under the influence of perspectival developments in the seventeenth century, see Thomas Frangenberg, "The Image and the Moving Eye: Jean Pélering (Viator) to Guidobaldo del Monte," *Journal of the Warburg and Courtauld Institutes* 49 (1986): 150–71.

36. For Burckhardt's rhetoric, see Michael Ann Holly, "Picturing Cultural History" in *Past Looking*, 29–64.

37. For reviews of Damisch's work, see Whitney Davis, "Virtually Straight," *Art History* 19, no. 2 (1996): 434–42; Margaret Iversen, "Orthodox and Anamorphic Perspective," *Oxford Art Journal* 18, no. 2 (1995): 81–84; and Christopher S. Wood, Review of *The Origin of Perspective*, by Hubert Damisch, *Art Bulletin* LXXVII, no. 4 (1995): 677–82.

38. On the topic of Damisch's use of Benveniste's language theory, see Mieke Bal, "First Person, Second Person, Same Person: Narrative as Epistemology," *New Literary History* XXIV (1993): 293–320.

39. For the mathematical aspects in Sánchez Cotán, see Martin S. Soria, "Sánchez Cotán's 'Quince, Cabbage, Melon and Cucumber,' " *Art Quarterly* VIII (1945): 311–18. See also Norman Bryson, "Rhopography," in *Looking at the Overlooked.*

40. Gérard Wajcman, "Tableau," *La Part de l'Oeil*, no. 2 (1990): 147–67.

41. Lacan, *Four Fundamental Concepts.*

42. Ibid., 95.

43. Ibid., 96.

44. "Support de l'image, de ce qui se voit, il est caché par l'image, en rélévant, l'image voile l'écran comme ce qui cache, elle voile le voile; support de la lettre, il est montré comme ce qui cache opacité vide; 'support' de l'objet, il montre ce qu'il cache, il est troué." Wajcman, "Tableau," 150. I thank Laure Katsaros for her assistance with the translation.

45. For an extensive discussion on the meaning of the different objects in this cabinet and their relations to science and humanism, see J. Muylle, " 'Fascinatio,' De betovering van en door het oog: Een 17de-eeuwse toonkast in *trompe l'oeil*: Verhulde kunsttheorie en humanistisch geïnspireerde vorstenspiegel," *De Zeventiende Eeuw* 8, no. 2 (1992): 232—45. See also Koester, *Illusions*, 164—67.

46. Leon Battista Alberti, *On Painting*, trans. John R. Spencer (New Haven: Yale University Press, 1966), 68—69.

47. Damisch, *Origin of Perspective*, 217.

48. Elkins, *Poetics of Perspective*, 251ff.

49. For the relation between anamorphosis and psychoanalysis, see J.-L. Graber, "Autour de l'anamorphose," *L'Effet trompe-l'oeil dans l'art et la psychanalyse*, ed. R. Court (Paris: Dunod, 1988).

50. Kemp, *Science of Art*, 80ff.

51. Deleuze, *The Fold*, 20.

52. Galileo Galilei, *Opere, IX*, quoted in Panofsky, *Galileo as a Critic*, 13.

53. J.-C. Margolin carefully details the relation between anamorphosis and verbal allegory in "Aspects du surréalisme au XVIe siècle: Fonction allégorique et vision anamorphotique," *Bibliothèque d'Humanisme et Renaissance* 39 (1977): 503—30.

54. Michel Foucault, *The Archaeology of Knowledge; and, The Discourse on Language*, trans. A. M. Sheridan Smith (New York: Pantheon Books, 1972).

CHAPTER FOUR

1. For an analysis of Holbein's *The Ambassadors*, see Stephen Greenblatt, *Renaissance Self-Fashioning; From More to Shakespeare* (Chicago: University of Chicago Press, 1980), 11—74.

2. Benjamin, *Origin of German Tragic Drama*, 223; Craig Owens, "The Allegorical Impulse: Toward a Theory of Postmodernism," in *Beyond Recognition: Representation, Power, and Culture*, ed. Scott Stewart Bryson et al. (Berkeley: University of California Press, 1992), 52—53.

3. Paul de Man, "The Rhetoric of Temporality," in *Blindness and Insight: Essays in the Rhetoric of Contemporary Criticism* (Minneapolis: University of Minnesota Press, 1983), 207.

4. Benjamin, *Origin of German Tragic Drama*, 166.

5. "Vanity of vanities, saith the Preacher, vanity of vanities; all is vanity. What profit hath a man of all his labour which he taketh under the sun? One generation passeth away, and another generation cometh, but the earth abideth for ever." Ecclesiastes 1:2—4, King James version.

6. Concerning the *vanitas* paradox, see Louis Marin, "Les traverses de la Vanité," in *Les vanités dans la peinture au XVIIe siècle: Méditations sur la richesse, le dénuement et la rédemption*, ed. Alain Tapié (Caen: Musée des Beaux-Arts, 1990), 21—30; Jean-Luc Marion, "The Reverse of Vanity," in *God without Being: Hors-Texte*, trans. Thomas A. Carlson (Chicago: University of Chicago Press, 1991), 108—38. Concerning *vanitas* painting, see Ingvar Bergström, "The Masters of the Vanitas Still Life," in *Dutch Still-Life Painting in the Seventeenth Century*, trans. Christina Hedström and Gerald Taylor (New York: Hacker Art Books, 1983), 154—90.

7. Ingvar Bergström, "De Gheyn as *Vanitas* Painter," *Oud Holland* 85 (1970): 144.

8. Ibid.

9. Ibid.

10. For the dialectic transformation of reverse and obverse in De Gheyn's *Vanitas*, see Stoichita, *Self-Aware Image*, 28—29.

11. Unless otherwise stated, citations of Benjamin are from *The Origin of German Tragic Drama*.

12. Stoichita, *Self-Aware Image*, 17—30.

13. See also Eliane Escoubas, "The Work of Art as the Reverse of the World," in *The Path of*

Archaic Thinking: Unfolding the Work of John Sallis, ed. Kenneth Maly (New York: State University of New York Press, 1995).

14. Karel van Mander, *Het Schilder-boeck* (Haarlem, 1603–4; facsimile reprint, Utrecht, 1969).

15. Schopenhauer, *World as Will*, 1:50.

16. Owens, "The Allegorical Impulse," 54.

17. G. W. F. Hegel, *Aesthetics: Lectures on Fine Art*, trans. T. M. Knox, 2 vols. (Oxford: Clarendon Press, 1975), 1:399.

18. Celeste Brusati discusses the reflecting figure in Claesz.'s *Vanitas* in "Stilled Lives: Self-Portraiture and Self-Reflection in Seventeenth-Century Netherlandish Still Life Painting," *Simiolus* 20, nos. 2/3 (1990–91): 168–83.

19. Merleau-Ponty, *Visible and the Invisible*, 139; and *Primacy of Perception*, 169.

20. The occasional overturned *roemer* is the sole relic that might directly refer to another *vanitas* maxim: "The glass is empty, the time is over; the candle is expired, man is mute." See Ingvar Bergström, "Notes on the Boundaries of *Vanitas* Significance," in *Ijdelheid der Ijdelheden: Hollandse vanitas-voorstellingen uit de zeventiende eeuw*, exhibition catalog, ed. I. Bergström and M. I. Wurfbain (Leiden: Stedelijk Museum de Lakenhal, 1970).

21. Blaise Pascal, *Pensées*, trans. A. J. Krailsheimer (Harmondsworth: Penguin, 1987), 38 (134–40).

22. Bryson, *Looking at the Overlooked*, 122.

23. Stoichita, *Self-Aware Image*, 279.

24. For details about this painting, see Koester, *Illusions*, 154–58.

25. The Museum of Fine Arts in Boston owns a *Vanitas Still Life* by Gijsbrechts that only displays the *vanitas* niche with the upper right corner detached from a stretcher. In this painting, the maulstick runs across the marble shelf and leans against it. This *vanitas* image, however, has been cut out of a larger canvas that probably had a trompe l'oeil background identical to the one in *Studio Wall*. Koester, *Illusions*, 154–57; Stoichita, *Self-Aware Image*, 268–79.

26. Stoichita, *Self-Aware Image*, 271.

27. Paul de Man, *Allegories of Reading: Figural Language in Rousseau, Nietzsche, Rilke, and Proust* (New Haven: Yale University Press, 1979). See also Warminski, *Readings in Interpretation*, and Warminski's introduction to *Aesthetic Ideology*, by de Man, 1–34.

28. De Man, *Allegories of Reading*, 10.

29. Pascal, *Pensées*, 35 (381–21). The translation is modified.

30. For a discussion of Pascal's fragment in relation to the *vanitas* problematics, see Marin, "Traverses de la Vanité," 21–30.

31. Damisch, *Origin of Perspective*, 54–55.

32. Panofsky, *Perspective as Symbolic Form*, 68.

33. Johann Joachim Winckelmann, "Versuch einer Allegorie, besonders für die Kunst," in *Kleine Schriften und Briefe* (Weimar: H. Böhlaus Nachfolger, 1960), 178.

34. For a discussion of Benjamin's notion of allegory in relation to his philosophical project, see Bainard Cowan, "Walter Benjamin's Theory of Allegory," *New German Critique* 22 (Winter 1981): 109–22.

35. Although the concept of history is central to Benjamin's thought, within the scope of this chapter, I cannot elaborate on this topic. I will, therefore, have to limit myself to observing that probably the clearest (and best-known) image of history that Benjamin sketched is a description of Paul Klee's painting *Angelus Novus* in combination with a fragment of Gerhard Scholem's "Gruss vom Angelus." Benjamin places Klee's angel on Scholem's poem and both merge into one emblem of history. Consequently, Benjamin's ninth "thesis" on the philosophy of history is an allegory, as well as being produced by an allegorical way of reading Klee's angel and Scholem's poem. Benjamin, "Theses on the Philosophy of History," in *Illuminations: Essays and Reflections*, ed. and with an introduction by Hannah Arendt, trans. Harry Zohn (New York: Schocken Books, 1969), 257–58.

36. My discussion of this chapter greatly profited from Christine Buci-Glucksmann, *Baroque Reason: The Aesthetics of Modernity*, trans. Patrick Camiller (London: Sage Publications, 1994);

and Susan Buck-Morss, *The Dialectics of Seeing: Walter Benjamin and the Arcades Project* (Cambridge, MA: MIT Press, 1991). On the notion of allegory, see Gail Day, "Allegory: Between Deconstruction and Dialectics," *Oxford Art Journal* 22, no. 1 (1999): 103–19; Joel Fineman, "The Structure of Allegorical Desire," *October* 12 (Spring 1980): 47–66; Angus Fletcher, *Allegory: The Theory of a Symbolic Mode* (Ithaca, NY: Cornell University Press, 1964); and Edwin Honig, *Dark Conceit: The Making of Allegory* (London: Faber and Faber, 1959).

37. De Man, "Rhetoric," 207.

38. Heinrich Wölfflin, *Principles of Art History: The Problem of the Development of Style in Later Art* (New York: Dover, 1952), 158.

39. Gombrich, *Art and Illusion*, 122.

40. Ibid., 134.

41. Warminski discusses Gombrich's example in his analysis of Hölderlin's poetry: "Hölderlin in France," in *Readings in Interpretation*, 42–44.

42. Gombrich, *Art and Illusion*, 328.

43. Joel Snyder, "Picturing Vision," in *The Language of Images*, ed. W. J. T. Mitchell (Chicago: University of Chicago Press, 1980), 219–47.

44. Heidegger, "What Calls for Thinking?"

45. Panofsky, *Early Netherlandish Painting*, 1:143.

46. Christopher S. Wood, "Review of *Jan van Eyck: The Play of Realism*, by Craig Harbison; *Petrus Christus: His Place in Fifteenth-Century Flemish Painting*, by Joel M. Upton; *The Reality of Symbols: Studies in the Iconology of Netherlandish Art 1400–1800*, by Jan Baptiste Bedaux," *Art Bulletin* LXXV, no. 1 (March 1993): 174–80.

47. Panofsky, *Early Netherlandish Painting*, 77.

CONCLUSION

1. Ann Banfield, "L'imparfait de l'objectif: The Imperfect of the Object Glass," *Camera Obscura* 24 (1990): 79.

2. Roland Barthes, "The World as Object," in *Calligram: Essays in New Art History from France*, ed. Norman Bryson (Cambridge: Cambridge University Press, 1988), 107.

3. Alpers, *Art of Describing*, 91.

4. Alpers's argument is based on Foucault's observation with regard to the classification of knowledge developed in *The Order of Things*. Alpers, *Art of Describing*, 79.

5. Paul Claudel, "Introduction to Dutch Painting," in *The Eye Listens*, trans. E. Pell (New York: Philosophical Library, 1950), 48.

6. Barthes, "World as Object," 107.

7. Ibid., 108.

8. Ibid., 114–15.

9. Merleau-Ponty, *Primacy of Perception*, 181.

10. Eliane Escoubas, *L'espace pictural* (Paris, Editions Galilée, 1995), 14 (my translation).

BIBLIOGRAPHY

PRIMARY SOURCES

Angel, Philips. *Lof der schilderkunst.* Leiden, 1642.

Hoogstraten, Samuel van. *Inleyding tot de hooge schoole der schilderkonst, anders de zichtbare werelt.* Rotterdam, 1678.

Houbraken, Arnold. *De groote schouburgh der nederlandtsche konstschilders—en schilderessen.* The Hague, 1753. Facsimile reprint, Amsterdam, 1976.

Junius, Franciscus. *The painting of the ancients in three bookes.* London, 1638.

Lairesse, Gerard de. *Groot Schilderboek.* 1707. Haarlem: Johannes Marschoon, 1740.

Leonardo da Vinci. *Codex Atlanticus.* 1483–1518. Fascimile reprint, Bibliotheek Rijksmuseum, Amsterdam.

Mander, Karel van. *Het Schilder-boeck.* Haarlem, 1603–4. Fascimile reprint, Utrecht, 1969.

Marlois, Samuel. *Opera mathematica . . .* The Hague, 1614.

————. *Perspective dat is: de doorsichtige . . .* Amsterdam, 1638.

Nicéron, Jean-François. *La perspective curieuse ou magie artificielle des effet merveilleux.* Paris, 1638. Biblioteca Thysiana, Leiden.

Piles, Roger de. *Abregé de la vie des peintres . . .* 2nd ed., rev. and corr. Paris, 1715.

Visscher, Roemer. *Sinnepoppen.* Amsterdam, 1604.

Willigen, A. van der. *Les artists de harlem: Notices historiques avec un precis sur la gilde de St. Luc.* Haarlem, 1870. Fascimile reprint, Nieuwkoop, 1970.

SECONDARY SOURCES

Ackermann, Jan. "Leonardo's Eye." *Journal of the Warburg and Courtauld Institutes* 41 (1978): 108–46.

Agamben, Giorgio. *The Man without Content.* Minneapolis: University of Minnesota Press, 1998.

Alberti, Leon Battista. *On Painting.* Translated by John R. Spencer. New Haven: Yale University Press, 1966.

————. *On Painting and On Sculpture: The Latin Texts of De Pictura and De Statua.* Edited and translated by Cecil Grayson. London: Phaidon, 1972.

Allen, Richard. "Representation, Illusion, and the Cinema." *Cinema Journal* 32, no. 2 (Winter 1993): 21–48.

Alpers, Svetlana. *The Art of Describing: Dutch Art in the Seventeenth Century.* Chicago: University of Chicago Press, 1983.

————. "Describe or Narrate? A Problem in Realistic Representation." *New Literary History* VIII (Autumn 1976): 15–41.

Alphen, Ernst van. *Francis Bacon and the Loss of Self.* London: Reaktion Books, 1992.

————. "Reading Visually." *Style* 22 (1988): 219–29.

Althusser, Louis. "A Letter on Art in Reply to André Daspre (1966)." In *Marxist Literary Theory: A Reader,* edited by Terry Eagleton and Drew Milne, 269–75. Cambridge: Cambridge University Press, 1996.

Bal, Mieke. "First Person, Second Person, Same Person: Narrative as Epistemology." *New Literary History* XXIV (1993): 293–320.

—————. *The Mottled Screen: Reading Proust Visually.* Translated by Anna-Louise Milne. Stanford: Stanford University Press, 1997.

—————. *Narratology: Introduction to the Theory of Narrative.* Translated by Christine van Boheemen. Toronto: University of Toronto Press, 1985.

—————. *On Meaning-Making: Essays in Semiotics.* Sonoma, CA: Polebridge Press, 1994.

—————. *Reading "Rembrandt": Beyond the Word-Image Opposition.* Cambridge: Cambridge University Press, 1991.

Baltrušaitis, Jurgis. *Anamorphoses; ou, Thaumaturgus Opticus; Les Perspectives Dépravées.* Paris: Flammarion, 1996. Translated by W. J. Strachan as *Anamorphic Art.* New York: Harry N. Abrams, 1977.

Banfield, Ann. "L'imparfait de l'objectif: The Imperfect of the Object Glass." *Camera Obscura* 24 (1990): 65–87.

Bann, Stephen. *The Inventions of History: Essays on the Representation of the Past.* Manchester: Manchester University Press, 1990.

—————. *The True Vine: On Visual Representation and Western Tradition.* Cambridge: Cambridge University Press, 1989.

Barthes, Roland. *Camera Lucida: Reflections on Photography.* Translated by Richard Howard. New York: Hill and Wang, 1981.

—————. "Diderot, Brecht, Eisenstein." In *Image-Music-Text.* Translated by Stephen Heath, 69–78. New York: Noonday Press, 1977.

—————. "The Reality Effect." In *The Rustle of Language.* Translated by Richard Howard, 141–49. Berkeley: University of California Press, 1989.

—————. "Rhetoric of the Image." In *Image-Music-Text.* Translated by Stephen Heath, 32–51. New York: Noonday Press, 1977.

—————. "The World as Object." In *Calligram: Essays in New Art History from France*, edited by Norman Bryson. Cambridge: Cambridge University Press, 1988.

Battersby, Martin. *Trompe l'Oeil = The Eye Deceived.* New York: St. Martin's Press, 1974.

Battock, Gregory. *Super Realism: A Critical Anthology.* New York: Dutton, 1975.

Baudrillard, Jean. "The Trompe-l'Oeil." In *Calligram: Essays in New Art History from France*, edited by Norman Bryson, 53–62. Cambridge: Cambridge University Press, 1988.

Baxandall, Michael. *Patterns of Intention: On the Historical Explanation of Pictures.* New Haven: Yale University Press, 1985.

Bedaux, J. B. *The Reality of Symbols: Studies in the Iconology of Netherlandish Art 1400–1800.* Maarssen: SDU, 1990.

Benjamin, Walter. *Illuminations: Essays and Reflections.* Edited and with an introduction by Hannah Arendt. Translated by Harry Zohn. New York: Schocken Books, 1978.

—————. *The Origin of German Tragic Drama.* Translated by John Osborne. London: Verso, 1998.

—————. "A Short History of Photography." In *One-Way Street, and Other Writings.* Translated by Edmund Jephcott and Kingsley Shorter. London: NLB, 1979.

Bergström, Ingvar. "De Gheyn as *Vanitas* Painter." *Oud Holland* 85 (1970): 139–49.

—————. "Disguised Symbolism in 'Madonna' Pictures and Still Life." Parts 1 and 2. *The Burlington Magazine* 63 no. 97 (1955): 303–8; no. 98 (1955): 342–49.

—————. *Dutch Still-Life Painting in the Seventeenth Century.* Translated by Christina Hedström and Gerald Taylor. New York: Hacker Art Books, 1983.

—————. "Notes on the Boundaries of *Vanitas* Significance." In *Ijdelheid der Ijdelheden: Hollandse vanitas-voorstellingen uit de zeventiende eeuw.* Exhibition catalog, edited by I. Bergström and M. I. Wurfbain. Leiden: Stedelijk Museum de Lakenhal, 1970.

Blanchard, Marc Eli. "Writing the Museum: Diderot's Bodies in the *Salons.*" In *Diderot, Digression and Dispersion: A Bicentennial Tribute*, edited by Jack Undank and Herbert Josephs, 21–36. Lexington, KY: French Forum Publishers, 1984.

Bok, Marten Jan. *Vraag en aanbod op de Nederlandse kunstmarkt, 1580–1700.* Utrecht: Universiteit Utrecht, 1994.

Bol, L. J. *Holländische maler des 17. Jahrhunderts nahe den grossen Meistern Landschaften und Stilleben.* Braunschweig: Klinkhardt & Biermann, 1969.

Bolger, Doreen. "Cards and Letters from His Friends: Mr. Huling's Rack Picture by William Michael Harnett." *American Art Journal* 22, no. 2 (1990): 4–32.

—————. "The Early Rack Paintings of John F. Peto: 'Beneath the Nose of the Whole World.' " In *The*

Object as Subject: Studies in the Interpretation of Still Life, edited by Anne Lowenthal, 4–32. Princeton, Princeton Univiversity Press, 1993.

Bomford, David. "Perspective, Anamorphosis, and Illusion: Seventeenth-Century Dutch Peep Shows." *National Gallery Technical Bulletin* XI (1987): 60–85.

Bonnefis, Philippe. "The Melancholic Describer." *Yale French Studies* 61 (1981): 24–35.

Brown, Christopher. "Samuel van Hoogstraten: Perspective and Painting." *National Gallery Technical Bulletin* XI (1987): 60–85.

Brusati, Celeste. *Artifice and Illusion: The Art and Writing of Samuel van Hoogstraten.* Chicago: University of Chicago Press, 1995.

————. "Honorable Deception and Dubious Distinctions: Self-Imagery in *Trompe-l'Oeil.*" In *Illusions: Gijsbrechts, Royal Master of Deception,* edited by Olaf Koester, 49–74. Copenhagen: Statens Museum for Kunst, 1999.

————. "Stilled Lives: Self-Portraiture and Self-Reflection in Seventeenth-Century Netherlandish Still Life Painting." *Simiolus* 20, nos. 2/3 (1990–91): 168–83.

Bruxelles, Galerie du Crédit Communal. *L'Art Gourmand.* Bruxelles: Crédit Communal, 1996.

Bruyn, Joshua. "Dutch Cheese: A Problem of Interpretation." *Simiolus* 31 (1997): 201–8.

Bryson, Norman. "The Gaze in the Expanded Field." In *Vision and Visuality,* edited by Hal Foster. Seattle: Bay Press, 1988.

————. *Looking at the Overlooked: Four Essays on Still Life Painting.* Cambridge, MA: Harvard University Press, 1990.

————. *Vision and Painting: The Logic of the Gaze.* Houndsmill: Macmillan Press, 1983.

————. *Word and Image: French Painting of the Ancien Régime.* Cambridge: Cambridge University Press, 1981.

Bryson, Norman, Michael Ann Holly, and Keith Moxey. *Visual Culture: Images and Interpretations.* Hanover, NH: University Press of New England, 1994.

Buci-Glucksmann, Christine. *Baroque Reason: The Aesthetics of Modernity.* Translated by Patrick Camiller. London: Sage Publications, 1994.

————. *La folie du voir: De l'esthétique baroque.* Paris: Editions Galilée, 1986.

Buck-Morss, Susan. *The Dialectics of Seeing: Walter Benjamin and the Arcades Project.* Cambridge, MA: MIT Press, 1991.

Burgin, Victor. "Diderot, Barthes, Vertigo." In *The End of Art Theory: Criticism and Postmodernity.* London: Macmillan, 1986.

Burgmer, Brigitte. "Studies on Holographic Anamorphosis: 500 Years After." *Leonardo* 22, nos. 3/4 (1989): 379–82.

Cadava, Eduardo. *Words of Light: Thesis on the Photography of History.* Princeton: Princeton University Press, 1997.

Cartwright, Michael. "Diderot's Discursive Eye: Peripatetics and the Search for Harmony." In *Diderot, Digression and Dispersion: A Bicentennial Tribute,* edited by Jack Undank and Herbert Josephs, 72–84. Lexington, KY: French Forum Publishers, 1984.

Cassirer, Ernst. *The Philosophy of Symbolic Forms.* Translated by Ralph Manheim. 3 vols. New Haven: Yale University Press, 1955.

Cataldi, Sue L. *Emotion, Depth, and Flesh: A Study of Sensitive Space: Reflections on Merleau-Ponty's Philosophy of Embodiment.* Albany: State University of New York Press, 1993.

Catalogus van Psijsische Instrumenten in Teijlers Museum. Teijlers archief, no. 196.

Caygill, Howard. *A Kant Dictionary.* London: Blackwell, 1995.

————. *Kant's Critical Philosophy: The Doctrine and the Faculties.* Translated by Hugh Tomlinson and Barbara Habberjam. Minneapolis: University of Minnesota Press, 1984.

Charpentrat, Pierre. "Le Trompe l'oeil." *Nouvelle revue de psychanalyse* 4 (Autumn 1971): 161–68.

Chong, Alan, and Wouter Kloek. *Still-Life Paintings from the Netherlands, 1550–1720.* Exhibition catalog, Rijksmuseum, Amsterdam. Zwolle: Waanders Uitgevers, 1999.

Claudel, Paul. "Introduction to Dutch Painting." In *The Eye Listens.* Translated by E. Pell, 1–52. New York: Philosophical Library, 1950.

Cohen, Huguette. "Diderot's Awareness of the Limits of Literature in the *Salons.*" *Studies on Voltaire and the 18th Century* 264 (1989): 1172–75.

Colin, Gordon, ed. *Power/Knowledge: Selected Interviews and Other Writings, 1972–1977*. New York: Pantheon, 1980.

Collins, Daniel L. "Anamorphosis and the Eccentric Observer: Inverted Perspective and the Construction of the Gaze I and II." *Leonardo* 25, no. 1 (1992): 73–82; no. 2 (1992): 179–87.

Copjec, Joan. *Read My Desire: Lacan against the Historicists*. Cambridge, MA: MIT Press, 1994.

Cowan, Bainard. "Walter Benjamin's Theory of Allegory." *New German Critique* 22 (Winter 1981): 109–22.

Cowart, Jack. *New/Photo Realism; Painting and Sculpture of the 1970's*. Hartford, CT: Wadsworth Atheneum, 1974.

Crary, Jonathan. *Techniques of the Observer: On Vision and Modernity in the Nineteenth Century*. Cambridge, MA: MIT Press, 1990.

Crimp, Douglas. *On the Museum's Ruins*. Cambridge, MA: MIT Press, 1993.

Crow, Thomas. "Diderot's Salons: Public Art and the Mind of the Private Critic." Introduction to *Diderot on Art*. Vol. 1, *The Salon of 1765 and Notes on Painting*, edited and translated by John Goodman. New Haven: Yale University Press, 1995.

Damisch, Hubert. *The Origin of Perspective*. Translated by John Goodman. Cambridge MA: MIT Press, 1995.

————. "The Underneaths of Painting." *Word and Image* 1 (1985): 200–24.

Davis, Whitney. "Virtually Straight." *Art History* 19, no. 2 (1996): 434–42.

Day, Gail. "Allegory: Between Deconstruction and Dialectics." *Oxford Art Journal* 22, no. 1 (1999): 103–19.

Deleuze, Gilles. *Cinema 2: The Time-Image*. Translated by Hugh Tomlinson and Robert Galeta. Minneapolis: University of Minnesota Press, 1997.

————. *The Fold: Leibniz and the Baroque*. Translated by Tom Conley. Minneapolis: University of Minnesota Press, 1993.

Delsaute, Jean-Luc. "The Camera Obscura and Painting in the Sixteenth and Seventeenth Centuries." *National Gallery Technical Bulletin* XI (1987): 111–23.

De Man, Paul. *Allegories of Reading: Figural Language in Rousseau, Nietzsche, Rilke, and Proust*. New Haven: Yale University Press, 1979.

————. "Pascal's Allegory of Persuasion." In *Aesthetic Ideology*. Edited by A. Warminski, 51–69. Minneapolis: University of Minnesota Press, 1996.

————. *The Resistance to Theory*. Minneapolis: University of Minnesota Press, 1986.

————. "The Rhetoric of Temporality." In *Blindness and Insight: Essays in the Rhetoric of Contemporary Criticism*. Minneapolis: University of Minnesota Press, 1983.

Demetz, Peter. "Defenses of Dutch Painting and the Theory of Realism." *Comparative Literature* 2 (Spring 1963): 97–115.

Derrida, Jacques. *Edmund Husserl's Origin of Geometry: An Introduction*. Translated by John P. Leavey Jr. Lincoln: University of Nebraska Press, 1989.

————. *Memoirs of the Blind: The Self-Portrait and Other Ruins*. Translated by Pascale-Anne Brault and Michael Naas. Chicago: University of Chicago Press, 1993.

————. *The Truth in Painting*. Translated by G. Bennington and I. McLeod. Chicago: University of Chicago Press, 1987.

Diderot, Denis. *Diderot on Art*. Vol. 1, *The Salon of 1765 and Notes on Painting*, edited and translated by John Goodman. New Haven: Yale University Press, 1995.

————. *Diderot on Art*. Vol. 2, *The Salon of 1767*, edited and translated by John Goodman. New Haven: Yale University Press, 1995.

Diderot, Denis, and Jean Le Rond d'Alembert. *L'Encyclopédie*. Paris, 1751.

Didi-Huberman, Georges. "The Art of Not Describing: Vermeer—The Detail and the Patch." *History of the Human Sciences* 2 (1982): 24–35.

————. *Devant l'image: Question posée aux fins d'une histoire de l'art*. Paris: Editions de Minuit, 1984.

Dillon, M. C., ed. *Merleau-Ponty Vivant*. Albany: State University of New York Press, 1991.

Doesschate, G. ten. *Perspective: Fundamentals, Controversials, History*. Nieuwkoop: De Graaf, 1964.

Duro, Paul. *The Rhetoric of the Frame: Essays on the Boundaries of the Artwork*. Cambridge: Cambridge University Press, 1996.

Ebert-Schifferer, Sybille, ed. *Deceptions and Illusions: Five Centuries of Trompe l'Oeil Painting*. Exhibition catalog. Washington, DC: National Gallery of Art, 2002.

Edgerton, Samuel Y., Jr. *The Renaissance Rediscovery of Linear Perspective.* New York: Harper & Row, 1976.

Elkins, James. *The Poetics of Perspective.* Ithaca: Cornell University Press, 1994.

Ember, Ildikó. *Delights for the Senses: Dutch and Flemish Still-Life Paintings from Budapest.* Wausau, WI: Leigh Yawkey Woodson Art Museum, 1989.

Escoubas, Eliane. *L'espace pictural.* La Versanne: Encre marine, 1995.

————. "The Work of Art as the Reverse of the World." In *The Path of Archaic Thinking: Unfolding the Work of John Sallis,* edited by Kenneth Maly. Albany: State University of New York Press, 1995.

Evans, Dylan. *An Introductory Dictionary of Lacanian Psychoanalysis.* London: Routledge, 1996.

Falkenburg, Reindert L., " 'Alter Einoutus': Over de aard en herkomst van Pieter Aertsens stillleven-conceptie." *Nederlands Kunsthistorisch Jaarboek* 40 (1989): 41–66.

————. "Matters of Taste: Pieter Aertsen's Market Scenes, Eating Habits, and Pictorial Rhetoric in the Sixteenth Century." In *The Object as Subject: Studies in the Interpretation of Still Life,* edited by Anne W. Lowenthal, 13–17. Princeton: Princeton University Press, 1996.

Farbé, Fabrice, and Dominique Chevé. "Les tableaux de trompe l'oeil ou la dénonciation de l'illusion." In *Le Trompe-l'oeil de l'antiquité au XX siècle,* edited by Patrick Maurières, 169–250. Paris: Editions Gallimard, 1996.

Feldstein, Richard, Bruce Fink, and Maire Jaanus, eds. *Reading Seminars I and II: Lacan's Return to Freud.* Albany: State University of New York Press, 1996.

————. *Reading Seminar XI: Lacan's Four Fundamental Concepts of Psychoanalysis.* Albany: State University of New York Press, 1995.

Findler, Paula. "Jokes of Nature and Jokes of Knowledge: The Playfulness of Scientific Discourse in Early Modern Europe." *Renaissance Quarterly* 43 (1990): 292–331.

Fineman, Joel. "The Structure of Allegorical Desire." *October* 12 (Spring 1980): 47–66.

Fink, Bruce. *The Lacanian Subject: Between Language and Jouissance.* Princeton: Princeton University Press, 1995.

Fletcher, Angus. *Allegory: The Theory of a Symbolic Mode.* Ithaca: Cornell University Press, 1964.

Folga-Januszewska, Dorota. "Trompe l'oeil de C.N. Gijsbrechts dans les collections du Musée National de Varsovie." *Bulletin du Musée National de Varsovie* XXII, nos. 2/3 (1981): 52–72.

Foster, Hal. "The Art of Fetishism: Notes on Dutch Still Life." In *Fetishism as Cultural Discourse,* edited by Emily Apter and William Pietz, 251–65. Ithaca: Cornell University Press, 1993.

Foucault, Michel. *The Archaeology of Knowledge; and, The Discourse on Language.* Translated by A. M. Sheridan Smith. New York: Pantheon Books, 1972.

————. *The Order of Things: An Archaeology of the Human Sciences.* New York: Vintage Books, 1973.

Frangenberg, Thomas. "The Image and the Moving Eye: Jean Pélering (Viator) to Guidobaldo del Monte." *Journal of the Warburg and Courtauld Institutes* 49 (1986): 150–71.

Franits, Wayne E., ed. *Looking at Seventeenth-Century Dutch Art: Realism Reconsidered.* Cambridge: Cambridge University Press, 1997.

Freedberg, David. *The Power of Images: Studies in the History and Theory of Response.* Chicago: University of Chicago Press, 1989.

Freedberg, David, and Jan de Vries. *Art in History, History in Art: Studies in Seventeenth-Century Dutch Culture.* Santa Monica, CA: Getty Center Publication Programs, 1991.

Fremlin, Gerald. "What Kind of Thing Is a Map? Not a Globe; Maybe a Picture," and "A Close Relative of Maps: Letter Rack *Trompe l'Oeil." Cartographica* 35, nos. 1/2 (Spring and Summer 1998): 25–36.

Friedländer, M. J. *Mededeeling in the Archief van den Kunsthandel P. de Boer te Amsterdam.* n.p., n.d.

Gadamer, Hans-Georg. *Truth and Method.* Translated by Joel Weinsheimer and Donald Marshall. New York: Crossroad Publishing, 1990.

Gammelbo, Poal. "Cornelius Gijsbrechts of Franciskus Gijsbrechts." *Kunstmuseets Årsskrift* XXXIX–XLII (1959): 125–56.

————. *Dutch Still-Life Painting, from the 16th to the 18th Centuries in Danish Collections.* Copenhagen: Munksgaard, 1960.

Gasten, Andrea. "Dutch Still-Life Painting: Judgments and Appreciation." In *Still-Life in the Age of Rembrandt,* edited by Eddy de Jongh, 13–25. Exhibition catalog. Auckland: Auckland City Art Gallery, 1982.

Gay, Peter, ed. *The Freud Reader.* New York: Norton, 1989.

Gelder, H. E. van. *W.C. Heda, A. van Beyeren, W. Kalf.* Amsterdam: H.J.W. Becht, 1941.

Genette, Gérard. *Narrative Discourse: An Essay in Method.* Translated by Jane E. Lewin. Ithaca: Cornell University Press, 1972.

Gibson, James J. *The Ecological Approach to Visual Perception.* Boston: Houghton Mifflin, 1979.

Gilman, Ernest, B. *The Curious Perspective: Literary and Pictorial Wit in the Seventeenth Century.* New Haven: Yale University Press, 1978.

Goedde, Lawrence. "A Little World Made Cunningly: Dutch Still Life Painting and Ekphrasis." In *Still Lifes of the Golden Age,* 35–44. Exhibition catalog. Washington, DC: National Gallery, 1989.

Gombrich, Ernst. *Art and Illusion: A Study in the Psychology of Pictorial Representation.* Princeton: Princeton University Press, 1972.

————. "The Sky Is the Limit: The Vault of Heaven and Pictorial Vision." In *Perception: Essays in Honor of James J. Gibson,* edited by Robert B. MacLeod and Herbert L. Pick Jr., 84–94. Ithaca: Cornell University Press, 1974.

————. "Tradition and Expression in Western Still Life." In *Meditations on a Hobby Horse, and Other Essays in the Theory of Art,* 95–105. London: Phaidon, 1985.

Graber, J.-L. "Autour de l'anamorphose." In *L'Effet trompe-l'oeil dans l'art et la psychanalyse,* edited by R. Court. Paris: Dunod, 1988.

Greenberg, Clement. "Modernist Painting." In *The New Art: A Critical Anthology,* edited by Gregory Battock, 100–11. New York: Dutton, 1966.

Greenblatt, Stephen. *Renaissance Self-Fashioning: From More to Shakespeare.* Chicago: University of Chicago Press, 1980.

Grimm, Claus. *Still Life: The Flemish, Dutch and German Masters.* Stuttgart: Belser Verlag, 1990.

Haak, Bob. *The Golden Age: Dutch Painters of the Seventeenth Century.* Translated and edited by Elizabeth Willems-Treeman. New York: Stewart, Tabori & Chang, 1984.

Hagen, M. A., ed. *The Perception of Pictures.* 2 vols. New York: Academic Press, 1980.

Hamon, Phillipe. "Rhetorical Status of the Descriptive." *Yale French Studies* 61 (1981): 6–23.

Harrison, Charles, Paul Wood, and Jason Gaiger, eds. *Art in Theory 1648–1815: An Anthology of Changing Ideas.* Oxford: Blackwell, 2000.

Hecht, Peter. "The Debate on Symbol and Meaning in Dutch Seventeenth-Century Art: An Appeal to Common Sense." *Simiolus* 16 (1986): 125–36.

————. *De Hollandse Fijnschilders: van Gerard Dou tot Adriaen van der Werff.* Maarssen: Gary Schwartz SDU, 1989.

————. "Dutch Seventeenth-Century Genre Painting: A Reassessment of Some Current Hypotheses." In *Looking at Seventeenth-Century Dutch Art: Realism Reconsidered,* edited by Wayne E. Franits, 88–97. Cambridge: Cambridge University Press, 1997.

Hegel, G. W. F. *Aesthetics: Lectures on Fine Art.* Vol. 1. Translated by T. M. Knox. Oxford: Clarendon Press, 1975.

Heidegger, Martin. *Being and Time.* Translated by John Macquarrie and Edward Robinson. New York: Harper & Row, 1972.

————. *An Introduction to Metaphysics.* Translated by Ralph Manheim. New York: Doubleday, 1961.

————. "The Origin of the Work of Art." In *Poetry, Language, Thought.* Translated by Albert Hofstadter. New York: Harper & Row, 1971.

————. *The Question Concerning Technology and Other Essays.* Translated by William Lovitt. New York: Harper Colophon Books, 1977.

————. "The Thing." In *Poetry, Language, Thought.* Translated by Albert Hofstadter. New York: Harper & Row, 1971.

————. "What Calls for Thinking?" Translated by Fred D. Wieck and J. Glenn Gray. In *Basic Writings.* Edited by David Farrell Krell, 369–91. San Francisco: HarperCollins, 1993.

Herbert, Zbigniew. *Still Life with a Bridle: Essays and Apocryphas.* Translated by John Carpenter and Bogdana Carpenter. New York: Ecco Press, 1991.

Hochstrasser, Julie Berger. "Feasting the Eye: Painting and Reality in the Seventeenth-Century 'Banck-etje.'" In *Still-Life Paintings from the Netherlands, 1550–1720,* edited by Alan Chong and Wouter Kloek, 73–86. Exhibition catalog, Rijksmuseum, Amsterdam. Zwolle: Waanders Uitgevers, 1999.

————. "Life and Still Life: A Cultural Inquiry into Seventeenth-Century Still-Life Painting." Ph.D. diss., University of California, Berkeley, 1995.

Hoeller, Keith, ed. *Merleau-Ponty and Psychology*. New Jersey: Humanities Press, 1994.

Holländer, Hans. "On Perspectives." *Daedalus* 11 (1984): 84–94.

Holly, Michael Ann. *Past Looking: Historical Imagination and the Rhetoric of the Image*. Ithaca: Cornell University Press, 1996.

————. *Panofsky and the Foundations of Art History*. Ithaca: Cornell University Press, 1984.

Honig, Edwin. *Dark Conceit: The Making of Allegory*. London: Faber and Faber, 1959.

Honig, Elizabeth. "Making Sense of Things: On the Motives of Dutch Still Life." *Res* 34 (Autumn 1998): 166–83.

————. *Painting and the Market in Early Modern Antwerp*. New Haven: Yale University Press, 1998.

Houghton, Charlotte. "This Was Tomorrow: Pieter Aertsen's *Meat Stall* as Contemporary Art." *Art Bulletin* 86, no. 2 (June 2004): 277–300.

Huizinga, Johan. *Nederland's beschaving in de zeventiende eeuw*. Haarlem: H. D. Tjeenk Willink, 1941.

Israel, Jonathan I. "Adjusting to Hard Times: Dutch Art during Its Period of Crisis and Restructuring (c. 1621–c. 1645)." *Art History* 20, no. 3 (September 1997): 449–76.

Iversen, Margaret. "Orthodox and Anamorphic Perspective." *Oxford Art Journal* 18, no. 2 (1995): 81–84.

————. "What Is a Photograph?" *Art History* 17, no. 3 (1994): 450–64.

Ivins, William M., Jr. *Art and Geometry; A Study in Space Intuitions*. New York: Dover, 1946.

Jacquette, Dale. "Schopenhauer on the Antipathy of Aesthetic Genius and the Charming." *History of European Ideas* 18, no. 3 (May 1994): 373–85.

Jansen, Guido M. C. " 'On the Lowest Level': The Status of the Still Life in Netherlandish Art Literature of the Seventeenth Century." In *Still-Life Paintings from the Netherlands, 1550–1720*, edited by Alan Chong and Wouter Kloek, 51–57. Exhibition catalog, Rijksmuseum, Amsterdam. Zwolle: Waanders Uitgevers, 1999.

Jay, Martin. *Downcast Eyes: The Denigration of Vision in Twentieth-Century French Thought*. Berkeley: University of California Press, 1993.

Jongh, Eddy de. "The Interpretation of Still Life Paintings: Possibilities and Limits." In *Still-Life in the Age of Rembrandt*, edited by Eddy de Jongh 27–38. Auckland: Auckland City Art Gallery, 1982.

————. "Some Notes on Interpretation." In *Art in History, History in Art: Studies in Seventeenth-Century Dutch Culture*, edited by David Freedberg and Jan de Vries. Santa Monica, CA: Getty Center Publication Programs, 1991.

Julien, Pascal. "L'anamorphose murale du college jésuite d'Aix-en-Provence: Jusqu'à Lisbonne par la barbe de saint Pierre. *Revue de l'Art*, no. 130 (2000): 17–26.

Julien, Philippe. *Jacques Lacan's Return to Freud: The Real, the Symbolic, and the Imaginary*. Translated by Devra Beck Simiu. New York: New York University Press, 1995.

Kant, Immanuel. *Critique of Judgment: Including the First Introduction*. Translated by Werner S. Pluhar. New York: Hackett, 1987.

————. *Critique of Pure Reason*. Translated by Norman Kemp Smith. New York: St. Martin's Press, 1965.

Kavaler, Ethan Matt. "Pieter Aertsen's Meat Stall: Divers Aspects of the Market Piece." *Nederlands Kunsthistorisch Jaarboek* 40 (1989): 67–92.

Kemp, Martin. *The Science of Art: Optical Themes in Western Art from Brunelleschi to Seurat*. New Haven: Yale University Press, 1990.

————. *Leonardo on Painting: An Anthology of Writings by Leonardo da Vinci with a Selection of Documents Relating to His Career as an Artist*. Translated by Margaret Walker. New Haven: Yale University Press, 1989.

Koester, Olaf, ed. *Illusions: Gijsbrechts, Royal Master of Deception*. Exhibition catalog. Translated by W. Glynn Jones. Copenhagen: Statens Museum for Kunst, 1999.

Krauss, Rosalind. *The Optical Unconscious*. Cambridge, MA: MIT Press, 1993.

Krieger, Michaela. "Zum Problem des Illusionismus im 14. und 15. Jahrhundert—ein Deutungsversuch." *Bruckmanns Pantheon* LIV (1996): 4–18.

Lacan, Jacques. *The Four Fundamental Concepts of Psychoanalysis*. Edited by Jacques-Alain Miller. Translated by Alan Sheridan. New York: Norton, 1981.

————. "Science and Truth." *Newsletter of the Freudian Field* 3 (1989): 4–29.

—————. *The Seminar of Jacques Lacan.* Book I, *Freud's Papers on Technique, 1953–1954.* Edited by Jacques-Alain Miller. Translated by Sylvana Tomaselli and John Forrester. New York: Norton, 1991.

—————. *The Seminar of Jacques Lacan.* Book VII, *The Ethics of Psychoanalysis, 1959–1960.* Translated by Dennis Porter. New York: Norton, 1992.

Lammers, Joseph. "Fasten under Genuss; Die Angerichtete Tafel als Thema des Stillebens." In *Stilleben in Europa,* edited by Gerhard Langemeyer and Hans Albert Peters, 402–30. Münster: Staatliche Kunsthalle, 1979.

Laplanche, Jean, and Jean-Bertrand Pontalis. *The Language of Psychoanalysis.* New York: Norton, 1973.

Lecercle, Francois. "Le Regard Dédoublé." *Nouvelle Revue de Psychanalyse* 44 (1990): 111–28.

Leeuwen, Titia van. "Still Life Painting in the Netherlands: Historical Facts and Facets." In *Still-Life in the Age of Rembrandt,* edited by Eddy de Jongh. Auckland: Auckland Museum of Art, 1989.

Lefebvre, E., and J. G. de Bruijn, eds. *Catalogus van psijsische instrumenten in Teijlers Museum van Martinus van Marum.* Vol. IV. Haarlem: Teylers Museum, 1973.

Lessing, Gotthold Ephraim. *Laocoön: An Essay on the Limits of Painting and Poetry.* Translated by Edward Allen McGormick. Baltimore: Johns Hopkins University Press, 1989.

Leupin, Alexandre, ed. *Lacan and the Human Sciences.* Nebraska: University of Nebraska Press, 1991.

Levine, Caroline. "Seductive Reflexivity: Ruskin's Dreaded *Trompe l'Oeil.*" *Journal of Aesthetics and Art Criticism* 56, no. 4 (Fall 1998): 367–75.

Lindberg, David C. *Theories of Vision from al-Kindi to Kepler.* Chicago: University of Chicago Press, 1976.

Loughman, John. "The Market for Netherlandish Still Lifes, 1600–1720." In *Still-Life Paintings from the Netherlands, 1550–1720,* edited by Alan Chong and Wouter Kloek, 87–102. Exhibition catalog, Rijksmuseum, Amsterdam. Zwolle: Waanders Uitgevers, 1999.

Lowenthal, Anne W., ed. *The Object as Subject: Studies in the Interpretation of Still Life.* Princeton: Princeton University Press, 1996.

Luijten, Ger, et al., eds. *Dawn of the Golden Age: Northern Netherlandish Art, 1580–1620.* Zwolle: Waanders Uitgevers, 1993.

Lukacs, George. "Narrate or Describe?" In *Writer and Critic, and Other Essays.* Edited and translated by Arthur D. Kahn, 110–48. London: Merlin Press, 1970.

Lyotard, Jean François. *Discours, Figure.* Paris: Klincksieck, 1978.

Madison, Gary Brent. *The Phenomenology of Merleau-Ponty: A Search for the Limits of Consciousness.* Athens: Ohio University Press, 1981.

Mander, Karel van. *The Lives of the Illustrious Netherlandish and German Painters.* Edited and translated by Hessel Miedema. Doornspijk: Davaco, 1994.

Manetti, Antonio di Tuccio. *The Life of Brunelleschi.* Translated by Catherine Enggass. University Park: Pennsylvania State University Press, 1970.

Margolin J.-C. "Aspects du surréalisme au XVIe siècle: Fonction allégorique et vision anamorphotique." *Bibliothèque d'Humanisme et Renaissance* 39 (1977): 503–30.

Marin, Louis. *La Critique du Discours: Sur la "Logique de Port-Royal" et les "Pensées" de Pascal.* Paris: Les Editions de Minuit, 1975.

—————. "The Frame of Representation and Some of Its Figures." In *The Rhetoric of the Frame: Essays on the Boundaries of the Artwork,* edited by Paul Duro, 79–95. Cambridge: Cambridge University Press, 1996.

—————. "Imitation et trompe l'oeil dans la théorie classique de la peinture au XVIIe siècle." In *Rencontres de l'Ecole du Louvre,* 181–96. Paris: Documentation française, 1985.

—————. "Les traverses de la Vanité." In *Les vanités dans la peinture au XVIIe siècle: Méditations sur la richesse, le dénuement et la rédemption,* edited by Alain Tapié, 21–30. Caen: Musée des Beaux-Arts, 1990.

—————. "Mimesis and Description" and "Representation and Simulacrum." In *On Representation.* Translated by Catherine Porter, 252–68, 309–19. Stanford: Stanford University Press, 2001.

—————. "Signe et représentation au XVIIe siècle: Notes sémiotiques sur trois natures mortes." *Revue d'Esthétique* 4 (1971): 402–36.

Marion, Jean-Luc. *God without Being: Hors-Texte.* Translated by Thomas A. Carlson. Chicago: University of Chicago Press, 1991.

—————. *La croisée du visible.* Paris: Presses Universitaires de France, 1996.

Marli, George. "C.N. Gijsbrechts, l'illusionniste." *Connaissance des Arts* 145 (1964): 96–105.

Marrow, James H. "Symbol and Meaning in Northern European Art of the Late Middle Ages and the Early Renaissance." *Simiolus* 16 (1986): 150–169.

Mastai, M.-L. d'Otrange. *Illusion in Art: Trompe l'Oeil, a History of Pictorial Illusionism.* New York: Abaris Books, 1975.

Matthews, Patricia M. "Kant's Sublime: A Form of Pure Aesthetic Reflective Judgment." *Journal of Aesthetics and Art Criticism* 54, no. 2 (1996): 165–80.

Mayer-Meinstschel, Annaliese. "Die Welt auf einem Tish; Das Stilleben under sein Gegenstand." In *Das Stilleben und sein Gegenstand,* edited by Irina Antonowa et al., 15–20. Dresden: Staatliche Kunstsammlungen, 1983.

Mazis, Glen A. "Merleau-Ponty: The Depth of Memory as the Depth of the World." In *The Horizons of Continental Philosophy; Essays on Husserl, Heidegger, and Merleau-Ponty,* edited by Hugh J. Silverman et al., 227–51. Dordrecht: Kluwer Academic Publishers, 1988.

Meijer, Fred G., ed. *Stillevens uit de Gouden Eeuw.* Rotterdam: Museum Boijmans Van Beuningen, 1989.

Meisel, Louis K. *Photorealism.* New York: Harry N. Abrams, 1980.

Merleau-Ponty, Maurice. "Cézanne's Doubt." In *Sense and Non-Sense.* Translated by Hubert L. Dreyfus and Patricia Allen Dreyfus, 9–25. Evanston: Northwestern University Press, 1964.

———. "Eye and Mind." In *The Primacy of Perception, and Other Essays on Phenomenological Psychology, the Philosophy of Art, History, and Politics.* Translated and edited by James M. Edie. Evanston: Northwestern University Press, 1964.

———. *Phenomenology of Perception.* Translated by Colin Smith. London: Routledge, 1994.

———. *The Visible and the Invisible, Followed by Working Notes.* Edited by Claude Lefort. Translated by Alphonso Lingis. Evanston: Northwestern University Press, 1968.

Milman, Miriam. *Trompe l'Oeil Painting: The Illusions of Reality.* Geneva: Skira, 1982.

Montias, J. M. *Artists and Artisans in Delft: A Socio-Economic Study of the Seventeenth Century.* Princeton: Princeton University Press, 1982.

———. "Cost and Value in Seventeenth-Century Dutch Art." *Art History* 10 (1987): 455–66.

Moxey, Keith. "Interpreting Pieter Aertsen: The Problem of 'Hidden Symbolism.'" *Nederlands Kunsthistorisch Jaarboek* 40 (1989): 29–39.

———. "Panofsky's Concept of 'Iconology' and the Problem of Interpretation in the History of Art." *New Literary History* 17 (1985/1986): 265–74.

———. "Perspective, Panofsky, and the Philosophy of History." *New Literary History* 26 (Autumn 1995): 775–86.

———. *Pieter Aertsen, Joachim Beuckelaer, and the Rise of Secular Painting in the Context of the Reformation.* New York: Garland, 1977.

———. *The Practice of Persuasion: Paradox and Power in Art History.* Ithaca: Cornell University Press, 2001.

———. *The Practice of Theory: Poststructuralism, Cultural Politics, and Art History* Ithaca: Cornell University Press, 1994.

Muylle, J. " 'Fascinatio,' De betovering van en door het oog: Een 17de-eeuwse toonkast in *trompe l'oeil*: Verhulde kunsttheorie en humanistisch geïnspireerde vorstenspiegel." *De Zeventiende Eeuw* 8, no. 2 (1992): 232–45.

Naitza, Salvatore. "Tra regola e licenza: Considerazioni sulle prospettive anamorfiche." In *La Prospettiva rinascimentale: Codificazioni e trasgressioni,* edited by Marisa Dalai Emiliani, 487–99. Florence: Centro Di, 1980.

Nancy, Jean-Luc, and Phillippe Lacoue-Labarthe. *The Title of the Letter: A Reading of Lacan.* Translated by François Raffoul and David Pettigrew. Albany: State University of New York, 1992.

Nochlin, Linda. *Realism.* New York: Penguin, 1971.

North, Michael. *Art and Commerce in the Dutch Golden Age.* Translated by Catherine Hill. New Haven: Yale University Press, 1997.

———. "Art and Commerce in the Dutch Republic." In *A Miracle Mirrored: The Dutch Republic in European Perspective,* edited by C. A. Davids and Jan Lucassen. Cambridge: Cambridge University Press, 1995.

Owens, Craig. "The Allegorical Impulse: Toward a Theory of Postmodernism." In *Beyond Recognition: Representation, Power, and Culture,* edited by Scott Stewart Bryson et al. Berkeley: University of California Press, 1992.

Ozanam, Jacques. *Récréations mathématiques et physiques*. 1694. Translated by Charles Hutton. London, 1803.

Panofsky, Erwin. *Early Netherlandish Painting: Its Origins and Character*. 2 vols. New York: Harper & Row, 1971.

————. *Galileo as a Critic of the Arts*. The Hague: Nijhoff, 1954.

————. "Jan Van Eyck's Arnolfini Portrait." *Burlington Magazine* 64 (1934): 117–27.

————. *Meaning in the Visual Arts*. Harmondsworth: Penguin, 1970.

————. *Perspective as Symbolic Form*. Translated by Christopher S. Wood. New York: Zone Books, 1991.

————. "Reality and Symbol in Early Flemish Painting: 'Spiritualia Sub Metaphoris Corporalium.' " In *Early Netherlandish Painting: Its Origins and Character*. New York: Harper & Row, 1971.

————. *Studies in Iconology: Humanistic Themes in the Art of the Renaissance*. New York: Harper & Row, 1962.

Pascal, Blaise. "The Mind of the Geometrician," and "The Art of Persuasion." In *Great Shorter Works of Pascal*. Translated by E. Cailliet and J. C. Blankenagel, 198–211. Philadelphia: Westminister Press, 1948.

————. *Pensées*. Translated by A. J. Krailsheimer. Harmondsworth: Penguin, 1987.

Phillips, James. "Lacan and Merleau-Ponty: The Confrontation of Psychoanalysis and Phenomenology." In *Disseminating Lacan*, edited by David Pettigrew and François Raffoul, 74–87. Albany: State University of New York Press, 1994.

Pirenne, M. H. *Optics, Painting and Photography* . Cambridge: Cambridge University Press, 1970.

Plato. *The Republic*. Translated by A. D. Lindsay. London: Dent and Sons, 1976.

Pliny. *The Elder Pliny's Chapters on the History of Art*. Edited by E. Sellers. Translated by K. Jex-Blake. Munich: n.p., 1896. Reprint, Michigan: Scholarly Press, n.d.

Poe, Edgar Allan. "Ligeia." In *Great Short Works of Edgar Allan Poe*. Edited by G. R. Thompson. New York: Perennial Library, 1970.

————. "The Purloined Letter." In *The Fall of the House of Usher*, 84–102. New York: New American Library, 1960.

Prendeville, Brendan. "Merleau-Ponty, Realism and Painting: Psychophysical Space and the Space of Exchange." *Art History* 22, no. 3 (September 1999): 364–88.

Reeves, Eileen. *Painting the Heavens: Art and Sciences in the Age of Galileo*. Princeton: Princeton University Press, 1997.

Riegl, Aloïs. *Das Holländische Gruppenporträt*. Vienna: n.p., 1931. Translated by Evelyn M. Kain and David Britt as *The Group Portraiture of Holland*. Los Angeles: Getty Research Center, 1999.

Riffaterre, Michael. "Descriptive Imagery." *Yale French Studies* 61 (1981): 36–48.

————. "On the Diegetic Functions of the Descriptive." *Style* 20, no. 3 (1986): 281–94.

Romanyshyn, Robert D. "Unconsciousness as a Lateral Depth: Perception and the Two Moments of Reflection." *Continental Philosophy in America*, edited by Hugh J. Silverman et al., 227–45. Pittsburgh: Duquesne University Press, 1983.

Ronchi, Vasco. *Optics: The Science of Vision*. Translated by Edward Rosen. New York: New York University Press, 1957.

Rose, Jacqueline. *Sexuality in the Field of Vision*. London: Verso, 1996.

Ruurs, Rob. *Saenredam: The Art of Perspective*. Amsterdam/Philadelphia: Benjamin/Forsten Publishers, 1987.

Salecl, Renata, and Slavoj Zizek, eds. *Gaze and Voice as Love Objects*. Durham: Duke University Press, 1996.

Schama, Simon. *The Embarrassment of Riches: An Interpretation of Dutch Culture in the Golden Age*. New York: Vintage Books, 1997.

————. "Perishable Commodities: Dutch Still Life Painting and the 'Empire of Things.' " In *Consumption and the World of Goods*, edited by John Brewer and Roy Porter, 478–88. London: Routledge, 1993.

————. "The Unruly Real: Appetite and Restraint in Seventeenth-Century Holland." *Daedalus* 108, no. 3 (Summer 1979):103–23.

Schapiro, Meyer. "The Apples of Cézanne: An Essay on the Meaning of Still-Life." In *Modern Art, 19th and 20th Centuries: Selected Papers*, 1–38. New York: Braziller, 1978.

————. " 'Muscipula Diaboli': The Symbolism of the Mérode Altarpiece." *Art Bulletin* 27 (1945): 182–87.

————. "The Still Life as a Personal Object—A Note on Heidegger and Van Gogh." In *Theory and Philosophy of Art: Style, Artist, and Society*, 135–42. New York: Braziller, 1994.

Schefer, Jean Louis. *La lumière et la table: Dispositifs de la peinture hollandaise*. Paris: Maeght éditeur, 1997.

Schopenhauer, Arthur. *The World as Will and Representation*. Translated by E. F. J. Payne. New York: Dover, 1969.

Segal, Sam. *Jan Davidsz de Heem en zijn kring*. The Hague: SDU Publishers, 1991.

——. *A Prosperous Past: The Sumptuous Still Life in the Netherlands, 1600–1700*. Edited by William B. Jordan. The Hague: SDU Publishers, 1988.

Sheperdson, Charles. "A Pound of Flesh: Lacan's Reading of *The Visible and the Invisible*." *Diacritics* 27, no. 4 (1997): 70–88.

Siegfried, Susan Locke. "Boilly and the Frame-up of Trompe l'Oeil." *Oxford Art Journal* 15, no. 2 (1992): 27–37.

Silverman, Kaja. *Male Subjectivity at the Margins*. New York: Routledge, 1992.

——. *The Threshold of the Visible World*. New York: Routledge, 1996.

——. *World Spectators*. Stanford: Stanford University Press, 2000.

Sluijter, Eric J. "Belering en verhulling? Enkele zeventiende-eeuwse teksten over de schilderkunst en de iconologische benadering van Noordnederlandse schilderijen uit deze periode." *De Zeventiende Eeuw* 4, no. 2 (1988): 3–28.

——. *De Lof der Schilderkunst: Over Schilderijen van Gerrit Dou (1613–1675) en een Traktaat van Philips Angel uit 1642*. Hilversum: Verloren, 1993.

Smith, A. Mark. *Alhacen's Theory of Visual Perception: A Critical Edition, with English Translation and Commentary, of the First Three Books of Alhacen's* De Aspectibus, *the Medieval Latin Version of Ibn al-Haytham's* Kitab al-Manazir. 2 vols. Philadelphia: American Philosophical Society, 2001.

Snyder, Joel. "Picturing Vision." In *The Language of Images*, edited by W. J. T. Mitchell, 219–47. Chicago: University of Chicago Press, 1980.

Soria, Martin S. "Sanchez Cotán's 'Quince, Cabbage, Melon and Cucumber.'" *Art Quarterly* VIII (1945): 311–18.

Sterling, Charles. *Still Life Painting: From Antiquity to the Twentieth Century*. Translated by J. Emmons. New York: Harper & Row, 1981.

Stoichita, Victor. *The Self-Aware Image: An Insight into Early Modern Meta-Painting*. Translated by Anne-Marie Glasheen. Cambridge: Cambridge University Press, 1997.

Strong, Donald Sanderson. *Leonardo on the Eye: An English Translation and Critical Commentary of MS. D in the Bibliothèque Nationale, Paris, with Studies on Leonardo's Methodology and Theories on Optics*. New York: Garland, 1979.

Sullivan, Margaret A., "Aertsen's Kitchen and Market Scenes: Audience and Innovation in Northern Art." *Art Bulletin* LXXXI, no. 2 (1999): 236–66.

Swan, Claudia. "*Ad vivum, naer het leven*, from the Life: Defining a Mode of Representation." *Word and Image* 11, no. 4 (October–December 1995): 353–72.

Taminiaux, Jacques. "Le penseur et le peintre: Sur Merleau-Ponty." *La Part de l'Oeil* 7 (1991): 39–46.

Tapié, Alain, ed. *Les vanités dans les peinture au XVIIe siècle; Méditations sur la richesse, le dénuement et la rédemption*. Caen: Musée des Beaux-Arts, 1990.

Turner, Norman. "Some Questions about E. H. Gombrich on Perspective." *Journal of Aesthetics and Art Criticism* 50, no. 2 (1992): 139–50.

Vasari, Giorgio. *The Lives of the Artists*. 2 vols. Translated by George Anthony Bull. New York: Penguin, 1987.

Veltman, Kim H. "Literature on Perspective: A Selected Bibliography (1971–1984)." *Marburger Jahrbuch für Kunstwissenschaft* 21 (1986): 185–207.

——. "Perspective, Anamorphosis and Vision." *Marburger Jahrbuch für Kunstwissenschaft* 21 (1986): 93–117.

Vouilloux, Bernard. "La description du tableau dans les *Salons* de Diderot: La figure et le nom." *Poetique* 73 (1988): 27–50.

Vroom, N. R. A. *A Modest Message as Intimated by the Painters of the "Monochrome Banketje."* 2 vols. Schiedam: Interbook International B.V., 1980.

Wajcman, Gérard. *L'objet du siècle*. Lagrasse: Editions Verdier, 1998.

——. "Tableau." *La Part de l'Oeil*, no. 2 (1990): 147–67.

Ward, John L. "Disguised Symbolism as Enactive Symbolism in Van Eyck's Paintings." *Artibus et Historiae* 29 (1994): 9–55.

Warminski, Andrzej. "Introduction: Allegories of Reference." In *Allegories of Reading: Figural Language in Rousseau, Nietzsche, Rilke, and Proust*, by Paul de Man, 1–33. New Haven: Yale University Press, 1979.

——. Introduction to *Aesthetic Ideology*, by Paul de Man. Minneapolis: University of Minnesota Press, 1996.

————. *Readings in Interpretation: Hölderlin, Hegel, Heidegger.* Minneapolis: University of Minnesota Press, 1987.

Wartofsky, Marx. "Visual Scenarios: The Role of Representation in Visual Perception." In *The Perception of Pictures*, vol. 2, edited by M. A. Hagen. New York: Academic Press, 1980.

Weber, Samuel. *The Legend of Freud.* Minneapolis: University of Minnesota Press, 1982.

————. *Return to Freud: Jacques Lacan's Dislocation of Psychoanalysis.* Translated by Michael Levine. Cambridge: Cambridge University Press, 1991.

Wheelock, Arthur K., Jr. "Illusionism in Dutch and Flemish Art." In *Deceptions and Illusions: Five Centuries of Trompe l'Oeil Painting*, edited by Sybille Ebert-Schifferer, 77–90. Exhibition catalog. Washington, DC: National Gallery of Art, 2002.

————. *Perspective, Optics and Delft Artists Around 1650.* New York: Garland, 1977.

————. *Still Lifes of the Golden Age: Northern European Paintings from the Heinz Family Collection.* Washington, DC: National Gallery of Art, 1989.

————. "*Trompe-l'Oeil* Painting: Visual Deception or Natural Truths?" In *The Age of the Marvelous*, edited by Joy Kenseth, 179–91. Exhibition catalog. Hanover, NH: Hood Museum of Art, 1991.

Winckelmann, Johann Joachim. "Versuch einer Allegorie, besonders für die Kunst." *Kleine Schriften und Briefe.* Weimar: H. Böhlaus Nachfolger, 1960.

Wölfflin, Heinrich. *Principles of Art History: The Problem of the Development of Style in Later Art.* New York: Dover, 1952.

Wood, Christopher S. " 'Curious Pictures' and the Art of Description." *Word & Image* 11, no. 4 (October–December 1995): 332–52.

————. Introduction to *Perspective as Symbolic Form*, by Erwin Panofsky. New York: Zone Books, 1991.

————. Review of *Jan van Eyck: The Play of Realism*, by Craig Harbison; *Petrus Christus: His Place in Fifteenth-Century Flemish Painting*, by Joel M. Upton; *The Reality of Symbols: Studies in the Iconology of Netherlandish Art 1400–1800*, by Jan Baptiste Bedaux. *Art Bulletin* LXXV, no. 1 (March 1993): 174–80.

————. Review of *The Origin of Perspective*, by Hubert Damisch. *Art Bulletin* LXXVII, no. 4 (1995): 677–82.

Zizek, Slavoj. *Enjoy Your Symptom! Jacques Lacan in Hollywood and Out.* London: Verso, 1992.

————. *Looking Awry: An Introduction to Jacques Lacan through Popular Culture.* Cambridge, MA: MIT Press, 1993.

Zola, Emile. *Le Ventre de Paris/Savage Paris.* Translated by David Hughes and Marie-Jacqueline Mason. London: Elek Books, 1955.

INDEX

Page numbers followed by an *f* indicate figures.